"Jennifer Allen Craft is one of the most ⟨...⟩gy and the arts today. This book provides ⟨...⟩ in relation to place, a much-neglected topic ⟨...⟩ry widely read."

Jeremy Begbie, Duke University

"This book performs an extraordinary service within the literature of theology and the arts. In far too many cases that conversation has held the arts at arm's length, believing that such cultural entanglements are merely optional. Craft's treatment of art as placemaking resists that foolishness by demonstrating that there is no neutral ground for human life and artistry (i.e., no nonplaced experience). Rather than avoiding the inherent tensions of art and place, she embraces the wonder of God's redemptive activity in a broken world. Through her careful consideration of how the arts enable us to embody a sense of home, experience more rooted and contextualized worship, extend hospitality to friends or strangers, or navigate our place in the world, we come to see that geography and culture mutually determine one another for good or ill. We should be thankful for the ways in which Craft's theological aesthetic of placemaking can restore us to our own imaginations, embedded as they are in specific times and particular communities. More than that, we should accept her invitation to renew these connections with the mutually transformative love of Christ."

Taylor Worley, associate professor of faith and culture at Trinity International University

"Jennifer Craft offers a profound exploration of how art may help us adjust the ways in which we see and inhabit places, and so live in God's world with greater sensitivity, faithfulness, and love. This engaging book is a rich contribution to the growing conversation about theology and place."

Murray Rae, department of theology and religion, University of Otago

"Jennifer Allen Craft's *Placemaking and the Arts* is an elegant and illuminating meditation on the importance of our lived environments. We are called, as both stewards and sojourners, to be deeply present to God's sensory creation—first by recognizing our rootedness within it and second by cultivating it as we were made to do. For Craft, the arts should be understood as the fruit of this connection and care, adorning and shaping the world for all of God's children. Drawing on a wide range of theological insights, *Placemaking and the Arts* points the way toward more humane and hospitable environments today."

Katie Kresser, professor of art at Seattle Pacific University

"In this marvelous book, Jennifer Craft shows us how God is in the business of making grace happen in our respective places on earth—*this* soil, *this* house, *this* street, *this* climate, *this* city, *this* people. What she offers the reader is not only a sorely needed theology of place but also a compelling vision for how the arts inspire us to create hospitable places that anticipate our life together in a fully emplaced kingdom economy."

W. David O. Taylor, Fuller Theological Seminary

"After a couple of generations of neglect and disinvestment, I'm delighted to see that place is being rediscovered within the Christian community as an important aspect of human flourishing. *Placemaking and the Arts* makes a significant contribution to this movement. In this book Craft develops a comprehensive theological framework for thinking about how the arts can help place us in time, space, and community. And she makes a convincing case for how art must play a critical role in any recovery of place. Many have expressed concern about the place of art in contemporary life; Craft helpfully extends this conversation to consider the role of art in place (and placemaking). Highly recommended."

Eric O. Jacobsen, senior pastor of First Presbyterian Church of Tacoma, author of *The Space Between: A Christian Engagement with the Built Environment*

"This brilliant book engages with a burgeoning interest in both the significance of place and the importance of the arts in God's way with the world, synthesizing the two in an impressively insightful and imaginative fashion. It is highly scholarly and at the same time accessible. I am full of admiration for what the author has achieved and hope the book will be as influential as it certainly deserves to be."

John Inge, bishop of Worcester

PLACEMAKING
AND THE
ARTS

CULTIVATING THE
CHRISTIAN LIFE

Jennifer Allen Craft

IVP Academic

An imprint of InterVarsity Press
Downers Grove, Illinois

InterVarsity Press
P.O. Box 1400, Downers Grove, IL 60515-1426
ivpress.com
email@ivpress.com

InterVarsity Press® is the book-publishing division of InterVarsity Christian Fellowship/USA®, a movement of students
and faculty active on campus at hundreds of universities, colleges, and schools of nursing in the United States of America,
and a member movement of the International Fellowship of Evangelical Students. For information about local and
regional activities, visit intervarsity.org.

Scripture quotations, unless otherwise noted, are from the New Revised Standard Version of the Bible, copyright 1989
by the Division of Christian Education of the National Council of the Churches of Christ in the USA. Used by
permission. All rights reserved.

Cover design: David Fassett
Interior design: Beth McGill
Images: The Bench at Saint-Remy by Vincent van Gogh at Museu de Arte, Sao Paulo, Brazil / Bridgeman Images

ISBN 978-0-8308-5067-9 (print)
ISBN 978-0-8308-8844-3 (digital)

Printed in the United States of America ∞

InterVarsity Press is committed to ecological stewardship and to the conservation of natural resources in all our
operations. This book was printed using sustainably sourced paper.

Library of Congress Cataloging-in-Publication Data
Names: Craft, Jennifer Allen, author.
Title: Placemaking and the arts : cultivating the Christian life / Jennifer
 Allen Craft.
Description: Downers Grove : InterVarsity Press, 2018. | Series: Studies in
 theology and the arts | Includes bibliographical references.
Identifiers: LCCN 2018022675 (print) | LCCN 2018031219 (ebook) | ISBN
 9780830888443 (eBook) | ISBN 9780830850679 (pbk. : alk. paper)
Subjects: LCSH: Christianity and art. | Art and geography. | Christianity and
 geography.
Classification: LCC BR115.A8 (ebook) | LCC BR115.A8 C73 2018 (print) | DDC
 246—dc23
LC record available at https://lccn.loc.gov/2018022675

P	24	23	22	21	20	19	18	17	16	15	14	13	12	11	10	9	8	7	6	5	4	3	2	1
Y	38	37	36	35	34	33	32	31	30	29	28	27	26	25	24	23	22	21	20	19	18			

For Brandon Keith,

my faithful partner in placemaking

Contents

Acknowledgments ix

Introduction: Art, Place, and Christian Life in the World 1

1 Why Place? Why Art? 7

2 Cultivating Responsible Relationships:
The Arts and the Natural World 23

3 Hospitality and Homemaking:
The Arts and the Home 69

4 Divine Presence and Sense of Place:
The Arts and the Church 123

5 Imagining God's Kingdom:
The Arts and Society 164

6 A Placed Theology of the Arts:
Cultivating Theological Imagination and Sense of Place 200

Conclusion 231

Bibliography 233

Image Credits 249

Author Index 251

Subject Index 253

Scripture Index 257

Acknowledgments

Any project of this size receives considerable support from a wide variety of individuals, so while the author's name is on the project, it remains an intensely communal undertaking. This book results from years of conversations, experiences, places, and events. It has been pieced together sometimes arduously and slowly and other times with the burst of energy attributed only to the work of the Spirit as muse. As a palimpsest of those experiences, it remains an expression of my own perspective and place in a variety of communities and locations.

Since the project began as a PhD dissertation at University of St. Andrews, completed from 2009 to 2013, there are a number of important people to thank. Trevor Hart, my patient and pastoral supervisor, helped shape the direction of the work and my acquaintance with such a wide variety of sources in the arts and theology. My examiners, Michael Partridge and Timothy Gorringe, asked thought-provoking questions and pressed me to flesh out areas for further discourse, while Michael introduced me to a number of philosophical sources for further interdisciplinary dialogue. A number of friends and colleagues helped shape ideas, particularly the other founding members of *Transpositions* blog for the Institute for Theology, Imagination, and the Arts, along with my close friends Maria and Leonard Randall. Their friendship and support helped me through thinking about sense of place, along with, very often, my own homesickness that emerged as result.

Other individuals and friends have read drafts, encouraged progress on the book, and supported me in life circumstances that held it up for some time, especially Barry Blackburn, Holly Carey, and many other colleagues and friends at Point University, where I now teach. My student workers in the Biblical Studies and Humanities Department at Point were particularly helpful in

the final stages of proofreading this book, while providing good conversation in the classroom on ideas about placemaking and the arts. Special thanks goes to Emily Plank for traveling with me to see many of the art pieces explored in the book in person, and to the whole Plank family, for providing more meals than I can count and who often forced me into much-needed leisure time. I am also incredibly grateful to the artists represented here, a number of whom have answered questions and read drafts of my interpretation of their work with a spirit of grace. Two friends, David Taylor and Taylor Worley, have been particularly encouraging along the way, and I thank them for their kind spirits, motivation, and community in the discipline of theology. Particular thanks also goes to Jeremy Begbie, who, at my first encounter with him while I was still in undergrad, encouraged me to do what makes my heart sing, and since then on several occasions has reminded me that this project was something of value. This book is in many ways a record of my heart's song.

The folks at IVP Academic have been incredible throughout this journey, particularly my editor, David McNutt, who was the perfect person with whom to work on this project. His insights have made it better and more precise. I am also much indebted to the editorial board of the Studies in Theology and Arts Series for giving me a place in their community. As must normally be stated in spaces like these, the faults that endure within the text remain solidly my own.

My family has also been immensely supportive during this project. My mom and dad, Debra and Floyd Allen, along with my Aunt Barbara and Uncle Jim, though perhaps confused and themselves daunted by the length of time this has taken to emerge in print, have been faithful supporters of my education and career. I wouldn't be where I am today without their love and encouragement. Finally, my husband, Brandon: on this pilgrimage for a place in the world, you have moved to another continent for me, bought me more books and artwork and museum tickets than is perhaps reasonably acceptable for one person, and have been my number-one supporter in all things. It is from you that I have learned what it means to truly love a place and its communities, and I cannot imagine making a place in this world with anyone else. It is to you, then, that this book is dedicated. All places and accomplishments are more beautiful with you by my side.

Introduction

Art, Place, and Christian Life in the World

What is the place of art in the Christian life? This is the question Francis Schaeffer asked in his little book *Art and the Bible*, first published in 1973, and it is one to which I have returned over and over again throughout my education and career.[1] My first experience with "theology and the arts" as a discipline, and the catalyst for my spending the bulk of my education and career thinking through issues on theology and the arts, was this little book, a serendipitous addition to the curriculum by my Introduction to Humanities professor my freshman year of college. Schaeffer's question in many ways sets the stage for the current project, and his use of language signals a focus for my own recasting of the question. What is the *place* of art in the Christian life? What *places* do the arts occupy in our lives? How do the arts affect our sense of place and imaginative participation in the variety of environments we find ourselves a part of?

This focus on place—the question of what it means to understand, love, and make "a place in the world"—began as a personal response to homesickness. I had moved from a small town in south Georgia to St. Andrews, Scotland, to take up work for a PhD on theology and the arts. And while I loved much of my time in St. Andrews, my husband and I found ourselves longing for home, often daydreaming about the sights or food or community culture of our native land. And it wasn't just us. This phenomenon of homesickness is common enough. Even when people love travel and adventure, most long to have a sense of rootedness somewhere. So my academic work took a turn as my mental life lingered in the past and current places of my life. I began to ask myself, Why does a sense of place even matter? How might we think about place and home from a theological perspective? And is there such a thing as a distinctly *Christian* sense of place?

[1]Francis A. Schaeffer, *Art and the Bible* (Downers Grove, IL: InterVarsity Press, 1973), 7.

So these two broad sets of questions are what drive the current project: Why place? And why art? In the chapters that follow, I will explore the central thesis that the arts are a form of placemaking, that they "place" us in time, space, and community in ways that encourage us to be fully and imaginatively present, continually calling us to pay attention to the world around us and inviting us to engage in responsible practices in those places. The arts help us to live locally and to know the places we are a part of. And this is a matter of supreme theological significance. As communities called to be service oriented, missionally minded, and worship focused, we must understand how our service, mission, and worship are situated in and affect the places around us. As embodied creatures made in the image of God and invited to participate in his creative work in the world, we might consider the significance of our own physicality, along with the ways in which we enter into relationship with God and his creation through that very physicality. The theology of the arts presented here, therefore, will be one that reflects that embeddedness in place and contributes to our imagining of what it means to be embodied creatures called to engage responsibly with the places of the world. Art, in a unique way, can cultivate a theological imagination and Christian sense of place so that we may become people who better participate with Christ and his church to bring about the kingdom of God in our places.

So art, I believe, holds an important place in the Christian life. Or rather, art holds many important places within our lives. Concentrating on four different arenas of Christian life and work—the natural world, the home, the church, and society—this book will explore the variety of ways in which the arts can cultivate a stronger sense of place and theological imagination in the respective "places" of our lives. Each section will take up key theological themes and questions from Scripture, systematic theology, and philosophy, while exploring the ways in which the arts might create a space in which to live out the kingdom of God in the places of this world.

Chapter one seeks to define our concepts of both place and art a bit further, arguing that being in place is an essential part of our being human, and that the development of a "sense of place" is integral for responsible and thoughtful action in our life's ecology, or the whole system of our relationships with God, people, and other creatures in place. Here we will also define our concept of the arts further so that we may later explore the ways in which various art

forms, particularly those of a visual nature, might function in and structure the places we are a part of. Throughout the book, I will focus mostly on contemporary artists (both those internationally praised and less well known) in order that we may witness how the arts can have a meaningful influence on life in the world today. This will lend a decidedly practical focus to the argument throughout. Furthermore, focus will be given to the visual arts: first, in order to form a cohesive language surrounding the chosen examples from the arts; second, as a response to the incredibly visual culture of which we find ourselves a part; and third, given the church's sometimes tense relationship with visual arts in the past. This argument, however, may be easily applied to the arts more broadly, but is a task perhaps left for another work.

Chapter two will then explore theological themes related to the natural world, including creation, incarnation, and new creation. This will form the theological backdrop for our engagement with visual artists who might give form to seeing the natural world in a new way, embodying an attitude of attentiveness to particular things, an appreciation and perception of goodness and beauty, and an embodiment of our responsible action in physical landscapes. Several case studies of contemporary artists dealing with these issues will be addressed in order to begin a dialogue on how Christians might be better enabled to understand, to love, and, as poet Wendell Berry writes, to "practice resurrection" in the created world through the arts.[2]

Chapter three will turn from the natural world to the domestic space of the home. This chapter will sketch out a theology of art that reflects on homemaking and hospitality in light of a biblical theology of home and its application for contemporary issues such as (existential) homelessness and disattachment from places, along with the effect of individualism and consumerism on our domestic home life and sense of hospitable space. We will study several examples from the contemporary arts—both craft and high art—in relation to homemaking and hospitality, memory and identity, and community responsibility and spirituality as it originates in the home place. The thesis of this chapter is that aesthetic reflection on the concepts of home, along with the development of beautiful spaces in the home through the arts and creative making, can combat the tendencies of the modern world to homogenize our

[2]Wendell Berry, "Manifesto: The Mad Farmer Liberation Front," in *The Selected Poems of Wendell Berry* (Washington, DC: Counterpoint, 1998), 87.

sense of place, which disconnects our personal sense of home from a theo-
logical model of hospitality.

Chapter four explores the role of the visual arts in the place of the church.
My argument here is that art in the worship space may serve to create a hos-
pitable place of worship and divine presence, while grounding our sense of
home and belonging in the community of God's people in that particular
place. The role of embodied action and liturgy in worship, as well as theo-
logical ways of "seeing," will set the stage for thinking through how the arts
might shape our architecture of worship. Chapter five will, finally, investigate
the role of the arts in society by looking at the cross in terms of place and
displacement, and applying these observations to how the arts might form
and influence Christian placemaking in society. We will address contem-
porary social issues such as the migrant crisis and the ethics of social place in
our case studies here. The goal of this chapter is to address how the arts can
contribute to the hospitality of our social imagination and implicitly motivate
our actions in the communities in which we find ourselves.

Of course, none of these "arenas" are quite so easily divided when it comes
to the contours of the Christian life. In this regard, we will see how issues of
the natural world may overlap with concerns and actions in society, how life
in the home is integrally linked with life in the church community, or how a
sense of place in the church affects our life in society. The delineation of these
spaces, then, will mainly serve to drive home the point that places are always
communally structured and understood. Thomas Merton writes that "No
man is an island," and in this spirit we might also say, "No *place* is an island."[3]
Our thoughts about and actions within places always have relationships to and
implications for the other places of our lives in the world.

The final chapter will tie together loose threads by using the examples ex-
plored in chapters two through five as a foundation on which to propose a
more detailed theological assessment of the arts in place. Here I will suggest,
as before, that the arts can cultivate a deeper sense of place and theological
imagination in the Christian life, which enables us to deeply and thoughtfully
engage with the issues of contemporary life that seek our attention today. This
chapter will sketch a theological model for the arts generally, and to that end,

[3] Thomas Merton, *No Man Is an Island* (New York: Barnes and Noble Books, 2003).

will assess the relationship among art, the theological imagination, and sense of place directly. For instance, as they embody meaning, as they connect the particular with the universal, as they reflect on and reinvent tradition for new communities, and as they invite us to self-reflection and active response, the arts can call us to imaginatively dwell in the world in a whole new way. Finally, this chapter will develop a "placed theology of the arts" whereby we evaluate the arts' role in life in terms of their calling us into placed response and action in the world. This last chapter serves, then, as a call to all Christians to engage with the arts more deeply in all the areas of their lives here on earth—whether through their own making, appreciation, or patronage—and in so doing cultivate an imagination and sense of place that transcends the limits of our own experience and perhaps situates our hearts, minds, and bodies more solidly in the kingdom of God here on earth.

Why Place? Why Art?

"It is impossible," Wendell Berry avers, "to divorce the question of what we do from the question of where we are—or rather, where we think we are."[1] Our actions in the world are deeply intertwined with our sense of place, that is, how it is we consider our dwelling in this place or another. It is no question that we live in a globalized world and an increasingly mobile culture. When we do stay put for very long, at least in the United States, it is very often in virtually indistinguishable suburbs, a simple car's-ride away from any big-box store or coffee chain we so desire to visit. When some anthropologists attempt to answer this question of where we think we are as a culture, they go so far as to state that we live in an overwhelmingly "placeless" society, building and spending time in what Marc Augé calls "non-places"—airports, waiting rooms, (inter)national chain stores.[2] For Augé, these places are not really places at all; they have no particular character and exist as holding tanks for individual and unconnected people who are merely passing through or consuming. What results is a lack of identity, structure, connectedness, and unique character, what James Howard Kunstler describes as a "geography of nowhere."[3] This picture of contemporary society is less than positive. However, in recent years there has emerged a cultural movement seeking community, particularity, and place. The topic of place has emerged on the scene as a major concern in a variety of disciplines, as evidenced in the writing of someone such as Wendell Berry, quoted above.

But what do we mean by "place" exactly? And what does it have to do with other contemporary theological questions and concerns—things such as

[1]Wendell Berry, *The Unsettling of America* (San Francisco: Sierra Club Books, 1977), 51.
[2]Marc Augé, *Non-Places: An Introduction to Supermodernity* (London: Verso, 1995).
[3]James Howard Kunstler, *The Geography of Nowhere: The Rise and Decline of America's Man-Made Landscape* (New York: Simon and Schuster, 1993).

social justice, ecological and environmental problems, questions of identity and human nature? Why should Christians even consider place at all? Everything we do happens in a place. Philosopher Edward Casey reminds us, "To be at all—to exist in any way—is to be somewhere, and to be somewhere is to be in some kind of place."[4] While his statement may at first seem rather straightforward—*of course* we exist in place!—Casey's writing reminds us that we cannot escape the essential fact of our emplacement and embodiedness in this world. Place is part of who we are; it is both a physical and social reality. While our bodies must physically dwell in places, our minds also structure knowledge and ideologies in relation to places. The word *place* can thus be used to refer to physical geography or landscape, the community existing within a place, or the place of someone in a social group or network. Physical places can also become metaphors for theological, philosophical, social, or political ideas. For instance, when one visits Notre Dame Cathedral in Paris, which exhibits Gothic motifs devised to emphasize the viewer's experience of God through particular visual elements, one experiences the beauty of the physical place itself, while also encountering the theological ideas associated with pointed arches or stained-glass windows. The place becomes somewhere the visitor can indwell physically while also providing metaphors through architectural styles for different experiences of God's transcendence or dwelling presence.[5] Similarly, Ellis Island is more often associated with immigrant emotions, ideologies, and experiences than with the physical geography itself, though certainly the physical still plays a primary role in one's understanding of the place—it is one of the first physical features one sees when sailing into Brooklyn Harbor.

Place, in this sense, can be understood as a location, an experience, a community, a set of relationships, memories, and habits, a measurement of time and history. Because we are embodied creatures, we cannot separate any of these things from the physical. In fact, all these things cannot be fully understood

[4]Edward S. Casey, *The Fate of Place: A Philosophical History* (Berkeley: University of California Press, 1998), ix.

[5]For a good exposition of Gothic architectural principles, see A. Welby Pugin, *The True Principles of Pointed or Christian Architecture* (London: Academy Editions, 1973). David Brown elaborates on this concept in David Brown, *God and Enchantment of Place: Reclaiming Human Experience* (Oxford: Oxford University Press, 2004), 272-81.

except *through* their association with the physical.[6] But place is not just a piece of ground—it is an undeniable fact of our existence in relationship with the whole of creation. We are necessarily a placed people. And what we do in and how we think about the physical places we are in matters very greatly.

SPACE VERSUS PLACE

Place, as a term, is often tied up with a discourse on *space*, and most disciplines seek to make a distinction between the terms *place* and *space*. While the terms are used in many different ways (what one writer means by the word *place*, another might be suggesting through the use of the term *space*), most agree that space tends to be universal in character, whereas place is particular.[7] Walter Brueggemann, speaking from a theological perspective, notes the essential difference between space and place:

> "Space" means an arena of freedom, without coercion or accountability, free of pressures and void of authority. Space may be imaged as weekend, holiday, avocation, and is characterized by a kind of neutrality or emptiness waiting to be filled by our choosing.... But "place" is a very different matter. Place is space that has historical meanings, where some things have happened that are now remembered and that provide continuity and identity across generations. Place is space in which important words have been spoken that have established

[6]George Lakoff and Mark Johnson, in their study of metaphors that structure our lives, propose this relationship between ideologies and physical space. In fact, they suggest, "Most of our fundamental concepts are organized in terms of one or more spatialization metaphors." George Lakoff and Mark Johnson, *Metaphors We Live By* (Chicago: University of Chicago Press, 1980), 17. They refer to orientational metaphors and container metaphors in particular as they relate to the concept of place. See 14-21, 29-30.

[7]The major French phenomenologists tend to reverse these terms. See Michel de Certeau, *The Practice of Everyday Life* (Berkeley: University of California Press, 1984); Henri Lefebvre, *The Production of Space*, trans. Donald Nicholson-Smith (Oxford: Blackwell, 1991); Gaston Bachelard, *The Poetics of Space* (Boston: Beacon, 1969). We are required, of course, to make certain delineations between concepts in order to properly define terms, but we must also keep in mind that space and place are not so easily divided—that, although in our elucidation of "place" we may desire to develop a set of independent concepts, J. E. Malpas instructs that "this temptation is one that ought to be resisted" (J. E. Malpas, *Place and Experience: A Philosophical Topography* [Cambridge: Cambridge University Press, 1999], 25). Place and space, like the particular and universal, are always intertwined, and our reimagining of place, and our actions within places, must always coincide with a simultaneous rethinking of space. Because "place" is such an expansive subject, as shown by the vast variety of literature in the area, devising a strict or linear definition of place will be insufficient if we are to grasp its true character and value. Malpas also notes that when we speak of place, most often we are only working with one or two definitions at a time (173-74). This phenomenological understanding of place and space will be important for our assessment of the role of art in the places of one's life, as well as the theological implications of maintaining (or failing to maintain) a strong sense of one's own place in the world.

identity, defined vocation, and envisioned destiny. Place is space in which vows have been exchanged, promises have been made, and demands have been issued. Place is indeed a protest against the unpromising pursuit of space. It is a declaration that our humanness cannot be found in escape, detachment, absence of commitment, and undefined freedom.[8]

Brueggemann provides a helpful, and very particular, picture of what place looks like in relation to space. Humanist geographer Yi-Fu Tuan writes it more succinctly: "'Space' is more abstract than 'place.' What begins as undifferentiated space becomes place as we get to know it better and endow it with value."[9]

What both of these writers hint at is that places don't just exist; places must be made. American author and essayist Wallace Stegner perhaps communicates place*making* in clearest terms when he writes: "At least to human perception, a place is not a place until people have been born in it, have grown up in it, lived in it, known it, died in it—have both experienced and shaped it, as individuals, families, neighborhoods, and communities, over more than one generation.... It is made a place only by slow accrual, like a coral reef."[10] Places are made, therefore, through relationships—through social interactions that

[8]Walter Brueggemann, *The Land: Places as Gift, Promise, and Challenge in Biblical Faith*, 2nd ed. (Minneapolis: Fortress, 1989), 4.

[9]Yi-Fu Tuan, *Space and Place: The Perspective of Experience* (London: Edward Arnold, 1977), 6. John Inge also adopts Tuan's language of differentiation (place originating from space) in John Inge, *A Christian Theology of Place* (New York: Routledge, 2016), 1, and discusses the issue further throughout chapter 1. Space, in the sense that these authors convey it, tends to be thought of as logically prior to place; space is a container that becomes filled with places. However, while Brueggemann and Tuan helpfully point out some very basic differences between space and place, the antecedent character of space is not the only way to consider the relationship and may not be the best way to think about the categories in light of the realm of human shared experience. Rather than thinking about space as prior to place, we might say that the *experience* of place actually precedes space and gives a sense of what abstract space is. Because place is particular and tangible, then, we actually come to understand it *before* the abstract notion of space. Many philosophers who prioritize experience in human understanding of the world share a phenomenological perspective on place, such as Martin Heidegger, Mark Johnson, Edward Casey, and, from a theological perspective, Phillip Sheldrake and Mark Wynn. Epistemologically, place comes first, then. What one knows and perceives is first particular, and then general knowledge stems from this more local knowledge. Though wider space may indeed be *ontologically* or *structurally* prior to place, as Brueggemann and Tuan suggest, people's actual experience and knowledge of the two categories suggests the reverse derivation, at least in terms of human perception. Edward Relph helpfully makes this distinction between the structural and the phenomenological when he suggests "that space *provides the context for* places but *derives its meaning* from particular places." When humans experience the world around them, they are first experiencing the particular. Edward Relph, *Place and Placelessness* (London: Pion Limited, 1976), 8, emphasis added.

[10]Wallace Stegner, *Where the Bluebird Sings to the Lemonade Springs: Living and Writing in the West* (New York: Penguin Books, 1993), 201.

shape both the community and physical place in relation to each other. A place becomes what it is by a long history of actions performed there. As we perform and reperform actions in a place, we are simultaneously drawing on that place's history and memory for our own understanding of ourselves, as well as adding back to the value of the place, remaking it over and over again in a sort of dynamic conversation and liturgy.[11]

SHAPING SENSE OF PLACE

But when we talk about a "sense of place" we are talking of something deeper still. This is because how we act in places—what our placemaking looks like—is a reflection of how we feel about it (whether self-consciously or unselfconsciously), and ultimately, how and whether we love it. Most scholars describe a "sense of place" using all the various associations highlighted above, including a sense of communal narrative and memory. A sense of place has to do with the nature of belonging within these systems—that is, how one belongs to a place or community *in both actuality and imagination.* There is, then, a mutual relationship between our feelings about a place and the manner in which we act in a place.

To highlight the relationship between placemaking (our actions in a place) and love of place further, Edward Relph's observations about an "authentic" sense of place may be a helpful starting point. What constitutes a sense of place for Relph is not one's insider/outsider label but whether one has an "authentic" attitude toward place. An authentic attitude to place, he says, "comes from a full awareness of places for what they are as products of man's intentions and the meaningful settings for human activities, *or* from a profound and unselfconscious identity with place."[12] The authentic sense of place, then, can be either a self-conscious product or unselfconscious producer.

[11]J. E. Malpas, though he insists on the dynamic relationship between human agency and place, insists that places are not *solely* a matter of human response, however. "Of course, the existence of some particular place—of some set of objects or of some subject—will be *causally* dependent on a set of physical processes and structures, but this does not mean that place can be simply reduced to such processes or structures." Malpas, *Place and Experience,* 37. Timothy Gorringe also calls attention to the fact that place is *more than* just human society. See T. J. Gorringe, *The Common Good and the Global Emergency: God and the Built Environment* (Cambridge: Cambridge University Press, 2011), 79. For discussion of human enacted space in the placemaking movement particularly, see Linda H. Schneekloth and Robert G. Shibley, *Placemaking: The Art and Practice of Building Communities* (New York: John Wiley and Sons, 1995), 191.
[12]Relph, *Place and Placelessness,* 64, emphasis added.

Though Relph distinguishes between these two modes of place discovery, he does not seem to regard one over the other. It is the main difference between these two, though, that suggests how important the cultivation of imaginative placemaking *practices* are for a worthwhile study of place in the world today.

Relph describes an authentic and unselfconscious sense of place as "being inside and belonging to *your* place both as an individual and as a member of a community, and to know this without reflecting on it."[13] Relph suggests that this way of thinking is most normally ascribed to "unspoiled primitive people," who depend on the land and tend to view places as related to both the spiritual and the physical. Contemporary Western people may unselfconsciously move about and act within their place, however, their relationship to it tends to be less about the sacred quality of the place and more about the utility and functionality of it, which is interchangeable with other secular places. Though Relph emphasizes that an unselfconscious and authentic sense of place "provides an important source of identity for individuals, and through them, for communities," he notes that most people cannot claim this type of relationship to place.[14] Spatial mobility has made it so that few people remain in relationship with a single place from birth, or for any significant length of time, for that matter, and as a result, the historic and symbolic quality of a single, particular place is lost on most individuals. Furthermore, the tendency in today's society to reflect on one's own identity makes it so that even the "insider" must self-consciously choose one's place. Wendell Berry illustrates this when he says of his return to his native Kentucky farm: "Before, it had been mine by coincidence or accident; now it was mine by choice."[15] Though Berry already had a relationship to his family land as an "insider," he made the self-conscious decision to return to it and acknowledge his identity within it in an act of homecoming.

For these reasons, Relph argues that it is more likely in today's society that people self-consciously acquire a sense of place. "In unselfconscious experience places are innocently accepted for what they are; in self-conscious

[13]Relph, 65. This is similar to the way that we "inhabit" various frameworks of meaning without necessarily being conscious of them. For his understanding of inhabitation and "tacit knowledge," see Michael Polanyi, *The Tacit Dimension* (New York: Anchor Books, 1967).

[14]Relph, *Place and Placelessness*, 65-66.

[15]Wendell Berry, *The Art of the Commonplace: The Agrarian Essays of Wendell Berry* (Emeryville, CA: Shoemaker & Hoard, 2002), 7.

experience they become objects of understanding and reflection."[16] Self-conscious experience of place tends to be related to the "outsider" who makes a place somewhere where she may not have been born or grown up, but yet learns and later maintains a sense of connectedness and identity within the particular community. It is just as often, though, that an insider, often on leaving her place for some time, comes to reflect on it in a self-conscious way and chooses to return and belong within it in a new or different way. It is through this degree of self-awareness that we should understand the way most people find identity within places.[17] An authentic sense of place requires openness, reflection, and intentionality: "The more open and honest such experiences are, and the less constrained by theoretical or intellectual preconceptions, the greater is the degree of authenticity."[18] According to this account by Relph, intentional thoughts, actions, and placemaking practices are the most important part of cultivating a sense of place. And if, as Relph suggests, the self-conscious attitude toward place is the primary way that most modern people engage with the world of places, then reflection on the practices of placemaking themselves will be an important part of any inquiry into what a Christian sense of place might look like.[19]

[16]Relph, *Place and Placelessness*, 66.

[17]See also Anne Buttimer, "Home, Reach and the Sense of Place," in *The Human Experience of Space and Place*, ed. Anne Buttimer and David Seamon (London: Croom Helm, 1980), 184-85.

[18]Relph, *Place and Placelessness*, 66. Exactly how to determine the measure of authenticity is not clearly outlined by Relph, though, as the matter is largely personal in nature. Some may criticize this as one weakness of Relph's argument for constructing a sense of place, since he depends so heavily on the concept.

[19]It deserves note, however, that Yi-Fu Tuan remains critical about Relph's notion of a self-conscious sense of place and believes that trying to evoke a sense of place is often too deliberate and conscious. A sense of place becomes clichéd and marketable, related not to one's actual belonging to a place, or even one's perception of belonging, but to an idea the person "buys into." Tuan writes, "Being rooted in a place is a different kind of experience from having and cultivating a 'sense of place.'" Tuan, *Space and Place*, 198. His description of place suggests that one's *actual* belonging to place is separated or distinct from a *cultivated sense* of belonging. Location, then, does not necessarily equate rootedness. For Tuan, a sense of time is more important in regard to a sense of place (186). Humans acquire a sense of place and become rooted and accepted in places through experience over stretches of time.

Tuan rightly reasserts the importance of time for our understanding of a sense of place. However, the relationship between time and a sense of place is not counter to the suggestion that placemaking is the primary activity by which people achieve a sense of place. Rather, we can bolster Relph's notion of self-conscious cultivation or making of place by including a sustained relationship with a place over time in order to know and identify with its geography, history, memories, stories, and the people who inhabit it. The terms *outsider* and *insider* are modifiable (the outsider may become an insider, or the insider may become an outsider), and a sense of place must in fact be cultivated in some way. But in order for this to happen, there must be a sustained relationship with or "submission" to a place over a long period of time. See Stegner, *Where the Bluebird Sings*, 206. Stegner argues that we do not need to be born into a place in

While Relph leaves his readers to wonder exactly what types of practices may help cultivate a self-conscious sense of place, Kent Ryden, in his study of writing and sense of place, identifies some potential practices, which include the learning of place names, speech, artistry and craft, building, and memories—in other words, practices related to knowing the place through living, loving, working, and participating in a place over time. But while he identifies several "layers of meaning" that can be expressed by those who actually belong to that place, he suggests finally that the main difference between the insider and the outsider is *love for the place*, which is exhibited in both *perception* of the place and one's *action* within it.[20] Ryden's conclusion that love is the main proof of a sense of place and belonging is interesting in light of our comprehensive project. A Christian sense of place, as I will argue in the following chapters, will be composed of love for the creation as a whole, a proper sense of community within it, and thankfulness for and responsibility with the gifts that God has given in gracious love.[21] In other words, to use rather Augustinian language, our sense of place and placemaking actions share a core relationship with *how we have ordered our loves within those places.* The identity of places, and our own identity and habits within them is, then, a reflection of those loves.

For those readers of the recent work of James K. A. Smith, this language of loves (and their relationship to practices) will sound familiar. Smith's work

order to be a part of it, but we must submit to its needs and character and see ourselves in relationship with it over time. If we are merely passing through, then we do not get a true sense of the land, people, and story involved in a place. But time cultivates relationship, and the self-conscious perception of place and one's relationship to it are suggestive of the more basic ways that we begin to "make places."

[20]Kent Ryden, *Mapping the Invisible Landscape: Folklore, Writing, and the Sense of Place* (Iowa City: University of Iowa Press, 1993), 58-67. For the concept of "love of place," see also Yi-Fu Tuan, *Topophilia: A Study of Environmental Perception, Attitudes and Values* (New York: Columbia University Press, 1990).

[21]Here the idea of belonging also finds theological parallels in the notion that Christians residing in the world are pictured as sojourners or outsiders, while their ultimate home or place of belonging is heaven. See Hebrews 11:13-14, regarding the patriarchs, who were displaced and exiled, and who sought a homeland on earth and in heaven. See also Frederick Buechner's essay, "The Longing for Home," in *The Longing for Home*, ed. Leroy S. Rouner (Notre Dame, IN: University of Notre Dame Press, 1997), 63-78, for the notion of longing for home in heaven. This paradox in Christianity reminds us that one might also be perceived as belonging to a place without having an immediate physical relationship with it. We see this idea in the person who cannot go home because of exile, immigration, destruction, or some sort of other displacement, but yet who still finds identity in the place they left. These people often still belong to a place in the imagination. They reside in one place yet long for another. While the other place may still have physical qualities (or at least, once did), they now "belong" to a world in the imagination that they can go back (or forward) to in time and memory.

lends a decidedly theological tone to the language of love outlined above, and so in what follows, we will explore the implications of Smith's philosophical theology for both a Christian sense of place and a theology of the arts in the Christian life. In his series on "cultural liturgies," Smith suggests that we are above all creatures of desire—creatures who love—and that these loves are reflected in our practices in the world.[22] But unlike Relph, he argues that these practices are most often *not* "thought through" in advance of their being practiced—they are unselfconscious. We are not first "thinking things," as Descartes suggested, but rather are motivated by love, desire, and imagination to engage in social practices that are largely determined by our wider communities and cultures, what Charles Taylor calls "social imaginaries."[23] And while our practices are largely motivated by these implicit social imaginaries, Smith suggests that the development of our habits and imagination can also motivate these wider cultural practices, transforming one's loves and reorienting them toward more directed ends. In this regard he picks up Relph's focus on placed practices as an indicator of our loves.[24]

Smith's writing resonates and often engages with the writing of French philosopher Pierre Bourdieu, who outlines a theory of habitus that can be described as personal, embodied motivations shared through practice.[25] Bourdieu sees this motivation and experience, as Mark Wynn describes of his work, as "rooted in the primordial intentionality of the body in its enacted relationship with the world."[26] While Bourdieu, like Smith, does not outline a theory of "place" as such, his understanding of human identity and knowledge finds itself practically rooted in embodied experience of the places of the world. A habitus can thus be described as a set of personal dispositions, skills, and motivations that are embedded in structuring and organizing

[22]In other words, we are always oriented toward a kingdom; the question is *which* kingdom? James K. A. Smith, *Desiring the Kingdom: Worship, Worldview, and Cultural Formation* (Grand Rapids: Baker Academic, 2009); *Imagining the Kingdom: How Worship Works* (Grand Rapids: Baker Academic, 2013); *Awaiting the King: Reforming Public Theology* (Grand Rapids: Baker Academic, 2017).

[23]See Charles Taylor, *Modern Social Imaginaries* (Durham, NC: Duke University Press, 2004), 24.

[24]Importantly, Smith fails to address sense of place directly in his series as a catalyst for habit-forming liturgies, though the theme remains implicit throughout his own work, along with that of many of his interlocutors.

[25]Pierre Bourdieu, *Outline of a Theory of Practice*, trans. Richard Nice (Cambridge: Cambridge University Press, 1977).

[26]Mark R. Wynn, *Faith and Place: An Essay in Embodied Religious Epistemology* (Oxford: Oxford University Press, 2009), 123.

practices, in Bourdieu's words, "structured structures predisposed to function as structuring structures, that is, as principles which generate and organize practices and representations."[27] In simpler terms, we might say that while our actions and perceptions are rooted in the "structures" or places in which we dwell (which includes all those habits, memories, histories, and relationships that we discussed earlier), these places are also "structured" themselves through the practices that we enact there. Our sense of place may in fact be both unselfconscious and self-conscious simultaneously, which Relph fails to acknowledge in his sharp distinctions.

If our sense of place (at its core, our *love* of place) and our placemaking practices (what Smith calls our "cultural liturgies") can be motivated or structured even as they shape us, we must ask ourselves an important question: What objects, habits, or practices might function best as a catalyzing and shaping influence or motivator in this regard? Can any habituating practices or objects shape our love of place and our Christian imagination? In answer to this question we will explore the role of the arts in the Christian life. Art can help cultivate this theological imagination and sense of place—it can direct and influence our cultural liturgies by helping to reorder our loves.

This has significant implications for how we develop a theological response to some of the wider contemporary concerns introduced earlier. If our sense of place—what I will define as our imagining of and love for the places and communities in which we are called—helps to structure our habits and actions in the world, then getting a sense of place right in theological terms is one important step toward engaging in more thoughtful and responsible Christian practices in the world more widely. By cultivating a love for places (which includes people, history, memories, stories, religious identity, etc.), we might be better suited to deal with the concerns and problems of the world today. For instance, while a sense of place will not completely solve something such as the migrant crisis, it might re-form our imaginations to understand what it truly means to love and leave one's place. And this right ordering of desires and imagination (in this case, the desire for hospitality and hope for homecoming) may help motivate our actions, as Smith argues. The arts, then, might become a catalyst in helping cultivate that habituated theological

[27]Bourdieu, *Outline*, 72.

disposition, enabling us to imagine the place of the other while motivating us to practice hospitality (Rom 12:13).[28]

This question of place, I believe, matters for many of the other big concerns of contemporary life, questions for which Christians must find an adequate answer both in abstract thought and particular practice—for instance, how we think about humans' impact on the natural environment, how we understand and treat social justice issues such as food and water shortages, homelessness and the migrant crisis, and how Christians deal with notions of cultural or personal identity. When we consider the problems of contemporary life in the world, many of them may seem too pervasive or difficult to provide any adequate solutions. While the development of a sense of place and theological imagination is, of course, not going to solve the world's problems, we might see it as an important, if not necessary, element of motivating a variety of responsible and loving practices of Christians in the world today. The inclusion of the arts in all the places of our lives may be one way in which to motivate our loves and cultivate a Christian sense of place and practice in the world. The arts might shape the places, and the sense of place, that shape us.[29] If our hearts are indeed the driver of our bodies and minds, as Smith argues— if we are motivated by our loves after all—then the arts, as an expression and exploration of all the tacit dimensions of human experience, of which our loves are central, may indeed have a central role to play in Christian personal and social experience in the places of the world.

THE PLACE OF ART IN LIFE

Why art? What's the significance of these objects or practices that often seem so distant from our daily lives? How could we assert the centrality of art to the Christian life when so many people rarely consider the visual space around them or, when they are confronted by it directly, fail to understand it? The question of what art *does*—how it functions in our lives—is related to the question to what art *is*—how it is defined. While the question has long been asked, the multiplicity of answers to this question seems to grow.

[28]James McCullough uses this language of the arts as "catalyst" in James McCullough, *Sense and Spirituality: The Arts and Spiritual Formation* (Eugene, OR: Cascade Books, 2015), 6.

[29]Smith gave a lecture using this language titled "Practicing Presence: Shaping Places That Shape Us," at Laity Lodge in St. Paul, Art House North, June 2016.

If we look at a brief history of "Art" we see that the manner in which modern society understands the objects and practices of art is relatively recent. Others have explored this topic more extensively, so here we will note changes that occurred in the eighteenth century, which as Paul Kristeller notes, is where we saw the system of the high arts beginning to take root. Here we saw aesthetics as a field of inquiry emerge with Baumgarten's inquiries into the manner of aesthetic taste and beauty, and with Immanuel Kant, the institution of high art and a philosophy of contemplation unfold.[30] This, along with new places such as the art museum and concert hall, set the stage for the separation of art from the everyday places and uses of life. Our modern grouping of the fine arts begins to take place at this time as well.[31] What is included in these lists may differ between theorists; for instance, Kristeller lists painting, sculpture, music, poetry, and architecture, while Nicholas Wolterstorff extends this list to "music, poetry, drama, literary fiction, visual depiction, ballet and modern dance, film, and sculpture."[32] In most lists, though, Wolterstorff notes the "triple-membered core"—poetry, music, and visual depiction—and also highlights their lack of association with one another before the eighteenth century.[33]

The story of the modern system of the arts is not a new one to be explored in theology and the arts, and others have done a more thorough job of addressing the main concerns present within that system.[34] For our purposes now, it is important to note a few of the more salient points regarding modern art theory and use, especially as it will pertain to the place of the arts in Christian life today. Kant's legacy, as Jeremy Begbie explains, resulted in many cultural changes regarding the arts. Included in his list, and most relevant to us here, is the gravitation toward the mental experience and away from the physical world, the divorce of art from action, the isolation of the work of art from everyday affairs, the hardening of the distinction between aesthetic experience and knowledge, and the stress on the subjectivity of aesthetic taste

[30]Paul Oskar Kristeller, *Renaissance Thought 2: Papers on Humanism and the Arts* (New York: Harper & Row, 1965). See especially Alexander Gottlieb Baumgarten, *Aesthetica* (Hildesheim: G. Olms, 1961); Immanuel Kant and J. H. Bernard, *Critique of Judgment* (New York: Hafner, 1966).

[31]Kristeller traces the history of our thinking on the arts, citing how ancient lists of the arts are quite different from modern groupings.

[32]Nicholas Wolterstorff, *Art in Action: Towards a Christian Aesthetic* (Grand Rapids: Eerdmans, 1980), 6.

[33]Wolterstorff, 7.

[34]Wolterstorff, parts 1-2; Jeremy Begbie, *Voicing Creation's Praise: Towards a Theology of the Arts* (London: Continuum, 1991), 186-204.

and solitary thinking. Kant's aesthetics overall, Begbie argues, leads toward *alienation*—of art from knowledge, of art from action, of artist from physical world, of artist from fellow artist, and of art from society.[35] This legacy, paired with mass production and consumerism today, has resulted in the tendency to think of art as occupying a very small portion of one's life. And when one does seek to "decorate" public spaces, the home, or the church, it is often accomplished with mass-produced images or objects, along with a failure to distinguish between shallow trends and those things of lasting aesthetic value. We'll return to this question of value a bit more in later chapters, but a working description of what we mean by "art" stills requires teasing out.

Wendell Berry, in his essay "Christianity and the Survival of Creation," posits the following definition of art: "By 'art,' I mean all the ways by which humans make the things they need."[36] Berry is known for his no-nonsense approach to issues, whether of land, religion, politics, or art. In a later interview with Marilyn Berlin Snell he reiterates the point. After stating that the arts are "essential to our lives," he clarifies his view of art:

> But when I speak of "arts" I would prefer to mean simply "the ways of making things." We have been using the term in the sense of fine arts, but when a culture is doing well, all its artifacts are made well and afford the kind of solace that only beautiful work can give. . . . If our ability to make things has degenerated to the point that we must go to museums to see art, then we no longer *have* art. Our museum is a mausoleum.[37]

Berry's definition, while broad and perhaps problematic in terms of establishing a set aesthetic theory, affords some possibilities for exploring the role art might serve in our everyday lives, and we'll pick up some of his points here in later chapters. Berry values the nature of human making more widely, expressing elsewhere that "everybody is an artist—either good or bad, responsible or irresponsible."[38] Ultimately, it seems, Berry seeks to ground his view of art in a wider aesthetic way of being in place, recalling language and ideas similar to those of Mark Johnson in *The Meaning of the Body*, where he

[35]Begbie, *Voicing Creation's Praise*, 186-204.

[36]Wendell Berry, *Sex, Economy, Freedom, & Community* (New York: Pantheon Books, 1993), 108.

[37]Morris Allen Grubbs, ed., *Conversations with Wendell Berry* (Jackson: University Press of Mississippi, 2007), 53.

[38]Berry, *Sex, Economy, Freedom, & Community*, 110.

describes the aesthetic as "the study of how humans make and experience meaning," and is interested, as Berry is also, in the nature of our embodiment in the world of places—the ways in which our identity is structured in aesthetic embodied experiences in the physical world.[39]

While Berry's language is much less philosophical, the two thinkers share a focus on aesthetic being in the world experienced through our physical engagement in and making of places. What this means for both of them is that the arts are one of the primary ways in which we go about experiencing and developing meaning.[40] Johnson even goes so far as to suggest that embodied meaning reaches its *fullest* potential in the arts.[41] In other words, the arts might be understood as akin to those placed practices addressed in our discussion of Smith and Bourdieu, a paradigmatic instance of those "structuring structures" that underlay and shape our imagination and understanding of the world in which we live and worship. Smith suggests a view of art sympathetic to that of Berry (at least in terms of its role in life), writing: "The art that cultivates an aesthetic sense is not art that you look at, but art that you *live with*."[42] Art, he argues, must thoroughly be bound up in the realm of life and practice and place. "Environments that are intentionally well adorned," he says, "are veritable schools for the soul—they create in us both a mood and a temperament. They are part of an embodied *paideia*, a kinaesthetic education."[43]

Berry's generalist definition does need some clarification, though. If we hold on to the main philosophical motivations behind these statements about what art does and how it functions *in our everyday lives*, while combining them with a few caveats, we might begin to flesh out a good working description. Wolterstorff, like Berry, seeks a more functional and social definition of the role of art in our lives, arguing that "works of art are objects and instruments of action."[44] Wolterstorff, in a way that Berry does not, though, narrows his vision of what

[39]Mark Johnson, *The Meaning of the Body: Aesthetics of Human Understanding* (Chicago: University of Chicago Press, 2008), 208.

[40]While Berry generalizes about the arts, in many places throughout his writing he appeals to the fine arts as instances by which we come to "know" and act in a greater way. See especially Wendell Berry, *Standing by Words* (San Francisco: North Point, 1983).

[41]Johnson, *Meaning of the Body*, 213.

[42]Smith, *Imagining the Kingdom*, 180.

[43]Smith, 180-81.

[44]Wolterstorff, *Art in Action*, 3. Berry also writes elsewhere that art is part of our "kit of cultural tools" that we use to dwell in the world. See Wendell Berry, *Life Is a Miracle: An Essay Against Modern Superstition* (Berkeley: Counterpoint, 2000), 121-22.

may count as art by delineating "works of art" as "product[s] of one of the (fine) arts."[45] While still sufficiently broad, this does help to delimit the terms of the discussion a bit. We will generally be referring to some practice or object of the fine arts when discussing the arts, though occasionally I will seek to expand this a bit more widely to consider the artistic merit and function of craft, folk art, and other "making" practices in the various arenas of the Christian life.

James McCullough, in his short book on the arts and spiritual formation, describes the arts as the confluence of three things: craft, content, and context.[46] Art involves the skill required of making, the message or subject of the thing being made, and the situatedness of the artist and artwork in a network or tradition of work, practice, and culture. These characteristics are helpful to note, especially as we will be exploring a wide variety of visual art forms, both those more traditional and those that are not. One divergence from McCullough's thinking on these three threads will be important moving forward, though. McCullough argues, "Artists do not create contexts; they work within them."[47] While the art "originates from" and "is received within" the context, the art cannot be a context itself for shaping meaning and practice. While art does always sit within a tradition of making and meaning, I believe art *can* create a place for the viewer to indwell (mentally and sometimes physically) and thus form a context for shared social practices (as is the case with public art), for contemplation and reflection, and as McCullough argues, for spiritual formation. It is, notably, this question of context with which this book deals directly throughout. Art not only exists within the places of our lives but may add value to those places, becoming a "structuring structure" by which places are made, and our sense of place habituated. Art can "shape the places that shape us" while also shaping our sense of place and imagination within them.

In this regard, I will espouse a somewhat functionalist approach to art theory here in the sense that I suggest that art does function importantly in our lives, though it must be noted that this designation is not meant to suggest that art is *only* valuable for its practical function.[48] That art can give form to

[45]Wolterstorff, *Art in Action*, 18.

[46]McCullough, *Sense and Spirituality*, 36.

[47]McCullough, 41.

[48]See for instance Rookmaaker, who affirms a noninstrumentalist view of art. Hans Rookmaaker, *Art Needs No Justification* (Vancouver: Regent College Publishing, 2010). I will take up these themes—both the uselessness and utility of art—throughout and especially in chapter 6.

seeing the world in an entirely new way is a point we will explore in regard to each "place" of the Christian life.[49] Art functions to draw out meaning from the world but does so in conversation with it. Art is, therefore, always known in relation to its context, but like Bourdieu's "structures," can also become a context.[50] The main concern of this book, of course, is not to present a co-hesive philosophical art theory, but rather to explore the dialogical dimen-sions of art and place within a theological worldview. The multidimensional purposes and character of the arts will stand as a testament to the multidimen-sional character of the places of our lives. What I present here, then, is not intended as a complete vision of everything the arts are capable of doing or being in the world, but rather a practical theology of the arts that, at least to some degree, clarifies their position as central to the human imagination and flourishing in place.

As we turn to the role of the arts in the particular places of our lives, these descriptions will help to lay the groundwork for theological engagement with the practices of both artistry and placemaking more generally. In what follows, our assessment will take a decidedly more theological tone, as we explore Christian life in the world today as well as how the arts in particular might shape our practices and imagination to live out our placed callings in the natural world.

[49]For a discussion of functionalism, including its criticisms, see Robert Stecker, "Definition of Art," in *The Oxford Handbook of Aesthetics*, ed. Jerrold Levinson (Oxford: Oxford University Press, 2005). My use of the term "giving form" here should be distinguished from someone such as Clive Bell, who sees art as the giving of "significant form." See Clive Bell, *Art* (New York: Putnam, Capricorn, 1958). Here I mean perhaps a more literal "form giving," especially as the concept relates to the visual arts, that the arts may make a physical (or conceptual) context or form in which to contemplate and experience a sense of place in the world.
[50]Bourdieu, *Outline*, 72.

Cultivating Responsible Relationships

The Arts and the Natural World

Whenever I have experienced homesickness in the past, my mind often wanders to the landscape of a place. I think of the longleaf pine of my native south Georgia and the deep red clay fields and roads that are structured on the flat topography of the coastal plain. A landscape can define a person. The natural environment contributes not only to the habits and practices of human life but also to the flourishing of its plants and animals. Geographical features such as rivers or mountains mark boundaries and determine weather. The composition of the soil defines how people think about producing their food and what their diet consists of. The landscape in many ways determines how society's building styles emerge and the manner in which people live for large parts of the year. A place, then, and all its cultural, political, social, or historical stories, is in large measure a reflection of its physical landscape. From very early on in Western cultural history, the notion of who we are— how we know ourselves—is linked, at least in part, to our relationship with that physical landscape.[1]

This being the case, it is not unimportant how stressed the human relationship to the natural world is today. When we fail to give the natural world its proper place in our cultural imagination, it becomes easier to misuse resources such as water, forests, soil, and fossil fuels. For instance, agriculture from the early twentieth century forward has become increasingly violent

[1] The relationship between dwelling sites and human longing is explored in Vitruvius Pollio, *The Ten Books on Architecture* (Huntington, WV: Empire Books, 2011). Michael Pollan also explores a brief history of landscape, identity, and building in Michael Pollan, *A Place of My Own: The Architecture of Daydreams* (London: Penguin Books, 2008).

toward the natural landscape. Homogenization of seed varieties and sources by corporate entities, mechanized planting and misuse of pesticides, genetic modification, and overuse of fertilizers only begin to paint the picture. The problems in our food system overlap in other areas as well—responsible water use, human impact on animal and insect populations, global climate change, and deforestation. For instance, the Food and Agriculture Organization of the United Nations records food wastage in the world at 33 percent, with a little over half of that occurring at the level of agricultural production and storage, a number that if more responsibly managed would halt deforestation for agricultural production in the Amazon rainforest altogether.[2] Soil fertility continues to decline in many regions of the world, with erosion and pollution due to chemical fertilizers on the rise. And all of this is a system that we participate in whether we realize it or not.

How we imagine and use the land and its resources is a moral and religious concern as much as it is a practical one. If we consider how often we are guilty of contributing directly to its ruin, it is no surprise that many of us lack a true sense of shalom with God's creation. But the Bible tells us very specific things about the goodness of the earth and calls us into a very particular type of relationship to it. At the end of the first creation account in Scripture "God saw everything that he had made, and indeed, it was very good" (Gen 1:31). From the moment of our creation by God, we are called into not only that same recognition of the world as good but also responsible action within it, participating in its very flourishing. But so often we have misused our ability and misread our calling. Lynn White Jr., in his now-famous article "The Historical Roots of Our Ecologic Crisis," argues that Christian theology should be held culpable for much of the ecological disaster brought forth on the planet. We carry, he says, "a huge burden of guilt," due in large result to our anthropocentric readings of Scripture and nature, our demythologizing of the natural world, and most importantly, the notion of human dominion over everything else God has made.[3] The modern culture of dominion, in other words, has largely been one of power that originates in the notion of humans not as *care*takers but as *over*takers of their environment.

[2]Food and Agricultural Organization of the United Nations, *Food Wastage Footprint: Impacts on Natural Resources Summary Report* (Natural Resource Management and Environmental Department, 2013), www .fao.org/docrep/018/i3347e/i3347e.pdf.

[3]Lynn White Jr., "The Historical Roots of Our Ecologic Crisis," *Science* 155, no. 3767 (March 10, 1967): 1206.

Since White's article was first published, many theologians have turned their attention to the ecological crisis, an issue intimately tied up with our sense of place and stewardship of the natural world.[4] Our perceptions of and habits in the natural world are indeed in desperate need of revision. This chapter will contribute to this wider discussion of Christian engagement with the natural world by exploring some key theological themes and doctrines relevant to our imagining of the natural world and humans' role within it. This will set the stage for our examination of how the arts can expand or reflect that theological framework, while cultivating a stronger sense of place and religious imagination. I will argue that the arts may be considered a sort of paradigm of placemaking practice in the natural world, giving form to different ways of perceiving the landscape and acting within it. They may, therefore, be a catalyst for the development of a love of place, provoking the types of habits necessary for a responsible relationship to the natural world.

NAMING GOD'S CREATURES: IMAGINATION AND SENSE OF PLACE

There is a close relationship between the image and the word—poetic expressions open up new ways of seeing, or imaging, the world. In his poem "The Naming of the Cats," T. S. Eliot addresses the significance of our naming of things as a form of identity-making. The particularities of naming things aren't foreign to us: we name our children, our pets, our buildings, and our places. We choose a name that is "fitting" of identity or attitude. "That Great Dane *looks like* an Aristotle." While we often engage in the action of naming without second thought, Eliot draws our attention to the magnitude of a name, leaving us to contemplate the reality of "His ineffable effable/Effanineffable/Deep and inscrutable singular Name."[5]

[4]See for instance Richard Bauckham, *Bible and Ecology: Rediscovering the Community of Creation* (Waco, TX: Baylor University Press, 2010); Pope Francis, *Laudato Si—On Care for Our Common Home*, Encyclical of the Roman Catholic Church (Our Sunday Visitor, 2015).

[5]Ben Quash, engaging with this same poem, suggests that the magnitude behind a naming action is that it involves becoming "found," drawing a parallel to the action and power of God in Isaiah 40—that the Israelites become found by God in his "calling them all by name" (Is 40:26). "They are not just 'found to be there,' as though by chance. They are really found, which is to say they are known and affirmed intimately; their election reasserted by God and felt powerfully by them." Ben Quash, *Found Theology: History, Imagination, and the Holy Spirit* (London: Bloomsbury, 2013), 12.

This involves both God's covenant relation with them as well as his calling to them—they are assured of God's abiding presence with them as the "people of God," a central aspect of their "namedness," but are also called to be responsive and obedient to God in the place to which they have been called. It is

Naming gives expression to our relationship with people, places, or things, and is a poetic and theological practice through and through. In Genesis 1 readers witness the supreme act of creation by God, along with the identification of plants and animals in relation to the spaces of creation.[6] After speaking his creation into existence ("And God *said* . . ."), God names its members, calling the light Day and the darkness Night, the dome Sky and the waters Seas (Gen 1:5-10). God's activity of creation (*bara*) is his and his alone, and he does it through language. This is God's own creative endeavor "out of nothing," or *ex nihilo*, and it is a gift to his creatures in love.

While God's activity needs no prerequisite "stuff" or order, he does invite his creatures into the responsive process of making the earth a fitting place for both creaturely and divine dwelling.[7] In addition to the activity of God (*bara*), we see creatures are also invited to participate in a form of making (*asah*), and this gift sees special focus in humankind made "in our image" (Gen 1:26-27).[8] Genesis 2:19-20 gives readers one of the first

interesting to note that, in a feature characteristic of Scripture's cohesive narrative of place, the nation of Israel is truly "found" by God in its naming upon its return from Babylonian exile (it being out of place and now being put back in a place), being found intimately but also being found somewhere. God's naming here is an echo of his power in all creation (driven home by Is 40:28: "The LORD is the everlasting God, the Creator of the ends of the earth") and calls attention to a more existential naming (and concurrent calling) in the event of creation, which we will explore below.

[6]Most often the exegetical focus in Genesis 1 is on time, but Richard Bauckham suggests that the marking off of the days of creation is a scheme that is "primarily spatial." In the first three days, God creates and separates environments, and in the next three days he creates inhabitants for these environments. However, construing the scheme spatially does not suggest the temporal aspect of creation should be relegated to the background. Space and time are integrally linked. See Bauckham, *Bible and Ecology*, 14. See also Craig G. Bartholomew, *Where Mortals Dwell: A Christian View of Place for Today* (Grand Rapids: Baker Academic, 2011), 11.

[7]For an alternative view that God uses existent "chaos," see Jon D. Levenson, *Creation and the Persistence of Evil: The Jewish Drama of Divine Omnipotence* (Princeton, NJ: Princeton University Press, 1988).

[8]There are two main verbs used throughout the Genesis creation narrative: *bara*, "to create" (Gen 1:1, 21, 24; 2:3, 4) and *asah*, "to make" (Gen 1:7, 16, 25, 31; 2:3, 4). The opening verse of Genesis designates God's activity by the term *bara*, which is "on principle, without analogy," and is used exclusively of God's activity. See Gerhard von Rad, *Genesis: A Commentary*, trans. John H. Marks (London: SCM Press, 1961), 47.

Because Yahweh is always the subject of this type of creation, and the text never suggests a material out of which God creates, it is typically understood that the Priestly writer is suggesting the difference of God's creative activity from that of humans. On the other hand, creation by "making" (*asah*) invites the participation of the rest of creation and here implies something more akin to an artist working with materials. Analogies are thus often made between human action and this particular "making" action of God. "Making" (to be distinguished from the typical sense of "creating") suggests, then, not the sense of *creatio ex nihilo* but rather an imaginative creative engagement where God forms and reacts to his creation in a dialogical way, giving the creation its character while at the same time working with that character in the creative process.

immediate echoes of this divine creativity in Adam's naming of the animals, and not only does the action recall divinely given power and creativity, but it also echoes a "putting into place" that is part of that original creative action.[9] In the act of naming, humans identify and reinforce their own relationship to the rest of God's creatures, while granting them a place in relation to one another—Adam "finds" them, as Ben Quash is apt to express, the animals becoming intimately known in relation to both humans and other creatures. Claus Westermann argues that where God gives the creation its purpose and task in his naming, humanity gives the animals a place in the community: "man gives the animals their names and thereby *puts them into a place in his world*."[10] Placemaking, here represented paradigmatically in the action of naming, is both an epistemological and liturgical activity; through this activity humans acquire knowledge of their own place and identity in the world in relation to other places and creatures.[11] Here, in other words, humans, through their own response to God in naming, grasp the meaning of their "ineffable effable/Effanineffable/Deep and inscrutable singular Name."

In the naming events of Genesis 1–2 we witness Scripture's first real account of a religious imagination. Adam's naming of the animals in the garden

Creation is subjected to perceptions, evaluations, naming, and other participatory activities of the creatures alongside and in harmony with God. For instance, Michael Welker describes the process as "equally reactive." Michael Welker, *Creation and Reality* (Minneapolis: Fortress, 1999), 12-13. For further discussion of these issues in the Genesis text see especially Gerhard von Rad, *Old Testament Theology: The Theology of Israel's Historical Traditions* (Edinburgh: Oliver and Boyd, 1962), 1:142-43; Claus Westermann, *Genesis 1–11: A Commentary* (London: SPCK, 1984), 26, 89.

[9]Von Rad, *Genesis*, 53. This echoing of God's activity from Genesis 1 establishes humans as special participants in the creation and recalls the calling of humans to have dominion in creation. While the man was no doubt working under different conditions in his prelapsarian state later, I will hold that his "poetic venture" is still a very clear account of placemaking through language rather than an exercise in rational reconstruction. Language should be understood as a creative activity here, rather than simply identifying the exact correspondence of things to their appropriate descriptors, as some modern language theories may suggest. Language becomes one very significant way that humans participate in God's created order. They construct "place" by naming and describing its elements. As Wendell Berry poetically suggests, through language the man "affirms and collaborates in the formality of the Creation." Wendell Berry, *What Are People For?* (New York: North Point, 1990), 89.

[10]Westermann, *Genesis 1–11*, 228, emphasis added. See also von Rad, *Genesis*, 81.

[11]Terence E. Fretheim, *God and World in the Old Testament: A Relational Theology of Creation* (Nashville: Abingdon, 2005), 41. It is especially important to notice here that the man orders his world through language. "Naming" is seen as parallel to "creating" both in the opening chapter of Genesis and other ancient texts such as the Enuma Elish. See Westermann, *Genesis 1–11*, 114, 229; Westermann, *Creation*, trans. John J. Scullion (London: SPCK, 1974), 85. For a modern study on the creative function of language as "reality making," see also J. L. Austin, *How to Do Things with Words* (Cambridge, MA: Harvard University Press, 1975); George Steiner, *After Babel* (Oxford: Oxford University Press, 1992), 144.

requires his perception of other creatures as part of his own place in the world—he had *to see* them as they were, along with how they might be known in relation to other creatures and himself. Adam, to use the paradigm Quash has suggested in *Found Theology*, must relate the "given" to the "found"; he must take that which has been offered and discover, with the help of God, its depth of meaning and purpose through new forms of creative engagement.

The link between imagination and action is embedded in the text of Genesis, both in reference to God and to humans. "And God *saw* that it was good" is a recurrent evaluation of the individual parts of creation, and the Priestly narrative concludes with the final judgment that the whole creation is "very good" or "completely perfect." Ellen Davis notes that while most exegetes focus on the *nature of* creation as good, she believes that it is God's *perception of* the world as good—his *seeing* of its good nature—that is of consequence for our understanding of the story's impact for humans' relationship to place.[12] Only rarely, Davis points out, do we see inside the mind of a biblical character, but in these instances we see that the way the characters perceive the world results in how they act within it, and this has lasting effects for both the biblical characters and contemporary readers involved. "As a liturgical poem," Davis writes, "Genesis 1 can give form to a certain way of seeing the world, and accurate perception provides an entrée to active participation in the order of creation."[13] Of special importance, she suggests, is that God's actions and perceptions become an exemplary model of our own placemaking practices as witnessed functionally and relationally in the *imago Dei*.[14]

This relationship between perception and action lies at the heart of our discussion on the role of the arts and imagination in the Christian life. Davis's thesis might be applied more broadly to all the arts (and it is important in this regard that we note that she is reading Genesis foremost as a liturgical poem): *the arts can give form to seeing the world in a whole new way.* As we saw in the discussion of James K. A. Smith in chapter one, there is a relationship between

[12]Davis's approach to Genesis gives her more hermeneutical freedom as she reads Genesis as a liturgical poem, which means that not only are the words thought to carry more power and intention but also that they hold a "surplus of meaning." See Ellen Davis, *Scripture, Culture, and Agriculture: An Agrarian Reading of the Bible* (Cambridge: Cambridge University Press, 2008), 44-45. This is different from more typical interpretations, such as that of von Rad, who says of Genesis 1 that "the language is succinct and ponderous, pedantic and lacking artistry." Von Rad, *Genesis*, 26.

[13]Davis, *Scripture, Culture, and Agriculture*, 10.

[14]Davis, 47.

what we *do* in the world (our habits) and how we *see* the world (what we love). Davis concludes that right perception of the world affects our habits in the world. And those practices reinforce and (often unselfconsciously) motivate our loves and the variety of ways that we imagine our places. Writing, for instance, of our habitual mistreatment of the land, Davis argues that our irresponsible actions in the natural world may be recognized as the result of "a failure of the imagination, an inability to imagine that this world could be significantly different, for better or for much worse, than we and every human generation before us have experienced it."[15] In the modern world we have suffered a failure to perceive rightly, and this has resulted in a misuse of the natural world that we have been called to steward.

In his epic photographs of land transformed by human use, contemporary artist Edward Burtynsky epitomizes this relationship between perception and action. Recalling Romantic landscape in both scale and theme, Burtynsky's photographs possess a sublime quality, demanding his viewers occupy a contemplative space beyond the beautiful and entering the realm of the terrible, expressing in pictorial form Rainer Maria Rilke's poetic assertion that "beauty is nothing but the beginning of the terrible."[16] Burtynsky's images convey a tension of both mood and beauty. Viewers will have difficulty reconciling their immediate perception of what appears to be a beautiful and abstract image, filled with expressive lines, shapes, and colors, with the story of the land use that formed it, and it is in this liminal space that Burtynsky invites us to dwell. The artist describes: "These images are meant as metaphors to the dilemma of our modern existence; they search for a dialogue between attraction and repulsion, seduction and fear. We are drawn by desire—a chance at good living, yet we are consciously or unconsciously aware that the world is suffering for our success."[17] These landscapes are most often not the way the world was supposed to be. Vibrant colors reveal toxic waste. Expressive lines reveal mass erosion or industrial intervention in the landscape. Everyday substances such as water are perceived through their manipulation for survival or comfort. Other series, such as *Oil*, speak of an amazement at human ability to extract

[15]Davis, 10.

[16]Rainer Maria Rilke, "The First Elegy," in *The Selected Poetry of Rainer Maria Rilke*, trans. Stephen Mitchell (New York: Vintage International, 1989), 151.

[17]Edward Burtynsky, "Exploring the Residual Landscape," accessed March 15, 2018, www.edwardburtynsky .com/site_contents/About/introAbout.html.

resources from the environment in order to make our lives more comfortable, coupled with a simultaneous disgust at the measures we take for economic prosperity. We are left wondering whether our freedom or comfort was won at too high a cost.

Burtynsky ultimately creates a sense of wonder through scale, opening up a space that speaks to universal human consciousness and questioning while calling us into a dialogue on the nature of our engagement in particular places. Burtynsky describes these works as laments, drawing us into simultaneous awe and despair in order to start a dialogue and force a universal questioning of human impact on the natural world.[18] The massive scale of his images is thus the place in which the particular meets the universal—the place where our personal sense of place meets that of the global community, the place where our own choices are seen as impacts in other environments. We ask, How do the metals in our electronics gouge this terribly beautiful landscape of Chile or Canada? The sense of place is thus an important part of the pictures he makes, and the large-format photographic medium, he says, can help us "reconnect" or "mediate between that place and our lives in the city."[19] Burtynsky's photos serve as responses to the modern myth of progress as they question and call attention to our dominion in the world. While the artist does not explicitly ascribe religious significance to his works, his focus on universal human questioning begs a religious reading. "Through the marks that we leave," Burtynsky says, "we tell our story about what our values are, what's important to us."[20] As Christians, how are our values revealed in the places of our lives together, and how might we begin to relieve the disparity between what we say we love and our actions in the natural world on a global scale? Through providing a space of reflection on both landscape and self, Burtynsky helps us question our perception of the landscape before us, along with the ways in which that perception has led to the world's abuse. "We need to find new ways to think about our world," Burtynsky argues, and perhaps these images can help us filter those new ways of thinking into transformed action.[21]

[18]Ian Toews, "Atacama Desert (Chile) with Edward Burtynsky," *Landscape as Muse*, Season 1, Episode 26, 291 Film Company (2007).

[19]Toews.

[20]Toews.

[21]Toews.

BIBLICAL THEMES FOR THE NATURAL WORLD

The imago Dei *and creational calling.* In formulating a distinctly theological anthropology, we find that the ability to model our perception after God's own is one marked characteristic of what it means to be made in the image of God. This theological theme of the *imago Dei*, though referenced only a limited number of times in the biblical text, may serve as part of the theological root system for both a theology of the arts and placemaking as presented here, while highlighting ontological and ethical considerations of human existence and placed experience. The phrase "image of God" is introduced in Genesis 1:26-28 and—in light of its placement very early on in Israel's historical narrative, along with its christological adoption in the writing of New Testament authors—forms a definite scriptural basis for the concept of human identity and action in the natural world, as it is formed in response to and in imitation of the kenotic outpouring of God's love and granting of freedom from the creation event itself.[22]

Two beneficial approaches to the topic may be taken here, the one particularly textual and the other expressly theological, but both of them highlight placed experience and the divine calling to creative placemaking as a matter of Christian concern. First, the phrase "image of God" (Gen 1:26-27) is connected textually with the dominion mandate, typically translated, to "subdue" and "rule over" (Gen 1:28), and to the call to physical procreation (Gen 1:28), which follows the male-female relationship (Gen 1:27). Michael Welker addresses this entire section of text in terms of the relationship between nature and culture.[23] When we interpret these elements of the text in relationship, Welker suggests, the *imago Dei* conveys something, ultimately, about the interconnectedness of humans to one another and with the rest of creation (an identity that is both "natural" and "cultural"), what Davis explains in terms of the "ecological" aspect of human life, a term she adopts from Aldo Leopold to refer more generally to the science of relationships.[24] Dominion does not

[22]The phrase "image of God" occurs three times in Genesis (Gen 1:26-28; 5:1-3; 9:5-6). Of course, Genesis was not the first book written in Israel's history, but as it serves to communicate the "origin story" of God's creation, it deserves attention "in the beginning" of our own account of a theology of place in the Bible. For issues of dating see Victor P. Hamilton, *The Book of Genesis: Chapters 1–17* (Grand Rapids: Eerdmans, 1990), 14.

[23]Welker, *Creation and Reality*, 69.

[24]Welker, 73; Davis, *Scripture, Culture, and Agriculture*, 56.

mean overpowering in this regard but participating in the membership of creation as both creatures and creators through various forms of placemaking.[25]

Welker's account says significant things about the possibility of creaturely participation in the divine project, along with the relational aspects of that participation. "We encounter in the classical creation texts," he says, "*a rich description of the creature engaged in the activity of separating, ruling, producing, developing, and reproducing itself*."[26] The earth sprouts (Gen 1:11), the fruits yield seed (Gen 1:11), the stars give light (Gen 1:17), the animals multiply (Gen 1:22), and the earth itself brings forth creatures (Gen 1:24).[27] Yet while creaturely community and participation in divine work find an important and necessary place in Welker's account, he fails to draw adequate attention to the link between divine command and creaturely making. Both animals and humans are *commanded* to "multiply and fill" the earth, and humans get a special command to subdue and rule over, to exercise dominion over the rest of creation. While human participation in creation is central to the divine project, as Welker suggests, we must not conflate human and divine roles, nor lose a sense of divine providence and plan. The dominion mandate is just that—a mandate—and the participation of creation is linked with divine instruction. Thus we should see the commands to fill and multiply, subdue and rule over, and the later command "till . . . and keep" (Gen 2:15) as a key to our description of the *imago Dei*—humans engage in the action of making and creative participation *as a result of God's call to do so*.[28]

Davis helpfully elucidates this sense of calling in her further description of the term *conquer* (Gen 1:28). "The earth may be 'conquered,' that is, claimed *for God's purposes* and rendered hospitable to the whole created order."[29] Conquering, or dominion, in other words, is a practice not of power but of love and should reflect the redemptive purposes of God in the world, a distinct feature that Welker adumbrates but fails to ground in

[25]Fretheim also makes the connection between the image of God and humans as social, relational beings. Fretheim, *God and World*, 55. For a communal interpretation of these texts, see also Bauckham, *Bible and Ecology*.

[26]Welker, *Creation and Reality*, 10-11.

[27]Von Rad, *Genesis*, 53, 55. Here he notes the importance of the participation of animals and plants in the creation. See also Welker, *Creation and Reality*, 11, 41, for participation of the whole earth in creation.

[28]See also Walter Brueggemann, *Theology of the Old Testament: Testimony, Dispute, Advocacy* (Minneapolis: Fortress, 1997), 181.

[29]Davis, *Scripture, Culture, and Agriculture*, 62, emphasis added.

an appropriate sense of divine calling. Humans are called to be a "transforming presence" in the world, and this is the heart of what dominion means not only in the Genesis account but also throughout the rest of the Bible, all across which relationships are explored in partnership to the whole created order.[30] Divine calling or vocation is thus a central feature of the way we understand the *imago Dei* as an indicator of human identity and ethical action.

This discussion of the *imago Dei*, then, bears within it the reality of divine election, not only calling to mind a central feature of God's engagement with the nation of Israel but also further connecting the *imago Dei* in Genesis to "the elect man, Jesus Christ," the image of the living God, and nodding in the direction of the incarnation as the particular *place* of divine-human meeting.[31] Nathan MacDonald draws this conceptual framework from the "frequent anticipations of God's covenant relationship with Israel" in Genesis 2 and argues for a connection between God's choosing of Eden and his choosing of Canaan.[32] By linking the *imago Dei* as given to humans in the garden with the calling of Israel and later of Jesus himself, the dominion mandate that accompanies the "image of God" text can be better construed as a special vocation that carries with it responsible stewardship of the blessings God has given through his elective purposes.[33] The *imago Dei*, then, as Norman Wirzba

[30]Norman Wirzba, *The Paradise of God: Renewing Religion in an Ecological Age* (Oxford: Oxford University Press, 2003), 124-25.

[31]Nathan MacDonald, "The *Imago Dei* and Election: Reading Genesis 1:26-28 and Old Testament Scholarship with Barth," *International Journal of Systematic Theology* 10, no. 3 (July 2008): 319.

[32]MacDonald, 319.

[33]Indeed, the election motif in Genesis 2 may help explain the gravity of the betrayal in Genesis 3. Humans were chosen not based on their own merits but elected for certain responsibilities. But in Genesis 3, the humans began to think that they deserved to be like God and achieve a certain status based on something akin to merit.

The idea of election as vocation, or "election for" something, is indicative of the scriptural paradigm of divine command in relation to human making. The link between divine command and human making can also be noted in other instances, such as God's calling of Noah to build the ark, the specification for the tabernacle, or the Sabbath and Jubilee commands later in the Pentateuch. For the notion of "election for" see H. H. Rowley, *The Biblical Doctrine of Election* (London: Lutterworth, 1952), 74, 120.

God calls us for specific tasks not as a result of human merit but as an extension of his divine generosity. Brueggemann suggests that command is "perhaps Yahweh's defining and characteristic marking." Brueggemann, *Theology of the Old Testament*, 182. Throughout the Old Testament God commands his people in all sorts of ways: the prophets are to engage in symbolic actions; the Israelites are to travel to and use their land in specific ways; the earthly kings are to abide by the rules of God's kingdom.

The connection between command and blessing should be noted here further, though. Jeremy Begbie suggests, however, that the language of "command" can become problematic in numerous ways if we are

argues, "rather than being a possession, turns out to be a calling, a task defin-itive of our humanity."[34] This task is relational in the sense that we carry it out only as we are in relationship with God, one another, and the rest of the cre-ation, what Richard Bauckham calls "the community of creation."[35] And as this relational calling refers to our engagement with place, it identifies the action of placemaking as some essential part of human identity and vocation. As members of the community of creation rather than as lords above it, humans have the potential and responsibility to enhance or add value to the gift of nature through their own making and imaginative ordering activities.

The second strand of thought, more particularly theological and yet related to the first, involves a kenotic reading of God's creation and our creative calling within it, while also further associating our reading of the *imago Dei* directly with the kenotic and incarnational work of Jesus. I will say more about the precise application of kenotic Christology's claims for a theology of place and creative making shortly, though we might begin to read the Genesis account

not careful. First, he suggests that if humanity is defined solely in terms of obedience, then the relational or covenantal aspect of the divine-human relationship is frustrated. We cannot grasp the full measure of our relational covenant with God if we consider the relationship to be only about our rote obedience to divine law. (The text, however, seems to mitigate against his type of reading, even when we understand "command" in the harshest of ways. For instance, in the text God aligns himself with humans in relation-ship—he walks with Adam and allows his freedom to name the animals. Though their relationship in the garden is accompanied by commands, it also allows for relationship through obedience and responsibil-ity.) Second, Begbie suggests that by weighting obedience to divine command or law too heavily, we lose the sense of creation as an outflow of divine grace and fail to live in the love and freedom God intends for us in the created world. Begbie suggests, instead, that the notion of divine command in the context of the *imago Dei* and dominion mandate should be conceived in terms of blessing. Genesis 1:28 links God's mandate with God's blessing: "God blessed them, and God said to them." Blessing, here, is best construed of in terms of "a command which carries with it the power of fulfillment, or, better still, a gift which in-cludes a demand." This argument, however, seems to be simply a matter of semantics. While it is important to understand "command" in a way that allows for, rather than precludes, relationship, it does not seem to be the case that the term *command* should simply be replaced with *blessing*. While command may carry a blessing with it, to do away with the language of command entirely seems problematic when accounting for God's interactions with humans in the rest of Scripture. Understanding command as including bless-ing, will, however, allow us to focus on the bond between divine gift and human making, particularly as it relates to place. Jeremy Begbie, *Voicing Creation's Praise: Towards a Theology of the Arts* (London: Con-tinuum, 1991), 151. For the notion of blessing as relational, see Kent Harold Richards, "Bless/Blessing," in *The Anchor Bible Dictionary*, ed. David Noel Freedman (New York: Doubleday, 1992), 753-55. See also Brueggemann, *Theology of the Old Testament*, 201; Fretheim, *God and World*, 41-42.

[34]Wirzba, *Paradise of God*, 128.

[35]Bauckham, *Bible and Ecology*, chap. 1. For a similar explication of this "relational model of creation," see also Fretheim, *God and World*, 269; Douglas J. Hall, "Stewardship as Key to a Theology of Nature," in *Environmental Stewardship: Critical Perspectives Past and Present*, ed. R. J. Berry (London: T&T Clark, 2006), 139. Hall contrasts his preferred phrase, "humanity with," to "humanity above" or "hu-manity in" nature.

through a trinitarian doctrine of kenosis in order to better understand the nature of the work of love to which humans have been called in response to divine calling, a reality that as we apprehend it is christological at its heart.

The language of creation as kenosis finds its way into many modern theologians' work not only as it creates a possible space for dialogue between theological and scientific inquiry of the natural world, but also as it offers a lens through which to understand divine-human relationship, along with human participation in the work of creation and redemption.[36] For instance, W. H. Vanstone writes of the precariousness or the risk of God's love, suggesting that God's love requires a self-emptying or kenotic outpouring in order to allow humans the full freedom of response. While divine kenosis itself is not at odds with a classical doctrine of God, Vanstone goes further to suggest that God opens himself up to "need" his creation, though Vanstone attempts to distance himself from a strict process theology that understands God to be in a state of constant becoming, unfulfilled except by his creation and its continuing process.[37] Others, such as Paul Fiddes or Jürgen Moltmann, employ the language of suffering to God's engagement with the world, not just at the christological level but also from the very point of creation.[38]

There are, however, questions that arise in response to Vanstone's and others' notion of God's risk. The eschatological implications seem the most pertinent, since if God risks too much, then his ability and desire to bring the world to eschatological fulfillment is put into question. Too much is levied on creatures in terms of creation and redemption in this sense. Furthermore, the suggestion that creatures can "add to" to creation raises, at least, an associate question—can we detract from God's goals for creation? Vanstone writes of the tragedy or triumph inherent in the gift of creativity, eliciting, again, the important question of the teleological ends of creaturely participation.[39]

[36]For example, see Jürgen Moltmann, "God's Kenosis in the Creation and Consummation of the World," in *The Work of Love: Creation as Kenosis*, ed. John Polkinghorne (Grand Rapids: Eerdmans, 2001).

[37]W. H. Vanstone, *Love's Endeavour, Love's Expense: The Response of Being to the Love of God* (London: Darton, Longman and Todd, 1977), 69. See also, for the notion of risk in open theism, Clark H. Pinnock, *Most Moved Mover: A Theology of God's Openness* (Grand Rapids: Baker Academic, 2001), and Clark Pinnock et al., *The Openness of God: A Biblical Challenge to the Traditional Understanding of God* (Downers Grove, IL: InterVarsity Press, 1994).

[38]Paul Fiddes, *The Creative Suffering of God* (London: Clarendon, 1992); Jürgen Moltmann, *God in Creation* (Minneapolis: Fortress, 1993).

[39]Vanstone, *Love's Endeavour*, 69.

While Vanstone's model offers much to a theological doctrine of both divine and human creativity,[40] given these important questions, we might pursue a more trinitarian framework for understanding the doctrine, kenosis being understood as the eternal outpouring of love within the Trinity itself and creation being a gift that results from divine desire and love, both of which mitigate the eschatological tension present in the language of "risk" as employed by someone such as Vanstone and which thereby forsakes limiting God's own ability to act or his providential role in the created world.[41] For instance, Balthasar distills the most important message of theology to the work of love revealed ultimately to us in the person of Christ himself, but which originates in the self-emptying of the persons of the Trinity to one another, the result of which is the kenotic outpouring of that love in the act of creation and subsequent creaturely calling to participate (as Vanstone asserts, to tragedy or triumph) in that wider work of creation and its redemption.[42] How we understand our identity and vocation in terms of the *imago Dei* might be situated, then, within this wider trinitarian context of kenotic love. We model that kenotic love, in other words, in both our perception of beauty in the natural world and our active pursuit of both goodness and truth within it. Vanstone and others are right to assert the unknown outcome necessitated in God's granting of human freedom, and the problem of evil points in that direction. Balthasar, however, gives readers the necessary eschatological focus so that whatever work creatures do, for good or ill, can find its ultimate fulfillment or redemption in the very love of God, from which all creation originates.[43]

Two points, then, might be made here regarding the relevance of such theological discourse for the current project. First, the act of creation as a kenotic and trinitarian work of love indicates the place from which our own

[40]On creativity under a kenotic model, see James M. Watkins, *Creativity as Sacrifice: Toward a Theological Model for Creativity in the Arts*, Emerging Scholars (Minneapolis: Fortress, 2015).

[41]Hans Urs von Balthasar frames a kenotic theology in trinitarian terms, and Jürgen Moltmann draws on Balthasar's theology and Jewish mysticism simultaneously to account for a kenotic theology of creation. See Moltmann, "God's Kenosis in the Creation and Consummation of the World." For discussion of providence, see John Polkinghorne, *Science and Providence: God's Interaction with the World* (Philadelphia: Templeton Foundation Press, 1989).

[42]Rowan Williams, "Balthasar and the Trinity," in *The Cambridge Companion to Hans Urs von Balthasar*, ed. Edward T. Oakes, SJ, and David Moss (Cambridge: Cambridge University Press, 2004), 37-50.

[43]Geoffrey Wainwright, "Eschatology," in Oakes and Moss, eds., *Cambridge Companion to Hans Urs von Balthasar*, 113-27.

perception and action as creatures derives. As this applies to the natural world, the ability to perceive the goodness of the natural world and use it appropriately is key. Balthasar argues that perception of beauty is the place from which goodness and truth derive. Applied in the context of Burtynsky's photographs, the orientation of our desire in the form of beauty in art may, therefore, result in re-formed action in the world. Creative making of the world, formed out of love in response to beauty, can participate in the reorientation of both our desires and practices, providing images through which we can make our place anew and reimagine the landscape and our impact on it.

Second, the theological account also says something about the direct, divine calling to humans to participate in the work of creation, which may take on the form of servanthood and kenotic love. While we will explore this subject further in the next section as witnessed in the person of Jesus as the image of God, we may note this dynamic in the artwork of Wolfgang Laib, whose work in the natural world might be understood in light of divinely given vocation to participate in the work of creative and kenotic love. Laib, a German-born artist, is known for using (extra)ordinary and unconventional materials: milk and marble, beeswax, rice, and pollen. His work takes the form of a kenotic, contemplative practice—Laib painstakingly collects pollen from plants around his home in the changing seasons or pours milk onto polished stone, the latter action rehabituated every day of the open exhibit in imitation of the initial outpouring by the artist. In the pollen works, the plants themselves pour out their life (pollen being the literal source of life for the plant) to be carefully and lovingly collected by Laib. His work softens the boundary between the natural and the cultural, his artistic practice participating with natural materials that keep their distinction and integrity while becoming something artistically new.

In this way Laib does not create beauty but participates in it, pouring himself into the process of collecting pollen (which is also a contemplative act of the artist) so that viewers may experience the beauty of the natural world in a new way. Life-giving pollen, which viewers may normally find ordinary and often annoying, is redeemed to a place of honor, its ethereal beauty shining forth in golden hues as it is presented on the floor or in jars in the gallery. Laib himself pours out his time and love in the collection of pollen, noting in an interview that the practice is "totally different" from what society

thinks one should achieve in that amount of time.[44] Time and place become key players in his artworks, then, as his own habits of love from season to season form an integral part of the execution of the work as presented in the gallery space, those preliminary practices to the gallery exhibit sometimes lasting fifteen to eighteen seasons, as in his *Pollen from Hazelnut* exhibit at the Museum of Modern Art in 2013 (plate 1). Laib's work, both in practice and presentation, suggests this kenotic practice as part of the way in which our natural and cultural lives meet together; beauty is both exposed in its extravagance and gratuitously presented anew. As we leave the gallery, we might feel challenged in both our sense of time and place as we learn the value of serving and participating in the form of beauty itself, pouring out our lives as both plant and artist have exemplified for us. In imitation we may apprehend the beautiful and offer it back to both God and community in self-giving love.

Incarnation and the work of creation and redemption. How we make our home in the world through our placemaking actions is better understood when we recognize how the *imago Dei* is reflected in the person and work of the incarnate Christ. Out of the handful of instances where the biblical writers use some version of the phrase "image of God," the New Testament records two (1 Cor 11:7; Col 3:10), with appropriations of the term *eikon* (image) also used in Colossians 1:15 and 2 Corinthians 4:4 to refer to Jesus himself. While the 1 Corinthians and Colossians 3 references both indicate humanity as the image of God (1 Corinthians using "image and reflection of God" and Colossians referencing the renewal of the self into the "image of its creator"), the designation of *eikon* for identifying Jesus as the true image of God reveals the precise manner in which our creational calling might be considered in imitation of the kenotic outpouring of divine love witnessed in the life and work of Jesus himself and in relation to his own election and calling in the work of redemption.

In Colossians 1:15-20 the terms *eikon* (image, Col 1:15) and *archē* (beginning, Col 1:18) are both used, indicating a clear connection to the Genesis text. In this case, N. T. Wright argues, the creation account would have also been related to the building of the temple (the garden being a metaphor for the temple as place of God's presence) and indicates Jesus's status as the new

[44]*Art in the Twenty-First Century*, season 7, episode "Legacy," created by Susan Dowling and Susan Sollins, aired Nov. 7, 2014, on PBS.

temple, the dwelling place of the Creator. "He is now the true temple, the place where heaven and earth meet (appropriately, since he was God's agent in their creation), the means by which, through his shed blood on the cross, heaven and earth are reconciled to God and, it seems, to one another."[45] What Paul is interested in here, as throughout many of his other epistles, is Christ as both Creator and Redeemer.[46] And while Jesus is the true temple, we are also called to be "temple builders," working through the Spirit to make fitting places in the world for God's holy presence.[47]

We witness, then, in the New Testament authors' sourcing of language from both creation and tabernacle/temple narratives to be applied christologically, a reemergence of the election theme in reference to the general concept of the *imago Dei* and particularly to Christ's own election by the Father in the story of creation and redemption. Balthasar calls this "the ultimate expression of the divine involvement"—God's elective choosing as manifested in the Old Testament, but this time concentrated universally in the one particular person of Christ.[48] God empties himself (Phil 2:6) in the incarnation and becomes the "very embodiment of [his] mighty act of liberation" through election.[49] Christ reveals how the God of Israel, who chooses people for specific purposes and who dwells with his people in fittingly made places on earth in the Old Testament, extends his invitation to all humanity to participate in the divine life through Christ.[50]

God's choosing of specific people and places, though, is predicated not on his exclusivity or favor, but rather reveals a calling *for* something that necessitates both human response and responsibility with the gifts given, a calling instantiated in the theological concept of the *imago Dei* as introduced in the creation account. It is a call to "ever purposeful service," recalling the command for stewardship and dominion in the first chapters of Genesis.[51]

[45]N. T. Wright, *Paul and the Faithfulness of God* (Minneapolis: Fortress, 2013), 675.

[46]Wright, 673. See also H. E. W. Turner, *Jesus the Christ* (Oxford: Mowbrays, 1976), 21. See Rom 8:18-23; 2 Cor 5:17; Gal 4:9.

[47]See especially chap. 2 of Nicholas Perrin, *Jesus the Temple* (Grand Rapids: Baker Academic, 2010).

[48]Hans Urs von Balthasar, *Engagement with God* (San Francisco: Ignatius, 2008), 26.

[49]Balthasar, 27.

[50]Larry Chapp, "Revelation," in Oakes and Moss, eds., *Cambridge Companion to Hans Urs von Balthasar*, 20; Hans Urs von Balthasar, *The Word Made Flesh*, Exploration in Theology 1 (San Francisco: Ignatius, 1989), 170.

[51]Rowley, *Biblical Doctrine of Election*, 74, 120; Lesslie Newbigin, *The Open Secret: Sketches for a Missionary Theology* (Grand Rapids: Eerdmans, 1978), 19.

Balthasar notes: "For the grace of God is fundamentally a call; it is being enlisted in God's service; it is being commissioned with a special task; and through all this there is bestowed upon us a unique personal identity in the eyes of God."[52] What this ultimately means for Balthasar is that we are called and commissioned to participate in God's own activity in the world, and this shapes the very nature of our identity as the people of God.[53] Through God's self-emptying love, he has allowed us a free place in his creative work and universal mission through Christ. And our identity as placemakers in the natural world, as those who give order to and care for the particular places we find ourselves in, is grounded in that divine love. That "God so *loved* the world that he gave his only begotten son," is perhaps, then, the most basic paradigm for our sense of place in the natural world—in an imitative way, we should pour our love into the world through active and transformative engagement with it. Our participation in Christ will be composed of various actions *in place*, which God uses to reveal himself to the world and transform it by his grace.

Participation in new creation. Earlier I addressed eschatological concerns for Vanstone's kenotic theology of creation, a view I argued perhaps levied too much on creatures and stripped teleological insight from a God who "risks" too much. As we conclude our theological exploration of human vocation in the natural world, these eschatological concerns will help weave together those themes elucidated thus far: divine calling and election, the *imago Dei*, and human participation in creation and redemption through practices of love modeled after Christ's kenotic work in the world. For this we will return briefly to the Colossians 1 text, along with highlighting the eschatological nature of Christ's work on the cross. By focusing in on Christ as the image of God and as both Creator and Redeemer in his letter to the Colossians (the central concern being that *all* of creation can be saved through Christ), Paul is able to speak to Israel's messianic and eschatological hopes while also recognizing the new scope of Christian mission to the entire world.[54] Our

[52]Balthasar, *Engagement with God*, 28-29.

[53]Balthasar, 29.

[54]Wright emphasizes that the work of redemption in Colossians 1:18b-20 is "aimed precisely at new creation," emphasis being put on the work of redemption through (*dia*) the son. Wright, *Paul and the Faithfulness of God*, 674.

 Christ as Creator renews the focus on all of creation, including, of course, but not limited to Israel's

theology of creation is thus reoriented in the New Testament with the particular presence of Christ in the places of this world, turning us not back toward Eden but forward to the new creation, and calling us into placed participation in Christ's redeeming presence in *all* the world.

Norman Wirzba draws attention to the "cosmic scope of Christ's work" in his theology of creation and new creation, highlighting Paul's christological hymn in Colossians 1:15-20. The Colossians text underscores not only the presence of Christ "in the beginning" but also his presence in the world to its final end, including his supreme role in redeeming and reconciling all things back to proper relationship with God. N. T. Wright similarly reinforces the role of Christ as the image of God for both creation and new creation:

> This is, then, a Christological monotheism which is most obviously *creational*, affirming the goodness of the original creation and announcing the dawn of its renewal. It is also *eschatological* monotheism, in the inaugurated sense that Jesus, as the divine Wisdom, is in himself the God of Israel who has returned to dwell among his people, and in the future sense that looks ahead to the final accomplishment of what has been launched in the Messiah's resurrection.[55]

What is interesting to note about how both these authors handle the text is that their discussion of the cosmic scope of Christ's work in creation and redemption results in a focus on the church's participation in Christ's work, which we see hinted at in the recognition of Christ as "the head of the body, the church" (Col 1:18) in the Colossians hymn. Wirzba argues that as we are "members of Christ's body and thus custodians and agents of the grace of God, we are implicated in and responsible for (in limited ways) the restoration of creation."[56] Wright offers a similar evaluation, drawing out the liturgical element of the proceeding Colossians text, specifically the church's call to thanksgiving. The Colossians' "cultural liturgy," and ours, must be one grounded in the creational, incarnational, and eschatological character of life in Christ, and it calls forth a deeply considered and habituated religious imagination in the places of the world.

land and people. See Wright's discussion of Israel in N. T. Wright, *The New Testament and the People of God* (Minneapolis: Fortress, 1992), especially 412-17. Even Israel's resurrection beliefs before the time of Christ reflect this in some way, citing the eschatological renewal of the whole creation and the physical resurrection. See 329-34.

[55]Wright, *Paul and the Faithfulness of God*, 676.

[56]Wirzba, *Paradise of God*, 49.

Our Christian sense of place will, therefore, be one that is simultaneously of this world (in the sense that it is rooted in the perception of the world as God's creation and good gift) and also more than this world, trading the sin and brokenness of the fallen world for a hope grounded in the knowledge of God as both Creator and Redeemer of all things, a perception that ultimately calls us into participatory action in the world through Christ and in anticipation of our fully resurrected life in the new creation to come. Our placemaking liturgies, in other words, must be ones that demonstrate these creational, incarnational, and eschatological aims. By putting on the mind of Christ, that divine perception of the world as good (yet in need of redemption) will be reflected in our own imagination and placemaking in the world. In imagining the creation anew, we may be better stewards and participants in the redemptive project that God is authoring and in which he commanded us to participate in the beginning.

To return to our initial considerations in this chapter, we cannot fall victim to a "failure of the imagination" if we are to imitate Christ's love in the world through our own placemaking actions.[57] Our eschatological hope for the natural world requires imaginative vision, but that hope shall not lie dormant until the *eschaton* but is worked out in all those encounters of the church with the world in *the here and now*.[58] In other words, that imaginative hope is one that must not fail *in this world*. A sense of place in and love for the natural world grounded in a biblical way of seeing must be cultivated so that we do not, in the words of Wendell Berry's character Hannah Coulter, make the world "unreal enough to be destroyed."[59] We must perceive the world as God does—as "very good"—and rightly act out of that vision.

Our model for both that imaginative perception and action in place must be Christ's supreme outpouring of love on the cross and in the resurrection.

[57]In *Life is a Miracle*, Berry describes the failure of imagination as obstructing compassion and obscuring particularity of creatures and places. Wendell Berry, *Life Is a Miracle: An Essay Against Modern Superstition* (Berkeley: Counterpoint, 2000), 86. Trevor Hart references this same "failure of imagination" in the tendency to pigeonhole or ignore particularity of the other. Trevor Hart, "Migrants Between Nominatives: Ethical Imagination and a Hermeneutics of Lived Experience," *Theology in Scotland* 6, no. 2 (1999): 37.

[58]See Richard Bauckham and Trevor Hart, *Hope Against Hope: Christian Eschatology at the Turn of the Millennium* (Grand Rapids: Eerdmans, 1999), along with my later discussion of Christian eschatalogy in chap. 6.

[59]Wendell Berry, *Hannah Coulter* (Berkeley: Counterpoint, 2004), 168. The main character, Hannah Coulter, remarks, "Want of imagination makes things unreal enough to be destroyed. By imagination I mean knowledge and love. I mean compassion." We might conclude that if our imagination is tied up with our loves, then, a failure of the imagination is their corruption.

An eschatology that fails to recognize the cross and its horror will be unable to engage with the problems of the world today. John de Gruchy makes the claim, then, that "from the perspective of the New Testament, the crucifixion is an eschatological event," that this ugly world "can only be redeemed by the alien beauty of the cross."[60] The work of creation and redemption, both Christ's work and our own, receive their decisive focus and meaning in the work of the cross and resurrection. Matthias Grunewald's *Isenheim Altarpiece* stands as a particularly challenging example of this, its closed position showing the gruesome crucifixion and suffering of Jesus on the cross, while the open position envisages the resurrected Lord, his newly transformed body surrounded by divine light. If Christ is the true image of God, then his suffering in love, and his transformation of bodily flesh, stand as a paradigm of what the Christian life may look like. It is through self-emptying love into that very ugliness of sin and death that transformation of disorder is achieved.[61] Rowan Williams remarks similarly that resurrection and transformation occur not by God "lifting us to 'another world'" or displacing us from the world we live in.[62] Rather, it is our placement within the world—in the everyday, physical places in which we live our lives—that forms the venue of our own transformation and our pursuit of beauty. We are very much *placed* in this often-disordered world, and by modeling our placemaking actions after Christ's own, we may help contribute to the reordering of reality through the power of Christ in us.

ART, BEAUTY, AND RELIGIOUS EXPERIENCE IN NATURE

So far I have referenced calling and responsibility in the natural world but have not said much about the role of beauty. When one pictures or thinks of the natural world, however, beauty is often one of the first associations that comes to mind, the power of a beautiful landscape standing out as a significant human experience. Nature holds indescribable beauty, and the experience of the natural world leads one to consider the God who is responsible for such beauty. Kathryn Alexander proposes a theological aesthetics of nature

[60] John W. de Gruchy, *Christianity, Art and Transformation: Theological Aesthetics in the Struggle for Justice* (Cambridge: Cambridge University Press, 2001), 124, 133. De Gruchy grounds his theological aesthetics in this assertion, focusing on the important role of ugliness in artists' attentive working with the world for the sake of beauty.

[61] Begbie, *Voicing Creation's Praise*, 175.

[62] Rowan Williams, *On Christian Theology* (Oxford: Blackwell, 2000), 207.

whereby our understanding of salvation and redemption is linked to our experience of natural beauty, experiences that trigger environmental awareness and responsible or ethical action.[63] Natural beauty, she says, functions as a form of religious insight, revealing spiritual presence and redemptive significance in the created world. We tend to, she argues, regard nature and culture as individual entities, nature being that which is "uncultured" and separate from the rest of built society. These distinctions, however, fail to represent our own imagining of nature and its value, the act of looking at a landscape, even if unpeopled or lacking built structure, as being an act of cultured imagining.[64] We saw precisely how this is represented in Genesis, Welker highlighting the interconnectedness between human and nonhuman communities from the beginning, and our perception and responsible engagement with that community being central to the proper enactment of our identity as God's image bearers.

For Alexander, it is our ability to notice and respond to beauty, which results, she says, in ecological and social justice, and ultimately in a salvific vision of reality that reflects this relationship between nature and culture, along with human calling in these terms. This is why we must develop what she calls "a loving eye," a term borrowed from Sallie McFague to designate an attitude of care, respect, and acknowledgment of mystery and complexity.[65] This is keenly a matter of developed and loving *perception* akin to what we have described in biblical terms. Trevor Hart similarly addresses this potential relationship between beauty and goodness, though with perhaps more precision. He argues, "What beauty calls out for and properly engenders in its beholders is goodness, yes—but goodness in the active form of love."[66] Beauty, therefore, must draw one out of oneself in an act of love; it "renders the self adjacent," in Hart's words, in order to bring about new perception and ethical or justice-seeking action.[67]

The manner in which we perceive beauty is thus key to understanding the ways that ecological and socially conscious action might occur by way of result. While Alexander, who draws heavily on the work of Josiah Royce,

[63]Kathryn B. Alexander, *Saving Beauty: A Theological Aesthetics of Nature* (Minneapolis: Fortress, 2014).

[64]Alexander, 113.

[65]Alexander, 139.

[66]Trevor Hart, *Making Good: Creation, Creativity, and Artistry* (Waco, TX: Baylor University Press, 2014), 312.

[67]Hart, 312. Hart is drawing on Elaine Scarry's work here. See Elaine Scarry, *On Beauty and Being Just* (Princeton, NJ: Princeton University Press, 1999).

helpfully assesses the dynamics of religious and aesthetic perception, Royce's friend and colleague C. S. Peirce may offer more to a model of aesthetic perception for religious experience and action, a task Ben Quash has taken up in his *Found Theology*.

In assessing Peirce's thought, Quash focuses on one aspect of logical inference called abduction, which takes the introduction of a new idea (a given) and fills in the gaps, creating new knowledge and experience as a result. It is not simply logical deduction or induction but a freer and necessarily imaginative operation that results in something clearly related to the set of givens but which operates on a new field—"the only logical operation which introduces a new idea"— and which results in a true "finding," what Quash identifies as a pneumatological experience in participation with the free human imagination.[68] The Holy Spirit, he says, is "the 'leader' of the abductive mind," actively training us to operate within this dynamic of the given and the found.[69] What is more, Quash explores this in terms of the arts, artistic abduction being one of the primary ways that experience is filtered into new knowledge and ideas.

Quash's modeling of Peirce's insights also provides a further foundation for understanding the role of sense of place in both aesthetic and religious experience. Peirce believes that our "percepts"—our conceptions about the world—have what Quash summarizes as "an inalienable experiential grounding to them, and are thus rooted in *perceptions* in the world."[70] This inalienable experiential grounding, our mind's experience through the senses, might be understood in the terms set out above as "sense of place," that way of being in the world that is expressed in a love of the environment one is in. We might see artistic beauty and beauty in nature, then, as both key players in the model of perception he outlines; *perception is grounded in the love of the natural world and experience of the beautiful*, both of which form a ground for logical inference and a given for the abduction of new ideas. In other words, in the type of abductive knowledge that Quash observes, knowledge is first given in our experience of the natural world and, according to Alexander, in those experiences of beauty there.

[68]Quash, *Found Theology*, 205.
[69]Quash, 215.
[70]Quash, 199.

Beyond this experience of the beautiful in nature itself, art that works in dialogue with nature takes us into a form of abductive thinking and becomes, as Alexander notes in her reflection of Royce, training for loyalty.[71] In my own assessment, it seems that art can train us in loyalty to the natural world by, first, "immers[ing] us in the physicality of the world more fully rather than furnishing an escape from it," as Hart suggests of the arts, and upon that immersion and attention to its particularity, becoming what Wendell Berry describes as "a complex giving of honor."[72] We become educated through beauty for perception, and our renewed perception through the arts then reciprocates with an environmental awareness, an ethical imagining of our places and experiences that serves to promote action in the world. Along with drawing attention to our context and place in the world, art may also provide its own context (grounded in that already-existing sense of place) for the work of the Spirit in our lives to mold us further into attentive and ethically minded action in the world. All of this acts in mutually influential ways—our actions then transforming places, which begins the cycle of perception over again, forming those basic experiences of the world over time that generate new knowledge and experiences, new findings through the Spirit's ever-present and active work in the world.

Since the Spirit is capable of drawing out meaning from a wide variety of images or experiences in the world, it is not necessary that the art work, nor its artist, identify as Christian in order to participate in this dynamic.[73] To this end, Timothy Gorringe recognizes the genre of landscape painting as potentially functioning as "parables of the kingdom," secular parables that highlight God's presence and revelation in the world.[74] Jesus' parables help hearers discover new realities about the world and religion while also motivating them to action. In the same way, art that engages us in perception of the natural

[71]Alexander, *Saving Beauty*, 88.

[72]Hart, *Making Good*, 273; Morris Allen Grubbs, ed., *Conversations with Wendell Berry* (Jackson: University Press of Mississippi, 2007), 54.

[73]While I have spoken of the role of beauty in perception, it is also important to note that neither must art always be beautiful in order to communicate or motivate one to new perception or action. One might look to Francis Bacon's decidedly ugly and often horrific depictions of human suffering by way of example here.

[74]T. J. Gorringe, *Earthly Visions: Theology and the Challenges of Art* (New Haven, CT: Yale University Press, 2011), chap. 1. David Brown also explores this dynamic of religious experience through a variety of avenues, including art and place, in *God and Enchantment of Place: Reclaiming Human Experience* (Oxford: Oxford University Press, 2004).

world and its beauty may not only give us an experience of God in nature but also motivates us to reformed action and ethical imagining of our work in those places. It motivates us to a deeper perception and experience of place, which produces just and responsible action in the world.

One relevant example of this might be found in the work of Christo (b. 1935) and Jeanne-Claude (1935–2009), the artistic couple known for creating artworks of epic planning and proportion, and who are some of the best-recognized environmental artists of the past century. Perhaps best known for their "wrapping" of objects—trees, buildings, coastlines, oil barrels—their work is at once elemental of painting, sculpture and architecture, and urbanism and environmental art.[75] By looking at the ways in which Christo and Jeanne-Claude's work engages us in the natural world while finding new ways of interpreting those environments, we might consider their work as a form of theological abduction, enhancing our inferences on beauty and meaning, and inciting action and environmental responsibility in the created world. Marina Vaizey observes, "Christo and Jeanne-Claude enhance the real world, sharpen our vision, make us more aware and observant, and finally, change the way we see things."[76] These insights on Christo and Jeanne-Claude's work serve to introduce us to the role of their monumental pieces of installation in environments across the world, along with the way in which they heighten our perception of the natural world and its beauty. Christo and Jeanne-Claude's work creates a context for people to perceive places in a whole new way and to reflect on the ways in which humans affect the natural landscape or built environment. These works become contexts themselves, and while they are temporary, they are no less valuable.[77]

Christo's newest project, *Floating Piers* (Lake Iseo, Italy, 2016) (plate 2), conveys his continued interest in the role of the natural environment on our senses: "All our projects involve real things—real wind, real sun, real wet, real

[75]Jacob Baal-Teshuva, *Christo and Jeanne-Claude* (New York: Taschen, 2016), 9.

[76]Baal-Teshuva, 39.

[77]It is in fact the temporary nature of their installations that calls more attention to the storied place, reminding viewers of the immediacy of our perception of the landscape—that if we don't pay attention now, we might miss both the beauty and the transforming presence at play in a given moment. Their art is about the experience of a landscape or environment at a particular point in time, and the ephemerality of their works is perhaps its longest-lasting feature. Like Cezanne's Mont St. Claire or Constable's Lake District, the place becomes storied as a result of their artistic engagement with the place, even when the site goes back to "normal."

danger, real drama. And this is very invigorating for me."[78] The physicality of
the experience is something Christo encourages his viewers to explore: the
feel of the wet, squishy fabric beneath one's feet and the warmth on one's skin,
the undulating water that moves the walkways as visitors embark on the two
hundred thousand floatable cubes stretching several miles across the lake to
islands and neighboring towns. He tells an interviewer, "Look! It's actually
breathing!"[79] For him, the project *is* the piers and the surrounding landscape,
the mountains and lake itself, "with the sun, the rain, the wind, it's part of the
physicality of the project, you have to live it."[80]

His intervention in the landscape serves to call attention to the goodness
of what is already there, enhancing for our perception what we may have over-
looked in everyday experience. The project thus takes on its own dwelling in
the world and becomes an event of potential revelation. Like Christo's past
projects, the landscape is integral to the identity of the project, and it is not a
possession either of the artist or of the visitors. It is borrowed, lived on, ap-
preciated, and valued for itself. It can be added to or subtracted from, worked
with or worked against. But as he has before, Christo has offered this land-
scape his love and attention, and therefore participates in granting it an added
value. Christo's installation reminds us that we are members of this land-
scape—of the sun and the water and the mountains and the air. And our own
walking on water—our own dominion over what might be expected possi-
bilities in the natural world—comes with a certain set of conditions: we must
recognize the natural world as an integral member of the divine project God
has invited his creatures into. It is the work of love that ultimately allows us to
walk on water.

Christo and Jeanne-Claude's projects create a temporary aesthetic context
that engages the whole person precisely *through* physical interactions with the
environment. While photographs record the event for later reflection, the art
is ultimately the experience of that particular moment in the landscape. Their
dominion over the natural and built environments of the world conveys their
attitude of responsibility and care not only to the beauty of the world but also

[78]Carol Vogel, "Next from Christo: Art That Lets You Walk on Water," *New York Times*, Oct. 21, 2015, www
.nytimes.com/2015/10/25/arts/design/art-that-lets-you-walk-on-water.html.
[79]Elisabetta Povoledo, "Christo's Newest Project: Walking on Water," *New York Times*, June 16, 2016, www
.nytimes.com/2016/06/17/arts/design/christos-newest-project-walking-on-water.html.
[80]Povoledo.

to doing good work within it. Their work emits a transforming presence on their environments through aesthetic attention, and in this way becomes a philosophical exemplar of how beauty can give voice to both goodness and truth. They are making a place that makes us—cultivating our relationship to the natural world through that vision of love and freedom. We might be saved as a result, but only inasmuch as that love reflects God's working in the world. We need, however, open our hearts to it, submitting ourselves to the power before us and letting that beauty transform us so that we may enact our calling to be a positive transforming presence on the landscape.

CASE STUDIES IN ART AND A THEOLOGY OF THE NATURAL WORLD

While this exercise in theology serves to highlight some key theological features of Christian life in the natural world, along with the manner in which our theological imagination takes root there, we will turn now to some extended case studies in order to show how the visual arts can provide a context for the development of a Christian sense of place and a catalyst for more responsible engagement in our natural environments. None of the artists here has a strongly Christian voice in their work, but we will see how their attentive reworking of and participation in the natural world enables Christians to perceive the transforming presence of humans on the landscape and the ways in which we might practice our loves as Christians in the natural world. As a work of love, these artists show us how to perceive more attentively and engage more responsibly in the beauty and particularity of the world, training us to participate in the kingdom of God in ever-new ways, while hoping for a transformed future for the community of creation.

Art calls attention to the incarnational particularity of place: Marlene Creates. Marlene Creates (b. 1952) is a Canadian artist who deals mostly in the medium of photography and land-art installations, often working on her own Newfoundland property in order to reflect on what it means to be embedded in a particular landscape over a long stretch of time. Over the course of her career, she has explored several themes related to place, including the particularity of place, the relationship between nature and culture, memory, narrative, and land use, among others. While her methods have no doubt changed over time, we might understand all her work to be engaged in a type of placemaking practice. The images and installations Creates produces

communicate and contribute to the particularity of places, and all her work carries a community-oriented focus, suggesting that a place becomes a place once "someone has been there."[81] By exploring both human absence and presence in the landscape, along with the impact that human action has in the landscape, Creates explores what it means to have a sense of place in the natural world. The relationship between perception of incarnational particularity and the potentially transformative habits that result will thus be a central theme of this exposition of her work.

While Creates has dealt almost exclusively with issues related to place over the course of her long art career, her work remains devoid of banality. Her careful attention to the particularities of places and human experiences in the natural world continually give viewers something to reflect on. Her earliest series, *Paper, Stones and Water (1979–85)*, records human ordering and action in a place with an eye to the essentially ephemeral nature of that action in the natural landscape. In this series of fifty-nine photographs (fifty-three color and six black and white), she records temporary landworks, over half of which include the placement of white paper in the landscape. The works record a natural environment, revealing touches of human presence in either the placement of paper or the organization of objects in the field of vision. In the paper works she records the effect of placing paper on water or stones and photographing the result. These works indicate the momentary nature of her relationship to the place, revealing what Creates suggests is our "fragility and temporariness in the landscape."[82]

But the photographs are even more complex than that. For, at the same time, by making a permanent photographic record of the experience in the landscape, they suggest the extent to which our actions may permanently affect the landscape, along with how the place itself makes a permanent record on us. For instance, *Paper and Water Lilies, Newfoundland 1982* reveals the imprint of the water lilies in the paper as it is immediately placed on the surface of the water. The paper immediately changes and draws up a record of the place within it. The water lilies leave their impression on the paper, and the result is caught in the photograph. The work is immediate and attached

[81]Susan Gibson Garvey, *Marlene Creates: Landworks 1979–1991* (St. Johns, Newfoundland: Art Gallery, University of Newfoundland, 1993), 17.
[82]Garvey, 7.

to the particular moment—therefore fleeting and ephemeral. After Creates photographs it, the moment is gone. But the image itself also reveals the extent to which we are affected by nature even when nature goes back to its customary state. The particularity of the place leaves its imprint on us as viewers, as it does in the photographed paper.

This dichotomy of permanence and ephemerality, and presence and absence, speaks to the artist's broader views on place. Place is never a singular entity. We can neither break it down to one description nor identify a general attitude toward place. J. E. Malpas, as we saw in chapter one, communicates this multiplicity of place that Creates seems to share. Our experience of a place is always complex—a combination of subjectivity and objectivity, spatiality and temporality, self and other or self and nature.[83] Creates's images and installations leave us questioning the nature of our own relationship to place while simultaneously shedding light on it. Creates concentrates more exclusively on the theme of presence and absence in the landscape in her series *Sleeping Places, Newfoundland 1982* and *A Hand to Standing Stones, Scotland 1983*. The former is "about a presence indicated by its absence," while the latter is about "an absence indicated by a presence."[84] *Sleeping Places* is a beautifully executed series of twenty-five black-and-white photographs, each recording an image of the artist's impression left on the ground after sleeping. Creates traveled around Newfoundland, sleeping outside each night and in the morning photographing the impression her body left on the ground. Each photograph is wonderfully unique, depicting crushed vegetation and grasses. These works, she says, express the idea that each site becomes a place after someone has been there. The absence of her body in the impressions communicates that the particular place has been made by her presence. The land itself remembers her bodily impression in the place, as does her camera.

In *A Hand to Standing Stones*, she indicates her own presence at the place by ritually putting her hand in each shot against the standing stone. We see the place absent of its original makers but visited by Creates, who communes with the history, spirituality, and tradition of the place.[85] Rather than choosing

[83]J. E. Malpas, *Place and Experience: A Philosophical Topography* (Cambridge: Cambridge University Press, 1999), 163.
[84]Garvey, *Marlene Creates: Landworks 1979–1991*, 17.
[85]Garvey, 18.

larger standing stones such as Stonehenge in England, she opts to visit smaller places of human presence such as the Outer Hebridean Islands of Scotland in order to focus on the local and particular ways that each society structured its rituals around places. At this point in her career, one commenter observes, "It is apparent that the human dimensions of place—the cultural in the natural, as it were—have begun to claim special attention."[86] The complex nature of places becomes more apparent in these works, and here especially we begin to be able to draw out some more theologically significant implications.

The communion between nature and culture, and presence and absence, that Creates observes in her works is important theologically, though the artist does not necessarily intend the images in this way. By giving place to human action *alongside* the actions of nature, she presents a relational view of the "community of creation." Advocating neither human dominion (in the negative sense) nor an overreliance on our "return to nature," Creates suggests realistically: "To banish all evidence of ourselves is yet another contrivance in a place where the natural environment has been turned into a contrived phenomenon. This makes nature an object. But nature—including human nature—is more accurately a subject. Or, as I like to think, nature is a verb. And we are not, in fact, aliens."[87]

Creates's works thus speak to the individuality and givenness of nature—specifically in its own ordering and reordering tendencies—and the place of our action within it. Nature is both active and acted on—a verb in the sense that it emits influence and action over us, as well as allowing human collaboration in its processes and products, a relationship akin to Bourdieu's "structured structures" that are also "structuring structures."[88] Nature is, as Creates suggests in her own reflective writing, never free of human action. Even in our absence, we manifest an extraordinary degree of presence in the landscape. Creates's depiction of the complexity of this relationship to nature provides a striking message to the relevance of our actions. It also images the types of relationship we see in Scripture, specifically the mutual relationship between creatures and creation and humans' responsible participation in and remaking

[86]Garvey, 18.

[87]Marlene Creates, "Nature Is a Verb to Me," in *Rephotographing the Land* (Halifax, Nova Scotia: Dalhousie Art Gallery, Dalhousie University, 1992).

[88]Pierre Bourdieu, *Outline of a Theory of Practice*, trans. Richard Nice (Cambridge: Cambridge University Press, 1977), 72.

of God's gift of creation. In her work Creates advocates a mutual relationship between nature and culture; humans are called to participate with places and nonhuman creatures rather than dominate over them, simultaneously recognizing our power to responsibly influence.

A Hand to Standing Stones brings out another important and related theological meaning along with Creates's similar recent project, *Larch, Spruce, Fir, Birch, Hand, Blast Hole Pond Road (2007–ongoing)* (figure 2.1). In the latter she also places her hand in the frame, but this time against trees standing on her own Newfoundland property. While both series of photographs reveal the

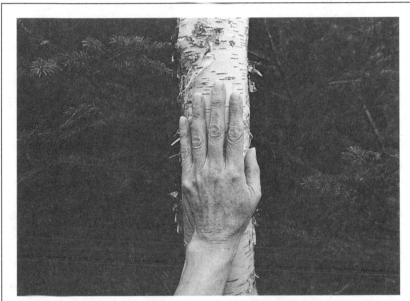

Figure 2.1. Marlene Creates, *Larch, Spruce, Fir, Birch, Hand, Blast Hole Pond Road, Newfoundland 2007–ongoing* (excerpt, 2014)

relationship between people and place, they also communicate the importance of the particular, that each place she touches is important in its own particularity. Every stone is different, every tree unique. And this particularity is so important that it merits her human touch, a sort of assent by the artist of the importance of each tree and stone, a perception of their goodness and givenness. Creates describes her most recent project as an exercise in attentiveness to the "thisness" or *haecceitas* of each tree, a term brought to her attention by Canadian poet Don McKay but more commonly associated with

the theology of Duns Scotus.[89] For Scotus, "everything without exception is rooted in the cause of creation."[90] All things, by their nature of being particular, participate in the unity of creation in Christ. Hence "this place," "this person," "this animal," are all important in the community of creation. Creates, in referencing the "thisness" of the trees on her property, communicates the importance of particular landscapes and places, along with their particular relationship to her, as shown by the presence of her hand. Her views on the communion of people and places meet the notion of particularity in these two projects in a striking and powerful way. By giving attention to the particular, Creates shows us how to participate in the unity of creation through it. Only by attending to the local do we understand the wider significance of things.

Creates's work, in this sense, is decidedly "incarnational," to connect her work further with the notion of *haecceity* on which she draws. The incarnation of Christ—his sharing with us in the most particular of ways as a human being in a specific place in time—suggests the significance each element of this creation holds in relation to its Creator. God pronounces a divine and blessed "Yes!" on creation in his advent here, calling our attention to the fact that his presence is precisely revealed in the particular. But Christ came not just to approve but also to transform creation. And this transformation is performed not in some broadly universal way but through engagement with the places to which we are called. Furthermore, Christ's invitation to us to be a people of God reveals that clothing ourselves with Christ (Rom 13:14) will mean actively responding to the obligation set on us to transform the places that *we* encounter, just as Christ did. Creates not only calls attention to the particularity of each tree and stone on her property but perhaps even *contributes* to it. Not only do the photographs suggest an alternative and scaled-down vision of the place, but they may also encourage different action within it as a result of renewed perception. In this way Creates's art and other art like it might be considered a tool for changed action in the landscape that results in a newly

[89]For a good summary of Scotus's views as they relate to place, see Philip Sheldrake, *Spaces for the Sacred: Place, Memory and Identity* (London: SCM Press, 2001). Creates cites McKay for bringing this term to her attention in an email to the author on October 12, 2010. The poet Gerard Manley Hopkins is also famously influenced by this notion in Scotus's work. See especially the poem "God's Grandeur" for an example of the importance of God's particular creation.
[90]Sheldrake, *Spaces for the Sacred*, 24.

devoted attention to its particularities along with a careful theological or ethical focus in terms of placemaking practice.[91]

While all of Creates's work deals with the relationship between people and place in some way, and therefore might serve a theologically instructive role, perhaps the most enlightening aspect of Creates's work revolves around her depiction of human placemaking, particularly as it is expressed in her work with "memory maps." In this stage of her career (beginning in 1987), we see a move from recording fainter images of human presence on the landscape—a stone being thrown into the water or an ordered arrangements of stones—to focused portrayals of people's perceptions, actions, and effects on the places they live. While Creates has always been interested in "the idea that [the land] becomes a 'place' because someone has been there," her work now turns to the telling of particular stories from particular places.[92] Now her interest is decidedly concrete—she "has ceased to be this kind of privileged witness because she has sought more relevant witnesses, ones seldom consulted"—the people that live in places oft forgotten yet important because they have made a place where they are.[93]

Creates first used the concept of the memory map in *The Distance Between Two Points Is Measured in Memories, Sault Ste. Marie, Ontario 1987.* The following year this series continued with eighteen assemblages based on memories of elders living in northern Labrador. Each assemblage includes a hand-drawn memory map, a transcription of an excerpt from a story told to Creates by the inhabitant of the place, a photograph of the person in their current home, a photograph of the place they described, and often an object or grouping of found, natural objects from the place.[94] Each map was drawn by an inhabitant who reported his or her own memories of a specific place. As a result, each map looks different and depicts the terrain in the ways that the people remembered it through their own

[91]For instance, more ecological land-management or forestry practices might be considered one important way that attention to particularity results in ethical placemaking practice.

[92]Jacqueline Fry, *The Distance Between Two Points Is Measured in Memories, Labrador 1988* (North Vancouver, British Columbia: Presentation House Gallery, 1990), 57.

[93]Fry, 57.

[94]Garvey, *Marlene Creates: Landworks 1979–1991,* 20-21. The original smaller series in Sault Ste. Marie was part of a larger group exhibition titled *Sans Démarcation (Without Boundaries)* and consisted of four assemblages that included "a 'memory map' etched in slate, a photograph of the place to which the map referred, and small pile of objects collected from actual places: stones, slag, sand, and a bundle of sticks."

individual experiences. By encouraging inhabitants to remember the land-
scape in this way, Creates draws on the wider history of experiences there and
is able to communicate something of the ways in which the natural place itself
was shaped by particular actions and events.

While often the major illustrative differences in the maps result from gender
distinctions (men often reported where they hunted or fished, while women
tended to focus on smaller, more domestic areas such as a home), the common
thread through the whole project is that of "sadness at the loss of nature in their
lives."[95] While the overall tone is nostalgic, it is not overly sentimental. Rather,
it expresses the desire to be in a full community with nature again, a desire that,
even if laced with nostalgic overtones, communicates a truth about the way in
which we tend to live in the natural world now. Creates connects these past
experiences of the inhabitants with her own by traveling to each of the sites
depicted in the maps in order to photograph it. Her own journey, then, is as
much a part of the work as the inhabitants' stories and maps.[96]

This project certainly served to inspire Creates's next series dealing with
memory maps, *Places of Presence: Newfoundland Kin and Ancestral Land, New-
foundland 1989–1991*, which focuses on her own ancestors' presence in the land.
In this series Creates focuses on her relatives' depictions and descriptions of
her ancestral land and is thus much more personal in terms of her own place-
making practice. It consists of only three assemblages this time—places where
her grandfather, grandmother, and great-grandmother were born. This is not
the land where she grew up, and in fact many of the places she had never even
been to. But the project holds personal meaning to her. She says: "I do this
work, every part of it, with my heart pounding in my chest. . . . I feel a poetic
inheritance that cuts across me as a woman and an artist. These intersections
are powerful, some are painful, and all are elusive, fragile, and improbable."[97]

Creates's work here is an example of what Edward Casey calls "mapping
with/in," a kind of "absorptive" or "productive" mapping that reflects the em-
beddedness of the maker in the landscape. "Instead of imposing a map on the
landscape, the artist-mapper exposes the landscape itself: shows it to be itself

[95]Fry, *Distance Between Two Points Is Measured in Memories*, 15.

[96]Garvey, *Marlene Creates: Landworks 1979–1991*, 21.

[97]Marlene Creates, "Artist's Statement," in *Places of Presence: Newfoundland Kin and Ancestral Land, New-
foundland 1989–1991* (St. John's, Newfoundland: Killick, 1997), 5.

a map or maplike."[98] As the people sketch the place as viewed through their human experiences, we gain a greater sense of how the landscape has affected their own narratives within the place. What Casey calls "absorptive mapping" is about the relationship of the body of the viewer to the landscape, and like Malpas earlier, Casey's picture of place revolves around experience and action. Rather than simply reproducing images of the natural landscape, the artist-mappers reflect their own experience there and recount the actual production of the place, while simultaneously re-producing it anew through the retelling of an implaced human narrative. Creates describes it as such:

> I see these places as palimpsests, as impressed with those people and events as the surface of an old slate blackboard or a marked wooden table-top. When we describe the land—or, more frequently, remember events that occurred at particular points on it—the natural landscape becomes a centre of meaning, and its geographical features are constituted in relation to our experiences on it. The land is not an abstract physical location but a *place*, charged with personal significance, shaping the images we have of ourselves.[99]

This expression of the place in personal experience, its re-presentation, is what Casey further describes as "mapping out."[100] As people identify the relationship between themselves and nature through "mapping with/in," they are able to enter a performative mode of placemaking for both themselves and other people by "mapping out." Essentially, in identifying their own actions and experiences as being linked to the landscape, they are "getting the experience into a format that moves others in ways significantly similar to (if not identical with) the ways in which [they have] been moved by being with/in a particular landscape."[101] Not only does Creates's work have the potential to encourage her relatives to experience the place in new ways, but she invites viewers to participate in that placemaking through various forms of identification with human experience, giving "expression to the complex workings of the geographical imagination."[102] Creates puts people into direct dialogue

[98]Edward S. Casey, *Earthmapping: Artists Reshaping Landscape* (Minneapolis: University of Minnesota Press, 2005), 189.

[99]Creates, "Artist's Statement," xxi.

[100]Casey, *Earthmapping,* xxi.

[101]Casey, xxii.

[102]Joan M. Schwartz, "Constituting Places of Presence: Landscape, Identity and the Geographical Imagination," in *Places of Presence,* 9.

with the places that they remember and/or currently live in, thereby increasing their sense of the particularity of place and encouraging a development of the geographical imagination needed for the continued making of places.

Though Creates would not be classified as a religious or Christian artist, her work in reflecting on the incarnational particularity of physical places and presence in the landscape shows us the significant theological value of place-based artistry. Creates's work causes us to consider the particularity of each aspect of place, noting the sometimes-paradoxical relationship of human engagement with it. Giving attention to particularity in the way she does, her work not only shows us something about specific place but also contributes to its particularity—it "adds value" to the place while drawing out its true nature.[103] By giving consideration to particular places, stones, or trees, Creates grants them a sense of purpose and meaning, calling attention to the potential value in all of God's creation as it reveals various modes of God's presence in the landscape. Furthermore, this adding of value points to the incarnational nature of places themselves—that there is value in the physical even while there is something "more" to it. The multidimensionality of place that Creates reveals in her works no doubt includes the spiritual or sacred. But this is not something the art takes us to *beyond* the places represented but something that lives *within* them. The physicality of place is important in its own right as it conveys the value of the landscape for us in historical, present, and future dimensions, while hinting at some grander presence within it that we call forth, at least for Creates, by virtue of our being intentional about our own presence there. Many of her earlier works convey presences in the landscape, and while most of these are allusions to the human community that resided there before us, the spiritual dimension of that presence is not lost on viewers or the artist herself. By drawing our attention to "places of presence," Creates suggests that there is more than meets the eye in this world we live in. We have a responsibility to participate in attentive ways with that presence, simultaneously taking note of what is already there and calling forth a presence that is not yet. While she often leaves her viewers to make that leap beyond for themselves, she invites them into a space christened for

[103]See Trevor Hart, "Through the Arts: Hearing, Seeing and Touching the Truth," in *Beholding the Glory: Incarnation Through the Arts*, ed. Jeremy Begbie (Grand Rapids: Baker Books, 2000), 5. For enriching or enhancing quality of creativity, see also Hart, *Making Good*, 257.

them, one that already calls attention to the particularity of the given world and encourages viewers to make something of it.

Art as a catalyst for participation in and waiting for new creation in place: Peter von Tiesenhausen. The ability to imagine the future of our places, as well as our present impact on them, is crucial as we enter a period of unprecedented human impact on the physical environment. If culture were ever in need of a fully formed geographical imagination, it is now. This is the theme of much of Peter von Tiesenhausen's work, as he becomes a sort of art activist for the natural environment, giving voice to issues such as climate change and forest health. Tiesenhausen (b. 1959) is an artistic everyman, working in painting, sculpture, printmaking, installation, event and performance art, and video. Tiesenhausen's artistic oeuvre is expansive not only in type but in scale, ranging from small-scale sculpture and installation on his own Alberta property to epic journeys across both land and sea (see *The Watchers* below). Furthermore, his own home often takes center stage as both site for and art itself. This latter fact is made even more interesting when we consider that the artist copyrighted his land as art in an effort to halt a Canadian oil pipeline company from encroaching on his eight-hundred-acre Alberta property. And he won the lawsuit, keeping the oil pipeline away by virtue of its copyright infringement on his art/land.[104]

When one meets Tiesenhausen, one is immediately confronted with charm and passion, a dedicated presence and attention to both the moment and the landscape he is in. Tiesenhausen does not consider himself a religious artist, but many theological themes emerge throughout his work that are worth noting. In an interview he states a "borderline" atheism when it comes to religious imagery, though his engagement with images and themes of a religious nature is always profoundly respectful and insightful.[105] For instance, one might contemplate a series of photographs where he urinated in the snow throughout the winter in the shape of a cross, forming a permanently discolored indentation in the pure white snow. By spring, when the snow had melted and grass grew back, a verdant patch of grass emerged in the shape of

[104]Stephen Keefe, "This Canadian Artist Halted Pipeline Development by Copyrighting His Land as a Work of Art," *VICE*, November 6, 2014, www.vice.com/read/this-canadian-artist-halted-pipeline-development -by-copyrighting-his-land-as-a-work-of-art-983.

[105]David Garneau and Peter von Tiesenhausen, *Deluge* (Leithbridge, Alta.: Southern Alberta Art Gallery, 2000).

a cross—growth and fertility persisted through a rather unseemly presentation and marked itself clearly on the landscape. In this "piss cross" viewers are reminded of Andres Serrano's *Piss Christ* in its attention to the broken beauty of Christ's presence in the world, his incarnation in and redemption of an unworthy world.

This religious presence is also seen in *Sanctuary* (2012), which consists of one thousand wooden poles, thirty feet high, that were installed at the Leighton Art Centre to form walkways or naves leading viewers toward the impressive mountain vista beyond it. Though the religious elements are more veiled, only really highlighted in the connotation of the title itself, the place is offered to viewers with a nod to its added presence. Akin to the standing stones of Scotland in Creates's work, the poles stand as a testament to both human and divine presence, which is now known only in relation to the natural landscape itself. Tiesenhausen's poles might be read like Jacob's stone at Bethel, marking a moment and place at which God enters the physical landscape. "Surely the Lord is in the place, and I did not know it" (Gen 28:16). The poles serve to direct viewers' attention to the landscape, which forms not only a venue but also part of the art itself. The evidence of human presence is relayed in the careful placement of the sticks, but unlike more lasting structures such as stones, the sticks will more quickly return to a disorganized state.

Like Christo's, this art will not permanently mark the environment, though it does show the lasting presence of humans there. The place, in its making, becomes a spiritual sanctuary for visitors, which reveals the landscape itself as the significant site of religious meaning. One is reminded of John Muir's description of being in the Sierra Mountains for the first time: "Our flesh-and-bone tabernacle seems transparent as glass to the beauty about us, as if truly an inseparable part of it, thrilling with the air and trees, streams and rocks, in the waves of the sun,—a part of all nature, neither old nor young, sick nor well, but immortal."[106] The wooden poles serve to orient our bodies to the landscape before us, which becomes a sanctuary or tabernacle not only for us but also for divine presence. Through this humble placemaking, our bodies are reoriented to the cathedral of nature, and we return momentarily to that moment when God and humanity walk through the cool night air of the garden together.

[106]John Muir, *My First Summer in the Sierra: With Illustrations* (St. Louis: J. Missouri, 2013), 20-21.

While Tiesenhausen is rarely explicit about spirituality (even in what may be perceived as his more religious works), he doesn't shy away from speaking more directly to human impact and presence in the environment. In these pieces he often calls attention to specific environmental threats. In *Balance* (2008) (figure 2.2), a public sculpture for the city of Prince George, he commemorates the impact of pine beetle infestations in local forests.

Due to rising temperature, pine beetles populations have risen to disastrous numbers in Canada, killing increasingly larger numbers of Canadian pine forests in the past several decades. In *Balance*, Tiesenhausen carves the form of a human figure from the trunk of dead tree killed by beetles, attaching a bronze cast of the upper branches of the tree, which appears to grow from the figure's head. In this piece, humanity is identified with the dead tree itself, human identity being the same as that of

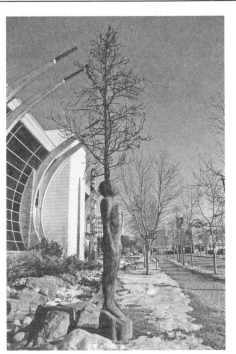

Figure 2.2. Peter von Tiesenhausen, *Balance*, 2008

its ravaged landscape. The sculpture speaks to our very direct role in affecting the environment, which contributed to the pine beetle outbreaks and therefore a loss of much of Canada's precious forested resources. He also highlights the denigration of our own human identity in the destruction of our natural environments. Paradoxically, the relationship between human identity and nature is shown as a positive relation (nature being an expression of the self, as well as in the beauty of the sculpture) while also featuring its denigration (our irresponsible actions in the environment constitute a "deadness" of human identity).

Perhaps his most impressive project to date, though, is *The Watchers* (1997–2002), a sculpture/installation/journey that involved the circumnavigation of five charred wooden figures thirty thousand kilometers around Canada and through the Northwest Passage (plate 3). These figures, standing over eight feet tall, were carved in wood and set on fire in a public event near Calgary, Alberta, before being displayed on a public rooftop overlooking the city of Calgary. After this exhibition was complete, they were secured standing straight up in Tiesenhausen's beat-up blue pickup truck and began their journey across Canada, stopping along the way for public exhibitions, truck repairs, and rest-stop conversations with interested onlookers. They were then placed and left at various places in the Canadian landscape over a five-year period, finding their way through many of the most impressive locations of the Canadian landscape, stopping to watch and wait while the artist would fly home for several months at a time. Eventually they made their way to the east coast and onto a Coast Guard icebreaker ship named *Henry Larson*, where they stood on deck while traveling through the Northwest Passage and Arctic Circle. From there they were lifted by helicopter onto a barge and made their way back to land before continuing their journey back down south to Alberta, this time down the western coast of Canada.

This massive journey says several important things about our relationship to the natural environment. The artist links the figures' "watching" with the changing landscape of Canada due to climate change, a most pressing threat to the natural world today. In Canada alone, a large percentage of glacial ice is melting due to rising temperatures, and this affects everything from rising oceans to animal and plant life on land. The figures stand in waiting, watching for changes in the landscape while being fully present within it, educating us in sorrow for the loss of the natural world through attention to its very beauty.[107] While perhaps unintentionally so, this project, I think, is his most theological. The five watchers stand as an expression of eschatological hope, a longing for a new creation that we may occasionally glimpse in the beauty of the here and now, and yet can never fully grasp. Of course, Tiesenhausen's project is at once hopeful and biting. *The Watchers* calls attention to our own role in the changing

[107]Alexander addresses this role of environmental art, drawing on observations from Royce on sorrow and beauty, when she writes, "Those wonderful expansive experiences of beauty in nature can lead to a profound sense of how much of created beauty has already been lost or destroyed." Alexander, *Saving Beauty*, 94.

climate and landscape of Canada, whether we are from there or not. We leave feeling condemned for the negative impact we have achieved in our conquering and dominion of the natural world. But the figures are also fully present in the landscape. While they seem to acknowledge a power outside their hands—the world *is* changing—they continue to participate in it, giving careful and devoted attention to the landscape that lies before them.

In this way, the watchers both indict us for what we have done and teach us what we must do. In some sense, our role in creation and redemption is simply to wait. We are called to live in a stature of waiting, always hopeful for the new creation that is to come and content to wait on the Spirit's presence, which may show up unannounced.[108] But that waiting is also active, and it involves a continued participation in and attentiveness to the world that is before us now.[109] Their charred bodies remind us of our own fire-licked heads, a memorial of the Spirit's presence on us, which calls us into action in God's kingdom. The watchers might be considered "wayfaring dwellers," a term used by Steven Bouma-Prediger and Brian Walsh in their study of Christian homemaking to refer to the way in which Christians are called simultaneously to be sojourners in this world, working toward the final homecoming/eschaton, and also belonging to and being fully present in the places in which they are put.[110] The watchers exemplify both these attitudes, waiting for something to come and yet fully becoming a part of the landscape in which they currently dwell. They are fully present on the landscape in which they are put even as they wait for an unknown future.

Tiesenhausen invites his audience to participate more directly in understanding their impact on the landscape in *Passages* (2010), a project that involved one hundred participants each releasing into the Bow River a carved, charred wooden boat, which was filled with earth from sites near the Bow Glacier upstream. The boats were each carved with the outline of a human figure and charred to leave a black veil over the wood. The boats also included the brand PVT-PASSAGES.CA so that people who found them downstream

[108]W. H. Vanstone, *The Stature of Waiting*, American ed. (New York: Morehouse, 2006).

[109]See James K. A. Smith, *Awaiting the King: Reforming Public Theology* (Grand Rapids: Baker Academic, 2017), 224, where he claims, "Active waiting is a distinguishing trait of citizens of the heavenly city, resisting both a quietism that concedes the world to the powers-that-be and an activism that imagines amelioration apart from grace."

[110]Steven Bouma-Prediger and Brian J. Walsh, *Beyond Homelessness: Christian Faith in a Culture of Displacement* (Grand Rapids: Eerdmans, 2008), 295.

could later report them. The artist invited people who found the boats to either keep or release them, and compiled stories of where they were later found downstream. The project communicates on several levels about human action in the landscape. First, it highlights that the results of our actions often cannot be witnessed until much later in the life of the natural environment, and often in places that we did not engage directly. People released the boats but had no control over where they ended up. While many of them were found later, only the landscape itself had full knowledge of where they all traveled and ended up. Second, the project drew attention to the source of river, the glacier, by filling each boat with some of the surrounding earth. In doing this the artist called attention to our dependence on certain parts of the landscape, even when we didn't see or realize them. The glacier is the source of the river and contributes to the fertility and flourishing of the surrounding places. When we misuse resources such as water or soil, we are committing a blasphemy not just to that place but also to the source of life for those places. Wendell Berry thus describes our misuse of creation as "the most horrid blasphemy" against God.[111] When we abstract ourselves from the community of creation, particularly the natural world, it becomes too easy to misuse resources and selfishly take from the world in the name of comfort or technology. If we do not love and know the places of which we are a part, we will make them unreal enough to be destroyed.

Like Creates, Tiesenhausen seems to have a profound sense of presence in the landscape, and his work gets at the heart of how Christians might think about our experience of and response to that presence. In some sense, we are invited to simply belong; the work invites a stature of hopeful waiting and expectation as we learn how to understand our own situatedness in the natural environment. But that stature is also a hopeful *practice*, and Tiesenhausen calls us into responsibly considered and habituated action in the landscape that is motivated and bolstered by those periods of waiting. Like the watchers, we ritually stay put and move about our environments, taking note of its beauty and health, while acknowledging the harmful repercussions of our own actions, which have led to bits of brokenness, disease, or ugliness. The liturgies of being present to and active within the natural world are exemplified for us in these artworks. Tiesenhausen's activism through aesthetic presence in the

[111]Wendell Berry, "Christianity and the Survival of Creation," in *Sex, Economy, Freedom, & Community* (New York: Pantheon Books, 1993), 98.

landscape thus reinvigorates our sense of calling as responsible participants in the natural world, pressing viewers to question how we enact our calling as image bearers on the natural places around us.

Conclusions: Visual Art and the Natural World

At the introduction of this chapter, I highlighted the relationship between perception and action, arguing in our discussion of Scripture's naming theme that art can give form to seeing the world differently, perceiving God's creation as good, and rightly aligning our actions to respond to that goodness and beauty through the practice of love. These artists we have explored here, at least in some sense, are involved in a similar naming of creation; they open up new ways for the landscape to present itself to us, and for us to respond to it, therefore altering and defining our relationship to it. George Pattison highlights this need for attention to the natural world by encouraging us to think differently about our approach to theology and the arts. "Instead of the grand anticipation of a 'theological aesthetics' (or of theology as aesthetics)," he writes: "Theology . . . would do better to linger, to spend time, to risk wasting time, with the world, with artists' (and scientists') efforts—fumbling and inadequate as they no doubt often are—to open up that world in material, verbal, and noetic transformation as the space-time of human dwelling."[112] Pattison's appeal to the significance of human dwelling reminds us of Heidegger's influence on the philosophy of both place and art, and while Heidegger was no doubt abstracting his philosophy of art beyond what is immediately useful, his basic assertion that "Poetry builds up the very nature of dwelling" is particularly germane here.[113] Pattison calls theologians to engage with art itself (and science) as a way to understand the nature of our being human. The arts "open up" the world so that we can see in a sometimes wholly different manner.

What is it about art that changes our perspective in this way? How does it open up the world so that we may see differently? Here I will summarize three qualities of the visual arts (though these aren't necessarily exclusive to the visual) that may

[112]George Pattison, "Is the Time Right for a Theological Aesthetics?," in *Theological Aesthetics After Von Balthasar*, ed. O. V. Bychkov and James Fodor (Aldershot, UK: Ashgate, 2008), 114.

[113]Martin Heidegger, *Poetry, Language, Thought* (New York: Harper & Row, 1971), 227. One is also reminded of Wendell Berry's assertion that art and science are our "kit of cultural tools" that helps us dwell in the world. Berry, *Life Is a Miracle*, 121-22.

help us think through this question for now. First, *the visual arts engage our actual vision of the world.* Yi-Fu Tuan suggests, "Of the traditional five senses, man is more consciously dependent on sight to make his way in the world than the other senses. He is a predominantly a visual animal."[114] Our culture is incredibly visual—we are motivated by advertisements, television, the internet, roadside billboards, the constant photographs that scroll through our phones daily. But of course the whole world engages us visually—when we step outside to see the sun has risen or the mail has come, when we drive to work and look out for other cars as we turn out of the driveway, when we navigate the spaces of the architecture in which we dwell, and look out for the landscape beneath our feet. Often all this is done as a sort of second nature, without reflecting on what we actually see before us. It becomes a part of our unselfconscious sense of place. Being so dependent on the visual to relay information, though, highlights the need for reflecting on how our imaginations process this constant barrage of images and spaces before us. As Christians, we might ask ourselves whether we can and should adjust the way we see in order to live more responsibly in the world. The visual artists here have attempted to do just that. Each of them invites us to actually see the natural world differently through their cultured engagement with it, while inviting us to remember our calling as responsible agents and caretakers of God's good earth.

Second, *the visual arts open up pointed and particular ways of perceiving and loving the landscape.* The artists explored above depend on the particularities of each landscape to contribute to and often become the artwork itself. They heighten our attention to our embeddedness in the landscape, both its natural beauty and physicality, along with how our actions particularly affect it for good or ill. This attention to particularity is instructive for how we order our loves in the natural world. To give affection to something, to truly love it, we must see it for what it is. We must let our imaginations fully grasp its value and "thisness" as a creation of God. Artistic attention to the particularities of creation shows us that each tree, each mountain, each plant is deserving of our love, and our identity as a creature of God is tied up in how that love is expressed in the rest of creation. One might argue that when artists help us to see the particular beauty of a landscape or place, they are helping us to see the world as God did in the final assessment of the world

[114]Yi-Fu Tuan, *Topophilia: A Study of Environmental Perception, Attitudes and Values* (New York: Columbia University Press, 1990), 6.

he had made: "And it was very good." Thus Wendell Berry writes in *A Timbered Choir* with regard to the poetic form, visual artists often help us "to sit and look at light-filled leaves" by drawing our *actual sight* to the things of the natural world, and in some cases actually sitting us down in a place simply to look.[115] By teaching us this disposition, by habituating our vision to notice the particular through artistic engagement, we may learn how to take notice of all those daily particularities of the environments around us. Engagement with the natural world through the arts, then, becomes a sort of practiced liturgy, as James K. A. Smith might advocate, for engaging more responsibly in God's good creation.

Third, *the visual arts create a context in which viewers may dwell* (either imaginatively or physically). These contexts force us to practice our situatedness in a place, and in the cases above, to feel our embeddedness and action in the natural landscape itself. In this sense, the arts draw our attention from the particular to the universal and back again. By learning to see how our actions are situated in particular contexts, we come to understand that those actions affect other places and communities, often on a global level. Without engaging us through the particular, these notions often remain too abstract. This is why artists such as Tiesenhausen, for instance, create particular contexts (such as his *Passages* project) in which *to show* us how our actions affect a place. All of these artists, to some degree, give form to seeing the natural world in its particularity and goodness, while at the same time imagining the potential of our transforming presence within it. And not only can artistry contribute to a place's identity, but art itself can also be understood as a kind of place in which we might dwell, Christo's work being the notable example here and illustrating how our placemaking can be a positive influence on the environment and communities there.[116] Thus, "to make art

[115]Wendell Berry, *A Timbered Choir: The Sabbath Poems 1979–1997* (Washington, DC: Counterpoint, 1998), 8.

[116]That art can be a type of place is picked up in the work of Yi-Fu Tuan, who suggests that art is a type of virtual place. Yi-Fu Tuan, *Place, Art and Self* (Charlottesville: University of Virginia Press, 2004).
In this short work Tuan makes eight more general points about how art and place correspond:
1. Art and place both function as a center of meaning, "primarily positive meaning."
2. Art and place have multiple meanings.
3. Art and place both re-present meaning.
4. Art and place invite pause, reflection, and imagination.
5. Art and place are temporally related and unfold over time.
6. Art and place both capture a mood.
7. Art and place both have a "presence."
8. Art and place are both related to and affect self-identity.

(which is to think about it)," Tacita Dean and Jeremy Miller observe, "is to make place."[117]

These observations produce significant fruit when we consider how the arts might actually be a form of stewardship of God's creation. In the book of Genesis, we saw how humans were placed in the garden to cultivate and keep it, called to have dominion over the rest of the world. Nicholas Wolterstorff directly relates the tasks that were given to humans in the garden—their embeddedness, vocation, and telos—with the tasks of the artist.[118] The special role of the artist in the world, then, is like the election of all other people as I have already defined it. It should be conceived as an "election for" something—a calling to work responsibly with the gifts of creation. "Art," Calvin Seerveld thus argues, "is one way for men and women to respond to the Lord's command to cultivate the earth, to praise his Name. Art is neither more nor less than that."[119] According to Seerveld, we can get a clearer grasp of what the arts might actually be for by understanding human artistic action within the context of our traditions and communities, as well as God's particular call and command to participate in his creative and redemptive work. The arts are not a tool to elevate some humans above others nor to abuse and improperly use creation. Human artistry is part of the way that God commanded us to respond to and responsibly participate in the community of creation.

As the artists here have illustrated, the ability to dwell in the natural world with gratitude, imagination, and love goes a long way. By living and engaging with art that envisages the natural world as part of our human community, we may become more aware of the ways in which our habits affect that landscape that we have been invited to perceive, appreciate, or engage with in its particularity. And these habits are crucial for the coming age. As Christians, we cannot risk a failure of the imagination any longer. We must take up our places with Christ in his creation now and work toward that shalom of the new creation to come.

[117]Tacita Dean and Jeremy Millar, *Art Works: Place* (London: Thames & Hudson, 2005), 26.

[118]Nicholas Wolterstorff, *Art in Action: Towards a Christian Aesthetic* (Grand Rapids: Eerdmans, 1980), 68-69.

[119]Calvin Seerveld, *Rainbows for a Fallen World: Aesthetic Life and Artistic Task* (Toronto: Toronto Tuppence, 1980), 25.

Hospitality and Homemaking

The Arts and the Home

In the summer of 2016 my husband and I found ourselves in a small Ethiopian village leading a theology and agriculture conference for local pastors and church leaders. After our four-day lecture series, one of the prominent families of the church invited us to their home for coffee and bread in a supreme act of hospitality. Their home was very nice by Ethiopian standards—two rooms with limited furniture, mud walls with one small window to let in natural light, a thatch roof, a cleanly swept dirt floor, and flowers planted outside the front door. As I sat there drinking coffee and listening to stories told in Oromifa and translated through my missionary friend, one of the most visually surprising features of the place was the artwork pasted to the mud wall and the photographs of the family's children and past missionaries to the community. Lining the walls were illustrated papers from old Sunday school lessons and "Happy New Year's" posters handwritten in English and illustrated with simplistic drawings. They also had printed photos—some had been put into albums and others (mostly of their children in graduation attire) were framed on a small table. Neither the images on the wall nor the photographs were "art" by traditional standards. But the visual adornment of their home spoke worlds to the nature of what it means to be a creative maker of one's place. The experience conveyed two things to me. First, no matter where you are in the world, people choose to make their places personal and expressive of their history and values, and very often this is visually communicated. Second, their personal and communal stories, which were told through these series of images, were intimately tied up in their act of hospitality toward us, setting the context for the hospitable actions extended to us as their guests.

These two insights will inform the general direction of the current chapter. When we make ourselves at home, we are constructing places that communicate who we are, and these places and the stories they tell can either magnify our sense of hospitality or deplete it. To this end, we will explore how the variety of ways that artistry that deals with the theme of or is actually integrated into the home communicates our stories while helping us practice hospitality. A Christian theology of place must contend with the ways in which our homes are expressive of wider values, and the manner in which we are shaped by the places we create. We will look first, then, to the concepts and practices of home in both the wider literature and in Scripture before turning to the ways that visual art contributes to our imagining of home and the hospitable practices that originate from within.

WHAT IS HOME?

There is no dearth of commentary or cultural reflection on the value and meaning of home. Home is, as the popular saying goes, "where the heart is." The theme arises throughout the history of art and culture, from Homer's *Odyssey* ("So nothing is as sweet as a man's own country")[1] to Dorothy's longing for Kansas in the *Wizard of Oz* ("There's no place like home").[2] Popular music affords several definitions from focus on belonging to a particular place, as in CeeLo Green's passionate ballad to his home state, "Georgia" ("You'll always be home to me/I belong to you/and yes you belong to me"),[3] to its association with particular people ("Home is wherever I'm with you").[4] Is a home, then, a dwelling place, a group of people or family, a particular landscape or country? Further reflection affirms all of these to some degree. Indeed, home is different for all of us, but in any case, home is not just the place where we sleep or eat but is a place where we feel we truly belong. This belonging is active, as Jen Pollock Michel argues, the biblical sense of home being a matter of shared human work.[5] As such, home is a primary expression of self-identity, both as an individual is

[1]Homer, *The Odyssey*, trans. Robert Fagles (Penguin Classics, 1999), 212.

[2]*The Wizard of Oz*, directed by Victor Fleming (Burbank, CA: Warner Bros., 1939).

[3]CeeLo Green, "Georgia," promotional single, *The Lady Killer*, produced by The Smeezingtons, Elektra Records, 2010.

[4]Edward Sharpe and the Magnetic Zeros, "Home," *Up from Below*, Vagrant Records, 2009.

[5]Jen Pollock Michel, *Keeping Place: Reflections on the Meaning of Home* (Downers Grove, IL: InterVarsity Press, 2017), 53.

made by their environment and as they exercise some *making of* their environment, most often with other people.[6]

Gaston Bachelard explores this sense of self and the home in his *Poetics of Space*, where he argues that one's memories and sense of self might be understood through a "topoanalysis" of the spaces of the childhood home.[7] How we learn to navigate space as a child gets incorporated into our habitus, our way of being in the world, so much so that when we experience similar places (through sight, touch, or even smell) we may be transported to those emotions and memories of childhood almost immediately. Our homes become the places of our most intimate psychological lives—our hopes and fears, our daydreams and doubts, our comfort or restlessness. They become expressions both of our reality and our ideal state of being. Alain de Botton argues that to call a space home is "simply to recognize its harmony with our own prized internal song."[8] The house thus becomes a "knowledgeable witness" both to who we are and to who we might potentially be.[9]

As expressions of the self the home exists, then, as a central place of comfort and personal identity, an idea Witold Rybczynski explores in his history of home as an idea, though he argues this notion, including ideas such as the need for comfortable furniture, private space (both interior and exterior), and a sense of personalization appeared only relatively recently in culture, emerging, he says, consistently in the Enlightenment.[10] Both Rybczynski and de Botton acknowledge the mutual influence between the physical space and the internal self, that our internal dispositions are externalized into our dwelling places, and in turn, our dwelling places influence and adjust our sense of self-identity to both positive and negative effect. One need simply sit in a place that makes one feel *un*comfortable to recognize that that is true. We have all felt that sense of discomfort in a place that we found too dirty, or smelly, or dangerous, or the temperature was too extreme. Sometimes we fail to realize to what degree places influence our internal state of being or comfort in this

[6]On home as self-identity, see Clare Cooper Marcus, *House as a Mirror of Self: Exploring the Deeper Meaning of Home* (Berkeley: Conari, 1995). See also John S. Allen, *Home: How Habitat Made Us Human* (New York: Basic Books, 2015). Here Allen argues that home is an evolutionary product, which also carries emotions and social status.

[7]Gaston Bachelard, *The Poetics of Space* (Boston: Beacon, 1969), 8.

[8]Alain de Botton, *The Architecture of Happiness* (New York: Pantheon Books, 2006), 107.

[9]De Botton, 10.

[10]Witold Rybczynski, *Home: A Short History of an Idea* (New York: Viking, 1986), 111.

regard until we leave them, sensing a feeling of relief as if we were holding our breath for a very long time in order to simply abide.

In addition to being "songs" of the self, the home also reveals something about the way in which we see ourselves in relation to other people. Architecture may function as an ethical practitioner, encouraging practices and sensibilities that bring one closer to the outside world or seclude one from it.[11] Along these lines, the ways in which one's home is built and ordered may reflect a desire for hospitality or an exclusion of the outside world. Norman Wirzba addresses this concern in his discussion of modern dwelling places that prioritize the garage on the front of the house rather than an inviting porch, the separation of the yard by privacy fences, or the arrangement of furniture around a television.[12] The architecture itself, as well as the ways in which the space is used and arranged by families, conveys a fierce individualism prominent in American society today.

We might ask ourselves, then, how these dimensions of home should be considered from a theological perspective. How might our architecture, landscapes, objects (both artistic and practical), rituals and practices (e.g., creative making, cooking, gardening, and media consumption) cultivate an imagination grounded in the Christian story of creation and redemption? And how, particularly, might the visual environments we create be a key context for developing an attitude and practice of openness, hospitality, hope, and delight in God's good world? As explored in chapter one, our practices in places are key to understanding what we love and truly believe, not only revealing the wider social imaginaries of our culture but also structuring our identity in place. Before turning to the practices of art and craft as they hold power to structure our home environments in sometimes startling and specific ways, we will look to some of the key practices and dispositions of being

[11]Though de Botton notes importantly: "Architecture may well possess moral messages, it simply has no power to enforce them. It offers suggestions instead of making laws. It invites rather than orders us to emulate its spirit and cannot prevent its own abuse." De Botton, *Architecture of Happiness*, 20. See also Karsten Harries, *The Ethical Function of Architecture* (Cambridge, MA: MIT Press, 1997). For theological engagement with architecture, including its social function, see Murray A. Rae, *Architecture and Theology: The Art of Place* (Waco, TX: Baylor University Press, 2017).

[12]Norman Wirzba, *Living the Sabbath: Discovering the Rhythms of Rest and Delight* (Grand Rapids: Brazos, 2006), 109. Modern living space in the city and suburbs has also been explored by other cultural theorists, such as James Howard Kunstler, *The Geography of Nowhere: The Rise and Decline of America's Man-Made Landscape* (New York: Simon and Schuster, 1993); Jane Jacobs, *The Death and Life of Great American Cities* (Harmondsworth, UK: Penguin, 1972).

at home in Scripture in order to form a theological foundation for a Christian imagination and sense of place as it emerges in the practices of homemaking and hospitality.

BIBLICAL THEMES FOR A THEOLOGY OF HOME

The Bible provides no explicit philosophical or theological reflection on the concept of home, though readers may identify the major themes of home-lessness and homecoming running throughout the text. Often Scripture conveys a tension when it comes to sense of place, not only in the Old Testament, where this tension emerges in the interplay between landedness and exile, but also and perhaps especially in the New Testament revision of the significance of land and the temple, or the biblical authors' eschatological imagining of what our "home in heaven" might look like, including its relation to our place in the current world. This section will attempt to deal with some of those themes and tensions for a theology of home as witnessed in Scripture and theology, while arguing that certain practices emerge in Scripture's imagining of home that continue to find relevance for contemporary Christian life and practice. Particularly, we will look at the practices of homemaking in the responsibility to land and creation, the act of remembering for one's sense of home as community, and the call to hospitable practice in the home place.

Responsibility and embeddedness in the land. As we saw in the last chapter, the garden is presented as humans' first home, and as a recapitulation of the temple project the text shows the significance of divine presence in humanly ordered places and the theological gravity of human responsibility in response to divine calling in the natural world. Moreover, we see humans make their home in relationship to the whole community of creation, which suggests from the outset that our fidelity to our own particular home place should include our fidelity to the whole of creation.[13] This means the practices habituated in the contemporary home should find moral resonance with the biblical call to take care of God's good creation more widely.

The Israelites' personal sense of home and its associated spirituality were intimately tied to the land itself. In Psalm 137, when their captors ask them to sing songs of Zion, they ask: "How could we sing the LORD's song in a foreign

[13]Wirzba, *Living the Sabbath*, 108.

land?" (Ps 137:4). To sing a song of home while exiled pains the psalmist, revealing a central feature of Jewish life and theology: *who* they are as God's people is related to *where* they are as God's people. Their sense of self is tied to particular geographical locations and their identity as the nation of Israel is understood through God's promise to Abraham in Genesis 12:7: "To your offspring I will give this land." Walter Brueggemann argues that we should understand the word *land* in two senses here: the literal, referring to the actual, physical earth; and the symbolic, referring to the pleasure, joy, promise, life, and freedom that are suggested through one's connection with land.[14] These two usages, the literal and the symbolic, though, are not mutually exclusive, as we saw in our discussion of place in chapter one—with the literal preserving the goodness of God's gift of physical creation along with the later incarnational focus on materiality in Christian theology, and then with the symbolical highlighting the social and historical connotations of land and people's belonging there.

Much of Israel's history is understood through the lens of their life in the land. This life, though, is markedly different from being bound to a national homeland, a "life in the land" being reminiscent of our more general relationship to the soil (*adamah*) rather than coercive nationalistic politics or maintaining closed borders of one's homeland.[15] The biblical sense of home is grounded in openness and care, responsibility for the gift that God has given humans not out of merit but out of grace. As it is connected to the land, then, our sense of place is one that recharacterizes home as "a state of being in the world" and "a place where one discovers new ways of seeing reality."[16]

For this reason we might characterize the Jewish concept of home not simply as a desire to stay put but as an active and particular type of relationship to place that includes responsibility to all the creaturely dimensions of the land itself. It is not simply *being in* the land that matters but *how one acts* within it. One might describe the Israelites' sense of home as profoundly liturgical in

[14]Walter Brueggemann, *The Land: Places as Gift, Promise, and Challenge in Biblical Faith*, 2nd ed. (Minneapolis: Fortress, 1989), 2.

[15]Timothy Gorringe, *A Theology of the Built Environment: Justice, Empowerment, Redemption* (Cambridge: Cambridge University Press, 2002), 58. It should also be noted that the idea of an entirely "personal" sense of home would have been a foreign concept in light of Israel's placement in ancient Near Eastern culture. Personal senses of home and its space did not arise until much later, as recounted by Rybczynski.

[16]Gorringe, 64, quoting Leoni Sandercock.

this sense. We can see this illustrated by looking to the narratives of Leviticus or Deuteronomy, which outline specific ways of living and being in the land and community. Food laws, treatment of the poor and the stranger, agricultural practices—all of these are situated within the Jewish concept of being at home in God's creation and in response to God's calling. And all of this depends on a notion of one's home in the context of an entire ecosystem, an ecosystem in which one's actions in one arena have implications for the others. Food laws were systems set in place not only to illustrate obedience to God but also to conserve animal populations and leave room for the poor to glean, along with allowing the land itself time to properly rest so that fertility wasn't compromised by either human or animal use.[17]

We can refer to this as the God-people-place relationship of Scripture, a triangulated relationship where failure in one part influences the other areas of one's life, sometimes spiritually and physically.[18] Norman Wirzba addresses these relationships specifically in terms of a Sabbath theology, and indeed we might see all of Israel's theology through this lens as an expression of how they understood their work in creation as a worshipful calling.[19] One's personal holiness is bound to one's treatment of places and communities, revealing that the biblical concept of home is always suggestive of a cultural liturgy grounded in love toward one's neighbors and the created world, a marked sense of openness to the outsider and "other," an attitude of care for those in need (both human and nonhuman), and a spirituality grounded in one's practices of homemaking in both the land and community.

Remembering as communal spiritual practice. These responsible relationships are founded on the sometimes-failing attempts of the community to remember its calling in the land. As a practice of their faith and a reflection of their embeddedness in the land, remembering is key for the people of God.

[17]Ellen Davis, *Scripture, Culture, and Agriculture: An Agrarian Reading of the Bible* (Cambridge: Cambridge University Press, 2008), 90-100.

[18]Wendell Berry addresses this idea in the title essay of Wendell Berry, *The Gift of Good Land* (Washington, DC: Counterpoint, 2009), 267-81. In the early essay "Discipline and Hope," these relationships (God and people; people and other people; people and place) are brought together under the central metaphor of atonement, or "at-one-ment" (152). See "Discipline and Hope," in *A Continuous Harmony: Essays Cultural and Agricultural* (Washington, DC: Shoemaker & Hoard, 1972), 83-161. See also John Inge, *A Christian Theology of Place* (New York: Routledge, 2016), 46-47, for his account of a relational account of place, which includes this trifold structure.

[19]Norman Wirzba, *The Paradise of God: Renewing Religion in an Ecological Age* (Oxford: Oxford University Press, 2003), 158-74; *Living the Sabbath*.

Scripture is shot through with injunctions to remember (Deut 8:18; Ps 77:11; Lk 22:19), and this imaginative practice not only centers on the past but can also contribute to the preservation of faith in the present and future. Without the bond of individual and corporate memory, the community easily becomes dis-membered, lacking in communal identity and failing to understand how future spiritual promises relate to currently practiced liturgies in life. Places themselves, I have argued already, might be understood as what Phillip Sheldrake calls "texts, layered with meaning,"[20] and the action of remembering preserves not only the stories but the current communities placed there. Rather than simply implying geographical location, places are the result of dialectical relationships between geography and practiced human narrative. Because people's memories and stories are linked together over time through place, they can maintain a sense of continuity with others past, present, and future through the attachment to place. To remember is thus to re-member.[21] Storied places gather memories and events into themselves, forming a thread throughout an entire history of people over time.[22] When one dwells in a physical place, then, one must simultaneously interact with the community and its accompanying narrative there in order for meaning to be truly understood. Remembering attaches us to that narrative, while a failure to remember cleaves the narrative, often to the point of breaking entirely.

While remembering is the means we use to imagine places in terms of their wider story, memories are also made and kept in relation to physical places. "Memories are motionless," Bachelard asserts in *The Poetics of Space*, "and the more securely they are fixed in space, the sounder they are.... For a knowledge of intimacy, localization in the *spaces* of our intimacy is more urgent than determination of dates."[23] To explore this localization of intimate spaces, Bachelard suggests the childhood home as the determiner of meaning and keeper of the most solid memories we have. "All really inhabited space," he writes, "bears the essence of the notion of home."[24] So more than causing nostalgia, the childhood home as a truly inhabited or indwelt space reveals something

[20]Philip Sheldrake, *Spaces for the Sacred: Place, Memory and Identity* (London: SCM Press, 2001), 17.

[21]Davis, *Scripture, Culture, and Agriculture*, 16.

[22]Brueggemann, *Land*, 198; Edward S. Casey, *Remembering: A Phenomenological Study* (Bloomington: Indiana University Press, 2000), 202.

[23]Bachelard, *Poetics of Space*, 9.

[24]Bachelard, 5.

about our most basic impulses, holding the memories that form our identity and allowing us to imagine or daydream from an already-inhabited space in the memory. Inhabited space, or intimately "made places," can be understood to form the actual structure of our memory, identity, and imagination.

For the Israelites, their sense of home and inhabited space bore direct resemblance to the land of Israel. The land was indeed what was promised, and as the physical sign of promise it came to hold the larger communal identity of God's people. While in one sense, God's people were placeless, called away from their homes to a new sense of home in the community of God (both in the Old Testament and the New), we must remember that people are always called *to* something or some*where*. Whether this is to the Promised Land itself or to the ends of the earth, that calling to some place is a central feature of the Christian life. We are not simply called *out of*. For Israel, this calling is centrally located in the land itself, and there is an intimate connection between their identity and their groundedness in and memory of the land and its promises. Much of their history is therefore told and remembered in relation to specific and sacred places: Bethel, Mount Sinai, Jerusalem.

Because memory and place are so closely intertwined, without a physical grounding and "memory place"[25] it is difficult to retain real connections between the past and the current places that we inhabit. This, of course, was the pain of Israel in exile. They no longer had their land to remind them of the promises God had given. Without the memory place, their songs of home were markedly different.[26] Remembering itself, however, grounded in the Torah, became a key sustaining feature of their faithfulness to the community. Wendell Berry notes in this regard, "It is what Israel 'remembers' that determines whether it remains faithful to the covenant."[27] In their writings, songs,

[25] Casey, *Remembering*, chap. 9; Paul Ricoeur, *Memory, History, Forgetting*, trans. Kathleen Blamey (Chicago: University of Chicago Press, 2004), 41.

[26] Of course, we must also consider that it was when the people were located in the land that they became disobedient, and of course, this disobedience resulted in their expulsion and exile from the land. In either case, though, the land itself is directly linked to the faith and ethical action of the people there. When they forget, they lose their place. And when they are out of place, it is more difficult to remember. In these times, we might say that Scripture itself forms a "memory place," which binds together the people in communal suffering and joy, promise and expectation, longing and hope.

[27] Joel James Schuman and L. Roger Owens, eds., *Wendell Berry and Religion* (Lexington: University Press of Kentucky, 2009), 120-21. God's own faithfulness to the covenant is related to memory as well. See Leviticus 26:41-42: "And I will remember my covenant with Jacob, and yes, my covenant with Isaac, and yes, my covenant with Abraham I will remember—and the land I will remember."

and traditions (all embodiments in some sense of the memories of their cov-
enant with God), the people sustained their own community of God even
while they were out of place.[28] The Israelites' historical status as the people
of God was linked with their present and continuing future as the chosen
people of God, even though they were now removed from the Promised Land.
Their memories provided them with what Mary Warnock calls in her study of
memory a "continuity of existence," and their memories served to bring past
events and promises into the future.[29] Warnock suggests that "our past deter-
mines how we interpret the present, in the light of the values we ascribe to
things, and how we conceive of the future."[30] Her notion of continuity shows
consistency with the biblical framework for memory and home; because we
know that we are continuous with the past, she says, "we feel that we are con-
tinuous with what we can foresee and take responsibility for in the future."[31]

How the people of God construe their future lies somewhat in their
memory of what God has done for them in the past, an experience we as
Christians practice weekly in the liturgy of the Eucharist: "Do this is remem-
brance of me." This practice not only functions as a remembering of Christian
history but also promotes Christian mission into the world, sending us out
with a renewed sense of home in God's community and a hospitable mission
to bring others into God's household with eschatological expectation. William
Cavanaugh writes that the "the Eucharist is both an act of 'dangerous memory'
of the past death of Jesus Christ at the hands of the powers and of his resur-
rection, as well as the eschatological anticipation of the future Kingdom of
God."[32] Remembering for the Christian community thus grounds us in the
past while propelling us into the future. This act of "dangerous memory," Ca-
vanaugh goes on to further argue, has all sorts of implications for the way that

[28]The Torah itself became "a portable Land, a movable Temple," the place of God's presence, likened to their
 relationship to "home." N. T. Wright, *The New Testament and the People of God* (Minneapolis: Fortress,
 1992), 228. See also Davis, *Scripture, Culture, and Agriculture*, 115.
[29]Mary Warnock, *Memory* (London: Faber & Faber, 1987), 170. For the relationship of memory to present
 and future, see also John Leax, "Memory and Hope in the World of Port William," in *Wendell Berry: Life
 and Work*, ed. Jason Peters (Lexington: University of Kentucky Press, 2007), 66-75; Bachelard, *Poetics of
 Space*; Sheldrake, *Spaces for the Sacred*, 16; Michel de Certeau, *The Practice of Everyday Life* (Berkeley:
 University of California Press, 1984), 82-90.
[30]Mary Warnock, *Imagination and Time* (Oxford: Blackwell, 1994), 170.
[31]Warnock, 169.
[32]William T. Cavanaugh, *Theopolitical Imagination: Discovering the Liturgy as a Political Act in an Age of
 Global Consumerism* (London: T&T Clark, 2002), 5.

we imagine the political and social spheres, challenging attitudes and practices of consumption and freedom. I might add that it has radical implications for the manner in which we consider the Christian practice of homemaking. "At the table of his supper," Jen Pollock Michel asserts, "we proclaim the gospel of home."[33] This gospel of home, in contrast to contemporary notions of home as personal, private space, is a radical and open community, our eucharistic homemaking being a sacramental instance of the way in which Christians practice (and practice for) hospitality to the other.

Practicing hospitality. While much of the story until this point has been focused on the Jewish narrative of home in the Old Testament, we see that the teachings of Jesus under a new covenant remain in continuity with these dispositions while also expanding their significance to all potential places of homemaking in the world. When "home" is mentioned in the stories of Jesus and his followers, it is often in recounting the value of leaving home or being uprooted for the sake of the gospel (Mt 4:18-22; 8:22; Lk 9:57-62). But Jesus also tells his followers to return home (Mk 5:19; Lk 8:39), and many of the most intimate sites of worship and communion occur within the homes of his followers. To suggest an entirely negative attitude to home in the New Testament, then, would be neglectful of the wider dynamics at play in the early church, particularly as the home functioned as the site of communal worship until Christianity was accepted within wider society.[34]

In Romans 12 we hear Paul speaking to the present concerns of house churches in Rome, and there he reflects on how believers might imitate Christ and practice their faith in the context of everyday life. Katherine Grieb notes that in this section of Romans we learn that "what we do with our lives, our embodied existence and materials of daily decision making, inevitably reveals the extent of the lordship of Jesus Christ in our lives."[35] This means that what we do in all the arenas of our life on earth will be reflections of our lived faith in Jesus Christ. In Romans 12:13 Paul exhorts his fellow believers to "extend hospitality," an injunction placed in the middle of his teaching on active love in community. This behavior is not distinguished, James Dunn

[33]Michel, *Keeping Place*, 174.

[34]Jeanne Halgren Kilde, *Sacred Power, Sacred Space: An Introduction to Christian Architecture and Worship* (Oxford: Oxford University Press, 2008), chap. 2.

[35]A. Katherine Grieb, *The Story of Romans: A Narrative Defense of God's Righteousness* (Louisville: Westminster John Knox, 2002), 119.

notes, as different inside or outside the church. "The same principle governs relations among believers and relations of believers with those among whom they lived."[36] There is no difference in hospitality and love between the insider or the outsider. While Paul of course is speaking within the context of Roman house churches in the first century, we might apply his claims to a wider vision of Christian home life in the contemporary world. Through Scripture we see this egalitarianism practiced in regard to hospitality, love extended in the context of the home to both the stranger and to family.

Both Old Testament and New reveal the calling to practice hospitality. The quintessential Old Testament narrative regarding the subject is Genesis 18, where Abraham is confronted by three visitors, who bring him good news of God's provision and gift.[37] While Abraham seems aware of the special presence associated with the visitors, they still represent the unknown, carrying a message that must be accepted on a profound act of faith.[38] The ancient concept of *xenia*, or guest-hospitality, drives this narrative, as Abraham gives them water to drink and washes their feet, inviting them for a dinner made with the best ingredients—"choice flour" and a calf, "tender and good" (Gen 18:6-7). The choice to include these descriptions should not be overlooked. Visually, the author has provided a picture of rest and comfort— Abraham wants them to be refreshed (Gen 18:5) while they are in his home place through the elements of food, which provide both physical nourishment and beauty. The narrative recalls the giving of a place deemed "very good" by God in the story of creation, trees placed in the garden that are good for sight and for eating (Gen 2:9), which are understood through a lens of calling and obedience.

[36]James D. G. Dunn, *The Theology of Paul the Apostle* (Grand Rapids: Eerdmans, 1998), 678.

[37]Christine Pohl suggests that hospitality in this story, the first of the formative tradition for Hebrew culture, is connected with the presence of God, promise, and divine blessing. Christine D. Pohl, *Making Room: Recovering Hospitality as a Christian Tradition* (Grand Rapids: Eerdmans, 1999), 24.

Additionally, there is some debate on the identity of the visitors, described in the text as *three men*, but who are addressed in both plural and singular form throughout the text. In Genesis 19:1, 15, they are referred to as *malakim*, messengers or angels, who accompany Yahweh. In any case, the message is divine, and the obscurity of the story is suggestive of wider Hebrew storytelling, the obscurity revealing something about divine revelation and the notion of possibility. Victor P. Hamilton, *The Book of Genesis: Chapters 18–50* (Grand Rapids: Eerdmans, 1995), 7-8.

[38]The use of the term translated "to see" in Genesis 18:2 suggests a knowledge or realization in addition to simple visual sight. See Hamilton, *Book of Genesis: Chapters 18–50*, 6. Abraham's perception is reflected in his hospitality toward the visitors.

While clearly this is a special case in the story of Israel, it has served as an image of hospitality throughout the life of the church and provided an example for the manner in which one should respond to the visitor.[39] Later in the Levitical commands, the service to one's neighbor and to one's food is highlighted again, especially in how one treats one's neighbor (either known visitor or outsider to the community), along with the ethical use of animal and plant resources.[40] This recalls the contemporary concern with good food and how one might act responsibly and hospitably both to land and neighbor in the context of one's home and eating practices. While discussion of food or cooking may seem a detour not only from the current discussion but also from the role of art in life, I'll suggest here that the metaphor of the meal might help us think through the role of art in the home. The same principles present in the "good food movement," and more artful engagements with the food we eat are also present in a theological understanding of visual art in the home and its role in the creation of hospitable places, a topic we will explore further below.[41] We can make a few preliminary statements at this point, in light of the Genesis story of Abraham's meal with the visitors.

First, the narrative asks us to consider the role of *good* food ("choice flour" and meat that is "tender and good") in extending hospitality. Here, as elsewhere in Scripture, "the best" is presented for the guest and contributes to the relationship that results from such exchange. Second, good food and aesthetic encounter result in a *sense of delight or comfort* in the guest as received by the host. This undoubtedly contributes to the ways in which friendship or communion will unfold in the experience. Third, we encounter the question of *responsible impact* on the environment in the materials we use. While not immediately evident in the Abraham story, when set against the backdrop of land and responsible use in Israel's history and culture, one can conclude that the

[39] For instance, see Andrei Rublev's *Holy Trinity* icon, which depicts the three winged visitors to Abraham as the three persons of God sitting around a table. A good theological discussion of this image can be found in Jim Forest, "Through Icons: Word and Image Together," in *Beholding the Glory: Incarnation Through the Arts* (Grand Rapids: Baker Books, 2000), 83-97.

[40] See especially Leviticus 19. See Davis, *Scripture, Culture, and Agriculture*, 84-87.

[41] For details on the "good food movement" and the history of American food systems, see information from the exhibit "Food: Transforming the American Table 1950–2000," The National Museum of American History, Smithsonian Institute, Washington, DC. http://americanhistory.si.edu/exhibitions/food. For good popular example from within the good food movement, see Michael Pollan, *The Omnivore's Dilemma: A Natural History of Four Meals* (New York: Penguin, 2007).

ways in which food is used in a hospitable context are a direct reflection of hospitable engagement with the environment or animals themselves. Fourth, the role of *physical materials and place in the extension of hospitability* to the outsider is key here. The host appeals to physical needs and desires to make a hospitable place for communion to occur, physical need being the primary means through which openness is offered and practiced.[42] Finally, we might infer the presence of a cohesive home economics that includes *the role of beauty* in determining good practice. Beauty functions *in practice,* the beautiful presentation of food or the creation of a welcoming space being the catalyst from which goodness and truth may emerge. All of these insights might also be applied in the context of art in the home, as we will see later, but function here to help us recognize the ways in which hospitable practices grounded in goodness, particularity and comfort, responsibility, physicality, and beauty create a space of communion in the biblical picture of home.

We can usefully compare and contrast the story of Abraham and the visitors with the Luke 15 story of the prodigal son, a narrative that similarly shows hospitality born from the home environment, but this time within the context of family or "insider" relationships. Both stories communicate hospitable practices as they are enacted in the home-place, though Genesis reveals a supreme hospitality to those who are unknown, while Luke reveals attitudes of hospitality to he who is known, or at least he who has been known before, even if the dynamics of relationship change in the conclusion of the story.

In some sense, the entire Gospel of Luke might be read through the lens of Christian hospitality, with Jesus' engagements with the outsiders in community regulated on openness and grace rather than traditional social rules of interaction. Very often this happens in the context of a shared meal. Like the Genesis narrative, which reveals the generosity of Abraham in the shared meal, Jesus extends a place at the table to the least of these—the poor, the openly sinful, women, and so on. Even God's hospitality in eschatological terms in imaged as a banquet (Lk 13:29; 14:16-24; 22:30).[43] In the prodigal son story, the father calls a banquet in response to the coming home of the

[42]See the good Samaritan parallel as example (Lk 10:25-37).

[43]John Navone writes, "Table fellowship with Jesus anticipates eschatological consummation in the context of the Jewish tradition, where the banquet metaphor is used to express messianic salvation." John J. Navone, SJ, "Divine and Human Hospitality," *New Blackfriars* 85, no. 997 (May 2004): 344.

son, an eschatological lesson, no doubt, but also a lesson in hospitality and social relationships as they arise in the home-place. Practices in the home become a metaphor for understanding salvation; the excessive love and hospitality offered in the context of the home are reflective of the salvation God hospitably offers to us out of perfect trinitarian love. As we practice hospitality in the home, we thus imitate Christ in our daily life.

The prodigal son story, then, gives us insight into the revolutionary character of God's kingdom and the ways in which our generous hospitality might be reflective of our participation in that work of creation and redemption. While typically referred to as "the story of the prodigal son," Trevor Burke argues that the parable's focus is not so much on the prodigal son as on the prodigal father, with the father's generosity, "reckless charity," and excessive hospitality to the younger son conveying the attitude of our heavenly Father in salvation, as well as being a model for human hospitality on earth.[44] Particularly Burke cites the social norms of the time as a lens through which to understand the actions of the father as prodigal or excessive. Not only does the father allow his son to take his inheritance early (an action that was openly regarded as inappropriate in that society), but he freely accepts the return of the son without question, running to greet him (an action no dignified man would do, particularly as it involved pulling up his tunic in public) and using the finest things to greet him (getting him the best robe and a fattened calf, making a feast before him). Like many of Jesus's own actions and commands, the father's generosity is out of character with social norms. This creates in listeners an alternate manner of thinking about not only family relationships but also openness and generosity to those who are lost more widely.[45]

In application for today's world, we might ask ourselves what a socially redefined generosity looks like today. How might Christian hospitality break open social boundaries and introduce the possibility of redemption into our otherwise ordered ways of living? A key characteristic of both this story and the Abrahamic narrative is the extravagance of both divine and human love. In both cases, we see God lavishly pouring his grace on his people. For

[44]Trevor J. Burke, "The Parable of the Prodigal Father: An Interpretive Key to the Third Gospel (Luke 15:11-32)," *Tyndale Bulletin* 64, no. 2 (2013): 220.

[45]Burke, 227-28. Burke also cites Luke 9:59. For other examples of excessiveness as discipleship, see the good Samaritan story in Luke 10:25-37 (he gives more than enough money to take care of the injured), and the woman with expensive perfume in Luke 7:36-50.

Abraham this means a son as revealed by the visitors after they are hospitably welcomed; for those in first-century Jewish society it is a lavish upheaval of their concept of sin and social expectation as exemplified by the father's love for his younger son.

Navone suggests that every act of hospitality, whether directed toward insiders or outsiders, is a reflection of divine hospitality and the exchange of love in the Trinity. "Human hospitality entails the originating love of the host (image of Father), the welcoming love of the guest (Son) in the communion-community-communication of the reciprocal love (Holy Spirit of Father and Son)."[46] Hospitality, in other words, requires a host, a recipient (known or stranger), and a communion or friendship that results from such exchange. We might also add the necessity of place for such exchange to occur. While divine love holds all space within that originating presence (and opens up a space for creatures to participate in that love), hospitality in the human sphere requires a place made *for* us (or a place made *by* us) in order to sustain such relationships. This is not only *metaphorical* space (an imaginative "opening up" for the other) but also a *physical* place, with creaturely embodied needs acknowledged in the making of a comfortable physical location in which hospitality might be better offered and received.[47]

Practicing a biblical sense of place in homesteading and homecoming. To understand this dynamic further, it will be helpful to return briefly to contemporary discussions of place and placemaking as they relate to a biblical theology of home. In *Getting Back into Place*, Edward Casey describes our active relationship to places as one of journey. Being in place, he avers, is never simply a matter of staying put; even if one never leaves, places become the ground for an "eventmental," imaginative pilgrimage.[48] "Places not only are,"

[46]Navone, "Divine and Human Hospitality."

[47]See Pohl, *Making Room*, chap. 8, on the role of place for hospitality to occur. Of course, in today's technology-driven society, the possiblity for an online community and opening up of space is important to note; however, these communities are still abstracted from daily life, which makes hospitality less easily practiced in an online environment. For example, cyberbullying becomes much more prevalent in a "metaphorical space" as opposed to a physical one, the imaginative requiring a larger leap to understand the humanity of the other in their place when that place is not physically shared, and therefore outcomes from such interactions more easily noticed or imagined.

[48]Edward S. Casey, *Getting Back into Place: Toward a Renewed Understanding of the Place-World* (Bloomington: Indiana University Press, 1993), 340. See also John Inge's discussion of place as pilgrimage and its connection to sacramental encounter experienced through active engagement (both human and divine) in place. Inge, *Christian Theology of Place*, chap. 4.

he says, "they happen."[49] Places are events. This cyclical journey within and to places, he argues, ends in one of two related practices or dispositions: homesteading and homecoming, the former suggesting how one makes a permanent place somewhere unknown, and the latter suggesting a return to someplace already known, though with renewed vision or perspective. Both of these actions, furthermore, have two things in common: reimplacement and cohabitancy.[50]

Reimplacement suggests that while one must become displaced in the act of homesteading or homecoming, the journey's end is met with a reimplacement, no matter how long or short. For homesteading, this reimplacement lasts into the future, while in homecoming, the reimplacement may last only as long as the moment of return, only to then motivate one's return to one's "contemporary home" from which the journey began. Cohabitancy, on the other hand, suggests the manner in which one communes with the place (which includes its people, traditions, memories, stories, and culture) across time. In an act of homesteading that is "ecologically sensitive," inhabitants must attempt an ongoing and dialogical conversation with the previous inhabitants, otherwise it becomes "abortive or even self-defeating."[51] *Homesteading* requires participation with that which is already there—the land, the community, the cultural framework and social imaginaries—on which new actions and one's own sense of place may be overlaid and into which one may enter as participant rather than spectator, or worse, exploiter. *Homecoming*, however, enters into conversation with those voices already known in a place, though the nature of the conversation may have matured or changed from previous relationships. To truly come home again, one must not only enter into the place but commune with the inhabitants there, whether in physical or memorial form, who reside in that place.

These dynamics, Casey argues, require the appropriate habitus, frameworks, and skills for getting to know the place for the first time or in a new way. Not only are these skills dependent on embodied encounters with places, but homesteading and homecoming both require a dialogical encounter with the place and community there, our sense of at-home-ness being secured in these

[49]Casey, *Getting Back into Place*, 330.
[50]Casey, 291.
[51]Casey, 291.

exchanges between that which is given and that which is discovered or found in our acts of placemaking.[52]

Above we explored the ways in which a biblical theology of place is founded on responsibility to the land and its promises, acts of remembering, and practices of hospitality to both outsiders and insiders, suggesting that our sense of home (on earth and in more eschatological terms) is principled on these practices. To model these practices on another philosophical framework, Henri Lefebvre's understanding of the production of space, one's sense of home is perceived (through physical "spatial practice"), conceived (through "representations of space" in the act of remembering), and lived (an exercise in "representational space" as realized through hospitable, imaginative practice), which may also correspond to the work, respectively, of the body, the mind, and the heart.[53] While these actions in no way exhaust the limits of Lefebvre's spatial modeling, they might provide a helpful way in which to understand the correspondences between the biblical and philosophical narratives of place and home, the physical underlying the imagined, the conceptual solidifying our dwelling in the physical, the imagined recalibrating the epistemic and ethical boundaries of our lives in place.[54] Lefebvre notes that these spaces are dialectical and presupposing of the others, the edges of which function as ecotones, merging sometimes indistinguishably into the spaces of the others and which all intertwine to form one's life in the world.[55]

Casey's model for placemaking shows a similar dynamic at play, reimplacement and cohabitation being mapped onto spatial practice (physical space) and representations of space (conceptual space). Homesteading and homecoming both include and result from these basic actions, and are encounters that suppose the given-received-reciprocated or the host-guest-communal relation dynamic. They may therefore be mapped onto

[52]See discussion of Ben Quash on this dynamic in chap. 2 above.

[53]Henri Lefebvre, *The Production of Space* (Oxford: Blackwell, 1991), 39.

[54]On the relationship between the imagined and the physical, see Trevor Hart, "Creative Imagination and Moral Identity," *Studies in Christian Ethics* 16, no. 1 (2003), 1-13.

[55]In ecology, it is important to note, ecotones are those edges where two distinct types of places or habitat merge and are often the most diverse with life—different types of creatures and plant life living together at the edges. Makoto Fujimura, interestingly, addresses the formative and generative space of the edges or borders by suggesting that artists function as *mearcstapas*, or "border-walkers," in culture today, translating various modes of being in the world and hospitably offering generative, beauty-giving life into the wider culture from these edges. Makoto Fujimura, *Culture Care: Reconnecting with Beauty for Our Common Life* (Downers Grove, IL: InterVarsity Press, 2017), 58 and throughout.

representational space (or productive social space), which, especially within the context of the biblical injunctions explored above, is exercised foremost as hospitable practice.

Both biblical and philosophical models prioritize a multidimensional model of place that focuses on physical, intellectual, and imaginative practices in places, which are oriented toward the development of a deeper sense of *self*-identity. This self-identity is rooted in a connection to place without prescinding *communal* engagement and openness; one's comfort and sense of self are only truly understood in the hospitable opening up of place for the other, an often surprising, excessive, and countercultural expression of our sense of home and self, particularly in the culture of the contemporary world.

In what follows I argue that the arts can function as one particular and paradigmatic form of this type of hospitable placemaking in the home, serving as binders not only for the interweaving of these placed practices of the home, as explored above, but also as contexts themselves for these dynamics to be bodied forth in acts of imaginative worldmaking. Art and craft may enable both creative homesteading and redemptive homecoming, inviting viewers, whether in explorations of the home in the gallery space or in principal visual components of the personal home, to open up a place—physically, intellectually, emotionally, spiritually—for hospitable connection to the other. The arts can be understood as a significant catalyst for the development and practice of a theology of home as we are called to in the Christian life.

HOMEMAKING THROUGH THE ARTS AND CRAFTS

Particularly in the context of this chapter on home, it is important to see how creative expressions in and about the home significantly contribute to the manner in which we understand our selves and our places, while also affecting our own hospitable practices and dispositions. In the domestic context, though, it is unlikely that most people will be able to afford fine art of the scope discussed in other places in the book, though it is highly likely that most have an old quilt made by a grandmother or a favorite coffee cup made by the hand of a potter, or that they engage in some other creative making of their own that would not typically find its way into the hallowed halls of the modern art museum. These practices are no less significant than those artworks we have already discussed, though clear distinctions can and must be drawn. It is

also important to note in this context what we observed earlier, that these designations of art and craft are relatively new on the scene of art-historical and critical discourse. Therefore they should be noted to have formed our contemporary position on the art-craft dichotomy but also questioned as they presuppose ontological or ethical considerations when it comes to art and craft, particularly as these assumptions apply to the functional definitions already offered for the arts earlier.[56] A brief introduction to distinctions in art and craft will be helpful as we proceed.

Modern dichotomies and theological dimensions of art and craft. Immanuel Kant argued for the removal of any considerations of usefulness applied to the work of art, elevating the contemplative function as the sole purpose of high art. On the other hand, crafts have at their core traditionally been associated with the making of useful physical objects, that is, objects whose purpose does not rest solely with contemplation.[57] Howard Risatti defines craft according to "practical physical function," indicating the importance of the physical quality of the object at hand.[58] Before aesthetics or communication, crafts, he argues, are made for applied use in a way that the arts are not. This clearly stands in stark contrast to the theoretical concern for "art for art's sake," which eschews any interest in use.

It would seem, then, under this theory that art is that which is decidedly *un*useful, while craft is useful.[59] Risatti fleshes out this distinction in terms of nature and culture, suggesting that while craft is "part nature, part culture," art is "all culture."[60] A longer excerpt from his writing provides further clarification:

[56]For a historical over view of these changes in terminology and functionality, see Edward Lucie-Smith, *The Story of Craft: The Craftsman's Role in Society* (Oxford: Phaidon, 1981); Paul Oskar Kristeller, *Renaissance Thought 2: Papers on Humanism and the Arts* (New York: Harper & Row, 1965); Nicholas Wolterstorff, *Art in Action: Towards a Christian Aesthetic* (Grand Rapids: Eerdmans, 1980), 68-69, parts 1-2.

[57]Wolterstorff relates the ways in which art theory has changed over time, resulting in the modern notion of the arts as objects of contemplation, separated from any other use or function. See *Art in Action*, part 1.

[58]Howard Risatti, *A Theory of Craft: Function and Aesthetic Expression* (Chapel Hill: University of North Carolina Press, 2007), 17. He differentiates between function and use here, the function being what the object was made for, and the use a subsequent inclusion of the object in a specific action that may or may not be what the object was originally intended for.

[59]Andy Crouch does speak to the importance of the unusefulness of art in "The Gospel: How Is Art a Gift, a Calling, and an Obedience?," in *For the Beauty of the Church*, ed. W. David O. Taylor (Grand Rapids: Baker Books, 2010). It is important to simply delight rather than being focused on utilitarian reading of the arts. While this may be true, we may also apply the designation of "art" to those practices specifically created or practiced *for* use, as Wolterstorff gives by way of example, mural art or work songs. See Nicholas Wolterstorff, *Art Rethought: The Social Practices of Art* (New York: Oxford University Press, 2015).

[60]Risatti, *Theory of Craft*, 224.

Craft objects are related to fine art in that both have a social existence as aesthetic objects. Yet craft objects are different from works of fine art because of their rootedness in nature. It is this rootedness that makes them special because it means they are both nature and culture. In this sense, and it is an important sense, they occupy a unique position in the world of man-made objects because they bridge the gulf between the world of nature and that of culture. They straddle the line between the two, partaking of both.[61]

While Risatti's exploration does much to aid the reader's perception of craft, in his attempt to distinguish between art and craft activities as such he seems to deprive art of much of its power and places craft in an awkward relationship to it, his argument resting on precisely those definitions of art that I and others have sought to dismiss. Trevor Hart argues that the limitations Risatti places on both art and craft not only fall prey "to the widespread myopia that generalizes a peculiarly modern and Western aesthetic," but also exclude "all sorts of things which common or garden discourse would naturally identify as craft, thereby leaving most of them in a particular limbo deprived of any identity at all."[62] While the rootedness of craft practices in the natural world is an important feature of their significance that I will seek to draw out, to remove "art" from this connection seems neglectful to the ways in which art, over much of its history, has sought to give us a proper understanding and sense of nature, often expanding the boundaries of our perception to imagine the wider ways in which nature influences our very soul. In his attempt to free craft from the constraints of modern high-art theory, an important and noble attempt no doubt, Risatti ultimately confuses the issue further by binding the arts more closely to that way of thinking.

Part of the complication may lay in that Risatti's main focus is on the *objects* of craft, whereas Richard Sennett, in his exploration of craftsmanship, centers his discussion on *practices*, and is therefore better able to see the familial relationship between art and craft. While certainly the two cannot be easily disentangled—as practices result most often in objects for both the arts and crafts—the focus on practices of making may help clarify some of the muddled

[61]Risatti, 231. In fact, John Ruskin writes of the relationship between art and nature, arguing in opposition to Risatti that art is a mixture of nature and culture. See, for instance, John Ruskin, *The Stones of Venice*, Dover ed., 3 vols. (Mineola, NY: Dover, 2005).

[62]Trevor Hart, *Making Good: Creation, Creativity, and Artistry* (Waco, TX: Baylor University Press, 2014), 295.

distinctions made so far. Sennett's focus throughout is "man as maker," *homo faber*, along with "what the process of making concrete things has to reveal to us about ourselves."[63] In some sense, what Sennett presents is an anthropology grounded in the impulse to creatively make the world around us, and while he makes no theological claims as to this impulse, we can easily draw the connections, given our observations in chapter two.

There are certainly key differences in the role of art and craft objects. In this sense Risatti is right to focus on the "applied physical function" of craft objects—a ceramic bowl is *used* in daily life, whereas a picture is often hung and looked at contemplatively or imaginatively. We might note, though, that in the context of the home, a painting or print being looked at daily may itself be understood as more of an applied function as it becomes caught up in daily ritual or the liturgy of the home.[64] For both art and craft, though, we see two related levels of engagement—one on the level of the physical practice, objecthood, or in the case of craft, applied use, and the other on the way in which the physicality of the thing or practice influences our state of being (what we might call the mental or spiritual impact of the art/craft in question). Sennett writes, "The craft of making physical things provides insight into the techniques of experience that *can shape our dealings with others*. Both the difficulties and the possibilities of making things well apply to making human relationships."[65] Risatti also makes a similar claim, suggesting that craft practices "help *shape how we see and understand the world*, the things in it, and our relationships to these things."[66]

For both thinkers on craft theory, the usefulness of the object is not simply in the applied physical function but in the ways in which the physicality of the thing influences our mental or spiritual lives, and particularly how it shapes our cultured liturgy of place. In encountering the physical thing, we are opened up to mental reflection and often a change of heart, which shapes or transforms our vision of the world. This is the case also with art, with its

[63]Richard Sennett, *The Craftsman* (London: Penguin Books, 2009), 6, 8.

[64]For instance, when I walk by certain artworks in my home, I think of their makers, whom I know, or the reasons why I bought the print or object. In these cases I may often pray for those individuals associated with the art objects, and so there is certainly applied function (while it may not be physical in the sense that Risatti concludes, it is perceivably *practical and practiced*).

[65]Sennett, *Craftsman*, 289, emphasis added.

[66]Risatti, *Theory of Craft*, 185, emphasis added.

engagement with the physicality of the world in literal or metaphorical ways shaping our vision, allowing us to see imaginatively through the act of literal seeing. This requires self-reflection (the contemplative) beyond one's immediate engagement with the material object, but this must happen just as much in engagement with a craft object as with an object of high art. For both, then, the material and the extramaterial are linked, neither being more important than the other but each contributing to the expanded sense of place that one experiences through engagement with the object or idea.

We may thus take Hart's conclusions on the art/craft distinction to mind when he suggests that it may illuminate our understanding further to remind ourselves of the *commonality* of all forms of human making rather than allowing their distinctions to drive the discussion.[67] Both Sennett and Risatti point to the role that the action of physical making has in the mental process, that one cannot fully expand one's conception or imagination except *through* the actual physical making of an object. Whereas one may stand before an art object, contemplating the physicality of that object, which leads to higher spiritual insight, it is in *the act itself* that both Risatti and Sennett suggest a different kind of transformation happens.[68] We may look at a work of art that someone else has made, but we may be more inclined to make a craft object ourselves, which gives heightened insight into the world in which we live. The value of domestic craft practice stands out here, then, as a potentially transformative feature of the making of a Christian home founded on those actions of the hands, head, and heart.

Wolterstorff makes this same connection to making in his discussion of the arts. Recall that Wolterstorff defines the arts as "objects and instruments of action,"[69] and his distinctly Christian aesthetic conveys this strongly creational and incarnational reading of the arts. By virtue of our calling as participants in creation and redemption we can understand more fully the claim that we are *homo faber*, makers of the world around us in material and extramaterial ways. While disinterested contemplation may be one way to approach the arts, it is certainly not the only way, and by considering art as social

[67]Hart, *Making Good*, 297.

[68]On the relationship between act and insight, see also Matthew B. Crawford, *Shop Class as Soul Craft: An Inquiry into the Value of Work* (New York: Penguin, 2009).

[69]Wolterstorff, *Art in Action*, 2.

practice Wolterstorff begins to set up a framework where art and craft can be more closely linked, craft being easily included in the realm of "art" and art being more closely associated with its existence as "craft."[70] The conclusion, then, is that perhaps we have been presented with a false dichotomy, that both art and craft may be understood as a creational calling to us as humans, which is to take those things that gave been offered to us and offer them back with value added. In further developing a theological perspective on art and craft in the home, I will return to those themes and practices addressed early on for the home in order to assess the ways that both traditionally conceived art practices along with craft practices and objects can function on a formative level in the home. We will see how arts and crafts' physicality, their relationship to memory, and their role in practicing hospitality—corresponding as they do to the physical, conceptual, and imaginative ways of our being in place— might help us live out a deeper faith and biblical practice of placemaking in the context of the personal home.

Art and craft as connection to the physical world. Both craftsmanship and artistry, as manual engagements with physical materials and responsible use of resources, reveal something about humans' relationship to the world as placemakers. Sennett suggests likewise: "Materially, humans are skilled makers of a place for themselves in the world," and so he argues we connect ourselves to places in the world through craft practices.[71] This is both a physical and a metaphorical claim, referring to one's material relationship to the physical world and one's conception of one's place within it. But as Sennett and Risatti both argue, the metaphorical or symbolic is *grounded in* and understood *through* the physicality of participation in the practice or object. The interaction, responsiveness, or conversation with physical materials renders insight into the world that God has made and perhaps his presence within it, and it is not just because the physical leads us to some higher place or meaning.

In theological terms, we participate in Christ's creative work in the world precisely through our calling to material acts of creativity, working with the stuff of this world in order to know it, and him, more fully, while also

[70]Wolterstorff explores these dimensions of art as social practice further in *Art Rethought*, a discussion we'll return to in chapter 5. Of course, it is also important to remember that as we defined art in chapter 1, art most often includes an element of craft, or skilled processes of making. James McCullough, *Sense and Spirituality: The Arts and Spiritual Formation* (Eugene, OR: Cascade Books, 2015), 36.
[71]Sennett, *Craftsman*, 13.

rendering objects of that world back to God with added value and beauty. Art and craft practices can therefore be understood as a work of creative love in response to creative love. Sennett, while lacking theological interest, reveals this focus on love in his discussion of the craftsperson's attention to detail in his materials and work: the craftsperson loves his materials and seeks to use them in the best way possible, obligating himself to the nature of the material in order to bring about the best possible state of affairs.[72] Trevor Hart understands the artist's creativity as a reflection of divine kenosis—just as God pours himself in vulnerable love into the world, allowing it freedom and possibility even in his guidance, so also the artist pours herself into the work in love, allowing the materials their own freedom and response to the artist's hands, material molded with the gentleness of divine breath as modeled after creation itself.[73]

Furthermore, as Christ's love is made tangible to us in the act of creation and redemption, so also we incarnate Christ's love through cloth or stone or wood and participate in that wider story of creation and redemption. Christ's love was reconciling for the relationship between Creator and creation, and our creative work might be understood as an echo of this love as it emplaces us in creation, giving us further understanding of the world we live in and rooting us there in the material, whether in the act of making or the process of contemplative engagement. Art, Hart argues, is "precisely an acute form of our wider human engagement with the world, with its distinctive dialectic of give and take."[74] In response to the Spirit's guiding presence, we do our part to practice reconciliation in imitation of Christ's material engagement with his creation, or as Wendell Berry writes, to "practice resurrection," in the physical world.[75]

Art and craft as memory work. The role of memory and imaginative projection are also significant for the artist's creative task as well as the creative

[72]Sennett, 97, on good-quality work, and 262, on avoiding degradation of the work through imposing self-goals rather than working with the materials.

[73]Trevor Hart, *Between the Image and the Word: Theological Engagements with Imagination, Language and Literature* (Dorchester, UK: Henry Ling Limited, 2013), chap. 5.

[74]Hart, 133. Hart, *Making Good*, 330.

[75]Wendell Berry, "Manifesto: The Mad Farmer Liberation Front," in *The Selected Poems of Wendell Berry* (Washington, DC: Counterpoint, 1998), 87. Hart thus argues that everything we do has eschatological significance and is understood through the lens of *tikkun olam*, the mending or perfecting of the world. Hart, *Between the Image and the Word*, 131-32.

making of one's home. Glenn Adamson suggests that craft practices in particular provide spaces that enable us not only to remember but also to project a vision into the future.[76] Adamson argues in *The Invention of Craft* that craft is a form of memory work that may give the maker a sense of continuity with the past while also questioning modes of practice in the future. Disapproving of those approaches to craft practices advocated by Pugin, Ruskin, and Morris in the arts and crafts movement, Adamson criticizes these thinkers' preference for an idealized (and therefore false) past in order to protest against modernity and as such offer craft practices as palliatives for the trauma of modernity.[77] Modernity, Adamson claims in response, had already made its mark on these men and therefore even their interpretation of these craft practices could not escape the industrial world against which they were posed. Adamson instead advocates for a theory of craft practices that moves beyond their role in sentimentalization of the past and understands those practices as a form of contemporary cultural engagement and meaning making. Craft practices necessarily function as a form of communal and personal memory, but they do not leave us there. Rather, in questioning a fragmented past (known only through the memory spaces we have created), we are better able to situate our practices in the present and evaluate them in moral, political, or social terms.

Places keep memory and offer, Paul Ricoeur suggests, "a support for failing memory, a struggle in the war against forgetting."[78] While the significance of being in place for remembering is noteworthy here, Ricoeur presses us to understand further how a sense of place is kept through creative practices, suggesting, "These places 'remain' as inscriptions, monuments, potentially as documents, whereas memories transmitted only along the oral path fly away as do the words themselves."[79] The arts—inscriptions, monuments, paintings, sculptures, rhymes—are a principal mode of transmitting memories over time and space and may indeed function as memory places themselves. This is suggestive for the ways in which the Israelites maintained their sense of home while exiled—their keeping of memory in texts and songs being significant here—and also offers insight into how we might consider art and craft

[76]Glenn Adamson, *The Invention of Craft* (London: Bloomsbury Academic, 2013), 182.
[77]Adamson, 185.
[78]Ricoeur, *Memory, History, Forgetting*, 41.
[79]Ricoeur, 41.

in the contemporary world as "memory places," responses to the culture of forgetting, especially as they relate to our concept of home.

Contemporary artist Jenny Hawkinson explores the concepts of home and memory places in her series *Remnants*, which question a fragmented past and our current engagement with places through memory (figure 3.1). Hawkinson uses the image of the quilt block to explore the fragmented ways in which we remember the past and envision our future. Mixing images of

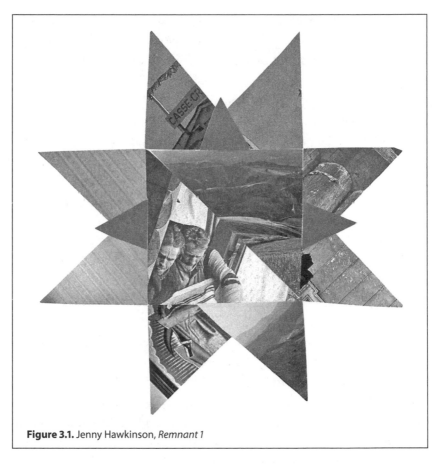

Figure 3.1. Jenny Hawkinson, *Remnant 1*

sacred places and objects, the natural world, features of the home, and photographs of people, the quilt blocks serve as symbolic forms for the re-membering and dis-membering practices we enact in our homes and society. The quilt block itself, as a central form of domestic craft, reminds us of the ways in which the sacred, the social, and the political all come together in a surprising and

unexpected way in the context of domestic life in the home. Popular writer Bill Bryson writes of the home in a way that reflects these influences:

> Whatever happens in the world—whatever is discovered or created or bitterly fought over—eventually ends up, in one way or another, in your house. Wars, famines, the Industrial Revolution, the Enlightenment—they are all there in your sofas and chests of drawers, tucked into the folds of your curtains, in the downy softness of your pillows, in the paint on your walls, and the water in your pipes.[80]

The home, then, becomes a space that simultaneously reflects and forms one's internal attitudes and external actions toward the outside world. Hawkinson's work reflects on this mutual relationship, situating fragmented and unified images into the context of domestic space and craft. The craftwork becomes a context for and active participant in memory making, and recalls the ways in which our practices of the home participate in these moral, political, and social realities at their core. Theologically, one's memory and sense of home become a key influence in one's kingdom work. The Israelites' sense of calling and purpose was located in their memory of divine promises even when they were dislocated from their homes. Their acts of memory making became places through which they practiced their calling—their songs and prayers, the Torah itself—all of these became the places in which they dwelt and found their sense of home. While these were often fragmented in exile or through their own disobedience, the act of re-membering a dis-membered society was accomplished through texts and images that served to hold their identity even in the tensions of absence from place.

To use another example, ceramic artist Keaton Wynn connected spatial practices in the land and memory making as conceptual space through a large-scale ceramics project in the Gansu Province of China in 2014, where he oversaw the making of bowls from local clay, which was hand-dug, tested, and thrown into bowls. The people in this region have lived on the land for generations, and so the land itself is key in their sense of home. The objects (which are both useful and beautiful) serve as reminders of the land and families who have lived on it for generations, while also serving to create a hospitable place for current residents to understand themselves and one another. After each family in the village was presented with a bowl from family land, they had a communal meal

[80]Bill Bryson, *At Home: A Short History of Private Life* (New York: Doubleday, 2010), 5.

involving the use of the bowls, which further participated in the making of hospitable space for all—for the artist, for the recipients, and for the land itself, which participates in the project. The project teaches us something about the role of land and art in our memory making, that to understand generations and family stories is to understand them in relation to places as participants. The bowls themselves also became memory places, serving as beautiful objects used in the everyday life of the people and providing a context in which to remind the residents of their continual participation in the story of that place. The craft objects became markers of their cohabitancy with the narrative of the place and invited them to engage in an emotional journey of homecoming, seeing the place and its stories in a new light and with redemptive significance for their own continued dwelling and future there.

Art and craft as creating hospitable space. Finally, as Wynn's project simultaneously reveals, art and craft may also profoundly call us to the experience and practice of hospitality. Hart's statement above is revealing here again, that art is "precisely an acute form of our wider human engagement with the world, with its distinctive *dialectic of give and take*."[81] In the hospitable exchange between artist and material, of artist and audience, and of audience and artwork, the work and made object provides a context or place in which hospitality can flourish in dialectic exchange.

Sennett argues that three key elements are at the heart of craftsmanship, which may help us understand how hospitality is at work in the process of making: the ability to localize, to question, and to open up. "The first," he says, "involves making a matter concrete, the second reflecting on its qualities, the third expanding its sense."[82] Localization requires attending to the particularity of an object or material, to the "thisness" or the "hereness" of some thing or place.[83] It means attending to the grain in a piece of wood or working with a particular type of fabric. It is ultimately a material attentiveness. Questioning involves further investigation of why things are the way they are and making connection to other things or relationships. It involves being reflective about the thing attended to or localized. The physical work of craft contributes to,

[81]Hart, *Between the Image and the Word*, 133.

[82]Sennett, *Craftsman*, 277. Note the connection to Lefebvre's three layers of relation to space: spatial practice, representations of space, and representational spaces in Lefebvre, *Production of Space*. I will draw out Lefebvre's theory further in chapter 4 in relation to sacred space.

[83]Sennett, *Craftsman*, 278. Recall my discussion of *haeccity* in Marlene Creates's work in chapter 2.

rather than is opposed to, contemplation and self-reflection. Finally, opening up involves drawing connections out further, expanding their application or meaning, making leaps between tacit knowledge and new possibilities for the thing in question. This will involve what Hart called the added value of art: it makes or contributes something new to the idea or thing in question.[84] All of these aspects of craftsmanship are essentially creative, involving seeing something in its uniqueness, making connections between it and other things, and drawing out new possibilities for it, and all require and call forth an attitude of hospitality, the ability to see something for what it is, to open up its meaning, and to allow it to open up meaning in oneself.

Sennett argues further that *all* humans have these capacities, and this point is important to a theology of creative placemaking through the arts in several ways. First, that all humans potentially share a capacity for craftsmanship or creativity suggests something about our basic calling as humans. God made us to participate in the creation by cultivating and transforming it through acts of creative making. While everyone is not a professional artist or craftsperson, nearly everyone can make things to some degree (as evidenced by the renewed interest in DIY and "Pinterest projects"). While the modes of practice and the outcomes of such endeavors are certainly different, the drive to creative making says something about basic human impulses. Sennett argues that focusing on the universal aspect of human craftsmanship can help us become better engaged with other people and the world around us. As crafts resituate us in place, craftwork can become an avenue to work for the common good, seeking reconciliation in and to the world we live in.

This is related to a second point, which suggests the paradigmatic role of the arts for conceptualization and practice of redemptive placemaking in the world. Artistic practices (and here I am including craft practices) are one of the very central, innate, and universal ways that humans make places in the world. By their nature (their making us attentive, questioning, and transfiguring), they are a paradigm of the way that humans acquaint themselves with and dwell within the places of this world. This manner of dwelling, as

[84]Trevor Hart, "Through the Arts: Hearing, Seeing and Touching the Truth," in *Beholding the Glory: Incarnation Through the Arts*, ed. Jeremy Begbie (Grand Rapids: Baker Books, 2000), 5. This might also be conceptualized in terms of what Ben Quash identifies as pneumatalogical abduction in *Found Theology: History, Imagination, and the Holy Spirit* (London: Bloomsbury, 2013), chap. 7.

exercised with a hospitable disposition, will open new ways of being in and conceptualizing our place in the world. It is out of this responsiveness to and opening up of new forms of communion with the world and one another that the artist might think about their participatory role in creation and redemption. When we materialize, question, and transfigure specific materials of this world, we reflect in a sort of crafted microcosm the structure of Christ's love and redemption in place. As Christians, this is the responsibility laid on us—to enable others to see the transfiguring presence of Christ in the world. By allowing art a central place in our lives, and by allowing it to form the context for hospitable exchange and communion, we can see this dynamic played out in particular and transformative ways.

One relevant example of this comes from the craftivist movement, which seeks to further understand the ways in which domestic craft can have wider social and cultural influence, and as such functions as a way to envision the connection between a sense of place at home and in society. Betsy Greer, an early adopter of the terminology and mindset of craftivism, writes, "Craftivism was, for me, a way to *actively recognize and remember my place in the world*, a way to remember how I can take steps toward being an agent of change."[85] The goal of the craftivist movement is to merge two ways of being in the world—one's role as a maker or crafter and one's role as a social activist. Craftivism thus contends that the practices cultivated inside the home can be a force of social change outside the home. Drawing from early women's protest art using hand-stitched banners, women have taken up craft practices (fiber arts such as knitting and embroidery in particular) as a form of protest to political or social issues. For instance, groups such as the Calgary Revolutionary Knitting Circle have banded together to practice something like a crafting sit-in, a peaceful opposition to contemporary capitalism and the commodification of nearly every aspect of our lives.[86] These have often been critiqued as flaccid attempts at protest, so nonconfrontational in their tactics that their techniques are themselves subverted as ineffective. Knitting, it seems, is too safe.[87]

[85]Betsy Greer, "Craftivist History," in *Extra/Ordinary: Craft and Contemporary Art*, ed. Maria Elena Buszek (Durham, NC: Duke University Press, 2011), 180, emphasis added.

[86]Kirsty Robertson, "Rebellious Doilies and Subversive Stitches: Writing a Craftivist History," in Buszek, *Extra/Ordinary*, 187.

[87]Robertson recounts the media's response to many of these protests as negating their impact by throwing their effectiveness into question (188).

While the validity of these criticisms could be called into question, particularly in light of the effectiveness of nonviolent protest more generally, both Robertson and Greer address the ways in which knitting is radical when extended into the economic sphere.[88] Craftwork becomes a form of activism against the dominating politics of a global economy that seek to separate us from local practices and customs, traditional skills and ways of community formation and remembering. While craftivism as a movement is powerful in the social sphere, one's own home economy and space are altered beginning in the practices habituated and formed in the domestic space of the home. One's sense of place as actualized in the act of making might then become a driver for more actively engaged social work in the world, and this reaches out from the interiors of one's own heart and home. Craft practices in the home can thus engage us in those activist dispositions, one homemade pie or bowl or blanket at a time.

As activist practices, and through their connection to the material world, their material manifestation as memory work, and their role in hospitable placemaking, craft practices in the home might cultivate instead a renewed focus on place and particularity while helping us discern and combat the placeless and consumerist culture in which we now live. Engagement in craft practices such as quilting or embroidery might actually be "a means of reintegrating ourselves into the material fabric of the world" and making places.[89] Isis Brook, in her short article on craft practices and placelessness, promotes a "new materialism" that focuses on engaging with matter, acts through which, she says, "I will be forging a new connection to where I am at the micro level of sitting here doing this and at the macro level of engaging with the material world with its attendant limits and balances."[90] This engagement with matter is a shared ability to work with the world by all humans. By engaging with things on a physical level, we are more closely acquainted with the places we find ourselves in. For instance, the unavoidable imperfections of craftwork actually reveal the importance of human individuality and the particularity of

[88]Robertson, 192.

[89]Isis Brook, "Craft Skills and Their Role in Healing Ourselves and the World," *Making Futures* 1 (2011): 304. There has recently been a rise in interest in women's domestic craft more generally as a way to combat consumerism. See, for a more popular example, Shannon Hayes, *Radical Homemakers: Reclaiming Domesticity from a Consumer Culture* (Richmondville, NY: Left to Write Publishers, 2010).

[90]Brook, "Craft Skills," 307.

human engagement with materials, while encouraging continued focus on manual skill and attentiveness to the materials being used.[91]

In addition to their rooting us in the material world both physically and epistemically, craft practices can be theologically suggestive for the ways in which we imagine the dynamics of consumption versus production in our home and society. We might ask ourselves whether the manner in which we participate in consumer culture has any theological significance and whether the ways in which we participate in acts of making might have any relevance there. William Cavanaugh argues for the value of being "productive" rather than "consumptive" in this regard, suggesting, "Making things gives the maker an appreciation for the labor involved in producing what he consumes. It also increases our sense that we are not merely spectators of life . . . but active and creative participants in the material world."[92] Consumerism gives us a sense of detachment and deprives humans of their sense of vocation as active sharers in the creative activity of God, but making things through craft practices (and in other nonartistic ways) focuses our attention back on this sharing in the work of God. As people engage in the material world through craft activities, they can add value to the life of a place and contribute to its particularity. As producers—as makers—we reflect our calling by God to the vocation of transformative placemaking.

Cavanaugh builds this discussion specifically in contrast to a different type of consumption in the Eucharist. In the Eucharist we consume Christ's body and blood and so take part in his presence in the community gathered in place. The sacrament is a place of transformative presence, and while the Eucharist is undoubtedly the most particular kind of divine-human encounter through the material, other actions of sign making are called forth from us and considered in similar ways. While understanding all art and craft as sacramental may lend additional theological difficulties, considering the eucharistic encounter helps us imagine how Christ's incarnational presence is experienced through other forms of human making in place.[93] This incarnational vision of placemaking suggests that Christ's presence is actively revealed to us in

[91]Sennett, *Craftsman*, 84. Sennett cites John Ruskin here regarding the importance of imperfections in craftwork and his distaste for the new use of machines for producing craft during his lifetime.

[92]William T. Cavanaugh, *Being Consumed: Economics and Christian Desire* (Grand Rapids: Eerdmans, 2008), 57.

[93]On art as sacramental, see David Jones, "Art and Sacrament," in *Artist and Epoch: Selected Writings by David Jones*, edited by Harmon Grisewood (London: Faber and Faber, 1959).

particular ways and places. And by understanding domestic craft practices through this lens, we can begin to understand the immediate impact of our artistry as it cultivates a sense of particular place, as it potentially makes a place on earth for heaven and earth to meet and for Christ's presence to work through the material in transformative and redemptive ways.

CASE STUDIES IN ART, CRAFT, AND A THEOLOGY OF HOME

In the context of the home, art may create the types of spaces that enable us to imagine and practice more deeply our theological sense of place. In the case studies below we will explore how the physicality of art and craft, their communal context and function, their transformational and redemptive roles, and their role as beautiful objects and beautifying practices that engender delight, surprise, memory, spiritual reflection, and hopeful envisagement all reveal the ways in which our sense of home can be expanded through the arts, both from the gallery space and the rooms of our houses. In Marianne Lettieri's gallery installations, we will see how she takes objects of craftwork in the home and sees their spiritual value and their role in memory keeping. In the quilts of Gee's Bend, we will explore the ways in which art and craft merge in the "quilt spaces" of women's craftwork, and how this work functions as communal placemaking, remembering and identity bound up in the tradition of learned craftwork in the domestic space. In these cases we will assess the role of the arts as they contribute to the formation of dispositions of hospitable placemaking that are applied foremost in the home.

Models for homemaking from the gallery: Marianne Lettieri. Marianne Lettieri, a San Francisco–based artist working in mixed media, sculpture, and assemblage of found objects, teaches her audience what it means to find sacred significance in the commonplace. While outsiders to the art world may often find much contemporary art difficult, either feeling like a stranger to the images themselves or ignorant of the practices and dispositions required for aesthetic engagement, audiences who find themselves in the presence of Lettieri's work are bound to feel more at home. This is because the artist hospitably welcomes audiences into the commonplace and everyday, feeding them images that, for many, will immediately recall family or childhood memories, objects that audiences are well acquainted with and that already bear some

personal significance.[94] But the manner in which these objects or images are presented is far from ordinary, as Lettieri takes objects such as pincushions or yarn, scissors or old gloves, and offers them back with value added, presenting them outside their normal contexts or places of use and thus reconfiguring the manner in which one might understand the symbolic significance of their ritual practice and place in everyday life.

Lettieri both challenges and affirms our constructions of home, memory, and self-identity, inviting viewers to engage in self-reflection through remembering and the conceptual restructuring of one's sense of home and its corresponding values. To this end, the artist works to find "the point where a commonplace object transcends functionality or idea and becomes transformed into a catalyst for personal reflection."[95] Setting the objects outside their everyday context and into the gallery space, the artist invites viewers into a new manner of reflection and heightened significance for the objects. Practicing in the gallery space, viewers may then return to their own homes with a new sense of the value of objects in the domestic sphere and their significance in relation to their own sense of self-identity and community practice. Alain de Botton affirms this dynamic, suggesting, "In whitewashed galleries housing collections of twentieth century abstract sculpture, we are offered a rare perspective on how exactly three-dimensional masses can assume and convey meaning—a perspective that may in turn enable us to regard our fittings and houses in a new way."[96] While Lettieri's art isn't made *for* the home, its objects originate *in* the home and influence our self-reflective dwelling there, challenging our ways of contemporary living that often fail to recognize the sacred significance of the places we create and driving us to realize that the ritual practices we perform are often oriented not toward community and hospitality but toward a selfish kind of consumption and dismissal of relationships created on habits and values of the home that are themselves homeless, negations of the very thing we so strive for.

Lettieri's work profoundly operates on the theology of place explored above, valuing physicality, memory, and hospitable practice. The domestic

[94]The artist acknowledges this accessibility and encourages such personal response. Marianne Lettieri, interview by Jennifer Craft, December 9, 2016.

[95]Marianne Lettieri, interview by Jennifer Craft, November 15, 2016.

[96]De Botton, *Architecture of Happiness*, 78.

objects she uses in her installations and assemblages operate through memory and selection.[97] Collecting items mostly from the late nineteenth and early twentieth centuries, Lettieri focuses on the history and memory of women's work, particularly in a domestic context. As a result, tensions necessarily arise in her work, with the value of women's work in the home and traditional domesticity framed in the object's original context (a context that more highly valued this type of labor for women). The value of women's work is further questioned against the backdrop of feminism of the 1970s and following, a movement that the artist acknowledges placed women's domestic work on a lower level compared to traditional male vocations outside the home. In women's desire to break free of the prison of domestic life, they devalued work there, making such distinctions and struggles felt more sharply. Lettieri notes, however, that in her elevation of the domestic craft and labor of women, she does not intend "to romanticize the homemaker of the past. Rather, I want to address her contribution and viewpoint."[98]

That viewpoint is one that finds expression in the physical labor of the everyday work in the home. In *27,000 Breaths*, the artist combines twenty-seven thousand inches of red twill hung neatly on the wall and threaded through an old sewing machine (figure 3.2). Every inch of fabric represents a breath taken by its maker, specifically the approximate number of breaths we normally take in a twenty-four-hour period, and thus marks the passage of time in a day's work. The resulting object contains those very breaths, even those thoughts and prayers spoken over the work, which become sewn into the made thing and transferred in its materialized form over time and place. Viewers who have sat at a sewing machine will know its labor to be sometimes harsh and physically exhausting, the feeding of material in rhythm with the machine, one's breath corresponding to the rate of stitch and only later realizing that one's body has suffered for the beautiful creation that results—an act of kenotic love, highlighted also in the bright redness of the twill.

Similarly, *Hierarchy*, an assemblage of three ironing boards stacked in classification of size—one regular sized and two child-sized, each smaller than the last—also speaks to the physicality of the domestic task and the lineage of domestic work and skill that is passed down in generations. Ironing, an action

[97]Lettieri, interview, December 9, 2016.
[98]Lettieri, interview, November 15, 2016.

somewhat unuseful when one considers that the basic value of clothing is to cover one's body, seeks in addition to functional use to invoke beauty and order onto a garment. Another tradi-

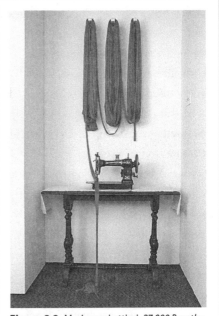

tionally female task, the assemblage speaks to the role of communal memory and tradition within a family, skills passed on that impart a quiet, simple beauty and order onto the lives of one's family in a way that is most often overlooked but that is the result of time and physical energy poured out in love.[99]

These objects of everyday ritual and domestic labor that are originally situated within the context of family or communal memory are also additionally consecrated for the audience and imbued with religious sig-

Figure 3.2. Marianne Lettieri, *27,000 Breaths*

nificance, being presented in ways that evoke the context of worship, religious ritual, and iconographic veneration, calling attention to the potentially spiritual significance of such rituals in the home. Pincushions form the pattern for a Gothic rose window (*Rose Window*, 2012) (plate 4), and doilies and crocheted items line the inside of wooden ribs reconstructing Gothic fan vaulting (*Concupiscence*). The commonplace is reconceived and re-placed as sacred: "A well-worn pin cushion is the soul of a woman—a tiny window onto holy ground."[100] In both of these works, objects that women have made or continually used are placed in the context of religious worship. As we have observed about liturgies in Smith's writing, the question is not *whether* we will have a liturgy that is oriented toward some end but rather what that liturgy

[99]It might be noted that this piece has also been interpreted as the diminishment of skills passed down in contemporary life and the removal of those liturgies such as ironing from our daily habits. In any case, the calling attention to the detailed practices of women's work that is lost and perhaps found again suggests the manner in which values change with time, and the role of art to remind us of that communal narrative.

[100]Lettieri, interview, December 9, 2016.

will be and to what end it will be directed. Our contemporary liturgies of the home often dismiss the value of tedium and repetition of domestic tasks, but just as in the worship liturgy of the church, where the repetition of prayers, readings, bodily movements, and physical expressions of faith is valuable and formative, so also our practices of placemaking in the home might be reconceived with the same religious import. The home and its attendant practices become like an *axis mundi*, holding all meaning within itself as center, constituting a microcosm of sacred space as exercised in the tasks performed at hearth, sink, or table.[101]

Sennett suggests that the postscript of the Industrial Revolution reveals our homes to be "a secular version of spiritual refuge, shifting the notion of sanctuary from church to domestic interior."[102] But in those moments of cultural change in the twentieth century and following, with the commodification of home interiors, gadgets, fast food, and a general culture of convenience, we have become further separated from those practices that form us spiritually. Norman Wirzba argues, therefore, that a revision of our thinking about the home is in order; the home must be a spiritual center in addition to a physical space, and we must "learn to see our households as 'a little church' or 'Christ's general receptacle' (St. John Chrysostom) in which our life together participates in the triune life of God."[103] Where Lettieri succeeds in her artistic offering is to resacralize those basic objects and tasks not for sentimentalization but in order to expose the sacred value that many have overlooked, reenchanting viewers' sense of what makes for valuable work and the abundant possibilities for different types of living in the world. This redemptive task may then encourage viewers to learn to see their households and their accompanying objects and practices as empowered with new spiritual significance, and which participate in making their homes "little churches" where hospitable practices and creative placemaking take root and grow.[104]

[101]Lucy Lippard writes, "The search for homeplace is the mythical search for *axis mundi*, for a center, for some place to stand, for something to hang on to." Lucy Lippard, *The Lure of the Local: Senses of Place in a Multicentered Society* (New York: New Press, 1997), 27.

[102]Summarized by Gorringe, *Built Environment*, 40.

[103] Wirzba, *Living the Sabbath*, 106.

[104]In the work *Emptied and Consumed* she brings these themes into the worship space, highlighting the eucharistic quality of everyday domestic tasks in the kitchen, and reconceives the place of meal preparation as a productive sacred space.

Lettieri's works are redemptive and reconciliatory, not only for the objects themselves as they are elevated to a place of honor but also as they transform our own sense of home in a culture of tension and displacement, our existential homelessness highlighted and challenged as we consider our own relationships to objects and memories in our most intimate physical and conceptual spaces. The commonplace image of eggs emerges throughout her oeuvre, most notably in *Small Scale Free Range Organic Eggs* and *Cathedral*, where whole wooden eggs are included; *Rituals*, where vinyl cutouts of cracked eggs (displayed "over easy") are presented in a Victorian case; and *Artist Reliquary*, where an overturned goblet holds what resembles a Fabergé egg, but rather than one with precious jewels is one made of sawdust, pulp from the artist's work apron, and candy foil.

In the immediate context of domesticity and home that the artist creates, the eggs serve as a symbol of the everyday, the mundane breakfasts made by your mother, or the sustenance that carried you through your childhood. But eggs within Christian iconography are also profoundly religious symbols, showing up in Orthodox icons of Saint Mary Magdalene and providing a metaphor for Christ's resurrection and the redemption received as a result. Here, in Lettieri's work, one need not know the iconographic imagery to feel their significance, as the everyday is imbued with sacred life, and ritual consumption is exposed as a part of living and being at home in the world. But behind these images, along with many others in her series, lies the message of redemption, cohabitancy with a past or remembered way of living that might alter our practices and vision for the future.

The manner in which ritual and the sacredness of the commonplace are envisaged in Lettieri's work is key for understanding why artwork in the gallery might be highly influential for one's own sense of living at home. The artist teaches us a hospitable disposition toward our rituals of homemaking and the everyday objects that carry personal significance. In a culture that is so readily commoditized, this disposition of care and memory, ritual and reuse, comes as a stark contrast to the ways in which many of us go about the journey of homemaking. The objects themselves become motivators or signposts for the types of ritual homesteading and homecoming explored earlier, at once creative and redemptive, combining the narratives of the past with a vision for the future. It is precisely because these objects have been removed

from their original contexts that they can be reevaluated with such imaginative force. They have been dis-placed in order to be re-placed, dis-membered so as to be re-membered. The objects themselves have gone on a journey of home-coming and have taken the artist and audience with them. Audiences will return home with new eyes to see, their imaginations expanded to enjoy the mundane tasks of home and to delight in their simple beauty, their existential homelessness redeemed at least momentarily as they sit down at that for-gotten old sewing machine, iron their spouse's clothes, or cook eggs for their family. The journey of homecoming results in one's making one's place anew one extraordinary task at a time.

Crafting sense of place through the domestic arts: The quilts of Gee's Bend. The quilts of Gee's Bend, as they've come to be known, would have all been lost to history if in the mid-1990s William Arnett, a folk art collector and re-searcher from Atlanta, had not discovered the imaginative quilt designs of the women of Gee's Bend. Arnett had seen a photograph of Annie Mae Young posing with two large quilts draped over a woodpile and was so impressed by the modern quality of the design aesthetic in the quilt that he traveled all the way to Gee's Bend to track it down. What he found was much more than a beautiful quilt. He found a whole community of women who had been pro-ducing beautiful quilts since their families were slaves on that same land. The small, mostly African American community of Gee's Bend, Alabama, was originally the plantation of the wealthy, white Pettway family in the mid-1800s. After the end of the American Civil War, it became home to the ex-slaves of that plantation, still enslaved in many other ways to white landowners and businessmen but this time with the freedom to try to make a living in their own place. About half of the current residents of Gee's Bend still bear the name Pettway, a small sign of this not-so-distant past.

The community has often been described as an island.[105] It sits in an oxbow of the Alabama River, has only one road on which to enter and leave, and covers a land area of only thirty to thirty-five square miles.[106] The small, iso-lated hamlet turned out to be a wellspring for a rich aesthetic tradition founded

[105]John Beardsley et al., *The Quilts of Gee's Bend* (Atlanta: Tinwood Books, 2002), 207.
[106]Gee's Bend is about five miles across by seven miles long, as stated in Michael Kimmelman, "Art Review: Jazzy Geometry, Cool Quilters," *New York Times*, November 29, 2002, www.nytimes.com/2002/11/29 /arts/art-review-jazzy-geometry-cool-quilters.html.

on the values of community, place, memory, and tradition. Arnett bought a large number of the quilts and eventually turned them into a museum show that traveled to high-art museums all over the country, including the Museum of Modern Art in Houston and the Whitney Museum in New York City. The women traveled along with the show and have received much acclaim as a result of their quilt showing. Since then, several books, articles, and even a series of US postage stamps have been printed on the Gee's Bend quilts, and the women have made a place for themselves in the world outside Gee's Bend.

The popularity of Gee's Bend quilts was largely the result of their modern design aesthetic. These quilts were more than just bedcovers; the museum exhibitions emphasized that these quilts were "Art" and the women "Artists."[107] In fact, the quilts were "reinvented in the name of art" so much so that often it is difficult to believe they were first created as humble coverlets, for warmth, comfort, and utility.[108] During the cold winters in the Bend, and without heating in their homes, they depended on having multiple quilts in the winter to keep warm. Often quilts were piled seven and eight high on beds, and people lined the walls and floors with quilts to keep out drafts in their clapboard houses. Even after the federal government and the Farm Security Administration came in to build "Roosevelt houses" in the late 1930s, quilts adorned the houses for both warmth and as aesthetic reminders of family traditions.[109] In the summers and other seasons, the quilts were put to use as well. Notably, the older, worn quilts were burned during the summer months to keep mosquitoes away.[110]

While the museum shows and guides highlighted the social context, the intensely modern designs were what gave the quilts enough clout to make it in the modern gallery. The quilters of Gee's Bend have repeatedly been compared to pillars of modern art such as Barnett Newman, Mark Rothko, Frank Stella, Henri Matisse, Jasper Johns, Joseph Albers, Paul Klee, and Sean Scully.[111]

[107]For instance, see Sally Anne Duncan, "Reinventing Gee's Bend Quilts in the Name of Art," in *Sacred and Profane: Voice and Vision in Southern Self-Taught Art*, ed. Carol Crown and Charles Russell (Jackson: University Press of Mississippi, 2007); R. Kalina, "Gee's Bend Modern," *Art in America* 91, no. 10 (2003): 104-9, 148-49.

[108]Duncan, "Reinventing Gee's Bend Quilts in the Name of Art."

[109]Paul Arnett et al., eds., *Gee's Bend: The Architecture of the Quilt* (Atlanta: Tinwood Books, 2006), 23; Beardsley, *Quilts of Gee's Bend*, 27.

[110]Arnett, *Gee's Bend: Architecture of the Quilt*, 23.

[111]Arnett, 76.

Michael Kimmelman in his *New York Times* review of the show writes that these quilts are "some of the most miraculous works of modern art America has produced. Imagine Matisse and Klee (if you think I'm wildly exaggerating, see the show) arising not from a rarefied Europe, but from the caramel soil of the rural South."[112] The abstract design, geometry, color choice, and minimalist aesthetic of the quilts are all highlighted in this regard. Richard Kalina elaborates:

> The Gee's Bend quilts are exemplars of [a] broadened approach to abstraction. Their elusive complexity—their scale, their reference to the body, to physical work, to social structures and to the land—greatly enriches our perception of them. *But there is something else.* . . . I believe that they are entitled, every bit as much as a Frank Stella or Kenneth Noland painting of that period, *to lay claim to an unfettered optical reading as well, in other words, to participate fully in the esthetics of modernism.*[113]

Kalina recognizes their complexity in terms of social and physical readings, but ultimately the quilts' significance lies for him in the modern visual quality of the colors, designs, and abstract expression. In order for their placement in high art museums to be justified, they were reconceived in terms of their aesthetic function and relationship to other high-art forms rather than their original function as coverlets.[114]

[112]Kimmelman, "Art Review: Jazzy Geometry, Cool Quilters."

[113]Kalina, "Gee's Bend Modern," 106-7, emphasis added.

[114]"This is not the first or most explicit time this has happened in regard to quilts being presented as "art." In the 1971 art exhibition *Abstract Design in American Quilts* at the Whitney Museum in New York, quilts were looked at through the "modern eye" and abstracted as far as possible from their original context in order to see the painterly designs present in them. Quilt collectors Jonathan Holstein and Gloria van der Hoof had envisioned a show that emphasized the artistic quality of the textiles as opposed to their quality as craft or the personal meaning and social context that might have accompanied the quilts. The quilts were hung like paintings against white walls, with attention given to the flatness of the quilt design rather than its original function as a bedcover. The artistic intent of the quilters was stressed, including their intentionality in design. And finally, originality, one of the key components of modern art, was stressed in relation to the quilt designs. Peterson notes the similarity in the 1971 quilt exhibition and the 2003 Gee's Bend exhibition at the Whitney Museum. The way the quilts were displayed is almost identical—hung on white walls and abstracted from immediate context in order "to facilitate the modern eye." There are differences, though, in the discourse used for the Gee's Bend show. There is a great amount of emphasis placed on the social history and tradition of Gee's Bend quilters. Photos and videos of the people and landscape of Gee's Bend accompany the exhibition. The exhibition catalog includes biographies, interviews, and stories of the quilters. The quilters themselves even tour with the quilts, often breaking out into gospel songs in the middle of the museum space. Karin Elizabeth Peterson, "Discourse and Display: The Modern Eye, Entrepreneurship, and the Cultural Transformation of the Patchwork Quilt," *Sociological Perspectives* 46, no. 4 (2003): 461-90.

While their resemblance to modern art is certainly one way to understand the quilts, and an important recognition to make at that, I argue that taking a rather different approach to the quilts and quilting practices of the women of Gee's Bend will produce more substantive fruit, both in terms of understanding what these women were actually up to in their quilting practices and elucidating the theological value of the arts/crafts and their relationship to home.[115] It is the quilts as functional, physical objects—the result of embodied interaction with materials in relation to their beauty—that is most important to a proper understanding of them. Their actual, everyday place in the social context of Gee's Bend, Alabama, reveals the truest meaning to what these women were doing in their craft practices. We will see, though, that the aesthetic design and choices that are so lauded are intensely bound up in this physical context. Perhaps this is the main problem with many evaluations of the Gee's Bend quilts—the art objects are too often abstracted from the physical, placed art practices.

The inspiration and influence of the place, its materials and structures, and its demands for use of the objects makes these quilts nothing less than an embodied art of place. The practice of quilting, by its nature, is an art of embodiment. Quilting large pieces can be physically exhausting, and the hard work that goes into each quilt is reflective of the importance such quilts have for the community, both physically and aesthetically. The quilts were first and foremost objects of action, intended for a specific function.

While the applied physical function of the quilts communicates a connection to the physical world, their aesthetic designs also suggest the women's relationship to the physical and built environment. While the quilts draw on a wider African American design aesthetic, they also have their own "locally intensified sense of design" in the Bend.[116] The layout of the land, the weather patterns, the colors of the natural environment, and the buildings and other monuments of Gee's Bend influence the design of the quilts. When family aesthetic is not the first intent or inspiration, commonalities in visual experience,

[115]The museum exhibits did highlight the relationship of these quilts to place, especially in the second exhibit, *The Architecture of the Quilt*. However, emphasizing the modern aesthetic of the quilts before their physical function and practice results in merely sentimentalizing the social context and relationship to the physical geography rather than highlighting its central relationship to both the designs and use of the quilts over time.

[116]Beardsley, *Quilts of Gee's Bend*, 78.

weather, and landscapes make for a shared, common style in quilting.[117] Often quilt designs "map" the landscape, "echo[ing] the layout of fields, garden plots, and houses of the neighborhood."[118] By mapping the landscape in this way, the women reacquaint themselves with the physical place and reinterpret it through imaginative and artistic practices.[119] Their geographical imagination inspires and is inspired by the physical landscape of Gee's Bend.

While some quilts may be more explicit in their mapping of the landscape, most women see a relationship between their quilt patterns and the world around them in a self-reflective way. The "Housetop" pattern becomes a way of looking at the world, informing everything the quilter sees (plate 5).[120] The design is connected with the physical and emotional issues of home. Not only do the quilters make their homes physically inviting (cozy, warm, hospitable), but they also act out other desires for the type of home or place they imagine or hope for. "I always did like a 'Bricklayer.' It made me think about what I wanted. Always did want a brick house," says Loretta Pettway.[121] The execution of a quilt in "Bricklayer" pattern serves to satisfy that desire for home in abstract form.

Pettway's reflection on the Bricklayer design suggests the connection between the quilts and built environment of Gee's Bend as well. While the natural landscape is key in how the people see themselves as a culture, the built environment bears the most direct relation to the quilts of Gee's Bend, most obviously because the quilts are made to be used inside homes as bedcovers.[122] The quilts, then, bear a close relationship with architecture. Not only are they spoken of in architectural terms, likened to building a house, but they also draw inspiration from characteristics of the built environment around them:

[117]Arnett, Gee's Bend: The Architecture of the Quilt, 126.

[118]Two quilts by Amelia Bennett and Sue Willie Seltzer serve as example, as they map the place in abstract design using community-driven designs such as the "Housetop," "Bricklayer," and "Lazy Gal." Roads, buildings, and outcroppings can be seen in the various sections of fabric and stitching patterns. Arnett, 46.

[119]See Edward S. Casey, Earthmapping: Artists Reshaping Landscape (Minneapolis: University of Minnesota Press, 2005), along with my discussion of artistic mapping in Marlene Creates's work in chapter 2.

[120]Arnett, Gee's Bend: The Architecture of the Quilt, 37.

[121]Arnett, 59.

[122]Teri Klassen, "Review of Gee's Bend: The Architecture of the Quilt," Museum Anthropology Review 2, no. 2 (Fall 2008): 124-26. Klassen notes the prominence of outdoor photographs that accompany the quilt show, suggesting that there is still a certain abstraction in the fact that quilting is a domestic craft, taking place inside the home. This serves to push the further separation of the quilts from the world of "craft" and situates them in the world of "art."

For these women, the quilt was the literal completion of physical architecture, insofar as the quilt enlivened and transformed the otherwise drab setting of the tenant home. In a greater metaphoric sense, quilts invested architectural space with the history, memories, and desires of the community and the individual maker. A quilt was unique—comparable only to religion and song—in its ability to link its makers to the wider ramifications of their lives.[123]

The built environment serves as inspiration for design, as a metaphor for the way the quilt-making process unfolds, and as the place where the work is put to most immediate use. *The Architecture of the Quilt* exhibition shows up-close photographs of barns, houses, and other buildings in order to show the relationship of abstract design in the quilts to the "put-together aesthetic" exemplified throughout the Bend. Indeed, the photos bear a strong resemblance to the blocks of patterns in the Gee's Bend quilts. Quilter Mary Lee Bendolph confirms this, explaining, "Most of my ideas come from looking at things. I can walk outside and look around in the yard and see ideas all around the front and back of my house."[124] Bernard Herman refers to the quilters as "quilt builders," likening them to building a house in the level of craftsmanship and design insight needed to put a quilt together.[125] Nancy Pettway also recalls this building metaphor in her description of her process: "Like you want to put your rooms together in your house . . . you put all your pieces together on your quilt."[126]

It is interesting, then, that the museum exhibition focused only on the external, "more masculine" realms of the built environment, since the women were actually "building" their places from the inside out. The quilts served first in the home and only secondarily in the outside world.[127] While the women gained inspiration from the outside world, their building process began in the domestic, more feminine spaces of the rooms of the house. Of course, the two are connected, but more effort to relate the women's geographical imagination, inspired by the outside world, to the actual places in

[123]Arnett, *Gee's Bend: The Architecture of the Quilt*, 31.

[124]Arnett, 7.

[125]Arnett, 208.

[126]Arnett, 208.

[127]They are, however, known for having "art shows" in the summer, when the women hang their quilts out to air. People walk around the community looking at quilts and getting inspiration from other women. Arnett, 215-16.

which the quilting practices were enacted would have been helpful. The first exhibition catalog hints at this when it tells of the newspaper-lined walls of their old clapboard houses, an indoor indicator of the influence of abstract design reflected in the quilts.

"All really inhabited space," Gaston Bachelard suggests, "bears the essence of the notion of home."[128] And because these quilts are not just made but "inhabited," they reflect the complexity of the women's sense of home as domestic space and its relationship to the outside world.[129] The women create "quilt spaces" that bear a direct relation to their sense of self, home, and physical relatedness in a community. In this sense, again, the quilts have a distinctly incarnational element, being the immediate place of inhabitation for women in the home and community, as well as the avenue through which the women transcend their immediate circumstances, allowing them to imagine things differently. Dreams, fears, and above all, hopes, are all bound up in the quilt spaces they produce. They can reflect spiritual and communal values simply by stitching cloth together. Their notion of home, in Gee's Bend and in the wider spiritual sense, is expressed through the materiality of the quilt objects and practices that structure their everyday lives. The women can find an immediate place of comfort in the cloth, which also serves to thread together their own lives in place with those that come before and after—their own material connection to the wider community of saints.

By making a quilt out of reused fabric, the quilters and those who use the objects maintain a spiritual connection with people and places that might otherwise be lost to forgetfulness and time. The women suggest that you can feel spirits and hear voices in the quilts. Work-clothes quilts embody their husband's or father's work in the field; they carry their grandmother's thoughts, songs, and prayers in the fabric of her old dress. The quilts become palimpsests of communal and personal memory, materialized in fabric and thread, and passed down among generations in both physical artifact and traditional craft practice. Their response to these memories, their contemplation and veneration of embodied spirits in quilts, is furthermore an act of religious import. These quilts become their icons—used to remember their "saint" of a grandmother or their father who provided sustenance throughout their lives.

[128]Bachelard, *Poetics of Space*, 5.
[129]Arnett, *Gee's Bend: The Architecture of the Quilt*, 207.

As the quilts and quilt practices bind together past struggle with future hope, they function largely as memory texts, or vehicles of memory that unite the past with the present and future.[130] This focus on quilts as memory texts is important theologically, as we explored above. Even when the memories are not explicitly theological or spiritual in their subject, the act of remembering itself links times and places through acts of sign making that recall a past presence through placed action. In both Passover and the Eucharist, as Jewish and Christian communities continue to enact these stories, the act of remembrance through sign making collapses the boundaries between the current time and the original event, allowing participants to experience the presence of the original moment itself. Taking the bread and wine, for instance, makes present the body of Christ in the *particular* community in place, even as it speaks to the presence of Christ in *all* eucharistic communities. In a similar way, the quilt as a memory text serves as the place through which members of the community may recall other members and events, experiencing a kinship and continuity with deceased family members and friends through the use of the quilt artifact. Spirits of the deceased may live in the present place through stitched-together cloth.

As objects that materialize relationships to and beliefs about home and community, the quilts of Gee's Bend suggest some wider possibilities for craft practices such as quilting in the context of the home. By making or using objects that embody physical relationships, memories, traditions, hopes, or aspirations, functional art and craft objects in the home make places for us and for our guests to participate in a larger story, inviting participants to cohabitate with us and our narratives that are on display or hospitably offered up for use. The Gee's Bend quilts, of course, are special circumstances, being offered up in the gallery space and introduced to us as art, in addition to their being functional craft objects for the home. While their role as high art should not be discounted, perhaps their role in the home helps us better understand what places art might occupy outside the gallery, that in the most intimate dwelling places of our lives there is room for the particular, the handcrafted, the extravagant, the useful object that presents itself in a way that is *more* than its functional use. The Gee's Bend quilts have functioned in both worlds, though

[130]Arnett, 73, 78. See also "memory places" above in this chapter as explored by Ricoeur. Memory texts can also be compared to Michael Foucault's understanding of "counter-memory."

their ontology remains unchanged, revealing the complexities of such desig-
nations as art and craft in relation to the spaces that they occupy. The quilts
remain both art and craft simultaneously—in both contexts of gallery and
home—suggesting that the boundaries we draw are hardly ever static and that
art and craft might both be understood in relation to the places they dwell and
the places they create, calling us *into* those places—into relationship, into con-
templation, into spiritual reflection, into remembering, into longing and hope,
into action.

Conclusions: Art and Craft in the Home

What conclusions might we draw from these reflections about art and craft
more generally regarding the role of art in the home? First, it is important to
note that context matters. Art in the home and art in the church, for instance,
while being unified in some ways, call for different approaches, the one being
a site of intimate personal dwelling and the other a place for corporate worship.
Both, though, require hospitality, for instance. Similarly, the discussion of dis-
tinctions between art and craft should also note the importance of context as
well, as the ways in which we will address art in the context of the home, and
for a sense of home in the world, might be different from, say, public art in
society. To this end I will note several ways in which art might be beneficial in
the home, while arguing that the sites of our most intimate dwelling and be-
longing might be better occupied and opened up (a reversal of the contem-
porary tendency to believe the home as closed or primarily) through en-
gagement in the arts and creative making.

First, and most generally, *art can contribute to a cohesive economy of the home.*
By cultivating attitudes reflected in the theology of home above—an acknowl-
edgment of the significance of physicality, a place for memory making and
keeping, and an opening up of the self and one's space to others and the world
through hospitable practice—art contributes to our whole life as it leafs out
from the root system of the home. Wendell Berry argues that we are in need
of a kingdom-oriented home economics, one that includes a whole pattern of
order and telos founded on the values of the kingdom of God.[131] Art, for Berry,
is a significant feature of this kingdom-oriented task and "critical to human

[131]See his essay "Two Economies," in Wendell Berry, *Home Economics* (Berkeley: Counterpoint, 1987), 54-75.

life," though he does assign it a "secondary value."[132] "Works of art," he says elsewhere, "participate in our lives; we are not just distant observers of *their* lives. They are in conversation among themselves and with us."[133] This is why he places art centrally in the context of the home, suggesting that if "we must go to museums to see art, then we no longer *have* art."[134] The arts, in Berry's mind, are those ways that we develop the imagination to live better in the world, to dwell in our physical places, to practice hospitality to one another, to remember the Lord our God.[135] The arts are linked with that cohesive and kingdom-centered home economy, the way of being that sees all that we do as participation in the story of creation and its redemption. And just as Hart urges us to see our creative undertaking as a work of kenotic love, so also Berry says that good work "turns on affection," our sense of place and Christian practice fundamentally built on an attitude of care and self-giving love.[136]

Within this cohesive and kingdom-centered economy, *art cultivates spiritual meaning and practice in the home.* The home, in ancient contexts, was also the primary place of spiritual life; from the hallowed rooms of our personal living space, it was believed that we practice the dispositions required for spiritual life in the world. James K. A. Smith provides a contemporary example of this commingling of the spiritual and domestic space, suggesting that "Our baptism opens the home, liberating the family from the impossible burden of self-sufficiency while also opening it to 'disruptive friendships' that are the mark of the kingdom of God."[137] Our baptismal life is markedly one of community, and being Christians, this should serve to open up the home

[132]Berry, 61. This secondary value is related to the fact that Berry sees our dwelling in place and community, our right relationship to the natural world, as the key indicator of our relationship to God. Art helps us engage this task but is separate from it. See also Wendell Berry, "Christianity and the Survival of Creation," in *Sex, Economy, Freedom, & Community* (New York: Pantheon Books, 1993).

[133]Wendell Berry, *What Are People For?* (New York: North Point, 1990), 64.

[134]Morris Allen Grubbs, ed., *Conversations with Wendell Berry* (Jackson: University Press of Mississippi, 2007), 53.

[135]But a more cohesive and proper way of dwelling goes hand in hand with the preservation of the arts. He argues, "We can't for long preserve the fine arts if we neglect or destroy the domestic arts of farming, forestry, cooking, clothing, building, home-making, community life, and local economy." Wendell Berry, *The Way of Ignorance and Other Essays* (Washington, DC: Shoemaker & Hoard, 2005), 76. See also Wendell Berry, *Life Is a Miracle: An Essay Against Modern Superstition* (Berkeley: Counterpoint, 2000), 83, 122. Here he argues that we join ourselves to the world through the tools of art and science, "by made things," which, he later elaborates, are used "to build and maintain our dwelling here on earth."

[136]Wendell Berry, *It All Turns on Affection: The Jefferson Lecture and Other Essays* (Berkeley: Counterpoint, 2012).

[137]James K. A. Smith, *You Are What You Love: The Spiritual Power of Habit* (Grand Rapids: Brazos, 2016), 118.

in countercultural ways. Sandra Bowden describes her attitude to art col-
lection as a calling, a "countercultural act" that causes personal enjoyment
along with deeper reflection and meditation, and places one in conversation
with artists and other collectors and viewers across time and place.[138] The act
of collecting becomes a spiritual discipline whereby one enters into a conver-
sation with those artists and viewers before them as a form of communion. As
these spiritual practices arise in the home, they can transform from within the
deepest spaces of the self, forming us in our day-to-day, ordinary lives, as we
learn see the world anew as if in the company of friends. Bobby Gross writes
similarly of this dynamic, suggesting, "In our home, we are surrounded by a
cloud of witnesses. Whenever we pause to behold these cultural creations, to
pay attention, to see yet again, we find ourselves quietly blessed."[139] The arts'
presence in our home can therefore serve as reminders of the baptized life, a
community of artists and friends already at home on our walls, or images that
convey spiritual truths that stretch and mold us into hospitable people. These
reminders may also encourage us to open up our place further to the guest or
outsider, letting go of our personal sense of space so as to make room for an-
other in hospitable love.

Third, *art in the home can give a storied identity to both place and self.* If the
home is indeed a song of the self, then the ways in which we decorate those
spaces will be indicative of who we are and who we imagine ourselves to be.
So what might it say, then, to have a mass-produced item of decoration on our
walls from a national chain store, something we have picked up because it was
marketed to us and exists as a reflection of changing trends, versus a print or
painting by an artist who has poured their love and creativity into the piece,
expressing a deeper sense of place in the world? When one looks at the latter,
one will remember the place and person from which one purchased the piece;
when one sees the signature, one will be reminded of the impact and value of
human touch. The latter piece of art holds a story and a place within it, even
as it becomes a part of the evolving sense of place and self in the home. Gross
suggests, "Each acquisition of art tells a story of opportunity and motivation.

[138]Sandra Bowden, "Collecting as Calling," *SEEN* 16, no. 2 (2016): 3.
[139]Bobby Gross, "To Have and to (Be)Hold: A Personal Reflection on Collecting Art," *SEEN* 16, no. 2
 (2016): 8.

Added up, these stories disclose the contours of my collecting experience."[140] They can become a way to reflect on the narrative of one's own identity; they "keep" you in a way by becoming a memory place. The mass-produced item that has been purchased in the chain store will likely end up in the landfill when the trend passes and something else is marketed to the homeowner. The original art piece holds something more universal—human connection, storied sense of place, memory and identity.

When this happens, art can become an expression of embodied meaning in the home. Our sense of self becomes embodied in material practices and objects, our works of art and craft becoming those songs of the self that make the home. Mark Johnson argues that the arts are paradigmatic forms of embodied aesthetic meaning, offering a lens through which to understand more tacit parts of our own embodied aesthetic experience in the world.[141] Glenn Adamson suggests similar possibilities for craftwork, proposing that "In reality, craft remains one of the most effective means of materializing belief, of transforming the world around us, and less positively, of controlling the lives of others."[142] Adamson affords a significant place to the objects in our lives, revealing the ways in which they communicate belief and meaning through their material form. In other words, to use the language of Smith, they become the props of our embodied cultural liturgy of the home and culture. Just as a play requires both stage (place) and props (art and craft objects being central here) in order for the actors to perform appropriately, so also our homes (the place of our most intimate dwelling) and the artwork there (those props that operate both functionally and decoratively) form the material backdrop for belief, action, and spiritual reflection.

Fourth, *art contributes to homemaking through the creation and addition of beauty.* While not all art must be beautiful, the context of the home is a space that calls for beauty, seeking out in material form the desires of our hearts for comfort and love. David Pye argues, "The value of beauty, then, is that along with human contact it enables us to break out of the otherwise impregnable spiritual isolation to which every one of us is born and to feel ourselves at home

[140]Gross, 7.

[141]Mark Johnson, *The Meaning of the Body: Aesthetics of Human Understanding* (Chicago: University of Chicago Press, 2008), 212.

[142]Adamson, *Invention of Craft*, 231.

in the world."[143] John de Gruchy further suggests that beauty is transformative and redemptive in society, and as the intimate site from which our social life is largely crystallized and which rejuvenates and often repairs those social relationships, beauty may in fact have a clear role to play in the home as well.[144] One's place can communicate a spiritual language that provides something like a musical refrain for life in the world, a "home key" that settles one into the comfortable, known self again.[145] Beauty creates a hospitable place for others to dwell and also for one's own homemaking practices, actively contributing to one's sense of rootedness in or connection to a place, the hanging up of pictures or placing of objects being practices that we perform in the act of homesteading. As expressions of the self, they also become contexts for connection with guests, as they question or comment on a drawing or photograph, which opens up a space for storytelling and connection. The visual images, in this case, perform incarnationally as mediator between host and guest, materializing a space for communion to unfold in the experience of beauty itself.

Fifth and relatedly, *art creates a culture of care and hospitality in the home.* In some sense this final point is a continuation of the last, as beauty is central to an attitude of care and hospitality. The care that we practice in our home liturgies functions as practice for that care extended to our guests, to the stranger, to those both inside and outside the home who are in need of care and attention. This must be, however, a disciplined care, not one practiced haphazardly or out of duty but rather out of love. Wendell Berry reflects this attitude as it is reflected in the arts in an interview with Marilyn Berlin Snell:

> When I think of art, I think of my home and what I want to live with. Made things can be either degrading or instructive, boring or uplifting. Behind my judgment of art is really a judgment about what kind of community I want to live in. . . . The best art involves a complex giving of honor. It gives honor to the materials that are being used in the work, therefore giving honor to God; it gives honor to the people for whom the art is made; and it gives honor to the maker, the responsible worker. In that desire to give honor, the artist takes on obligation to be responsibly connected both to the human community and to nature.[146]

[143]David Pye, *The Nature and Aesthetics of Design* (New York: Van Nostrand Reinhold, 1978), 102.

[144]John W. de Gruchy, *Christianity, Art and Transformation: Theological Aesthetics in the Struggle for Justice* (Cambridge: Cambridge University Press, 2001).

[145]Jeremy Begbie talks about the role of the home key in Jeremy S. Begbie, *Theology, Music and Time* (Cambridge: Cambridge University Press, 2000), 126.

[146]Grubbs, *Conversations*, 54.

In making our homes sites of beauty, care, and honor, we reflect, even in minute ways, that creational calling received from the very beginning, to responsibly care for, to take delight in, and to add value to the gifts we have been given by our Creator. Art teaches us how to give honor, love, and attentive care to something outside ourselves, functioning as an activist response against a culture of self-centeredness.

Many artists, such as Doug Aitken and Lia Chavez, treat their entire home like a piece of art. From room to room, every aesthetic choice has been meticulously considered, from Aitken's table, which functions as a musical instrument, to Chavez's modern aesthetic and clean white space, which uses light and minimalism to reflect the artist's sensibilities.[147] In all matters of reflection on the home, the question of authenticity arises when domestic space is elevated (or even discussed, for that matter), as it draws the sense of home out of the realm of the indwelt (tacit) and into the self-reflective. While these artists have built their art into every feature of their lives, for most of us the home functions in far less elevated ways. But this everyday, ordinary aesthetic way of being is perhaps more important for our purposes. The ways that each of us feels at home, where we put our keys when we walk through the door, what our view is from our favorite seat on the sofa, all of these make up the habits and liturgies that form our lives without our knowing.

Very rarely will our homes look like Chavez's, nor should they, as this would not only be financially impossible for most but also impractical. But, to quote Berry again, "To preserve our places and to be at home in them, it is necessary to fill them with imagination."[148] One way to do this is through purchasing art—even small art prints or a coffee cup from an artist or craftsperson, where cost is a concern—which not only enables the artist to practice their own calling but also invites oneself to reflect differently on objects in the home and, by association, the society outside the home. These two arenas are never disconnected; our practices in the home are profound reflections of our concerns outside the home. Our hospitality might be practiced by opening up a space for the presence of others in paintings or prints that reside on our walls. These

[147]Laura Neilson, "One Artist's Long Island Home: A Meditation in White," *New York Times Style Magazine*, September 12, 2016, www.nytimes.com/2016/09/12/t-magazine/art/lia-chavez-artist-long-island-home -tour.html; Linda Yablonsky, "Sound Garden," *New York Times Style Magazine*, March 30, 2012, www .nytimes.com/2012/04/01/t-magazine/doug-aitkens-sound-garden.html.

[148]Wendell Berry, *Standing by Words* (San Francisco: North Point, 1983), 90-91.

may then form the context for remembering and self-reflection as well as conversation with guests on their entrance into the home, forming surprising and different ways of looking at the world from the sign purchased from the trendy arts-and-crafts store. Art objects and practices can, therefore, provide a context for hospitable communion, continually forming our imagination and inviting us to practice our theology of place in both home and world.

Divine Presence and Sense of Place

The Arts and the Church

"I can worship God just as well in a warehouse as I can in a cathedral. I can't see why the worship space matters very much." I have often received this response when I suggest that the visual place of worship matters for our sense of community and divine presence, the implicit suggestion behind these remarks being that somehow I've forgotten that *people* are the church, not the *place*, and therefore the place doesn't matter very much when it comes to our worship. In some sense, they are right. One *can* worship in a storage building or a Gothic cathedral, in one's living room or on a mountaintop. But that isn't the point. Rather, God calls us to make places fitting for divine dwelling and community to occur, and while this can be actualized in a strip mall, to negate that the visual matters at all seems naive not only to the makeup of human embodied (and therefore visual) experience but also to the history of Scripture and the church as it records instances whereby people seek to makes places that communicate the divine (and *with* the divine) in the best way possible by marking out sacred spaces. After all, one *could* sleep on the floor in a room with no windows or furnishings, but is it comfortable or fitting to do so? I, for one, like my bed designed specifically for sleeping comfortably and warmly. That many do not have the luxury of such a comfortable sleeping space does not make it sinful for me to sleep the way that I do. Similarly, while worship spaces may differ markedly according to preference or accessibility to resources, the ways in which these places are built, designed, and used *do* affect the nature of our worship there.

I have adapted some of the material in this chapter from my chapter "Art, Place, and the Church," in *Contemporary Art and the Church: A Conversation Between Two Worlds*, edited by W. David O. Taylor and Taylor Worley, 143-57 (Downers Grove, IL: IVP Academic, 2017).

This chapter will explore the ways in which art might help us participate more deeply and meaningfully in the corporate life of worship in the church by making fitting and hospitable places through which to deepen our relationships to one another, to the world, and to God. While we may indeed worship everywhere, most Christians decide to attend a weekly service or meeting of believers. The relationship between communities and the spaces of those meetings, then, is what this chapter seeks to address, along with the ways in which the particular design and decoration of those places might be understood to function in the practice of worship while at the same time becoming a primary expression of the local identity and sense of place for the worshiping community.

First we will investigate the ways in which the biblical account handles the topic of divine presence and community experience in place, particularly in the Garden of Eden, the tabernacle and temple narratives, and the life of the early church. The ways in which artistry and creative making function in these spaces and contexts will be highlighted as a foreshadowing of the ways in which the arts might be included in contemporary liturgical practice and evaluated in terms of their relationship to human experience of divine presence, social identity and placemaking, and missional calling for the community fostered within the place of worship. From this biblical-theological account, we will draw out several themes for a contemporary liturgy of place that prioritizes vision, embodied action, and sense of place in the act of worship as a way to discover God's presence, cultivate community belonging, and encourage Christian mission through beauty. Concluding this section I will argue that arts might function as a form of creative homesteading and redemptive homecoming in the church, fostering a sense of place that is integral not only for theological imagination but also for love and service in the world. Finally, two case studies will explore these themes in practice as they investigate *temporary* installation and *permanent* visual art in their roles in community placemaking and worship in the church.

BIBLICAL THEMES FOR ARTISTIC PLACEMAKING
AND EXPERIENCE OF DIVINE PRESENCE

As physical sites for worship and experience of Yahweh's presence, the Garden of Eden, the wilderness tabernacle, and the Jerusalem temple all

suggest the centrality of place and visual experience in the development of the divine-human relationship and communal liturgical practices. While the New Testament keeps these themes, its focus changes somewhat drastically, even while keeping place as a central image for understanding salvation.[1] Each biblical writer takes up themes of divine presence and action differently, suggesting myriad possible readings for God's relationship to space and place, and the nature of his dwelling there. For instance, with different readers in mind, the Deuteronomic writers emphasize the transcendent nature of God, insisting that only God's name can dwell in the temple, while the Priestly writers, on the other hand, attempt to hold onto a balance between God's transcendence and the simultaneous possibility of his indwelling glory in the temple, developing a theology of divine presence in humanly constructed places such as the temple and throughout all of creation.[2]

Scripture thus leaves us with a multifaceted picture that furnishes and often confuses our theological understanding of God's relationship to place, but despite their divergence on issues of sacred space or divine presence, these traditions speak overall to a significant relationship among God, people, and place. They also suggest among other possibilities a significant theology of place where both God and people dwell in relationship, along with the role of artistry to construct fitting places for such relationships to flourish. Places, as John Inge notes, "are the seat of relations and of meeting and activity between God and the world."[3] Two important theological threads are thus woven into the biblical tapestry of worship: first, God's active relationship to people and places (specifically understood through a doctrine of divine presence and election), and second, people's relationships to one another and to God

[1]John Inge, *A Christian Theology of Place* (New York: Routledge, 2016), 57. He argues that "it is very difficult to imagine salvation in terms of anything other than place."

[2]See Moshe Weinfeld, *Deuteronomy and the Deuteronomic School* (Oxford: Clarendon, 1972); R. E. Clements, *God and Temple* (Oxford: Basil Blackwell, 1965). Scholars also differ in their view on the relationship between the tabernacle and temple. G. K. Beale suggests that the symbolism of the tabernacle is the same as that of the later temples. G. K. Beale, *The Temple and the Church's Mission: A Biblical Theology of the Dwelling Place of God* (Downers Grove, IL: InterVarsity Press, 2004), 32. Benjamin Sommer, on the other hand, suggests a distinctly different interpretation of the temple versus the tabernacle. Benjamin D. Sommer, "Conflicting Constructions of Divine Presence in the Priestly Tabernacle," *Biblical Interpretation* 9, no. 1 (2001): 41-63.

[3]Inge, *Christian Theology of Place*, 68. Inge also suggests a threefold relationship among God, people, and place that is useful for understanding both Old and New Testament images of God's engagement with people and places. See 46-51.

through placed liturgical action (often formed in response to divine calling). Both of these, I argue, take on a significantly spatial and aesthetic character throughout Scripture.

The garden sanctuary as site for worshipful placemaking. While the place of the church might seem to find its closest corollaries in the worship environments of ancient Israel's tabernacle and temple, the garden sanctuary serves as the first place of divine-human meeting and relationship in Scripture and therefore sets the stage for our evaluation of experience of divine presence in a place of worship. The creation narrative, in any case, has a striking connection to the tabernacle and temple texts, often understood in parallel to the construction and purpose of the dwelling places of God.[4] This connection can be identified in the scholarly assessment of particularities of the texts, such as the days of creation as they are related to the stages of the tabernacle construction,[5] as well to broader conceptual links such as the relationship between temple and world.[6] G. K. Beale, in *The Temple and the Church's Mission*, outlines the ways in which the temple and tabernacle can be seen as "reflections and recapitulations" of the first temple, the Garden of Eden.[7] Both garden and temple are the place of God's unique presence on earth: God walks with Adam in the garden, he comes to meet his people in the tabernacle, and he is known to dwell permanently in the temple.[8]

[4]The most explicit place in Scripture where the connection is made is Ezekiel. Others who suggest the connection between creation and the tabernacle/temple space include Terrence E. Fretheim, *Exodus* (Louisville: John Knox, 1991); John D. Levenson, *Creation and the Persistence of Evil: The Jewish Drama of Divine Omnipotence* (Princeton, NJ: Princeton University Press, 1988); John H. Walton, *Ancient Near Eastern Thought and the Old Testament: Introducing the Conceptual World of the Hebrew Bible* (Grand Rapids: Baker Academic, 2006); John H. Walton, *The Lost World of Genesis One: Ancient Cosmology and the Origins Debate* (Downers Grove, IL: IVP Academic, 2009); Joseph Blenkinsopp, *The Pentateuch: An Introduction to the First Five Books of the Bible* (London: SCM Press, 1992).

[5]Margaret Barker, *Temple Theology: An Introduction* (London: SPCK, 2004), 16-18. The building of Solomon's temple also follows this "seven acts" structure in relationship with the tabernacle and creation account. See Levenson, *Creation and the Persistence of Evil*, 79; Beale, *Temple and the Church's Mission*, 61.

[6]Jon D. Levenson, "The Temple and the World," *The Journal of Religion* 64, no. 3 (July 1984): 275-98.

[7]Beale, *Temple and the Church's Mission*, 66. Ezekiel 28:13-18 is the most explicit place in Scripture to refer to Eden as the first temple sanctuary. There are a number of points at which Beale makes this parallel; however, I will address only the most significant of these here. Others include associating Eden with the first guarding cherubim (the angel at the gates of the garden), the first arboreal lampstand (the tree of life), the garden as the basis of imagery for Israel's temple (wood carved to resemble flowers and palm trees), Eden as the first source of water and as the center of the world (Zion is later seen as having all rivers flow from it in Rev 21). See generally Beale, 66-80.

[8]Beale, 66.

Adam is understood as the high priest of the garden sanctuary, a role that parallels both the priests in the temple and Christ as the first high priest of all of creation.[9] This parallel is also reinforced by the authors' vocabulary used to describe human actions in both garden and temple (*abad* and *samar*). These terms in the Genesis account should first be understood in light of their immediate context—as having an agricultural connotation (Adam tills and keeps the garden)—but as the words are used elsewhere in Scripture, they are most often understood as "serve and guard," in reference to serving God's word or keeping the tabernacle.[10] Beale suggests in this regard: "While it is likely that a large part of Adam's task was to 'cultivate' and be a gardener as well as 'guarding' the garden, that all of his activities are to be understood primarily as a priestly activity is suggested not only from the exclusive use of the two words in contexts of worship elsewhere but also because the garden was a sanctuary."[11] That the phrase is repeated in both contexts is significant, and Adam's tasks in the garden, therefore, should be read as ones of both agricultural concern and the more general human task to serve God's purposes in creation and keep his word. Adam's activity in the garden, in these terms, should be construed as a priestly activity, key to inviting the relationship between God and people in place.

As God's image bearer and priest of the garden sanctuary, Adam was also called to spread God's presence outward from the garden to the rest of the world.[12] The hospitable sanctuary of Eden was understood, from this perspective, to move out in concentric circles to the inhospitable places of the world, eventually filling the entire earth with God's presence through his people.[13] The image of God, then, has both a relational and a functional sense, denoting something about human createdness along with the calling of humans to actually cultivate and make places, to spread the divine image throughout the entire earth.[14] The placemaking actions in the garden are understood as a microcosm of wider human activity, integral to the reception of God's presence throughout the earth.

[9]Beale, 66. See Hebrews 4:14.

[10]Beale, 66-67. For references to this linguistic pair, see Num 3:7-8; 8:25-26; 18:5-6; 1 Chron 23:32; Ezek 44:14.

[11]Beale, 68. This connection between the garden and temple does not negate the importance of the physicality of Eden. The general agricultural background always lingers, and the Old Testament preoccupation with land is ever-present.

[12]Beale, 83.

[13]Beale, 85.

[14]Beale, 83.

Adam's placement and calling in the garden suggest the importance of human making and participation for God's creational vision and universalizing presence. This is no less the case for human actions in the tabernacle and temple contexts, and later in the church. Interpreting the accounts in relation to each other suggests that placemaking remains a central religious activity throughout our encounters with God. The experience of the presence of God in place, as Timothy Gorringe states, is a relational event, tied to the community and actions of the people.[15] Meeting and revelation are made possible only though divine action, but the reconciliation between God and people that takes place later in the temple context (and ultimately in Christ, who is the embodiment of the temple) is understood as being accompanied by acts of human sign-making and sacrifice. Human placemaking works *in relationship with* divine placemaking in the garden, along with the tabernacle, temple, and church later, so that God's presence can be made known and the people reconciled to both God and one another.

Placemaking and human artistry in the tabernacle. As recounted in Exodus 25–40, a third of the book of Exodus deals with the construction and theological vision of the tabernacle. Since Scripture rarely ever develops issues at such length, this should clue readers in to the significance of the constructed space in Israel's religious practice while giving a clear point from which to develop a theology of place that privileges human making or artistry.[16] The wilderness tabernacle provides the first space constructed expressly for the divine presence to dwell and at the same time provides one of the most explicit endorsements and longest descriptions of human artistic practice in Scripture.[17] While the arts, especially music and dance, are described in other places in the Bible, in Exodus readers are invited to imagine the primarily visual character of worship, with the account revealing not only a divine stamp

[15]Timothy Gorringe, *A Theology of the Built Environment: Justice, Empowerment, Redemption* (Cambridge: Cambridge University Press, 2002), 40-46.

[16]For example, important events such as the creation of the world or Christ's birth and baptism receive much less textual space.

[17]One might suggest that Noah's ark was a constructed place where God's presence dwelt with his chosen people; however, as the ark was made for the physical salvation of the people and animals, and not specifically for *worship*, here I identify the tabernacle as the first *explicit* instance of humanly constructed space made for the special divine dwelling. Jacob's setting up of a stone at Bethel can also be noted as a marking off of sacred space following a divine intervention, but not necessarily a *construction* of it in the sense that we are suggesting here.

of approval on artistic practice but also the process by which the artists are inspired and the specific relationship of their artistic actions to divine calling and subsequent divine dwelling. This passage thus tells us not only *that* God values the visual arts but also shows us *how* to think about them, suggesting a relationship between human artistry and divine inspiration and calling.[18]

In Exodus 31 we are introduced to Bezalel and Oholiab, artisans commissioned with overseeing and undertaking the main work on the tabernacle. Immediately the writer of Exodus tells readers that the craftsmen are filled with the Spirit of God to make beautiful things: "I have filled him with divine spirit, with ability, intelligence, and knowledge in every kind of craft, to devise artistic designs, to work in gold, silver, and bronze, in cutting stones for setting, and in carving wood, in every kind of craft" (Ex 31:3-5). This is not just a call to artistic action of any sort, however. The artists are to make all that is *commanded* of them (Ex 31:6, 11). The craftsmen's actions are related in a very explicit way to the will and action of God. "Every detail of the structure," Brevard Childs suggests, "reflects the one divine will and nothing rests on the *ad hoc* decision of human builders."[19] It is through divine inspiration that the people create, and their actions do not result in just any creative product but in a place meant to house the divine presence itself (see Ezek 40–48 [temple]; Heb 8:2 [tabernacle]).

Bezalel and Oholiab are not the only two artists employed to construct the tabernacle and its accouterments, though. In Exodus 35–36 "all who are skillful" are commanded to take part in the construction. While the writer does not make the same connection to divine inspiration in these cases, he does link the craftsmen's work with divine commandment. "As the Lord had commanded" is a constant refrain throughout the account, especially Exodus 39–40. The place of divine dwelling, we are told, will not be the result of human will or desire. This fact is emphasized in the account of the golden calf, placed noticeably just one chapter after the introduction of the divinely inspired craftsmen. Rather than creating in convergence with divine command, calling, or blessing, the people of Israel construct an idol to represent or house the divine while Moses is

[18]Relatedly, William Dyrness explores the Bible's connection between glory (which is indicative of divine presence) and beauty (which often has a strongly visual connotation). See William Dyrness, *Visual Faith: Art, Theology, and Worship in Dialogue* (Grand Rapids: Baker Academic, 2001), chap. 3.

[19]Brevard S. Childs, *Exodus: A Commentary* (London: SCM Press, 1974), 540.

up on the mountain (Ex 32:1). The tabernacle-construction and the golden-calf accounts are similar in that both depict the people bringing their gold, earrings, other jewelry, and precious belongings to contribute to the making of the artifact (compare Ex 32:2-4 to Ex 35:22-24). But the actions are noticeably different as well, the calf incident being the result of unholy humans' misplaced attempts to locate and manipulate God's holy presence outside his calling to do so. The story is reminiscent of the eating of the forbidden fruit in Genesis 3, when humans' desires to be like God resulted in divine anger and expulsion from the garden. In both cases God commanded and called his people to participate in his presence in place, but the people's attempts at idolatry (in both the statue and their own desire to be like God in the garden) resulted in a loss of divine-human relationship.

This narrative says important things about artistically constructed space. The people are actually called to participate creatively in the making of a physical place for God to dwell, and they continue to help spread that presence out from those sacred spaces in ever-new ways of making and engaging with other places in the world. In the tabernacle the divine presence is explicitly connected with the artistically constructed space, the narrative communicating not only the importance of symbols such as the tabernacle and temple for the life of Israel but also pointing to the wider theological significance of *all* constructed space in the world. This paradigm is identified by Timothy Gorringe as the "potentially sacred" nature of all places, which wait for "the moment of encounter" that will reveal the presence of God in both event and community.[20] In these cases God may choose to meet those who call on him in fitting ways, while human participants make spaces through which to understand themselves and their relationship to God.

[20]Gorringe, *Theology of the Built Environment*, 40. This moment of divine action and encounter is key and should clarify any overly generous reading of divine presence in a place where God might be revealed apart from his particular divine action there. For instance, David Brown argues in *God and Enchantment of Place* for a sacramental reading of place and the arts by arguing from divine generosity, suggesting that "the more generously they are interpreted, the more it becomes possible to see specifics in nature and human creativity as a reflection of the divine, *there to be experienced as such even in advance of any specific revelation.*" Brown, *God and Enchantment of Place: Reclaiming Human Experience* (Oxford: Oxford University Press, 2004), 33, emphasis added. Interestingly, his views on divine action are much more "interactionist" in his earlier writing, especially *The Divine Trinity* (London: Duckworth, 1985). We might contrast this sacramental approach with John Inge's theology of place, which uses the language of sacrament to secure his understanding of divine-human meeting in place but clearly highlights the role that divine action must serve in the sacramental encounter. See Inge, *Christian Theology of Place*, chap. 3.

While the tabernacle forms a temporary home for God's presence, it also orients the temporary home of the Israelites in the wilderness toward God. This reveals the multidimensionality of sacred space and place more generally—while the tabernacle can be understood first as a place fitted for divine dwelling and related to the salvation and redemption of humanity, it might also be construed as a social space, with the divine calling to artistic place-making in the narrative interpreted as partly for the sake of the human community and their needs to feel at home in both their worship and the wilderness. Mark George suggests this concomitant social view of the tabernacle and seeks to reinterpret the structure in light of the philosophy of place outlined by French philosopher Henri LeFebvre. In *The Production of Space* LeFebvre outlines three levels or types of space in human experience: spatial practice, representations of space (what George calls conceptual space), and spaces of representation (what George calls social space).[21] Working within this methodological framework, George considers the social and religious implications of actions involved in the construction and use of Israel's tabernacle space, and while George's study is often overly dependent on modern social theory to describe the ancient Israelites' action and thus engages in a sort of reverse derivation of Israel's attitudes from modern philosophy, he does make some relevant points for linking divine and human identification with constructed, relational places. This can inform our concept of sacred space and the role of artistry in the church today.

Importantly, George draws attention to the physical quality of the place—the inventories, detailed descriptions, instructions about arrangement of items, the portability of the structure, and the orientation of the structure—all of which all highlight the materiality of human engagement with the sacred space.[22] It is worth noting that the tabernacle is

[21]Mark K. George, *Israel's Tabernacle as Social Space* (Atlanta: Society of Biblical Literature, 2009). See also Henri Lefebvre, *The Production of Space* (Oxford: Blackwell, 1991). Lefebvre uses the term *space* like I and many more contemporary authors use the term *place*. Therefore his understanding of space should be considered in the way that we have described place throughout. George takes up this usage of *space* in order to emphasize that the tabernacle was a movable space and was not a grounded, permanent object, as would normally be identified with a place. This terminology speaks again to the various ways in which the terms might be understood. For instance, a boat or ship is often understood as a place, a movable place, or Bedouin culture often speaks of their tents and movable homes as places rather than spaces. In the same way the tabernacle might also be seen as a place, especially as it is associated with the creation, temple, and new creation, as we will later see.
[22]George, *Israel's Tabernacle*, 56.

an *embodied practice* as well as a spiritual discipline that is simultaneously divinely inspired and commanded.[23] That the tabernacle is taken apart and reassembled on a regular basis speaks not only to the relationship between the physical and spiritual embedded within such places but also to the liturgical character of worship in the place—the making and remaking of the tabernacle space provides an opportunity for Israel to reorient themselves, both physically and mentally, to God.[24] This physical, spatial practice is "performed space"; human actions are required on a repeated basis in order for their relationship to God and one another to be realized and reframed, and in this sense, the place can be understood as event, repeated and re-practiced in their habituated engagement with God in the sacred space.[25]

Edward Casey, a contemporary philosopher of place, writes in this regard: "Rather than being one definite sort of thing—for example, physical, spiritual, cultural, social—a given place takes on the qualities of its occupants, reflecting these qualities in its own constitution and description and expressing them in its occurrence as an event: *places not only are, they happen*."[26] Not only does Casey ground human identity in our habitus in the world—the ways in which humans move and work and be-in-the-world—but his description of this identity is active, reflective, and liturgical. Places happen, and we happen in them.

Importantly, the artists' actions also become a relational and revelatory event in the tabernacle narrative—they are called to create in conjunction with divine will so that God may be present among his people and the entire community can go to meet God. The artists' actions are paradigmatic for the wider community's encounter with God as they receive inspiration from God and create a space for divine dwelling there. Jeremy Kidwell notes the

[23]George, 64.

[24]George, 82.

[25]George, 86. See also Fretheim, *Exodus*, 274. Here, he claims, "Each time it is taken down and then erected again, the process of making and joining is renewed. It is in the ongoing dismantling and reassembling of the tabernacle, day in and day out, that the new creation is being formed and shaped." This suggests a key difference in the movable tabernacle and the stationary temple. These features of the tabernacle reflect some of Belden Lane's axioms for understanding sacred space, which suggest that sacred space *chooses*, rather than being chosen (divine initiative being the key point here), and that "sacred place is ordinary place, ritually made" (the space becomes sacred through liturgical actions performed there repeatedly over time). Belden C. Lane, *Landscapes of the Sacred: Geography and Narrative in American Spirituality*, expanded ed. (Baltimore: Johns Hopkins University Press, 2001), 19. John Inge also notes the event-nature of place and ties it to the sacramental encounter. See Inge, *Christian Theology of Place*, 67.

[26]Edward S. Casey, *Getting Back into Place: Toward a Renewed Understanding of the Place-World* (Bloomington: Indiana University Press, 1993), 330, emphasis added.

importance of this artistic design as an *experience* rather than as blueprint, that the text leaves many instructional features for building unaccounted for while providing *a visual image for* communal worship. Exodus then offers a "liturgical poetics" rather than a rulebook, the tabernacle narrative intending "to commend a visual and liturgically oriented contemplative reading" by conveying a visual experience for the people.[27] The tabernacle functions, therefore, not only as a sacred or religious place but also as a visual social space for the community, with the deity's presence and place in the tabernacle, and the people's own acts of worship, reconstrued in light of the visual experience and its important social implications for the identity of Israel as Yahweh's people.

Temple theology and sacred space. Alongside the tabernacle milieu, which provided a concrete performed space in the midst of movement, is the Jerusalem temple, a permanent place of divine residence and dwelling informing the life of Israel in both their landed existence and their longing for home while in exile. While these narratives differ markedly in context, in some sense both take readers back to creation itself, drawing attention to the calling and vocation of humans made in the image of God, along with what that calling means in terms of divine presence and plan. In all cases (garden, tabernacle, and temple), the constructed space functions as both home and cathedral— the space exists as site of both cultivated social relationships and worship of God through various agricultural, artistic, or ritual practices.

The reality of the temple conveys an important overarching dialectic in both Jewish and Christian theology, the relationship between the particular and the universal. As the particular (and in this case, permanent) place of God's universal presence, the temple serves as a central image and reminder of the manner in which God goes about his redemptive work in the world— through active engagement with particular people and places. Two themes in studies of sacred space illustrate this dynamic: place as center, and place as microcosm, both of which are related to a broader assertion regarding the integral connection between temple and world. The temple, in other words, stands conceptually as both *center* of divine presence and meaning in the world, which then organizes the rest of space around it through its role as the

[27]Jeremy H. Kidwell, *The Theology of Craft and the Craft of Work: From Tabernacle to Eucharist* (London: Routledge, 2016), 25.

center of meaning, and as *microcosm* of divine and human action on earth (a concretely universal site).[28] Of course, the sacred place as center is not to suggest that God does not work at the margins, a point Belden Lane makes regarding the concept.[29] Rather, the concepts of place as center and microcosm must be kept together, the site of a sacred meeting between God and part of his creation functioning, *wherever it is*, as a center of meaning particularly while simultaneously existing as a microcosm of some more universal reality about God's engagement with the world.

While the Jerusalem temple is one very specific example of this, Mark Wynn argues that places more generally have microcosmic significance—that is, places can be understood to stand for something more universal; in other words, place "epitomizes or bodies forth in miniature some fundamental truth concerning the nature of things in general."[30] Wynn indicates, further, that the significance of human action in place has the same sense of outward movement. While he seeks to relate this concept to the notion of God as "genius loci" or "genius mundi," a move latent with questions regarding the nature of God's presence in place as active event, the most significant aspect of Wynn's study, and particularly relevant to my wider thesis, is his attention to the aesthetic nature of this type of placemaking. Giving priority to poetry in particular,

[28]Even minute aspects and features of the Jerusalem temple were seen to have microcosmic significance, as well. For instance, early Judaism understood the priests' clothing as a microcosm of the whole creation. The colors and symbols corresponded to parts of the heavenly and earthly realm. Beale, *Temple and the Church's Mission*, 48. For discussion on place as center, see W. D. Davies, *The Gospel and the Land: Early Christianity and Jewish Territorial Doctrine* (Berkeley: University of California Press, 1974), 6-7; Levenson, "Temple and the World," 283-84; Mircea Eliade, *The Sacred and the Profane: The Nature of Religion* (Orlando: Harcourt Brace, 1987), 44; Raphael Patai, *Man and Temple: In Ancient Jewish Myth and Ritual* (London: Thomas Nelson and Sons, 1947), 85; Harold W. Turner, *From Temple to Meeting House: The Phenomenology and Theology of Places of Worship* (The Hague: Mouton, 1979), 21. The religious temple as *axis mundi* is an idea carried throughout most ancient myths and traditions. For instance, see Yaron Z. Eliav, *God's Mountain: The Temple Mount in Time, Place and Memory* (Baltimore: Johns Hopkins University Press, 2005). This understanding of temple as microcosm not only is found in the Judeo-Christian context but extends to the general Near Eastern understanding of temples as microcosms of a heavenly temple or the universe, as, for example, Marduk's temple in the Enuma Elish. Beale, *Temple and the Church's Mission*, 51.

Edward Casey uses the term "concrete universal" to refer to places in this manner, while Hans Urs von Balthasar engages this language in his discussion of the person of Jesus. See Casey, *Getting Back into Place*, 332, and discussion of Balthsar's concepts in footnote below in this section.

[29]Lane, *Landscapes of the Sacred*, 48.

[30]Mark R. Wynn, *Faith and Place: An Essay in Embodied Religious Epistemology* (Oxford: Oxford University Press, 2009), 36. Belden Lane seems to be arguing something similar regarding the supralocative power of placed encounter with God, arguing that "all places acquire meaning through their participation in God as place." Lane, *Landscapes of the Sacred*, 244.

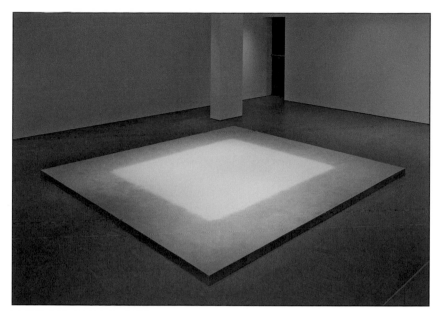

WOLFGANG **LAIB**
Pollen from Hazelnut, 2013

PLATE 1

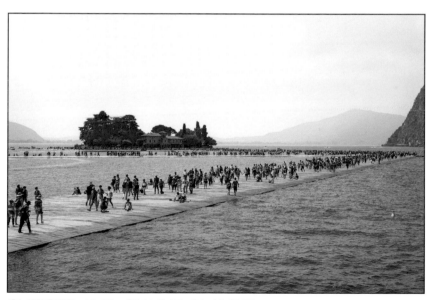

CHRISTO AND JEANNE-CLAUDE
The Floating Piers, Lake Iseo, Italy, 2014–2016

PLATE 2

PETER **VON TIESENHAUSEN**
The Watchers/Journey, 1997–2002

PLATE 3

MARIANNE **LETTIERI**
Rose Window, 2012 PLATE 4

SUE WILLIE
SELTZER
"Housetop," ca. 1955

PLATE 5

TRACEY **EMIN**
For You, Liverpool Cathedral, 2008

PLATE 6

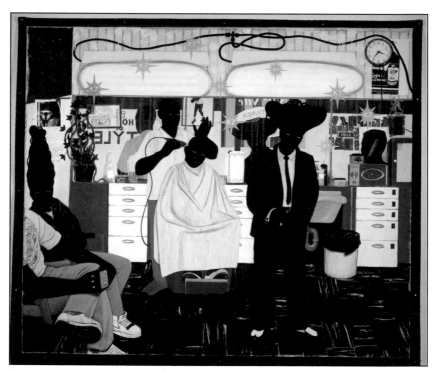

KERRY JAMES **MARSHALL**
De Style, 1993

PLATE 7

Wynn argues for the significance of "artistic" placemaking, suggesting that aesthetic engagement with place can give a sense of the wider presence of God as it pictures place in terms of its microcosmic significance.[31] Our localized placemaking and aesthetic engagement with places thus contribute to the spreading out of God's presence throughout the world, granting this wider significance precisely through the particularity of human action in place.

To apply Wynn's suggestion in a more direct way, our localized and creative placemaking actions in the contemporary church might actually communicate the universal presence of God in the project of creation and redemption precisely by grounding us in the particularity of placed existence together as a worshiping community. Our actions in response to divine beauty in the church might form a center or microcosm from which to understand the church's wider work in the world, work that takes the cruciform beauty of Christ as its central image and seeks to understand the ways in which Christ's presence on the cross is articulated in all our interactions with those people yet to experience the community of the faithful.[32] And if Wynn's suggestion

[31] See especially the last chapter of Wynn, *Faith and Place*.

[32] Hans Urs von Balthasar suggests a similar dynamic in his discussion of beauty and Christ. Throughout his *Theological Aesthetics*, Balthasar argues that rather than being mere appearance, beauty should be understood as *form*, particularly the form of Christ, the particular man made present in the world for the universal possibility of redemption. How we apprehend beauty in this world has analogy to the apprehension of divine glory made manifest in the active engagement of God with the world in the incarnate Son. As we experience particular realities of beauty in the material world, we may encounter the person of Christ and the experience of divine grace. Hans Urs von Balthasar, *Seeing the Form*, vol. 1, *The Glory of the Lord* (New York: Ignatius, 1983). See also Oliver Davies, "The Theological Aesthetics," in *The Cambridge Companion to Hans Urs von Balthasar*, ed. Edward T. Oakes, SJ, and David Moss (Cambridge: Cambridge University Press, 2004), 131-42.

Furthermore, Christ is understood as "concrete universal," a particular embodiment of divine presence and purpose, whom we experience in our particular encounters in places in the world. The implications for a theology of placemaking (including human artistry) are such that when we call on and respond to God in our places and encounters with beauty, we can be assured of the experience of his grace. This is not to say that God's presence is there to be apprehended in advance of special revelation, but rather that the event of Jesus's incarnation—the *place* of Jesus's incarnation as event—is formally experienced in microcosm through our imagining of and action within the places of this world. For Balthasar, all beauty and experience find their meaning in the form of Christ, who, in his kenotic love, images our manifest calling and mission in the world. As we are called to image Christ in the world, others may experience the presence of Christ in concretely universal sites of Christian placemaking. Furthermore, those bodily engagements with one another in places, which occur by virtue of our being human, are shared with Christ himself in his taking on of our place, and therefore might be understood to have redeemed status as well, at least in inaugurated form. Hans Urs von Balthasar, *Exploration in Theology 1: The Word Made Flesh* (San Francisco: Ignatius, 1989), 170; Larry Chapp, "Revelation," in Oakes and Moss, *Cambridge Companion to Hans Urs von Balthasar*, 20. Balthasar shares this idea with Barth as well. For discussion, see John Webster, "Balthasar and Karl Barth," in Oakes and Moss, *Cambridge Companion to Hans Urs von Balthasar*, 252.

may be taken here, that artistic engagement with place is the paradigmatic instance of this type of work, then the role of the artist in both church and world receives further clarification as a practice called for by God and supported in community.

New Testament images of temple, community, and place. All of these Old Testament images filter into our Christian understanding of what it means to be a people of place. God's acts in the Old Testament come into particular focus in the New, and John's opening to his Gospel—"The Word became flesh and lived among us" (Jn 1:14)—perhaps more than any other reference in the New Testament, suggests the immediate reality of God's own placemaking action, his making a place on earth.[33] That John uses this tabernacling language should clue us in to the ways in which Christ fulfilled and perfected those images of divine presence as set out in the past. Particularly the relationship between microcosmic temple work and Christ's kingdom work is accentuated in the continuation of the temple theme in the New Testament as applied to both Christ and his followers. We can see how the particularization of God's redemptive work in Israel and his eschatological plan for the renewal of creation culminates in these images.

Jesus is not simply the metaphorical fulfillment of temple hopes but physically embodies the temple himself.[34] This means that Jesus now serves as the actual place of redemption by providing a once-and-for-all action that reconciles creation back to God. By embodying the temple, Christ could show how his identity was the same as that of God. While God used to dwell in the Jerusalem temple, providing access for the redemption of Israel's people, the

[33]Importantly, John uses the term σκηνόω in John 1:14. The term here, unlike perhaps some of its other instances in Scripture and ancient literature where it refers to the "in-betweenness" or episodic quality of dwelling in a place, instead "is designed to show that this is the presence of the Eternal in time," not in some temporary way but in terms of "staying put." Wilhelm Michaelis, "σκηνόω," in Gerhard Friedrich, ed., *Theological Dictionary of the New Testament* (Grand Rapids: Eerdmans, 1971), 7:386. This term is also used in Revelation 7:15; 12:12; 13:6; and most importantly, Revelation 21:3. Throughout the rest of John's Gospel, though, he repeatedly uses the term μένω ("to remain in a place, to tarry, to dwell") to refer to the abiding of Christ with us. In these same instances, he refers to the "immediate possession of the divine presence as opposed to the merely eschatological promise of the divine presence with us. F. Hauck, "μένω," in Gerhard Kittel, ed., *Theological Dictionary of the New Testament* (Grand Rapids: Eerdmans, 1967), 4:576. μένω is used thirty-three times in John's Gospel and another twenty in his letters.

[34]Nicholas Perrin, *Jesus the Temple* (Grand Rapids: Baker Academic, 2010), 12. See also the repeated connections Jesus makes between himself and the temple, as in Mark 12:1-11 (which references Is 5 and Ps 118:22-23) or John 2:19.

divine presence is now immediately in Christ, and through him people now achieve their salvation. The permanent structures in the Old Testament thus provide a lens through which to understand Christ, and the Jerusalem temple remains a central image through which Jesus is identified.[35] The significance of the Jerusalem temple is therefore not eschewed in the incarnation of Jesus but rather fulfilled within it. Redemption understood geographically and temporally in the temple building is now folded into "the temporal and geographical particularity of a genuinely human person."[36] The creational telos of the world is tied up in this one center of God's action, now identified with Jesus himself as both Creator and Redeemer.

How Christ's work in both creation and redemption gets worked out in the church can be theologically formulated in terms of our own identity as temple and "temple-builders,"[37] an ecclesiastical designation reminiscent of the placemaking or building activities identified in relation to the wilderness tabernacle as well as God's own placemaking in the incarnation. The church thus "takes the place" of Christ in the sense that it now embodies this temple-building role on earth, which corresponds to Christ's own work in heaven.[38] In one sense Christ goes to "prepare a place" for us in heaven (Jn 14:3), but he also leaves the church with the command to prepare places that look forward to the new creation.[39] This relationship between earthly placemaking and heavenly fulfillment is suggested in the church's command to go "to the ends of the earth" (Acts 1:8)—to expand God's presence in all the world. While the calling is universal, this spreading of God's presence will take place in *all the*

[35]Thomas F. Torrance, *The Mediation of Christ* (Exeter, UK: Paternoster, 1983), 27-28. Christ's identification with the temple is now able to provide reconciliation for these dual notions of divine dwelling in place that plagued the Old Testament writers (39). Jesus the man, sharing in the divine identity of God, allowed for the earthly tabernacling presence of God in the creaturely while keeping his distance as Creator; the glory of the Creator is seen in the Word made flesh and creaturely (Jn 1:14).

[36]Richard Bauckham, *Bible and Mission: Christian Witness in a Postmodern World* (Grand Rapids: Baker Academic, 2003), 79. On the divine identity of Jesus, see Richard Bauckham, *Jesus and the God of Israel: God Crucified and Other Studies on the New Testament's Christology of Divine Identity* (Grand Rapids: Eerdmans, 2008.)

[37]Perrin, *Jesus the Temple*, chap. 2.

[38]Perrin, 69. See 119 on eschatological nature of temple building. Also see 1 Corinthians 15:45 on Christ's identification as Yahweh's high priest.

[39]The divine presence here is linked with the command and calling to *do* something. In fact, Samuel Terrien notes the connection between appearances of Christ postresurrection as "channel[s] of an exhortation, a command, or a commission." Christ's presence among us sees its fruit in our acts of making that tell of the kingdom of God on earth. Samuel L. Terrien, *The Elusive Presence: Toward a New Biblical Theology* (San Francisco: Harper & Row, 1978), 428.

particular places of the earth. In the incarnation of Jesus and the establishment of the church as the body of Christ, we see a decidedly theological emphasis on place and particularity, not just as reminders or symbols but also as significant sites of redemption and renewal. The particularity of the person and place of Christ should therefore be understood as the culmination of God's elective acts within Israel and as a central way of understanding the universal significance and meaning of Christ for the wider world.

Perrin makes this explicit link between temple practices and the new church community, suggesting, "*All* the practices which Jesus was to enjoin upon his followers are to be seen essentially as *temple* practices."[40] As the new place of God's presence on earth, the people of God will participate in building his temple again, though this time it will include all sorts of placemaking practices and will encompass all the earth in its eschatological realization. While the particular person of Christ leaves us, the community, established and strengthened by particular relationships, will take on this role with the help of the Holy Spirit. This is witnessed in our sacramental actions in the context of liturgical practice, but also in the manner in which Christian communities are built in places.[41] By participating in Christ as the concrete universal in these various places and practices, our own work may reveal that divine mission in concretely universal ways as well. These moments of revelation and presence must always be understood within the category of divine action, while occurring in "eventmental" places, characterized by both divine and creaturely placemaking.[42]

What then does this mean for our imagining of a contemporary liturgy of place for the church, one that prioritizes the incarnational particularity of the places we dwell in, while understanding the microcosmic dimensions of our actions in those places? How we "happen" in place is an acute matter of our "happening to" places (and of the Spirit's happening to people

[40]Perrin, *Jesus the Temple*, 79.

[41]See role of place and particularity in sacraments in William T. Cavanaugh, *Theopolitical Imagination: Discovering the Liturgy as a Political Act in an Age of Global Consumerism* (London: T&T Clark, 2002), 98-99, along with role of geographical particularity and place for the church in Craig G. Bartholomew, *Where Mortals Dwell: A Christian View of Place for Today* (Grand Rapids: Baker Academic, 2011), 293.

[42]Casey, *Getting Back into Place*, 340. On role of particular divine action in revelatory encounter, see Karl Barth, *Church Dogmatics*, vol. 2, part 1, *The Doctrine of God* (London: T&T Clark International, 1957), 264, 473. See also Trevor Hart, *Regarding Karl Barth: Toward a Reading of His Theology* (Eugene, OR: Wipf and Stock, 1999), 12, on Barth's thought on general and specific revelation.

in places), and so the manner in which presence is invited and liturgies practiced emerges as critical.[43] In what follows we will draw out a more theological and philosophical argument for placemaking in the modern church, highlighting the relevance of these themes for a consideration of the visual arts as a potential catalyst for spiritual formation that unites the community's experience of divine presence. The visual arts can also cultivate a hospitable sense of home and community belonging through aesthetically formed places and particularized practices of worship.

CULTIVATING A CONTEMPORARY LITURGY OF PLACE THROUGH THE ARTS

Broadly speaking, a contemporary liturgy of place for the church should be articulated in terms of the narrative of creation and redemption, that drama in which we see God's love poured out for the world and into which we are invited to participate. As we have seen in our study of biblical literature thus far, our conception of the Christian worship space must be linked to both divine presence and calling: How do we experience God's presence in fittingly made places and respond to God's calling to participate in the story of creation and redemption, enacted centrally in the liturgy of communal worship? We are called to be both temple and temple builder, dwelling in God's dwelling presence even as we communicate that presence out into the world, our own lives in community functioning as both center and microcosm of divine presence as witnessed in the work of the Holy Spirit, who enables our participation in the kingdom of God. What we do in church is a profound reflection of this wider creational calling, and James K. A. Smith argues in this regard that the church is where we practice for our other cultural liturgies in the world.[44]

I will highlight three general characteristics that are central to the practices of worship as told in both creation and temple/church narratives: first, delight in and discovery of beauty and God's presence in the world (at least partially called forth in conjunction with artists' creation of a beautiful context in which to respond to that presence); second, response to God's involvement

[43]On places that "happen," see Casey, *Getting Back into Place*, 330. Karl Barth uses the same language to describe the event of revelation ("It is *a definite happening within general happening*") in *Church Dogmatics*, vol. 2, part 1, 264.

[44]See James K. A. Smith, *Desiring the Kingdom: Worship, Worldview, and Cultural Formation* (Grand Rapids: Baker Academic, 2009), part 2.

within the world through communion with him and one another in liturgi-
cally practiced placemaking; and third, a kenotic outpouring of love in service
and mission as an imitation of God's own creational and incarnational in-
volvement with his creatures. Smith identifies the model of effective Christian
liturgy as gathering, listening, communing, and sending, and in some sense
my own modeling follows the last three of these—on gathering together
(Smith's first point), we listen for God's call, which is often apprehended
through aesthetic experience and discovered in his presence; we commune
with each other and God in active encounter and event; and we are sent out
in response to the outpouring of God's love and calling to serve his kingdom
in the world.[45] These, then, will be our primary focus as we explore aspects
of the Christian liturgy that might be profoundly influenced and re-formed
through an aesthetic reimagining of our place in the world and cultivated
through engagement with the visual arts in the church's liturgy. Art in the
church may therefore be a catalyst and center for spiritual formation as it crafts
places and creates contexts for the formation of desire, of community be-
longing, and of service in place.

*Forming desire: Discovering beauty and God's presence in place through
the arts.* Art in the church space can be formative for our desire for God, cul-
tivating an openness to God's presence through training in the language of
beauty. As the place where we learn "to see"—historically, theologically, so-
cially—the role of beauty in the worship space of the church cannot be under-
scored enough.[46] Beauty is that which arouses desire, and earthly experiences
of beauty can attune our hearts to desire God, who is Beauty himself. The
Greek philosophers understood this to be true, and St. Augustine situated the
concept theologically in terms of our delight in and response to God. By
sharing in divine beauty, beautiful objects (and places) participate in that
divine beauty and so become formative in our relationship to God.[47]

How our desire is formed and practiced, then, has roots in our experi-
ences of beauty in the places of the world. Smith suggests that the liturgies
we practice in the church and in our daily lives are reflective of our desires,

[45]For this dynamic see James K. A. Smith, *You Are What You Love: The Spiritual Power of Habit* (Grand Rapids: Brazos, 2016), 96-99.
[46]William A. Dyrness, *Poetic Theology: God and the Poetics of Everyday Life* (Grand Rapids: Eerdmans, 2011), 217.
[47]Robin Margaret Jensen, *The Substance of Things Seen: Art, Faith, and the Christian Community* (Grand Rapids: Eerdmans, 2004), 6-14.

and that in reimagining our practices in these liturgies, we can recalibrate our desires to God. Visual art and aesthetic experience can contribute to this practice or *habitus*, what Pierre Bourdieu described earlier in his rather dense phenomenology as "structured structures predisposed to function as structuring structures, that is, as principles which generate and organize practices and representations."[48] The arts, in some sense, may function as "structuring structures" for the church, providing images and practices for articulating its desire for God and grounding us in the place of worship. They underlay and shape a sense of belonging in the church community while motivating us to conceive and practice new modes of aesthetic place-making in both the church and world. By showing us how to see physically, they teach us how to see imaginatively. In other words, the arts can become "part of an embodied *paideia*, a kinaesthetic education," which teaches us how and what to love, educating us in the language of beauty and forming a habitus that structures not only our communal worship together but also our missional work in the world.[49]

Beauty can enrapture, but as Balthasar is focused to point out, not for its own sake but for the sake of mission.[50] In the act of seeing, he says, we experience a rapture: "a breaking out from ourselves in the power of being called and affected, in the power of the divine love which draws near to us and enables us to receive itself."[51] But before we can speak too much of the missional call of beauty, though, we must first allow ourselves to simply sit in its physical presence. Robin Jensen is careful to observe: "If we reflect upon something of beauty long enough, we should begin to be like it. If we study an image of horror or suffering, we will be moved to rage or pity. If these are only passing responses, we will not be truly changed. But if we are changed at all, if the images take root in us, we will act differently in the world."[52] One formative role of art and beauty in the worship space, then, is to provide images in which to root us in our sense of God's presence there

[48]Pierre Bourdieu, *Outline of a Theory of Practice* (Cambridge: Cambridge University Press, 1977), 72.

[49]James K. A. Smith, *Imagining the Kingdom: How Worship Works* (Grand Rapids: Baker Academic, 2013), 180-81.

[50]Edward T. Oakes, "The Apologetics of Beauty," in *The Beauty of God: Theology and the Arts*, ed. Mark Husbands, Daniel Treier, and Roger Lundin (Downers Grove, IL: IVP Academic, 2007), 213.

[51]Hans Urs von Balthasar, *The Glory of the Lord: A Theological Aesthetics*, vol. 7, *Theology: The New Covenant*, ed. Joseph Fessio, SJ, and John Riches (San Francisco: Ignatius, 1989), 389.

[52]Jensen, *Substance of Things Seen*, 21.

with us, along with our place in the wider Christian story. An image on a projector screen as passing illustration cannot compare to permanent or semipermanent objects that attune our thoughts and actions to the story of God's work in creation and redemption. One must be allowed to remain in the presence of beauty for a long time, and thus experience the presence of God in it.[53] The great medieval Gothic cathedrals encapsulated this philosophy, creating spaces of beauty and delight so that viewers could indwell both the physical space and the divine presence called forth there. It is therefore a *placed* beauty, experienced over and over again in the life of worship that effectuates our desires permanently.

For the church, the image of the cross ultimately stands as the central image of beauty—Beauty itself poured out for the sake of broken humanity, Beauty broken in order that beauty may be ransomed back from the grip of sin. This is God's love and desire for us, a model after which both our own artistry and actions in place can best embody Christ's calling on us.[54] In inviting this cruciform beauty into our spaces of worship, we invite our congregations to be hospitable to the presence of God in all its forms—from that shining glory on the mountaintop or the hovering presence between the angels, to the brokenness and suffering of our Lord on the cross. In habituating ourselves to see the variety of images that form our story, we enable our congregations to better respond to the diversity of encounters in their own lives. Engagement with artistic objects and practices (whether through enjoyment and contemplation or through our own making and participation in the aesthetic practices of the liturgy) teaches us an openness to God's presence and beauty, good art eliciting different responses and interpretations and calling forth varying outcomes and experiences.[55] This habitus, which accompanies contemplation of the arts, may filter into our life of worship, training our responses to the Spirit's work and fostering an openness to divine beauty in both the natural world and in people made in his image.

[53] Recall Yi-Fu Tuan's focus on time for sense of place as recounted in chapter 1.

[54] Bruce Benson, *Liturgy as a Way of Life: Embodying the Arts in Christian Worship* (Grand Rapids: Baker Academic, 2013), 119. He differentiates that which is beautiful from that which is "pretty." One example of this in visual form is the difference between the work of Thomas Kinkade and someone such as Bruce Herman (see his *Body Broken* series, 2004), where the former is sentimental and devoid of truth, and the latter embraces brokenness in its image of beauty.

[55] Jensen, *Substance of Things Seen*, 21.

Forming community: Response and communion through embodied artistry and action in place. Both George and Kidwell argue, as we saw earlier, that the practices of the Israelites in the tabernacle narratives were not only personal but also social practices and should be understood within the context and practice of their own embodied physicality and spirituality. The physicality of our being in the world and its implications for the social practices of worship are key for understanding the role that the visual arts might have to play in the worship space as well. As we saw in chapter one, knowledge of who we are is intensely a matter of knowing where we are, both in geographical and metaphorical terms. This knowledge, rather than being purely rational, is what Maurice Merleau-Ponty calls in the *Phenomenology of Perception* "antipredicative," prior to predication or reflection.[56] He writes, "There is a knowledge of place which is reducible to a sort of *co-existence* with that place, and which is not simply nothing, even though it *cannot be conveyed by a description*."[57] Even without reflection, we navigate and dwell in places, and this coexistence or navigation counts as a more basic form of knowledge than rational thought or belief.[58] It is our living, moving, and being in places that defines our sense of self and meaning. Therefore the body and its place are not things that may be separated from spiritual or mental experience but form the locus of meaning making itself.[59] Furthermore, we are not only made by the places to which we belong but are also skilled *makers* of our places, acting physically in and on them, transforming them even while they transform us.

That our being in places is antipredicative reveals the significance of visual cues offered up by physical environments. Even when we fail to reflect on them, the environments we dwell in influence our sense of self and action in the world. Robin Jensen argues, "What we see (or listen to, or read, or watch)

[56]Maurice Merleau-Ponty, *The Phenomenology of Perception* (London: Routledge & Kegan Paul, 1962). See also Smith, *Desiring the Kingdom*, 52-53.

[57]Merleau-Ponty, *Phenomenology of Perception*, 121, emphasis added.

[58]Edward Relph describes something similar when he speaks of an unselfconscious sense of place. Edward Relph, *Place and Placelessness* (London: Pion Limited, 1976), 64.

[59]Mark Johnson, *Body in the Mind: The Bodily Basis of Meaning, Imagination, and Reason* (Chicago: University of Chicago Press, 1987). Johnson and others are attempting to push past the dualistic framework of understanding the body as somehow inferior to the spirit or mind, suggesting instead that though we may speak of them as two separate realities, they cannot ultimately be disentangled. This, of course, conveys a more unified metaphysic of the mind-body problem than many Christians have traditionally asserted who perhaps follow a more Neo-Platonic influence in the keeping of clear distinctions between the sensual body and the rational mind.

even in passing is part of what we become, even when we aren't fully aware of it."[60] When practiced within the context of the worship liturgy, then, art plays a key role in calibrating our imagination not only to recognize the beauty of God's presence but also to imagine our belonging in and service outside the church. The physical and epistemological experience of place, in other words, includes the aesthetic practices and artistic objects that define their character. Martin Heidegger argues, furthermore, that our dwelling in the world is always "poetic," that is, that we are "aesthetically involved" in the world through various forms of building or placemaking.[61] We dwell in the world before our self-consciousness affirms those relationships, and this dwelling is expressed in the ways in which we move in and act on those spaces, both practically (how we use the space for different functions of life) and artistically (how we aesthetically arrange those spaces). While Heidegger refers to a more general *poiesis*, or aesthetic making of the world, his point can fruitfully speak to the role of the arts in our relationship to place.

The arts can, of course, be a powerful locus in which to incarnate meaning, understanding, and even spirituality through the realm of the physical. Paul Crowther suggests just such an embodied aesthetic, writing that artwork "reflects our mode of embodied inherence in the world," helping us to contemplate our own self-identity and allowing us enjoy what he calls "a free belonging to the world."[62] In other words, art engenders self-consciousness about our being-in-the-world and might help us reflect on how to dwell more fully in the places of our lives. While physical places make their mark on us in ways that we often fail to reflect on, we also actively make our places sites of self-expression, ideological concerns, and theological values, sites that become signs of longing or mission as a community. The visual arts in worship thus form theological loci whereby the congregation can explore its own identity and theology as individuals and as a corporate body of believers.

Rather than abstracting us from reality, art can call our attention to the physical reality around us, to its nature, its needs, and to its theological significance in the story of creation and redemption. For instance, the processional cross for St. Martin-in-the-Fields, designed by sculptor Brian Catling, reminds

[60]Jensen, *Substance of Things Seen*, 20.
[61]Martin Heidegger, *Poetry, Language, Thought* (New York: Harper & Row, 1971), 143.
[62]Paul Crowther, *Art and Embodiment: From Aesthetics to Self-Consciousness* (Oxford: Clarendon, 1993), 7.

participants in the worship service of the physicality of Christ's mission (figure 4.1). Christ came precisely in the flesh to redeem the flesh. The mangled wood tied together reminds viewers of broken human nature, but the gold speaks to the glory Christ brought on the flesh, a beauty in which we too will one day share more fully in the new creation and which we glimpse already in Christ's resurrection. This beauty, of course, is something that we as the

church might communicate to the world now. Just as Christ tabernacled in the place of this world (Jn 1:14), so we too might make our place in the world beginning in our worship of God in placed community. And as the arts help us imagine what this calling in place looks like—our calling to be Christ's hands and feet in a broken world—we might consider them central to the act of corporate worship. The arts can further *locate* us in places and communities rather than distracting us

Figure 4.1. Brian Catling, *Processional Cross,* St. Martin-in-the-Fields

from them. In taking seriously our place and embodiment in the world, the church might begin to see the visual arts, in particular, not as a threat to intellectual understanding of truth or spiritual experience in worship, but a complementary mode of envisioning our embodied participation in the places to which we have been called, as well as an affirmation of the unified relationship between our body and spirit.[63]

[63]See Margaret Miles, *Image as Insight: Visual Understanding in Western Christianity and Secular Culture* (Boston: Beacon, 1985). She argues here that the visual arts are *especially* capable of uniting these aspects of the whole person. They are a significant, if not *the* significant, way to engage and affirm the relationship between the material and the extramaterial.

 Frank Burch Brown notes similarly that "What is exceptional about art is the extent to which, at the same time that the sensory and the imaginal is focused on and even gloried in, the deeply felt and keenly

Art can to some degree serve as a context for both call and response in the liturgy, providing a place in which we can apply those learned theological dispositions and habits for service in the world.[64] The visual space of worship, including the visual arts within the more permanent architectural space, *makes a place* for the viewer to indwell and so form a sense of belonging to the space itself, to one another within it, and more universally to the communion of all saints. They become sites for encounter of God and of ourselves, helping us to know and to see through the embodied aesthetic experience.

This aesthetic experience must be learned socially if it is to have any lasting place in worship, the visual arts forming a *communal* theological language and sense of place for the church rather than an individual contemplative encounter. The event-nature of the aesthetic encounter is reflected in the communal liturgy of the people, art being experienced in communal seeing and establishing social memory and story. Ben Quash describes the medieval mindset of communal seeing, images being understood as primarily communal and engaging us in a shared vision that is at once corporeal, spiritual, and intellectual, but all apprehended precisely in the visual encounter.[65] While many modern liturgies have shifted their focus to what happens intellectually or internally, both the phenomenology and the theological anthropology explored above in relation to place suggest that such internal dispositions are formed first in response to communal engagement and shared habitus. How we cultivate vision as a community, then, will influence the ways in which hospitality is experienced and extended to both the insiders and outsiders of our congregations, our places being both structured and structuring, as Bourdieu claims, influenced and influencing for our communal life of worship.

pondered elements of the body and mind all can be drawn into the artwork's milieu." Brown proposes that art presents us with three layers, which correspond to the makeup of the human—the body, mind, and heart—and that these three layers are working on and in one another in the world of the work. We need not adopt Brown's specific model here in order to assert the more basic fact that art embodies these material-extramaterial relationships, which makes it a significant tool for understanding the nature of our being human, along with the manner in which our spiritual worship takes place in material bodies and places. Frank Burch Brown, *Religious Aesthetics: A Theological Study of Making and Meaning* (Princeton, NJ: Princeton University Press, 1989), 100.

[64]Benson uses this language of call and response to refer to the liturgy. In this case, I am arguing that art may serve as context for call and response. See my discussion of art as a context in chapter 1. Benson, *Liturgy as a Way of Life*, chap. 1 especially.

[65]Ben Quash, "Contemporary Art and the Church" (keynote address, Christians in the Visual Arts Conference, Grand Rapids, Calvin College, 2015).

Forming service in church and world: Art, place, and beauty for Christian mission. Communal seeing filters into communal action; what we do and experience in worship floods out from a center of both presence and meaning into the world and in response to divine calling. If our mission as a church is to respond to this call—to meet together in community for the sake of all communities—then it will be important to assess the role that beauty and creative making might have to play in such dynamic. Wynn suggests that aesthetic placemaking is a paradigmatic instance of the way in which place bodies forth microcosmic significance, and art can show us the ways in which these dynamics play out in tangible ways.

While Wynn is concerned more with presence, Balthasar's theological aesthetics are relevant here in terms of Christian mission as he demonstrates the ways in which the power of beauty and love can bring forth both ethical action (goodness) and true contemplation of the form of God (truth), the ancient transcendental formulation of beauty, goodness, and truth suggesting something of this microcosmic moving out, the particular moment of Beauty apprehended in form, which motivates both ethical action and knowledge of God. One might pursue the application of Balthasar's thesis in two ways. On the one hand, focusing on the sacramental nature of beauty reveals its ability to convey divine presence in the world and therefore to incite ethical action and true knowledge of God through the sacramental experience. On the other hand, conceiving beauty within the context of trinitarian love and calling helps us understand beauty (which is the catalyst, Balthasar notes, of love and desire) as the form through which we enter into the kenotic and missional Christian life itself.

Beauty, in this understanding, is a mode through which we work out our salvation in fear and trembling (Phil 2:12)—an allusion to the *terrible*, which, it is important to remember, occupies a central place in the life of Beauty crucified. While the one seeks to justify the experience of art and beauty in that which may lie beyond the object or experience (though of course, depending on one's sacramental theology, thoroughly tied up in the object or experience), the other grounds the movement of the missional Christian life as motivated by beauty itself, and in approaching a Christian sense of place (in eschatological as well as presently ethical terms) through that particular and microcosmic experience of the beautiful. Here it is the latter that seems

the most pertinent (though one cannot be neatly disentangled from the other in Balthasar's thought), as my focus is the way that art and beauty "enthuse us for work"—provoking delight and discovery of God's presence, upholding and cultivating Christian community, and encouraging us for mission.[66] In this regard beauty first *places* us rather than immediately moving us beyond. Given the church's uneasiness with being in place and some movements' aversion to embodied experience, the sense of place associated with beauty might be a more pressing way of approaching the formative power of the arts in this context rather than the sacramental approach.

Sense of place, I argued in chapter one, is primarily a matter of love. The ways in which our thoughts and action are effectuated on our environments all turn on affection.[67] The ways in which we love and understand the places to which we have been called are a claim grounded in a christological reading of place—Christ becomes the place through which redemption is achieved, coming to our place so that we can occupy his place, and prepares a place for us in heaven as we are called to prepare fitting places for his presence. Our sense of place, as both earthly and heavenly, both material and spiritual, thus embraces the hypostatic union of the divine and the human in Christ himself, that meeting of two places, the boundaries of which seem so impermeable as to break apart immediately. Yet, in the love of Christ these boundaries have been opened up in reconciliation and in hope of the final resurrection. Christ did this by pouring himself out into the particular and human. And this pouring out of beauty resulted in mission—in his becoming obedient unto death on the cross.[68]

Art, by analogy, can be transformative not simply for one's own internal dispositions but for the sake of mission by the church, a mission whose claim to transformation lies in communicating the ability of Christ to transform brokenness into beauty, sin and death into life. Jeremy Begbie suggests that this is precisely why we cannot forget about the resurrection when it comes

[66]Jensen, *Substance of Things Seen*, 9, quoting Pope John Paul II.
[67]Wendell Berry, *It All Turns on Affection: The Jefferson Lecture and Other Essays* (Berkeley: Counterpoint, 2012). See also the dynamic of John 3:16, that "God so *loved* the world ..."
[68]On beauty that results in mission, see Oakes, "Apologetics of Beauty," 213. On art as mission as understood through the theology of Karl Barth, see also David McNutt, "Finding Its Place: How Karl Barth's Ecclesiology Can Help the Church Embrace Contemporary Art," in *Contemporary Art and the Church*, ed. W. David O. Taylor and Taylor Worley (Downers Grove, IL: IVP Academic, 2017).

to a theological evaluation of the arts—art thus becomes a transformation of disorder in its engrossment in the world, in its placing of itself and its audience in the particularity of creaturely existence, a redemption that involves all members of creation, not just its human participants.[69] When visual art entangles us in the world—entangles us in the world of places—we may find a proper ground for our own self-reflection and perception, our forming of community, and our motivation to missional service.

The church as home: A model for artistic placemaking in the church. In the worship experience—which is both spiritual and physical, both religious and social—we learn dispositions for practicing hospitality in both church and world. Given the dynamics of both divine presence and human social needs, we can say that members of the church would benefit from a proper sense of place in order to better understand their relationship to God and to one another, reflecting not only on their place within the story of creation and redemption but also their location in the physical community. The church may benefit, then, from its own "topoanalysis," what Gaston Bachelard describes as "the systematic psychological study of the sites of our intimate lives."[70] Bachelard, as we noted in chapter three, explores our sense of self in relation to the spaces of one's childhood home, but we might beneficially think about the church as home, investigating how our sense of the self and Christian community can be understood and located within the context of our congregational worship.

Smith argues something similar when he says that our church liturgies can be formative for our desires, which are then put into practice in our wider cultural liturgies. We can make a place in the church that makes us into better people outside the church, crafting a space that then crafts us in the process of discipleship and experience of divine presence together. It can, Robin Jensen argues, as other places do, "reflect, enhance, contradict, or undermine both our ways of *thinking* (theology, values, identity) and our ways of *acting* (liturgies, mission, service)."[71] William Dyrness corroborates that we learn

[69]Jeremy Begbie, *Voicing Creation's Praise: Towards a Theology of the Arts* (London: Continuum, 1991), 173-75, 213-14. In this sense, Barth argues all art is eschatological. Roger Lundin, "The Beauty of Belief," in Husbands, Treier, and Lundin, *Beauty of God*, 207.

[70]Bachelard, *Poetics of Space*, 8.

[71]Jensen, *Substance of Things Seen*, 107. Jensen suggests that the church home is the place of initiation into the Christian tradition; it forms our memories and establishes our values; and it is also the place of our spiritual reintegration and sustenance throughout our lives.

to see first within the sanctuary; indeed, "the church is the primary location for articulating and constructing the commitments we make as Christians."[72] This is at once social, historical, and symbolical—the places of the church reflect the manner in which people relate to one another both in and outside the community, they reinforce the historical shape of the worshiping church over time (including its artistic and liturgical expressions), and they symbolize our theology, mission, and service to the world.[73]

While "the church" transcends the boundaries of this physical location, its meaning, missional expression, and sense of identity are bound up precisely within the church's expression in place, meeting together to worship, study, and take Communion as a *particular* community, with the purpose of being sent out weekly *into* the wider community, to serve its neighbors in all their physical places. Without this sense of belonging in particular, physical place— the concrete site of our body's dwelling and the Spirit's dwelling within us—it becomes difficult to ground our sense of belonging to, and participation in, the wider kingdom of God. Our sense of mission in all the particular places of the world results from our first belonging in *our* particular place, a community in which ties are not easily broken and service not easily forgotten.[74]

In the last chapter I argued that the home is the most intimate central site of our memory and our sense of self, forming the taproot for our hospitable

[72]Dyrness, *Poetic Theology*, 217.

[73]See Dyrness, 224-38.

[74]It is interesting to note, then, that very often the seeker-friendly evangelical church movement attempts to homogenize its worship space, to imaginatively locate its congregants outside any sense of particular place. That many evangelical churches look more like airport terminals than sacred spaces illustrates this shift. These seeker-friendly churches often convey a blank or generic-looking space that churchgoers may fill with their own personal imaginative thoughts or meaning. William Dyrness has commented on the positive nature of this "Protestant imagination" by noting that it opens up further possibilities and images from which congregants may draw rather than being provided with a set of ready-made and often too-familiar images. This is an important observation; the blank spaces of the church may indeed help the community imaginatively focus its thoughts on belonging to the community of heaven. But this "de-placialization" of the church can also have a profoundly negative impact. Given what we have said about the nature of humanity as embodied and placed, creatures whose aesthetic meaning making stems precisely from their placed experience, it seems that the implication of stripping the worship space of all particular character is to also strip the community of its character (or at least the ability to properly understand its character). It becomes too abstract. These abstractions may result not only in easy detachment of oneself from the worshiping community but also in abstraction of one's faith from placed works— works of hospitality, of feeding the local poor, of influencing local education, of preserving and protecting the vitality of local land and resources, of contributing to and responding to the particular beauty of the place of *this* church. See William A. Dyrness, *Senses of the Soul: Art and the Visual in Christian Worship* (Eugene, OR: Cascade Books, 2008).

imagination. It may be beneficial, then, to develop a phenomenology of the church as home, which includes a strong sense of belonging to a particular place with close attention to all its aesthetic symbols and cultural practices enacted there. Steven Bouma-Prediger and Brian Walsh outline eight characteristics of a "phenomenology of home," which include home as a place of permanence, dwelling, story, safe rest, hospitality, embodied inhabitation, orientation, and affiliation and belonging. All of these may be fruitfully applied to the church as home or to our theological understanding of what it means to have a home here on earth as people of God.[75]

If the church should be considered as home in this manner, then it will be important to cultivate attitudes and housekeeping practices that are reflective of this phenomenology.[76] As we explored in chapter three, Edward Casey suggests that our active relationship to places as home can be understood through the lens of homesteading or homecoming, the former suggesting a new arrival to *places unknown*, but with the intention of staying there, and the latter suggesting a return to *places already known*. In both of these practices there is an element of inhabiting what is already given in the place combined with a creative placemaking and construction of meaning. On the one hand, homesteading becomes a sort of homecoming, as we are invited into what is already given so that we may feel a sense of belonging to the place, though new; on the other hand, homecoming evolves into a kind of homesteading, a delighting in the familiar qualities of place but with new eyes and an attitude of discovery.[77] It is in this sense, perhaps, that T. S. Eliot writes in "Little Gidding" that "the end of all our exploring will be to arrive where we started and know the place for the first time."[78]

If our worship spaces and liturgies are informing for our wider practice in the world, as Smith suggests—if the church as home structures our identity and story as God's people—then we are responsible to make our churches sites of both creational homesteading and redemptive homecoming,

[75]Steven Bouma-Prediger and Brian J. Walsh, *Beyond Homelessness: Christian Faith in a Culture of Displacement* (Grand Rapids: Eerdmans, 2008), 56-66.

[76]Jen Pollock Michel, *Keeping Place: Reflections on the Meaning of Home* (Downers Grove, IL: InterVarsity Press, 2017), 137. "The church is *home*," she writes, "and part of our daily housekeeping is learning to belong to one another."

[77]Casey, *Getting Back into Place*, 291-95.

[78]T. S. Eliot, *Four Quartets* (Orlando: Harcourt, 1971).

dynamics for which the visual arts may be a key component. These sites will engender a sense of belonging in community while also preparing us for transformational action within the wider world; they will be sites that are both rooted and missional, both grounded in the created world and anticipating the new creation.

The *Wales Window*, designed by John Petts, which is installed in 16th Street Baptist Church in Birmingham, Alabama, is one beautiful example of how this dynamic might be envisioned through the visual arts (figure 4.2). This church has a complicated history, most notably being the site of a 1963 bombing

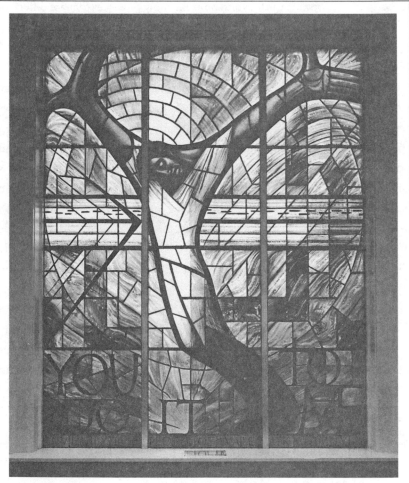

Figure 4.2. *Wales Window*, Sixteenth Street Baptist Church, Birmingham, Alabama

during the American civil rights movement in which four little girls were killed. When the church was later being restored, the country of Wales donated a large stained-glass window to the church, which hangs not only as a reminder of the community's history but also as a sign of hope for a resurrection life in the kingdom of God. The *Wales Window*, which hangs in the sanctuary space of the rebuilt church, depicts a black Christ with arms outstretched in front of a white cross, accompanied by the words "You do it to me," an evocation of Matthew 25:40. The window provides a reminder of the painful history to which the church and wider culture belongs but also offers a redemptive picture of community in Christ. The artwork brings together the people of both the local place and the wider world, inviting them into shared lament and shared hope simultaneously.

This vision of a crucified black Christ not only serves as a place of memory (this is what we *have done* in our places) but also calls viewers into missional action in our culture today (this is what we *can do* differently in our places today). The words still ring true as we consider the actions that we do to our neighbors outside the church building; what we do in our local places, we will have done to Christ himself. Our creative homesteading in the world thus has the potential to be a redemptive presence in our local communities, a message we see exemplified in the crucified Christ himself. But we must learn over and over again what this redemptive presence might look like in the contemporary world, and in this sense the window becomes a sight of homecoming for the church community every Sunday, a return to a place already known, but which gains new significance as they come together to worship locally as the body of Christ.

Some may argue that focusing on human presence in place in this way and privileging vision (rather than hearing the Word) focuses too much on living by sight rather than by faith, resulting in an overrealized eschatology in the present time. But to dismiss *vision* of divine redemption in our local communities altogether is equally problematic and may result in an eschatology that remains too *under*realized, abstractly longing for a distant home rather than taking up the cross and beginning the process of embodying and enacting God's kingdom now.[79] Christ, of course, has already triumphed over death and evil in the resurrection—redemption is *already* made possible and can be

[79]Dyrness, *Poetic Theology*, 248.

witnessed this side of the eschaton. If we are truly living in the "already but not yet" then we must learn to see glimpses of the new creation in the here and now—we must cultivate a vision for creation and redemption that allows us to be fully present in our belonging to the community of the Spirit (the already), all the while anticipating the future and final redemption of new creation made available through the person of Jesus (the not yet).

"Vision," David Morgan writes, "is one medium whereby people engage in embodiment, the process of imagining oneself as an individual as well as belonging to a corporate body."[80] The arts' use in corporate worship may ground our vision in the places of our local congregations, but it does not keep us there entirely. Rather, their use focuses our vision on what we are called to do in our places now for the sake of the kingdom ultimately. In this way the arts cultivate a sense of belonging in our particular communities while highlighting the sojourning nature of those communities, creating in us a love of our created places, but without necessitating our clinging to them in their current state.[81] The *Wales Window* at 16th Street Baptist Church calls the congregation through physical vision to long for more, even while they are invited to dwell in the present space of both church and culture.

The visual arts can thus craft spaces that allow us to feel "at home," even if that sense of belonging will never *fully* be felt this side of the new creation. As creatures who are invited to navigate this inaugurated (but not yet fully consummated) eschatological reality of God's kingdom, we must do our best to sink roots into the places to which we have been called, as these will be the sites of our participation in their redemptive transformation. While capable of teaching or illustrating the Word, the visual arts need not *only* serve those purposes, nor should they primarily. However else they may be functioning, the visual arts can also cultivate a congregation's sense of place, simply inviting them into belonging in the worshiping community, which functions as a central site of Christian placemaking in the world. By inviting the congregation to see anew, the visual arts can open up additional meaning in the

[80]David Morgan, *The Embodied Eye: Religious Visual Culture and the Social Life of Feeling* (Berkeley: University of California Press, 2012), xvii-xviii.

[81]In this sense, sometimes the arts may also make us uncomfortable, a feeling that, though more emotionally difficult, is an important aspect of our placemaking. We are invited to think of *why* we feel this way and reflect how this feeling motivates our actions in the world. Feeling at home is, therefore, not always settled, but it is always marked by participation in the places around us.

corporate worship experience by providing a physical space to be fully present together and with the Spirit, who dwells there. And as they invite us to fully belong in these physical communities in which we find ourselves, they enable both creative homesteading and redemptive homecoming, beginning in the worship spaces of the church.

The church's vision or picture of its work in the world is thus practiced every Sunday in the worship space, the visual elements of which reinforce our place in Christ's mission to the world—to be people who hospitably make a place for those who have yet to find a home in Christ's kingdom, or to open up a hospitable space for those already at home to see their work with new or added significance as if for the first time. As we go about our practice of worship, the visual arts may become key sites of meaning making and hospitable placemaking for the worshiping community, giving us particular and often localized pictures of what it might look like to participate in Christ's work of creation and redemption in the contemporary world.

CASE STUDIES FOR ARTISTIC PLACEMAKING IN THE CHURCH

In the case studies that follow we will see how the arts in the worship space can function in a variety of ways, concentrating theological themes for the church community through temporary installations that surprise and delight through beauty or through permanently installing artwork that forms a space of sustained communal sight and mission. In both cases we will see how the arts may form a liturgical context for the practice of placemaking as a church community, forming us into people who belong, and invite others to belong, in the kingdom of God as home.

Temporary art in the church. In her book *Spaces for Spirit: Adorning the Church*, Nancy Chinn explores the role that temporary art might have in the sanctuary space to enliven worship. Providing several examples of how art can contribute to the worship environment—through color, texture, space, movement, or transparency and opacity—she describes the arts as allowing us to take notice of God's presence in a place and time in a special way.[82] Visual display in church has been tasked with lots of things over time—it can make the biblical story come alive, it can instruct or teach, it can become a part of

[82]Nancy Chinn, *Spaces for the Spirit: Adorning the Church* (Chicago: Liturgy Training Publications, 1998), 32.

our ritual of devotion, or it can simply decorate. Chinn, though, calls attention to the attention-calling quality of the arts here, that rather than being explicit in their instruction or illustration, the arts are better suited to train us "to notice that someone has paid attention to this place. So we do, too."[83] The arts can ground us in an experience of particular place and train us to truly be present there, and as a result be able to experience the presence of God and community in wholly new or freshly remembered ways. By being grounded in the place of worship first, we might be better enabled to transcend the particularity of that experience and therefore understand the nature and purpose of worship as it is understood universally.

One way to think about this dynamic is the use of temporary art in conjunction with the church calendar. Tabernacle Baptist Church in Richmond, Virginia, for instance, often invites its own congregation into participatory art projects for the liturgical seasons—from flowing red fabric during Pentecost to Moravian stars during Epiphany, the sanctuary is transformed into someplace new, inviting the congregation's delight in the beauty of light and fabric and promoting discovery of new meaning in the church season and in the hospitable place of worship itself.[84] Many other churches have instituted art gallery spaces in their church buildings, providing a space for both congregation and outside community to reflect on aesthetic and spiritual values outside the worship environment of the sanctuary.[85] In just such an effort to help its members see the story of creation and redemption in the liturgical seasons, Elijah Smith of Queen's Park Govanhill Parish Church on the outskirts of Glasgow installed a temporary artwork for the season of Lent in 2015. Titled *Vesuvius*, the work consisted of a pile of soil with a cone on its top placed on the front dais of the church for Ash Wednesday. There it remained for Lent until Good Friday, when the cone was covered and a small wooden cross affixed to the top of the pile of soil, which, when viewed from the front, aligned with the permanent crucifix behind the altar, its own miniature Calvary. On Easter Sunday, the cone was opened, and soil sprung forth yellow daffodils, a

[83]Chinn, 22, emphasis added. The discussion regards the role of color here, but I think the point can be fruitfully applied more widely.

[84]Edie Gross, "A Congregation Deepens Worship with Collaborative Visual Displays," *Faith and Leadership* (2015), www.faithandleadership.com/congregation-deepens-worship-collaborative-visual-displays

[85]Two relevant examples of this are Warehouse 242 in Charlotte, North Carolina, and Grace Point Church in Bentonville, Arkansas.

flower that, those who have lived in Scotland will know, is one of the first flowers to bloom throughout the country at the end of winter—a symbol of the beginning of spring and more physical light as the seasons change. The light of the world could not ultimately be extinguished but experienced resurrection and brought forth beauty.

The installation helped the congregation move through the season of Lent and experience the end of the season's darkness with grace and beauty. The original installation to unknowing congregants may have looked bland or confusing, lacking color or complexity—a pile of soil intruding the space of worship. But as was the case for the apostles on Easter Sunday, the transformation came at a surprise, a moment of delight for the congregation that all things perhaps can truly be made new. This church's mission through the arts is made even more meaningful when we know that many of Govanhill's parishioners are not originally at home in Scotland but have moved from someplace else, forming one of the largest migrant communities and most ethnically diverse regions in the United Kingdom outside London. The church, then, becomes a home space, a place where people can dwell in the story of creation and redemption that unites them all in their own particular stories in that place. The artwork allows the congregation to see the beauty present in all of this and visualize the redemptive ways in which God causes our own particular communities to flower and grow as we participate daily in Christ's suffering.

Temporary art in the worship space can become an event in the life of the church, creating both challenge and growth during liturgical seasons, inviting the community to think in new ways, to see new things, to be surprised in moments of childlike imagination. Whether such art is the work of a well-known artist or a participatory project for the congregation, the people can unite together in the experience of looking and imagining, grounding them in a placed experience while offering new ways of imagining and practicing their wider work in the kingdom of God.

Permanent art in the church. While temporary art in the church is able to surprise and draw us out of our ordinary experience, permanent art may form a place of stability and identity for the church, forming a theological structure for the community that functions as a context for continual reflection and the development of a visually heightened sense of place. While there are many

ways to do this, the role of original artwork in the context of the church can be to open up a space for community belonging, which takes shape through artistic engagement that is particular to and designed especially for *that community*. Not only can original art convey certain attitudes and identities of a particular place or community, but it can also be a form of communion itself with the artist, along with the traditions of art on which the artist draws. The communion of saints that we enter into and participate with in the liturgy of the church is expanded through the realm of art, which forms both a context and aid for devotional practice.

Liverpool Cathedral in the United Kingdom, for instance, has commissioned several Royal Academicians to make permanent pieces for their church. Its website elaborates: "Today all these works are offered both to enhance the building, and to advance the mission and work of the cathedral. As well as helping people to look deeper, there is the declared purpose of Liverpool Cathedral *'to be a safe place to do risky things in Christ's service.'"*[86] The church opens up a space for artists to use their creativity as an expression of that risk of divine love, to see what happens when we think or see differently. Tracey Emin, for example, was commissioned to make *For You* (2008), an installation of pink neon lights in the artist's own handwriting that says "I felt you and I knew you loved me" over the west doors of the cathedral (plate 6). In an interview with the *Liverpool Echo*, the artist comments:

> The Church has always been a place, for me, for contemplation. I wanted to make something for Liverpool cathedral about love and the sharing of love. Love is a feeling which we internalise, a feeling very hard to explain. I thought it would be nice for people to sit in the cathedral and have a moment to contemplate the feelings of love. It is something which we just do not have enough time to think about and I hope this work creates this space in time.[87]

The artist charges the space with a surprise of color and a visual form not normally found in churches (neon lights being perhaps better reserved for bar signs). This surprise, paired with the written message, encourages the viewer into a space of self-reflection.

[86]"Art in the Cathedral," Liverpool Cathedral, accessed March 16, 2018, www.liverpoolcathedral.org.uk /home/about-us/art-in-the-cathedral.aspx, emphasis added.

[87]Catherine Jones, "Tracey Emin Loves New Liverpool Cathedral Artwork," *Liverpool Echo*, September 19, 2008, www.liverpoolecho.co.uk/news/liverpool-news/tracey-emin-loves-new-liverpool-3472750.

Other churches, such as St. Martin-in-the-Fields or Cologne Cathedral, use modern stained glass to bring a contemporary visual language and experience into the traditional worship space while inviting congregants into new ways of contemplating ancient theological ideas through the permanent fixtures of the church. What is interesting about all of these is the way in which old and new come together—Romanesque arches or Gothic vaulting sitting alongside modern, abstract stained glass or sculpture. In St. Martin-in-the-Fields, artists Shirazeh Houshiary and Pip Horne have designed *East Window* (2008) to speak more through what is absent than what is present, the opening up of an egg-shaped space in the center of the window inviting us to open up a space in our hearts and minds to experience what might be made present there. Both *East Window* and *For You* invite viewers to personally and spiritually reflect while also grounding the communal sense of place in the worship environment.

Cologne Cathedral in Germany commissioned Gerhard Richter, perhaps one of the most successful abstract artists alive today, to create *Cathedral Window* (2007) in the south transept, a large work composed of roughly 11,500 squares of glass in seventy-two colors.[88] The glass resembles computer pixels, each square self-sufficient and yet bound together to create an image, though the glass lacks representational subject matter. It sits as a testimony to Paul's description of the church, many parts of one body (1 Cor 12:12-27; Rom 12:4-5), which exist in unity and yet are differentiated. While the image is abstract, the message is not. We come together as a body of believers to open up a space of relation for one another. Though we cannot always see the whole picture, we are united in individual purpose. The window, like the other works cited here, communicates through a simple yet profound beauty, allowing us to sit in a beautifully structured place so as to let it absorb into our very soul as by osmosis, our being in the place habituating an attitude and practice of worship that is centered on beauty and the wonder of communion with each other and God in that hospitable space. Each of these pieces opens up a place of hospitality to situate one's own identity and spirituality in relation to another soul, to understand oneself within the hospitable space of the church, which, through aesthetic experience, stabilizes and

[88]For a description on the artist's own website, see "Cologne Cathedral Window," Gerhard Richter, accessed March 16, 2018, www.gerhard-richter.com/en/art/other/glass-and-mirrors-105/cologne-cathedral-window -14890/?p=1.

catalyzes our sense of what it means to be partakers of his true nature (2 Pet 1:4) and share in his divine love.

While the inclusion of internationally renowned artists' work in the church can be uplifting and spiritually moving, it is unlikely that most churches will be able to patronize works on such scale or from artists of such clout. For this reason it is important to understand the ways in which the church might utilize local artisans and craftspeople in church design and architecture, along with the ways that such inclusion affects the local economy, sense of place, and community belonging. Holy Innocents Episcopal Church in Atlanta has embraced this local aesthetic in the architecture and design of its worship space, empowering local artists and creative members of its congregation to participate in making the place not only beautiful but also reflective of their own sense of local community. Regarding the relationship between aesthetics, the liturgy, and spiritual formation of the congregation, senior associate rector Buddy Crawford suggests that at Holy Innocents, "aesthetics enhance liturgical practice."[89] There is an incredibly self-reflective cohesiveness of design throughout the space, witnessed especially in the articulation of the Holy Innocents cross design and integration of previous historical forms and church design. The visual components of the worship space neither distract from nor become erased within the liturgy but work centrally to locate the community in *that particular place* for liturgical practice, which microcosmically reflects the worship of the church universal. This cultivates not only spiritual formation through the visual experience but also a sense of community belonging or feeling of home in the space.

In an interview with the American Craft Council, Michael Sullivan, the rector at the time of renovation, articulated the need of the congregants in this way: "I say they're starving because they want community and connectivity, and I believe that environments such as this one provide community and connectivity in ways that other environments do not."[90] The people are able to find community identity through particular images and practices. When the worship space was under renovation and the church held worship in a cafeteria space associated with the adjoining Episcopal school, it used a borrowed

[89]Buddy Crawford, interview by Jennifer Craft, 2016.

[90]Monica Moses, "Faith in Craft," *American Craft Magazine*, volume 74, issue 2, 2014, https://craftcouncil
 .org/magazine/article/faith-craft.

image of the Theotokos from another church to enhance the temporary space. The congregation became so at home with the image that when they returned to their permanent space, several women in the congregation made a large-scale gold paper-cut version of the image of Mary, and it now hangs in the lobby area outside the sanctuary. What is unique about this is not only that the congregation felt at home with the image but that members of the community sought to contribute to that sense by making a piece of artwork as a memory space, not only to remind them of their history as a church but also to hold their sense of togetherness in the image of the Theotokos.[91]

Furthermore, by participating artistically in the life of the church, the people may also be motivated to participate in other ways, aesthetic engagement leading the way to social engagement or service in the church and community. This seems to be particularly reflected in the use of the Holy Innocent's design throughout the space—a teardrop design recalling tears shed for those affected by violence, or perhaps the blood of Christ to cover that violence once and for all. The church was established as a refuge for women and children, and the history of the church reveals a strong sense of continued service to those children and women in need in the community today.

Artistic practices such as these are put in service to the church and God. Artists must work within constraints, but like the artists in the tabernacle, they are able to exercise free creativity in response to divine gift. Artistry then becomes a calling like any other calling in the church—through artistry and craft practices we may participate in the story of creation and redemption in our being made in his image and called to do good work out of love. This can serve the role of art for mission, but it can also construct places that reflect God's presence in local communities, cultivating a sense of belonging and at-home-ness so that we may practice in our current places what it will look like to be placed finally and fully in God's presence in the new creation. In their calling us to pay attention to this place, the artist invites both christological and eschatological reflection on the nature of our belonging in the church community.

[91] The role of community buy-in is key in any public or community artwork, including the crafting of a worship space. Because the space holds memories and histories, those must be respected and acknowledged, even when something new is added or changed. The personality of the community must show through, otherwise the space will fail to function as spiritually formative. Rather than providing a hospitable space for spiritual reflection, the space might seem distant or foreign, uncomfortable even to those who know the place well.

CONCLUSIONS: VISUAL ART AND THE CHURCH

I have argued that the arts can ground us in the liturgy and worship space, making us feel more at home in the community of God's people and in his presence, not to keep us in this world entirely but rather acknowledging the necessary limitations of what our dwelling can look like this side of new creation. Karl Barth writes of the necessarily eschatological nature of the artist's work, "The artist's work is homeless in the deepest sense."[92] In light of the theological suggestions above, however, the artist's work might, paradoxically, be considered most at home, best equipped to navigate the boundaries between homesteading and homecoming, allowing us to dwell in the interstices between contentment and longing, affirmation and challenge, contemplation and action, memory of the past and imagination of the future. Art might function as a "thin place," like the space between the angels in the tabernacle, a permeable locus of meaning making and presence, which actually calls us to feel more at home, though this may best be described as a sense of "vertiginious at-home-ness."[93] The eschatological nature of our dwelling in the world reveals the episodic quality of both God's and our own presence in places, the Spirit working to fit "us to our environment," all the while expanding our sense of what that environment truly looks like, what meaning it holds in light of Christ's role as both its Creator and Redeemer.[94] Ben Quash thus suggests:

> We belong less fully to God if our anticipation of the future leads us to belong less fully to the world (though the deeper our belonging to God and world, the more critical we are likely to be in relation to that world). We become part of the transformation we hope for as our imaginations are resourced by the Spirit, and in our transformation we draw forward and transform the reality around us.[95]

In our thinking on the arts for the church, we must hold these tensions in mind, that the church's eschatological imagination presses us to be more fully present even while longing for that which is not yet. This longing, however, may invite us to dwell more fully, participating in the redemption of those places and people to which we minister.

[92]Karl Barth, *Ethics*, ed. Dietrich Braun, trans. Geoffrey Bromiley (New York: Seabury, 1981), 507.
[93]Quash, *Found Theology*, chap. 8.
[94]Quash, 262.
[95]Quash, 279.

By way of conclusion, we can make a few salient points regarding art in the church as regards the manner in which our theology of place and our theology of the arts come together in the space of worship. First, *art engages us further in the physicality of worship*, through which we know God and one another. The visual arts train us in our vision and orient us toward a physical way of being in the world, highlighting the goodness of God's creation and calling our attention to the physical places that form "the seat of relations" for our events of encounter.[96] They may help us see those places in new ways and train us further in a placed imagination. Second, *art helps us feel a sense of belonging to a particular community*. Images can help unite us in communal seeing or vision, providing a context from which our communal belonging springs forth. In uniting our physical vision, we become united in our conceptual vision, those images filtering into our ways of being in community and motivating us as a community to practice our faith in the world in correspondence with that vision.

Third, *art invites us to active, hospitable response, which enables mission in the world*. It does this through telling our stories alongside the stories of Scripture while also presenting us with new narratives, which expose us to new ways of thinking and imagining. Art finds a way of transcending our particularity without abrogating it, challenging us to regard different and particular narratives as related to the wider narrative of creation and redemption. Fourth and finally, *art conveys an eschatological sense of home*, a "vertiginous at-home-ness," as Quash asserts, as it participates in both creative homesteading and redemptive homecoming for the church, looking forward to the new creation as practiced from within our own places and communities. Art makes a place for us in the environment of worship so as to draw us out of ourselves and back into ourselves in liturgical refrain, enabling and anticipating that ever-steady and ever-new transforming presence of the Spirit in our lives together.

[96]Inge, *Christian Theology of Place*, 68.

Imagining God's Kingdom

The Arts and Society

The sounds of static and sirens could be heard in the distance when İ walked through the doors, at first functioning as white noise but culminating in an unsettling sense of distance and danger. Images of chaos and makeshift physical structures filled my periphery—shelters, safety gear, telltale signs of human suffering and longing, people's striving to find a place in the world and the visual cues that that place was so far yet to be found. I'm not describing a refugee camp or war zone but rather an art exhibit at the Museum of Modern Art in New York City. The exhibit, *Insecurities: Tracing Displacement and Shelter*, was a stirring glimpse at issues related to the migrant crisis and the human longing for place, issues that pervade societies today across the globe. Relics of humanitarian aid, including shelters and supply boxes, photos of displaced people and their physical pursuits of home, were placed alongside artistic engagements with questions of home, shelter, and locatedness. These included memory maps of family homes drawn by displaced peoples, overlaid with architectural drawings by Thamotharampillai Shanaathana, and most impressively Reena Saini Kallat's *Woven Chronicle*, a map of the world made with intertwined wires of varying colors shaped to look like barbed wire and fence, all connected to a system of speakers projecting the recorded sounds recounted above.

The exhibit spoke of the human desire for connection and identity, tradition and place, all of which can fail to find their proper telos due to physical lack of shelter and the power struggles of society. We are simultaneously connected and yet disconnected, separated by ideologies and politics,

religion and socioeconomic status. The exhibit leads viewers to ask, What is our response when thousands of people are removed from their homes because of war, political unrest, or a longing for a better life? Television and newspapers produce such images almost daily in some parts of the world, so what then is the purpose of art in such matters? What might an art exhibit at perhaps one of the most elitist art spaces in the world have to teach us not only about a sense of place but also about our Christian response to those seeking it?

For far too many people the question of place is not simply a matter of how one might decorate one's home but rather a longing for a home at all, for shelter and dwelling. Thus we will explore the ways in which we approach a sense of place on the level of society not so much through a discussion of personal making, as in the chapter on home, but in conversation with the justice of placemaking on a social scale and the ways in which social spaces, and artworks in relation to them, reflect the values and identity of the kingdom of God or move us further from it. Differing social and cultural conditions reveal markedly contrasting ways of approaching the question of dwelling. Whether one is poor or rich, urban or rural, from the so-called first world or the Majority World, whether one experiences political and religious security or whether that freedom is unknown—all of these influence the tacit and self-reflective ways in which dwelling is perceived and practiced. Regardless of origin, however, our identity as people placed in the world is one of shared fate and the manner in which love of place cultivated and community upheld is a shared theological task.

How we go about our work in the kingdom of God may vary between different societies, but it will always embody what is perhaps one of the best-known statements of Scripture, John 3:16—that God so *loved* the world that he gave his only begotten Son. In an imitative way, we go about our work in the world with love. Here in the story of Scripture, then, we will begin in order to map certain theological loci that may help trace in story form the structure of our placement and displacement in the world. Following this theological evaluation, this chapter will explore the ways in which art might contribute to the structuring of society according to these principles, providing a context for the kingdom of God to be liturgically awaited and enacted in the particular places of society today.

BIBLICAL THEMES FOR SOCIAL LIVING

In developing a theologically centered view of place in contemporary society, we must not forget the metanarrative at play in Scripture. Craig Bartholomew argues that a theology of place should be christocentric and trinitarian, developed on our understanding of and responsibility within the wider story of creation and redemption. "Redemption, examined through the prism of place," he writes, "has the structure of implacement-displacement-(re)implacement."[1] How we see both current practice and our final telos can be conceived along these lines. The story of creation and redemption will be the overarching lens to which we shall return, but another narrative sits within the larger and also forms its climax—the story of Jesus' incarnation in the world and his subsequent death and resurrection. To this story of how Jesus takes our place by becoming displaced we now turn in order to evaluate the liturgical framework in which our story can be conceptualized.

Incarnation, cross, resurrection. Stanley Spencer (1891–1959) set his 1958 crucifixion scene in his hometown of Cookham, England—High Street turned into Golgotha, the cross sitting on a pile of dirt turned over from workmen laying drainage in town (figure 5.1).[2] The painting is violent; the workmen are hammering nails into Christ's hands, doing so excitedly and with a look of delight, as we can see clearly because their faces are in full view rather than Jesus'. The caps that adorn the brewers' heads are those of the local Aldenham Brewers School, the same organization that had given Spencer the commission for painting. "I have given the men who are nailing Christ to the Cross—and making sure they do a good job of it—brewers' caps," Spencer writes to the boys at the school, "because it is your Governors, and you, who are still nailing Christ to the Cross."[3] Spencer's picture reveals a profound interest in the way in which the story of Scripture intersects with our own, with his placing of scenes from Christ's life, whether *Christ Carrying the Cross* (1920; set in the neighborhoods of Cookham), or the resurrection (set multiple times in the Cookham churchyard cemetery), or *The Crucifixion* (1958), in places of his own life.[4] In these images, Christ is literally in our places, our

[1]Craig G. Bartholomew, *Where Mortals Dwell: A Christian View of Place for Today* (Grand Rapids: Baker Academic, 2011), 31.

[2]Kenneth Pople, *Stanley Spencer: A Biography* (London: HarperCollins, 1991), 490.

[3]Pople, 492.

[4]See *The Resurrection, Cookham* (1921) and *The Resurrection of Soldiers* (1929).

hometowns, our struggles, our moments of life in society that are far removed from that hill of Golgotha—or are they?

These visual incorporations of narratives past and present reveal the way in which Christ as particular man makes a place *for* us in the kingdom of God by making a place on earth *with* us in the incarnation. T. F. Torrance explores the significance of our thinking about Christ's incarnation within the dwelling of

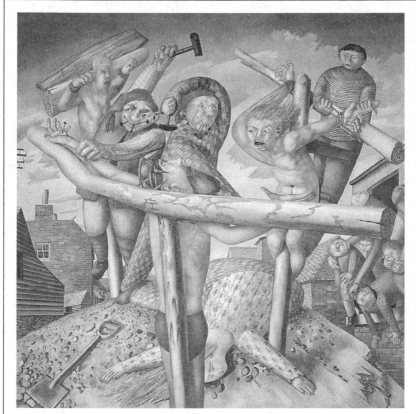

Figure 5.1. Stanley Spencer, *The Crucifixion*, 1956

space and time, and while he addresses the spatial concerns of historical philosophy in relationship to Christ's self-emptying in the space of his creation, it is to the language of *place* that he ultimately appeals in his concluding chapter. A long section of his writing deserves quotation here as it reveals the category of place as a key feature of the relational work of God in the incarnation. Torrance writes:

The relation established between God and man in Jesus Christ constitutes Him
as *the place* in all space and time where God meets with man in the actualities
of his human existence, and man meets God and knows Him in His own divine
Being. That is *the place* where the vertical and the horizontal dimensionalities
intersect, *the place* where human being is opened out to a transcendent ground
in God and where the infinite Being of God penetrates into our existence and
creates room for Himself within the horizontal dimensions of finite being in
space and time. It is penetration of the horizontal by the vertical that *gives man
his true place*, for it relates his place in space and time to its ultimate ontological
ground so that it is not submerged in the endless relativities of what is merely
horizontal. Without this vertical relation to God, *man has no authentic place on
earth*, no meaning and no purpose, but with this vertical relation to God *his
place is given meaning and purpose.*[5]

If humans aren't to lose "[their] place under the sun," Torrance argues, God
must dwell with humanity so that humanity can dwell with God.[6] The rela-
tionship reveals both the kenosis of God in Christ and the theosis made pos-
sible for humankind, the giving of "an authentic place on earth" while a place
in heaven is made by Christ, his being made less so that we might be made
more.[7] Torrance's exploration in spatial terms recalls the Gospel of John,
which tells of this vertical divine movement down. This is simultaneously ac-
complishing a *divine placement* in the world of humanity—a placing of himself
with us as God Emmanuel—and a *divine displacement* from his place of glory.

If the incarnation serves as the first stage of divine displacement, the cross
broadens that distance created between God and himself in the event of the cross.
In the cross we see indescribable beauty and ugliness, the epitome of divine love
shown in the pouring out of oneself for the other.[8] In *Mysterium Paschale*, Balthasar
explores the final end of kenosis—the descent into hell on Holy Saturday—as the

[5]Thomas F. Torrance, *Space, Time and Incarnation* (London: Oxford University Press, 1969), 75-76. All ex-
cept for the first set of italics are mine for emphasis of the theme.

[6]Torrance, 76.

[7]For the idea of theosis throughout Torrance's theology, see Myk Habets, *Theosis in the Theology of Thomas
Torrance* (London: Routledge, 2009).

[8]This "exteriorisation of God (in the Incarnation)" has its conditions in the trinitarian movement of love
and self-gift, an eternal exteriorization of the self for the other within the Godhead. In the trinitarian self-
gift, each person is eternally filled as the person is poured out, love made complete in their perichoretic
hospitable exchange. But the incarnation sees a new form of self-emptying as well. "For God," Balthasar
writes, "the Incarnation is no 'increase,' but only emptying." Hans Urs von Balthasar, *Mysterium Paschale*
(San Francisco: Ignatius, 1990), 25. This emptying was made complete in Christ's obedience unto death
on the cross but has its conditions in the life of the trinitarian exchange of love. Balthasar, 28.

"centre of all Christology" and the lens through which we truly understand Easter.[9] This is the most extreme event of displacement, the occupying of a place designated for that which is counter to God's presence. Here the divine presence has removed himself from his heavenly home and occupies the space of hell in a supremely kenotic event, the love of God made manifest *through his displacement*. Timothy Gorringe, accordingly, believes "all revelation is displacement," and here his words are seen to be most true in their christological completion; Christ the Revelation is displaced to such an extreme on Holy Saturday so that all may potentially find their place in and experience the revealed glory and mystery of God's presence—their reimplacement in the new creation to come.[10]

On Easter, Christ takes his place as the risen one, a prefigurement of the resurrection of the dead to come later as well as a picture of new creation, the earthly being made new and put into relationship once again with the divine presence. Here that transformation takes place precisely through the physical, not in spite of it (Jn 20:24-29), and so the displacement of God in Christ occurring at the cross event is resolved in the bodily form of the resurrected Lord and Christ's later bodily ascension to heaven, where he takes his place once again at the right hand of the Father until the second coming. The resurrection and ascension serve as a reimplacement in microcosm of the future eschatological event to come, the story of creation and redemption already completed in the resurrection event and yet waiting for the fulfillment of all things in teleological completion. The resurrection, then, as a re-placing of Christ in the communion of God, makes possible our own reimplacement as well.

What does this mean for our understanding of the church's possibility of a sense of place in society today? Can the church have a proper sense of place and belonging this side of heaven? The answer comes in both the affirmative and the negative. Gorringe writes:

> To be church, disciples of Jesus, is to have "nowhere to lay your head," to be continually journeying, to find no totality until God brings in the kingdom. Cross and resurrection are the *cor inquietum* which *continually displace us*, dissolving all claims to totality which rest on human self-sufficiency, and quite different notions of "victory" from those which seem self-evident to the world.[11]

[9]Balthasar, 7.
[10]T. J. Gorringe, *Discerning Spirit: A Theology of Revelation* (London: SCM Press, 1990), 121.
[11]Gorringe, 26. My emphasis on dis-placement.

If the cross and resurrection are the best examples of self-giving love, it is in fact *displacement* that the church is called to, an offering of ourselves over and over again for the sake of the world and in response to the Spirit's movement in our lives. The cross, as in the Gospel of Mark, is a pattern for our own action.[12] We must take up our cross and follow him, being made homeless for the sake of the kingdom.[13]

But this displacement is only understood through another lens: the role of community in the life of the church. Christ's actions with the disciples following his resurrection are always socially and communally oriented events, the most prominent being the sharing of meals.[14] While Christ must once again leave them, and we know that the disciples will scatter "to the ends of the earth" following Jesus' tenure on earth, they then go to all the places of the world, places that require love and attention, time and presence, places that require digging in to the particularity of human existence and community in order to understand the ways in which the event of the cross can take hold in those societies.

This is simultaneously an act of placement *and* displacement, the disposition required for transformation being to disentangle oneself from old ways of being and stepping into a new place (mentally, physically, emotionally, spiritually). Ultimately this is an entanglement of oneself in the place of the kingdom that is "already but not yet" and is decidedly different from the secular world.[15] The contemporary Christian experience of place in the world might be best understood, then, through the language of pilgrimage, or as we have seen already, the dynamic of creative homesteading and redemptive homecoming, which requires both cohabitancy and reimplacement on a regular basis.[16] This is what Bouma-Prediger and Walsh call a "journeying homemaking," which requires both a grounding of oneself in place along with the expansion of one's theological imagination on a

[12]Richard B. Hays, *The Moral Vision of the New Testament: A Contemporary Introduction to New Testament Ethics* (New York: HarperOne, 1996), 80.

[13]See Mark 8:34 and Gorringe, *Discerning Spirit*, 9.

[14]See Luke 24, where the only events recounted between Jesus and his disciples involve the sharing of hospitable meals.

[15]Smith highlights this marked difference between the kingdom of God, the "heavenly city," and secular culture throughout James K. A. Smith, *Awaiting the King: Reforming Public Theology* (Grand Rapids: Baker Academic, 2017).

[16]John Inge, *A Christian Theology of Place* (New York: Routledge, 2016), chap. 4; Edward Casey, *Getting Back into Place: Toward a Renewed Understanding of the Place-World* (Bloomington: Indiana University Press, 1993), 291.

continual basis to revise what we understand as place, community, action, and love extended to the other, states of being that require the liturgies of both displacement and reimplacement.[17]

The story of creation and redemption: Kingdom of God and sense of place. The cross sits at the climax of the story of creation and redemption, which ironically also serves as its lowest point. It is beauty in the midst of the terrible, the possibility for redeemed (re)implacement realized in the depths of the most extreme displacement. This paradox makes possible the rest of the story, creation and redemption completed in their unification in the new heaven and new earth, God making his home among mortals (Rev 21:3). The cross thus prepares us for an eschatological reading of place in the Christian life; as Christians, we are ones whose place is simultaneously not of this world, and yet we are called to fully entrench within the world for the sake of those who are spiritually homeless. The great paradox of the Christian life, then, is that we remain irrevocably located in community even while we are evermore dislocated through the process of discipleship and spiritual growth. We are made homeless so as to find our home in God and his kingdom.

But what might this mean for our relationship to society and our sense of place in that grand story of creation and redemption? The Gospels themselves present different pictures of our relatedness to and place in the world, the "world-affirming character" of Luke sitting alongside John's affirmation that we are a kingdom not of this world.[18] Richard Hays understands the continuity of these narratives by addressing three key images or lenses for interpreting their sometimes-disparate characterizations of the Christian life: community, cross, and new creation.[19] Applied as a framework for biblical interpretation and moral action, Hays suggests these images can "encapsulate the crucial elements of the narrative and serve to focus our attention on the common ground shared by various witnesses."[20] The paradoxes of Christian life in the world, then, are filtered through these images into order to present a cohesive picture of kingdom living and participation in the trinitarian work of creation and redemption. These images, applied to the category of place in Scripture,

[17]Steven Bouma-Prediger and Brian J. Walsh, *Beyond Homelessness: Christian Faith in a Culture of Displacement* (Grand Rapids: Eerdmans, 2008), 297.

[18]Hays, *Moral Vision*, 134, 147.

[19]Hays, chap. 10.

[20]Hays, 194.

suggest that while our being in the world may be one of displacement, our ultimate telos is one of implacement, best pictured in that glimpse of the new heavens and new earth in Revelation 21.

Our theology of place in the Christian life, then, will be one that is eschatologically oriented toward new creation, while working itself out in community and in the taking up of our cross as an expression of love in society now. "Jesus is coming," Craig Bartholomew urges, so "get on with placemaking!"[21] This is simultaneously future oriented and realized, worked out in the day-to-day actions of placemaking in society that look forward to and participate in the work of creation and redemption. "The Kingdom," however, "is something we await, not create," James K. A. Smith argues.[22] As Christians we respond to the cross by displacing ourselves in the revelation of God set against our cultures and societies, while simultaneously modeling reimplacement in our communities for the world, shaping the world's sense of place to include a vision of our future place in the new creation, society's hopes and dreams for "a better place" reshaped and recentered on the person and place of Christ.

The life of artists and the role of artworks in society might be understood similarly. Art can navigate those paths of placement and displacement, displacing us from ourselves while creating new contexts and places in which we might imagine more fully, reimplacing us through imaginative journeys or pilgrimages. Karl Barth suggests that all artists are homeless as they work against an eschatological framework, situated in the interstice between this world and the world that will be.[23] And yet, they somehow make us at home. As they work at these boundaries of existence in the already but not yet, artists both place and displace us, all the while creating spaces in society in which we might hope for new creation.

The Placemaking Movement and the Formative Power of the Arts

This cycle of displacement and reimplacement suggests the liturgical reality of placemaking in society. In *The Death and Life of Great American Cities*, Jane

[21]Craig G. Bartholomew, *Where Mortals Dwell: A Christian View of Place for Today* (Grand Rapids: Baker Academic, 2011), 246.

[22]Smith, *Awaiting the King*, 220.

[23]Karl Barth, *Ethics*, ed. Dietrich Braun, trans. Geoffrey W. Bromiley (New York: Seabury, 1981), 507.

Jacobs describes the movement of the city sidewalk as "an intricate ballet" that is constantly changing and reordering itself through the improvisations of social interaction and placemaking.[24] What Jacobs and other urban theorists, city planners, architects/artists, and social critics of the mid- to late twentieth-century came to argue is that placemaking is about more than just creating beautiful physical spaces, architecture, or natural environments; it is about the space between the buildings, the *people* actively and repeatedly making a place as a community in the "built environment."[25] The placemaking movement, as it came to be known, thus focuses on enacted space, or the ways in which a place is liturgically made through the back-and-forth efforts, both grassroots and institutional, of the people, which include, of course, architecture and other visual expressions.[26]

To use the term *liturgical* to describe this feature of the placemaking movement is intentional and underutilized in discussions of place until recently. Placemaking, I have argued throughout, can be formative for Christian belief and practice in the world. In other words, how we make our places then makes us, or forms us, into people whose imagination is in rooted in the story of creation and redemption, and who therefore act hospitably and responsibly within the world in accordance with our calling by God. The placemaking movement, as a wider secular liturgy, contains and contextualizes these theological echoes, seeking to form community participants into people *of* place by being people *active in* place.[27]

Placemaking, as understood in urban development and planning, has a broad set of aims. Susan Silberberg summarizes them as follows:

> At its most basic, the practice aims to improve the quality of a public place and the lives of its community in tandem. Put into practice, placemaking seeks to build or improve public space, spark public discourse, create beauty and delight, engender civic pride, connect neighborhoods, support community health and

[24]Jane Jacobs, *The Death and Life of Great American Cities* (New York: Random House, 1961), 50.
[25]Eric O. Jacobson explores this from a Christian perspective in *The Space Between: A Christian Engagement with the Built Environment* (Grand Rapids: Baker Academic, 2012).
[26]Jacobson, 17. Some organizations that champion these issues include the Project for Public Spaces, ArtPlaceAmerica, and the National Endowment for the Arts Creative Placemaking initiative.
[27]The language of secular liturgy, a series of habits and practices centered on achieving a certain end goals, is borrowed from James K. A. Smith's cultural liturgies series, cited throughout.

safety, grow social justice, catalyze economic development, promote environ-
mental sustainability, and of course, nurture an authentic "sense of place."[28]

As it draws together all these features of community in place, placemaking is an
interdisciplinary pursuit at its heart. Resisting specialization, the placemaking
movement is the work of the people and values the formative process over the
potential end product.[29] The goal is not just a pretty place. Justice, diversity, in-
clusion, health, democracy—all of these communicate the variable imaginative
frameworks for understanding place and placemaking in the arena of society,
which then get contextualized in a variety of practices, including the arts.

Placemaking can very often be a form of protest *against* public space and
practice that is exclusionary or oppressive, for instance, images of the city
that are conceptualized within a masculine framework and tend to produce
places that are prohibitive against women in the public realm.[30] These ex-
clusionary spaces very often relate to gender, race, socioeconomic status, or
religion, and what the liturgies of the placemaking movement seek to create
in response are places that embrace otherness, solidifying our sense of
identity in positive ways while reconciling relationships that have had bar-
riers set between them (sometimes metaphorical and sometimes physical).[31]

[28]Susan Silberberg et al., *Places in the Making: How Placemaking Builds Places and Communities* (Cambridge,
MA: Massachusetts Institute of Technology, Department of Urban Studies and Planning, 2013), 2. Though
a constructed sense of place is not always authentic (much of the time cities or new subdivisions are ar-
tificially constructed, marketed as having a charming sense of place, when in reality no community exists
there and the neighborhood is merely cosmetic), we cannot be mistaken that the arts *can* in fact enhance
the atmosphere of a town through beauty or socially aware activism through the arts, which thereby
contributes to the sense of community created and sustained there. Fleming notes the inauthenticity of
sense of place in order to highlight the need for an authentic vision of placemaking through the arts.
Ronald Lee Fleming, *The Art of Placemaking: Interpreting Community Through Public Art and Urban Design*
(London: Merrel, 2007), 14.

[29]Silberberg et al., *Places in the Making*, 3, on the importance of process. For discussion of liturgy as work
of the people, see H. A. Reinhold, *Liturgy and Art* (New York: Harper & Row, 1966), 22. For ancient
context, see also H. Strathmann, "Λατρεύω" and "Λατρεία," in *Theological Dictionary of the New Testament*,
ed. Gerhard Kittel (Grand Rapids: Eerdmans, 1968), 4:65.

[30]Malcolm Miles, *Art, Space, and the City: Public Art and Urban Futures* (London: Routledge, 1997), chap.
2. See also Doreen Massey, *Space, Place, and Gender* (Minneapolis: University of Minnesota Press, 1994).

[31]On the theological relevance of the language of exclusion and embrace, see Miroslov Volf, *Exclusion and
Embrace: A Theological Exploration of Identity, Otherness, and Reconciliation* (Nashville: Abingdon, 1996).
Social behavior and the dynamics of exclusion and embrace are often built on geographical boundaries,
and therefore the intersection of both a "sociological imagination" and a "geographical imagination" is
required for communities to understand their relationship to one another and the places they inhabit,
both of which require new and active *practice* within one's own life. See David Harvey, *Social Justice and
the City*, rev. ed. (Athens: University of Georgia Press, 2009), 23-49.

Placemaking thus depends on attitudes of openness, hospitality, and belonging, and creates places that sustain a variety of actions—work, play, rest—that are made to flourish on the cultivation of those attitudes. The practice of placemaking, in other words, works toward the common good for the diverse groups of people that make up the public realm, neither collapsing individual or local identity into a wider, more universal "cause" by a top-down program, nor advancing grassroots platforms that conflict with the common flourishing of all the citizens. In this regard the practice of placemaking must navigate that space between particular and universal frameworks, displacing and reimplacing its community participants into what, in all hope, becomes something like a hospitable embrace.

What role, then, does art serve in the dynamics of public placemaking? Jacobs argues that a city itself "cannot be a work of art" because a city is made up of much more than art.[32] While art and life are integrally tied, they are not identical. While this may be true in some regard, it is important to understand the central role that aesthetic features of environments play for the common good. When buildings lack good design or when public art fails in its communication of a community's identity or story, civic life suffers.[33] This is why Timothy Gorringe suggests in reply to Jacobs that because every city or village has an aesthetic, "every settlement can be considered a work of art, which does not preclude there being bad art."[34] As we have seen throughout, visual environments matter and can become contexts for self reflection, communal storytelling, or worship. This is no less true of the processes of placemaking in society. While placemaking is certainly much more than its visual arts or aesthetic environments, one would be hard-pressed to argue that these things do not matter at all. For instance, while Jacobs is reticent to call the city a work of art, she argues that "visual reinforcements" or "visual interruptions" are a key part of one's sense of place and can bring either chaos or order to the surrounding environment.[35] For Gorringe, the significance of these aesthetics *as a part of life* is precisely what he uses to ground the identity

[32]Jacobs, *Life and Death*, 272.

[33]James Howard Kunstler, *Home from Nowhere: Remaking Our Everyday World for the Twenty-First Century* (New York: Simon and Schuster, 1998), 38-40. See also T. J. Gorringe, *The Common Good and the Global Emergency: God and the Built Environment* (Cambridge: Cambridge University Press, 2011).

[34]T. J. Gorringe, *A Theology of the Built Environment: Justice, Empowerment, Redemption* (Cambridge: Cambridge University Press, 2002), 194.

[35]Jacobs, *Life and Death*, 376, 380.

of places as art, art and life being capable of neither separation nor seclusion in one set time.[36]

Whether one takes the broadened approach to art, like Gorringe, or agrees with Jacobs, one will find that beauty and the arts can contribute significantly to the transformation of a city or people by creating places and contexts in which spiritual formation is actualized and out of which ethical response is practiced in a community or world. Trevor Hart, while speaking of imaginative constructs more generally, suggests just such mutual interaction between actions in place and aesthetic imagining. Following on the thought of Mark Johnson and Charles Taylor, Hart argues that metaphor and imaginative construction are structured by the world in which we live, but also that "in a profound sense, imagination creates the human world that we indwell."[37] Or, as Charles Taylor himself notes, we are motivated by social imaginaries and "inescapable frameworks," but we also poetically shape and reshape the world through acts of discovery and creation, imagination and sensory engagement.[38]

One paradigmatic way that we do this, these writers suggest, is through the arts, which provide an instance of the relationship between imagination and practice, "a culmination," Johnson argues, "of the possibility of meaning in experience."[39] Applied on the scale of society, this suggests that art can create and cultivate meanings that are conducive to ethical action in the trinitarian work of creation, reconciliation, and redemption, or in opposition to that dynamic. Perhaps in this sense Margaret Miles writes, "Religion needs art to orient individuals and communities, not only conceptually but also affectively, to the reality that creates and nourishes, in solitude and in community, human life."[40] Art, I have suggested, does this in at least one sense through its role in

[36]Gorringe, *Theology of the Built Environment*, 194. He argues that settlements are embodied art and temporal art that extend over time and that can contribute to long-term spirituality as palimpsests of memories and placed behavior.

[37]Trevor Hart, "Creative Imagination and Moral Identity," *Studies in Christian Ethics* 16, no. 1 (2003): 7.

[38]Charles Taylor, *Modern Social Imaginaries* (Durham, NC: Duke University Press, 2004), part 1; Hart, "Creative Imagination and Moral Identity," 9. Interestingly, Taylor insists that public space is most formative when it comes to our indwelling of these frameworks—whether this is public family space or society more widely. This contrasts with a purely psychological or internal disposition that forms our outward practice. In Taylor's assessment, along with that of Johnson, one's engagement with physical and social structures motivates internal dispositions, and only in a recalibrating of the imagination can one then retrain the habits of social practice. See also Smith, *Imagining the Kingdom*.

[39]Mark Johnson, *The Meaning of the Body: Aesthetics of Human Understanding* (Chicago: University of Chicago Press, 2008), 212.

[40]Margaret Miles, *Image as Insight: Visual Understanding in Western Christianity and Secular Culture* (Boston: Beacon, 1985), 4.

placemaking for society. Art not only helps create and decorate places but also may potentially become a context through which religious questioning and experience may occur, providing "images" through which we can filter our interpretation of society on a wider scale and develop a placed imagination out of which ethical practices grow. In a social context, the arts serve to simultaneously place and displace, uprooting old ways of thinking and acting, while re-placing them with new contexts that communicate, hopefully, a vision of the kingdom and the beauty of the cross. The arts, therefore, become key components of the wider liturgies of placemaking and very often paradigmatic instances of such dynamics.

As to the arts' capacity for moral influence, Hart's focus remains on the arts' evocation of the "sympathetic imagination," the ways in which art imaginatively motivates us to interact with fellow human beings (and perhaps, we might say, nonhuman creatures too) who may have experienced the world in ways other than our own record has allowed. The "other's" identity as such may be disintegrated into a new identity as neighbor on the stimulation and extension of empathy of some sort.[41] The arts, in this case, provide worlds that we may indwell imaginatively, frameworks that are not our own but that we are invited into that cause us to reexperience the given state of the world in a way different from our own real-world experience.[42] They provide contexts in which the sympathetic imagination might be practiced. The imaginative and the real worlds intertwine as a result, with one's moral capacities heightened and stimulated to encounter "the other" in a different light. While one's moral positions may not be significantly altered, the manner in which moral discourse takes place can mature.[43]

In addition to the role that art plays on this personal level, on a more public scale the arts can create beautiful physical spaces, which then cultivate shared belonging, a communal sense of place, and neighborly hospitality. The role of beauty here is key: while beauty remains a feature distinct from art (not all

[41]Hart, "Creative Imagination and Moral Identity," 12. On loving one's neighbors as an act of the moral imagination, see also his "Migrants Between Nominatives: Ethical Imagination and a Hermeneutics of Lived Experience," *Theology in Scotland* 6, no. 2 (1999): 37, along with my discussion of this in chapter 2.

[42]See Wolterstorff and Begbie on imaginative world-making and metaphorical engagement with reality. Jeremy Begbie, *Voicing Creation's Praise: Towards a Theology of the Arts* (London: Continuum, 1991), 233-52; Nicholas Wolterstorff, *Art in Action: Towards a Christian Aesthetic* (Grand Rapids: Eerdmans, 1980), chap. 3.

[43]Hart, "Creative Imagination and Moral Identity," 13.

good art must be beautiful), a Christian theological engagement with society cannot neglect the important role that physical beauty might serve in that dynamic of creation, reconciliation, and redemption.[44] John de Gruchy argues that the visual arts can create places in society that are conducive to human flourishing and communal belonging, citing the strong role the arts have played in apartheid struggles in South Africa in the twentieth century. For de Gruchy, like Balthasar, beauty is a transcendental and finds its identity in relation to goodness and truth. Beauty can, he argues, be redemptive inasmuch as it communicates the form and love of Christ in a broken world and calls us into ethical action.[45] The missional role that art might have to play, then, is not so much in the realm of religious ideas or didactic themes but rather in the promotion and cultivation of beauty itself. Art therefore becomes a formative presence and practice in society (a cultural liturgy) through which communal sense of place is discovered and flourishes as a result of its participation in beauty. De Gruchy writes:

> So it is that the beautiful serves transformation by supplying images that contradict the inhuman, and thus provide alternative transforming images to those of oppression. We are, in a profound sense, redeemed by such beauty, for art does not simply mirror reality but challenges its destructive and alienating tendencies, making up what is lacking and anticipating future possibilities.[46]

The visual arts, de Gruchy argues, are involved in the transformation and enhancement of society and its spaces, and they do this through their social connections and embeddedness in culture *as* aesthetic form.[47]

[44]In *Theology of the Built Environment*, Timothy Gorringe has highlighted the need for a trinitarian theological ethic of creation, reconciliation, and redemption when it comes to the built environment and social engagement with places. The ways in which places and communities are built, the manner in which beauty is cultivated, and the moral considerations we make in regard to human shelter and hospitality can promote or disparage an authentic vision of the kingdom of God.

[45]John de Gruchy, *Christianity, Art and Transformation: Theological Aesthetics in the Struggle for Justice* (Cambridge: Cambridge University Press, 2001), 104-5.

[46]De Gruchy, 200.

[47]De Gruchy, 176. Here de Gruchy articulates the role of architecture as "creating space" and visual art as "enhancing" or "transforming" life in space.

Gorringe argues something similar in his theology of the built environment, while also highlighting the role of spirituality and connectedness for our perception of beauty. Along with the artistic nature of the city space, Gorringe highlights five "constituents of the image of the city" that make it beautiful: respect and responsible relation to the natural environment, the fact that it "exude[s] life," a respect for past and communal memory, the existence of common space and communal buildings (a claim that implicitly suggests a hospitality of some sort in those spaces), and finally, the place of the poor (how a society deals

We might highlight the differences at this point between Nicholas Wolterstorff's view of art as social practice and de Gruchy's here. Wolterstorff, in *Art Rethought*, rejects the grand modern narrative of the arts as it separates art from life and, in contrast, embeds art in what he calls social practice. The key category for his thinking about the arts is not one of aesthetics, but one of practice and purpose, their embeddedness within social culture, practices, and meanings of their makers and audiences.[48] Wolterstorff's goal is to suggest that there are a wide variety of art forms that engage us not primarily through aesthetic contemplation but rather through their structuring of social practice, for example, work songs, memorials, or public murals. The implications of his theory are significant, particularly in regard to the role that art might play in structuring social practices of placemaking. De Gruchy, on the other hand, employs the language of aesthetics and beauty to understand the transformative cultural functions of art in everyday life and society, with his central claim, though he does not state it as such, dependent on our underlying *aesthetic experience* of places in the world. De Gruchy suggests, therefore, that the power of art lies "precisely in its aesthetic form and creative character" rather than in its political context or didactic purpose.[49]

While Wolterstorff is much more keen to separate talk of aesthetic form from the purposes of the arts (a response to the culture of disinterested contemplation, which separates art from life), the distance between the two approaches is not unbridgeable. Both are interested in the central role the arts have to play in social life, and both understand this role to be significantly theological.[50] The two in some respects are addressing either side of the same

with the poor members of society in ways that are demeaning or uplifting). All of these, the author states, are related to the spirituality of the city; spirituality gives life and "provides aesthetic unity of the city." In other words, spiritual life becomes intertwined in aesthetic life and practice, the theological beliefs and practices of the community corresponding to the visual nature and creation of spaces. This is why Gorringe takes such care to develop a theology for the built environment, exacting a theological lens through which to make beautiful and spiritually uplifting places in society. If we can get our theology right, Gorringe essentially argues, then we are better enabled to create hospitable, redemptive places in society. Gorringe, *Theology of the Built Environment*, 216-20.

[48]He includes a discussion of the difference between his view and that of John Dewey, who also seeks to situate art within life but conceives art in relation primarily to aesthetic experience rather than social practice. Nicholas Wolterstorff, *Art Rethought: The Social Practices of Art* (New York: Oxford University Press, 2015), 104.

[49]De Gruchy, *Christianity, Art and Transformation*, 199.

[50]Wolterstorff explores the theological claims related to this dismissal of "the grand narrative of the arts" more closely in *Art in Action*, part 1.

issue—which in my reading relates strongly to a sense of place—de Gruchy laying claim to the underlying enhancement that art gives to places through beauty, and Wolterstorff focusing on the active creation of meaning and social practices in place that emerge from such works. Its seems to me that while art does not have to be *contemplated* in its aesthetic form, its role *as* aesthetic form implies its underlying connection to the social practices of place, *art in place* and *art as place* producing the formative aesthetic structures on which social practices lay claim and in response to which we make meaning for ourselves and for our communities.

One relevant example of these dynamics may be found in public mural painting. Murals both function as aesthetic contexts for a community and can become part of the shared social practice or liturgy for a community. For instance, murals can contribute to place identity by combating the homogenization of spaces and accompanying placelessness that results. A city can use murals to distinguish neighborhoods and shopping districts from every other placeless place in America. For example, Atlanta has recently pushed to integrate murals into its city landscape, as in the Beltline Project which constructs an environment in which other placemaking actions can occur, similar to New York City's High Line, or the Venice Beach area of Los Angeles is known for the decoration of its businesses and homes with mural art that defines the place as different from other places. Very often these accompany the renewal of areas that formerly served the community more centrally but that in urban sprawl or changes in industrial use were left for "better" development elsewhere, often in suburban areas. Murals and other actions of artistic placemaking can serve to energize these places and make people want to be there, inviting members of the community, along with tourists, into a hospitable and beautiful space that has become a place of unique identity with the help of the arts.[51]

These "visual interruptions," as Jacobs identifies them, can also be inquiries and critiques into the social dynamics or practices of a place—religiously, politically, socioeconomically, or racially. For instance, Belfast is widely known

[51]Of course, the arts are not magical in these areas. There must be community buy-in and support if these projects are to have the impact intended. For instance, if a community lacks engagement on other levels, what are left are empty painted spaces, the murals neither being transformative nor functioning as a catalyst for community engagement and placemaking. Other placemaking practices, then, are required *in addition to* the arts, which highlights that the work of placemaking is not a practice by an individual artist but should rather be identified as "the work of the people" in those aesthetically enhanced places.

for its abundance of political and memorial murals. Wolterstorff notes that "the murals change when the political climate changes; by taking note of changes in the murals one can get a sense of changes in the political climate."[52] In Belfast not only was the public art tied up in politics, but it also remained predominantly a matter of religion, the Protestant unionists and the Catholic nationalists arguing for two very different outcomes for Northern Ireland's political status in the late twentieth century. Some murals still remain as a history of "the Troubles" but also as memorial signs of ongoing social conflict or agreement. Similarly, in Los Angeles, the Social and Public Art Resource Center creates murals in relationship with participants in the community, motivated by social and ethnic divides in the city. *The Great Wall of Los Angeles*, the largest mural to be produced out of the organization, depicts immigration, war, and ethical concerns for treatment of Native Americans, providing a space in which to question one's own place in wider social and political history as well as inspiring ethical response.[53]

While often the work of a single artist, the best murals collaborate with communities to visualize a storied identity that is already present within a place rather than attempting to create new ones as an outsider. While some have contested the association of community with public art (*which community does it represent?*), it remains true that as a *corporately experienced piece of art*, it creates a connection between people in a society that is both aesthetically and socially practiced, and very much of the time it serves to unite those people in a communal sense of place.[54] Very often this corporate identity is associated with the history of a place as depicted in a series of murals, a merging of current and past times for the presentation of a new sense of identity grounded in inhabitation of the memory of the place that filters into the present. For instance, the murals of Steubenville, Ohio, serve to teach its residents town history while also unifying the community around its

[52]Wolterstorff, *Art Rethought*, 156.

[53]Ronald Lee Fleming, *The Art of Placemaking: Interpreting Community Through Public Art and Public Design* (London: Merrel, 2007), 104.

[54]For instance, one might say, "I frequent the coffee shop next to the bird mural," or "I live down the street from the peanut mural." The community knows itself in association with the images. For the idea of community as contested see Lesley Murray, "Placing Murals in Belfast: Community, Negotiation and Change," in *The Everyday Practice of Public Art: Art, Space and Social Inclusion*, ed. Cameron Cartiere and Martin Zebracki (New York: Routledge, 2016).

storied history.[55] Or Diego Rivera's murals in Detroit chronicle the motor industry of the city and communicate the history of the workforce and innovation that is so central to the identity of the town. While public murals cannot account for every individual's or subcommunity's sense of the place, they *can* in very real ways contribute not only to the identity of the place but also to the people there, providing images through which members may see themselves and know themselves in relation to a place and its history.

While we could say much more about specific projects and their economic, social, or political impact, this brief exercise serves to highlight the manner in which public mural art, and other forms of public art as well, serves to expand our social imagination while grounding us further in places through memory, attention, activism, emotional response, or delight. While many artworks seek to comment on political or social realities, others simply seek to make a space beautiful, enrapturing the hearts of adults and children alike in a whimsical landscape or series of shapes and colors adorning the side of a building. By giving communities a diversity of images through which to contemplate their identity and practice their social engagement, public artists are performing a task that is also theologically significant, moving audiences and community members through the liturgical process of placemaking for themselves and others.

By way of theological conclusion, the formative power of practices is significant to note. The ways in which the arts can structure and form places in society that are beautiful, transformative, and perhaps redemptive speak to the manner in which art might be a theological vocation when viewed and practiced under the right lens. The arts can cultivate a theological imagination that promotes new ways of engaging in our public places and imagining the kingdom of God in relation to society. We might model our understanding of the liturgies of placemaking in society after Christ's own obedient response at the cross. As a paradigmatic form of beauty, Christ's incarnation was a matter of *action* in the world. And this action has implications for other social practices as we participate in our own places in the world. As a matter of social practice and liturgy, we might consider artistry as inviting us into imitation of that redemptive cruciform beauty, simultaneously displacing us from the broken world and providing an avenue for reimplacment in the beauty of the

[55]Fleming, *Art of Placemaking*, 116.

kingdom of God. Wolterstorff's "practiced" way of thinking about the arts, in Christian dialogue, becomes profoundly a matter of inviting that cruciform beauty into our practices, with Christian art in society being a matter of reflecting that cruciform aesthetic to the world that gives hope to the broken by being a form of broken beauty, and that liturgically displaces and reimplaces us through acts of imaginative discipleship, responsible action, and ethical response in society.[56]

CASE STUDIES IN ART AND KINGDOM LIVING FOR SOCIETY

Like those conceptual images of Hays's evaluation of Scripture of above, we might begin to think about the role of actual artistic images in unifying different experiences of place and life in society as a Christian. How do the arts cultivate community belonging and transformation by providing spaces of connection and hospitality in a society of exclusions? How do the arts present the event of the cross in both literal and metaphorical ways so as to displace us in our current ways of being and reimplace us for renewed action and ethical imagining? How might the arts motivate us to work out our calling and responsibility as participants in society while looking forward to the eschaton with hope and imagination? The visual arts can provide alternate images from those most pervasively present in society.

While I have explored public art in the form of mural painting above, in the case studies that follow I have chosen two significant artists whose work communicates important social dispositions and practices for our sense of place in the world today. Ai Weiwei works against the story of global displacement, and much of his art can be classified as public. Kerry James Marshall's paintings, on the other hand, are displayed primarily in the gallery space but provide images of the black figure in a world where those images have been neglected or stereotyped, thus contributing to our imagining of race and social place in society. While many examples from public art, street art, or participatory art may seem the more likely choice for a discussion of placemaking in society, these artists are some of the most notable working in the world today and

[56]In this sense Gorringe says all art is a form of revelation, and all revelation is a form of displacement. As a motivation to hope, which in ultimate terms must be grounded in the event of the cross and its meaning for our new creation, art reimplaces us, moving us as the pilgrim on a journey between states of spiritual dislocation and relocation. Gorringe, *Discerning Spirit*, 121.

contribute significant voices to our understanding of the placemaking movement from the world of contemporary art. Not only can these works be a profound form of social action, but they might also recalibrate the Christian imagination to include new pictures of what it means to be citizens of the kingdom of God while participating in the places of public life.

Art as social activism and political engagement with displacement: Ai Weiwei. None of the featured artists here emulates the image of artist as social activist quite like Ai Weiwei (b. 1957). Whether he is photographing himself breaking Han Dynasty vases or literally flipping birds at government buildings, Weiwei calls attention to unjust political systems and social problems while questioning both social identity and history. Weiwei acts as a prophet; his art is forthtelling and calls society to a revision of its current actions. Much of what he makes, therefore, is explicitly political art, inviting audiences into an acknowledgment of the aesthetic *practices* of society through the aesthetic *form* of art. His art points not so much to the future as to a corrupt present, tasking its viewers to self-reflection through sometimes difficult and overpowering images of a displaced contemporary society.

Weiwei has been working in the contemporary art world since the late 1970s and is no stranger to controversy, particularly as his work is perceived by the Chinese government.[57] As a child he was uprooted when his family was sent to a labor camp after his father upset Chinese government officials, and he was not allowed to return home to Beijing until the age of twenty. This early history, combined with his later acquaintance with Dada and pop art in his decade spent living in New York City in the 1980s, set him on a path to engaging in the art world from a distinctly social perspective.[58] Art and social life, for Weiwei, cannot be so easily disentangled. Therefore much of his work on returning to China, and most recently in response to the global refugee crisis, demonstrates this merging of art and life. Weiwei's work shows a particular concern for place through displacement, his own uprooted childhood influencing not only his own sense of home in China but also his perceptions of what it means to be placed and displaced in the contemporary world.

[57]The documentary *Ai Weiwei: Never Sorry,* directed by Alison Klayman, produced by Alison Klayman and Adam Schlesinger, New York City: IFC Films, 2012, reveals some of this political tension on the part of the Chinese government. From 2012–2015 his passport was taken by Chinese officials, and it was only returned in July 2015, at which time he left China to document the Syrian refugee crisis.

[58]Karen Smith, Hans Ulrich Obrist, and Bernard Fibicher, *Ai Weiwei* (London: Phaidon, 2009), 63-79.

Since 2015, in particular, place and displacement in society has been a central focus of Weiwei's work, explored primarily in his engagement with the Syrian refugee crisis. Weiwei has scrupulously documented the status and living conditions of the millions of refugees and displaced people who have resulted from the Syrian civil war. An avid Instagram user, he takes thousands of photographs documenting people and their displaced living conditions while detailing shelters and humanitarian aid projects in refugee camps and travel areas. Laundry hung over a fence to dry, children playing with cats in muddy streets, tents and blankets crammed together in tight living arrangements—for Weiwei these details reveal the humanity of the refugees, their longing for shelter and community, and their hope for a stable future.

His most recent projects integrate many of these artifacts that have been left behind. For instance, some engage viewers on the level of escape and survival, taking lifeboats and jackets and compiling them for public display. For instance, in early 2016 the artist wrapped the columns of Berlin's Konzerthaus with fourteen thousand life vests he had collected from refugees escaping to the island of Lesbos, crossing the Mediterranean Sea in hopes of a more stable life. Hundreds have died and continue to do so daily on the sea crossing, realities documented by photographers, perhaps most famously in the image of the three-year-old Alan Kurdi, who washed up on a Turkish beach, a photograph Weiwei himself recreated later by laying on a patch of sand and pebbles on the island of Lesbos. The life vests that Weiwei collects, then, are memorials to both those who lived and those who drowned, calling us to pay attention to what is happening daily in some parts of the world.

In 2016 Vienna's Belvedere Palace also received an installation of life vests, titled *F. Lotus*, as they were connected together in the shape of lotus flowers and floated on the pond at the entrance to the palace. In a similar expression, in early 2017 the Palazzo Strozzi in Florence, while running a major retrospective exhibit of Weiwei's old and new work in its museum, installed inflatable boats from refugee crossings on the façade of the building. What is striking about all of these exhibits is the way in which the artist takes relics of chaos and invokes order on them, putting them into a place of distinction while maintaining their identity as objects of survival and sometimes death. The disparity between the extravagant buildings on which they are placed and the unstable existence of the people who have used them gives the audience

a sense of social vertigo—What is my place in all of this? Where are we all going? And where are these people now?

While many of these exhibits serve to point to an international emergency—the life jackets or inflatable boats screaming at us "Pay attention!"—Weiwei turned to a more redemptive approach to refugee relics in his late 2016 exhibit *Laundromat* at Jeffrey Deitch Gallery in New York City. As in the previous exhibits, he collected discarded objects from refugee camps and resituated them for a wider public, opening up the meaning of what it is to be displaced for people who are already in place and who very often are of high social standing or class to be attending the gallery show at all. It serves to disorient and dislocate the viewer in order to awaken a desire for reorienting and relocating others. In the *Laundromat* project the artist took discarded clothing and shoes left behind after refugees had moved on to other sites. Migrants, as one might imagine, after having traveled long distances in harsh conditions, cannot take the time to wash their clothes, and as a result often throw away dirty or seemingly unrepairable things. Weiwei decided to take these abandoned objects and wash them, turning his own studio into a Laundromat of sorts and then displaying these objects on racks and in neatly organized rows, as if at a secondhand store.[59]

When asked why he decided to wash the items, he remarked, "For me, it's human dignity to be clean. So basic."[60] Washing the items returns dignity to those who have worn them while at the same time calling our attention to the many bodies in need of dignified care. Each piece of clothing (2,046 pieces to be exact) was washed, dried, ironed, and hung in the artist's studio before being displayed in New York alongside walls of floor-to-ceiling Instagram photos of the artist and refugees at Greek camps. The floors were covered in newspaper articles and WhatsApp messages, all of which serve to create a disorienting effect as one tries to read headlines and media posts only to quickly get lost in a flood of information.[61] The overall effect is one of order

[59]For a similar reordering theme, see his *Straight*, 2008–2012, where he salvaged mangled rebar from the Sichuan earthquake remains and meticulously straightened each piece to its former identity.

[60]Robin Pogrebin, "Ai Weiwei Melds Art and Activism in Shows About Displacement," *New York Times*, October 20, 2016, www.nytimes.com/2016/10/21/arts/design/ai-weiwei-melds-art-and-activism-in -shows-about-displacement.html.

[61]Hrag Vartanian, "Ai Weiwei Explores the Scale of Crisis in Four Large Installations," *Hyperallergic*, November 4, 2016, https://hyperallergic.com/335914/ai-weiwei-explores-the-scale-of-crisis-in-four-massive-installations/.

in chaos—or chaos in order, one is never sure—and viewers transition between being called to notice the particularity of each object or image and being overwhelmed by the sheer number of things, photos, and stories. It is too much to handle, and one could easily slip away. But then a baby's sweater peeks its arm out of the rack, and the viewer is returned to empathy for the child who wore it. That one child—what is his or her fate in the world?

The *Laundromat* exhibit was held concurrently with three other shows from the artist in New York City—the others all sharing the title *Roots and Branches* at two locations of the Mary Boone Gallery and one at the Lisson Gallery. The *Roots and Branches* exhibits focused less on migrant and refugee relics, and more on ideological claims to place and displacement. What does it mean to be rooted in the world, and how should society respond to cultural displacement?

These shows included a variety of artistic media—found objects, sculpture, photography, LEGO portraits, furniture, and wallpaper designed by the artist. The most monumental of these, however, were his tree sculptures, large sections of roots and tree trunks cast in iron. The sculptures convey that theme of uprootedness, the objects suggesting a displacement of these objects from their original place in the world. But these aren't the trees themselves but iron casts of natural objects. Like his *Sunflower Seeds* from 2010, humanly engineered items parading as natural objects led viewers to question what the objects' appropriate place is after all. The Lisson Gallery press release for the show explains: "Not born of nature but made by human hands, the works, themselves contorted by the surrounding landscape, represent a society uprooted by industrialization and modernization, illustrating how progress can often come at the expense of cultural and societal well-being."[62] Here Weiwei discloses a more general social problem when it comes to place. Whereas the refugee crisis may seem like an acute political circumstance, the manner in which it has been handled has resulted in some sense from the underlying uprootedness of society on a global scale. The question of dwelling is one we all need to encounter, and the realities of shelter and clothing for displaced people may call attention to a wider sense of disconnect that many people have from places and communities all over the globe. The failure of societies

[62]Noreen Ahmad, "Ai Weiwei, 2016: Roots and Branches," Lisson Gallery press release, 2016.

to welcome the stranger may indeed result from their failure to understand their own place, an empathetic response to their foreign neighbor a failure of their own local imagination in place.[63]

While these exhibits raise awareness of the need for the development of one's own local imagination, they also question the rights to place each member of society holds, and the ways in which societies can create hospitable environments for communities to take root or make environments that encourage further displacement. The wallpaper at each *Roots and Branches* exhibit best communicates this theme, the medium itself revealing that background images and stories structure our lives, which we often fail to adequately pay attention to. From far away the wallpaper has a remarkable beauty, the colors and shapes suggesting opulence and the pride of place one must need to decorate with such care. On a closer look, though, the design consists of golden-hued surveillance cameras and Twitter birds connected with chains, a reflection not only of our consumption of information but also of the ways in which we are manipulated in such pursuits. The Lisson Gallery space had wallpaper modeled after a Greek frieze or ancient pottery design, a continuous narrative that was actually not Greek at all "but morphed to represent 21st century political realities of militarization, migration, and escape."[64] Refugee boats, military vehicles, barbed wire—all images of violence and displacement—reveal the grand narrative of modern society's military culture.

Weiwei's work reveals the need for a renewed language of place in the dialogue on social justice. What rights do people have to home? What do we do when we uproot communities and cultures, failing to find a place to replant them? Can all trees grow in all climates, or are we marking our futures for a continued feeling of *Sehnsucht*, a longing for a place yet to be known? What hope do people have to feel at home in this world? All of these questions are at once political and theological, answered in both present and eschatological terms.

Steven Bouma-Prediger and Brian Walsh suggest feeling at home is "a posture, a way of being in the world. It is a journeying homemaking characterized by all the things revealed by that phenomenology: permanence,

[63]See my discussion of failure of the imagination in chapter 2.
[64]Vartanian, "Ai Weiwei Explores the Scale of Crisis in Four Large Installations."

dwelling, memory, rest, hospitality, inhabitation, orientation, and belonging.[65] This biblical view of homemaking, as these authors call it, is not a dismissal of physical places, even though it is more than that. The possibility of emplacement or being at home *anywhere*, without any stated attachments to particular physical places, can be overly simplified and suggest something that Scripture may not have actually intended in regard to place. Both Old and New Testament depict God as calling people *away from* places to fulfill his divine purposes: Abraham was called to leave his home, and Luke 9:60 relays Jesus' instruction to "Let the dead bury their own dead." But while certainly God calls some people away from their homes, as Scripture attests, he also calls some to stay put, and this is equally as suggestive of God's calling to proclaim his coming kingdom on earth.[66] In fact it is only in these local engagements that we get a true sense of the universal significance of Christ's work in the church and world.[67]

In light of this it is important not to see the displacement of people in these refugee contexts as a positive calling away from their homes. Displacement, in Weiwei's work, is presented in a negative tone. These people were not called by God but forcibly removed through unjust political systems. We are called, however, by both God and artist to respond to that longing for home with shelter, with hospitality, and with openness. While we may all ultimately be sojourners until heaven and earth reach their final purpose, we are responsible for the places in which we and our brothers and sisters in Christ sojourn until our final homecoming. Bouma-Prediger and Walsh note that "The Christian gospel, in other words, is a grand story of redemptive homecoming that is *at the same time grateful homemaking.*"[68] As they suggest here and throughout their work, placemaking both is a central activity to the type of work that Christians are commanded to do on earth and will have redemptive and eschatological implications for the way we understand our membership in the

[65]Bouma-Prediger and Walsh, *Beyond Homelessness*, 297.

[66]Often when Christ performed miracles, he commanded people to return to their homes. See, for example, the story of the exorcism of Legion in Luke 8:22-39.

[67]William Cavanaugh communicates the relationship to local emplacement in his study of the Eucharist. As he states, "The Eucharist produces a catholicity which does not simply prescind from the local, but contains the universal *Catholica* within each local embodiment of the body of Christ." William T. Cavanaugh, *Theopolitical Imagination: Discovering the Liturgy as a Political Act in an Age of Global Consumerism* (London: T&T Clark, 2002), 98-99.

[68]Bouma-Prediger and Walsh, *Beyond Homelessness*, 320, emphasis added.

kingdom of God. At the foundation of this community building is love, what the authors cite as the necessary component of "any possibility of being at home in creation."[69] The making new of creation will thus begin in our own localized placemaking activities embodied in the love of God in community, though true redemption is always a divine act.

Weiwei reveals this responsive love in his own artistry and calls us as viewers and participants into that same disposition. The artist tends to highlight this need in a particularly confrontational way, a feature of both his artistry and own demeanor as an artist, which may sometimes seem offputting to wider audiences. Weiwei's work might sometimes easily verge on spectacle, and when an artist is such a well-known personality, it becomes difficult to disentangle the ways in which attention is called to the work, in this case the refugees, versus the artist's own actions. Despite the difficulties of disengaging the work from such a well-known artistic personality, Weiwei's work seems to transcend any narcissistic critiques that might be pointed toward the artist. Over and over again, he questions the values of modern society and the role that unjust governments play in displacing millions of people, both physically and spiritually. By giving the materials that he uses a new telos, as in his *Laundromat* exhibit, or in his reimagining of tree trunks or teapot spouts in *Roots and Branches*, viewers are left with both pain and a longing for a hopeful future. The question that remains is how people will continue to respond. For this reason, the sheer magnitude of Weiwei's output and work are an important feature of the way in which he has engaged this question. In 2016 alone he exhibited in multiple places around the globe, sometimes simultaneously, serving to call the world together on an issue that is at the forefront not only of political discussion on practical measures for housing and refugee status but also of philosophical and theological discussion of what it means to be human at all. What right do we have to place at all, and how do these places participate in the flourishing of the human spirit?

In the Christian life the language of rights is transferred over into the language of responsibilities, and Weiwei's work calls to mind the liturgies of displacement and reimplacement present in the Christian life, the responsibilities

[69]See Bouma-Prediger and Walsh, 278.

in both ethical and aesthetic terms that result from such calling to take up our cross and follow him. "To know God's revelation," Tim Gorringe writes, "is to be a displaced person, to be made homeless, driven beyond the self-contained set of assumptions which constitute a totality, be it our egoism, our world view, or the culture of the day."[70] While Gorringe focuses on our own displacement that results from the revelatory event, the dynamic is initiated in Christ himself becoming displaced for us in the supreme act of revelation of God's will and love on the cross, an event that breaks open the possibility of our reimplacement in the story of creation and redemption. Weiwei invites us in his own way to take up our cross and follow Christ in loving our migrant neighbors (a matter that for him is construed simply in terms of human dignity). This practice of loving our neighbors is an imaginative stepping out that involves acknowledging displacement and putting into hopeful practice the process of reimplacement in the world.

Art gives voice to race and place in society: Kerry James Marshall. If one skims the canon of Western art history, one is unlikely to find many black figures in the great history paintings of France or Italy, the genre scenes of the Dutch masters, or the landscapes of the English countryside. Western art, for the most part, is dominated by European artists painting white figures in society. Kerry James Marshall (b. 1955) seeks to change this narrative, however, focusing his entire oeuvre on the black figure while simultaneously questioning and expanding the traditions of art that have created and sustained the overarching social narratives of Western society. But it is not simply black subject matter that defines Marshall's work (though certainly this is the most obvious) but also the way in which he deals with the institution of art itself. Helen Molesworth contends, "Marshall's oeuvre is a sustained exegesis on the ways in which the museum, painting, and the discipline of art history have participated—both historically and presently—in the defining, and maintaining, of race as a naturalized category."[71] Marshall uses an engagement with the tradition of art through the practice of representational and large-scale narrative *painting* in order to draw out social implications for all races in society, making present what is absent and giving a place to those who until

[70]Gorringe, *Discerning Spirit*, 9.
[71]Helen Molesworth, "Thinking of a Mastr Plan: Kerry James Marshall and the Museum," in *Mastry*, ed. Helen Molesworth (New York: Skira Rizzoli, 2016), 32.

this point had only a relegated place not only in the world of art but also in many sections of society itself.[72]

We might indeed build further on Molesworth's observations to suggest that the manner in which Marshall deals with both of these—the museum and race—are reflections of concerns more generally about *place* in society, both physical and social, which surface as an interest in both *the place of art* (along with, correspondingly, the place of the museum in the creation of social narrative) and *the place of the black figure* in society today. Marshall's desire is to participate not just in a critique, though, but also in an *expansion* of commonly held practices and beliefs about those places.[73] He wants to add *more* to the traditions of art history, not take away from its narrative.

Marshall's paintings contain allusions to the great masters hidden in titles, color choices, subject matter, and composition. Viewers well acquainted with the major painters of art history will recognize nods to Eakins or Courbet, Holbein or Mondrian. In these allusions Marshall has a brilliant way of acknowledging kinship as well as distance, and his art-historical questioning often centers on beauty itself explored in relation to race. For instance, in *Beauty Examined* (1993) he points to the exceeding beauty of the black female figure as it is (mis)imagined under the scrutiny of white eyes. The composition recalls Rembrandt's *The Anatomy Lesson of Dr. Tulp* (1632) and Thomas Eakins's *The Gross Clinic* (1875), as it investigates the form of the naked body lying on a table, each part explicitly labeled as in a scientific diagram: "big tits," "big ass," "big thighs." Here Marshall calls attention to the fact that the world of Western high art often lacks diversity, telling only some of the stories of people in its society, and when it does it often fetishizes or stereotypes them. Marshall's job, he believes, is to put those untold stories in relation to those told, to give them a place at the table.

This giving of a place at the table involves devoting much attention to the physical and social *places* of the black community. Marshall questions the

[72]Molesworth, 31. In fact, Marshall himself says that he gave up on the idea of making "Art" because he wanted to make *paintings*.

[73]Marshall states in an interview with the *New York Times*: "You can talk about it as an exclusion, in which case there's a kind of indictment of history for failing to be responsible for something it should have been. I don't have that kind of mission. I don't have that indictment. My interest in being a part of it is being an expansion of it, not a critique of it." Wyatt Mason, "Kerry James Marshall Is Shifting the Color of Art History," *New York Times Magazine*, October 17, 2016, www.nytimes.com/2016/10/17/t-magazine/kerry -james-marshall-artist.html.

commonly held social imperative to know one's place by inviting a new form of knowledge, creating an epistemic and aesthetic investigation into the ways we have known the black figure and his relation to the predominant narrative of Western society. Eschewing the grander and more emotionally wrought stories of black society such as slavery and civil rights, we encounter, rather, the everyday places of the black community—the barber shop, the neighborhood, the domestic home. These spaces reveal the untold stories of the black community, their everyday striving and work, joy and hope.[74] The images convey the metaphorical density that places of the black community hold for its own members as well as for those outsiders to it. The museum, of course, is not without its own ideology, and in its absence of black figures, particularly black figures *in everyday life*, the standards of beauty, goodness, and truth in art continue to be determined by whiteness. This "omnipotent white presence," Molesworth contends, can only exist as a result of the "absence of blackness," and is therefore confronted throughout Marshall's project "through daily lived presence" of the black figure, a presence that viewers will find simultaneously alien yet hospitable, and always startlingly beautiful.

As I am a white viewer, Marshall's paintings are powerful and sometimes alienating, pressing me to understand the racial dynamics at play in society and probing my own heart to discover whether I am part of any injustice practiced. We are pressed to that same imperative—"know your place"—and this time it is biting. *They Know That I Know* (1992), for example, depicts a black Adam and Eve under a blanket, from which a family tree of life with white faces grows—Turks, Lapps, Proto-Indians, Nordics, modern Mediterraneans, all these are labeled and grow from the two figures. The title further presses us to self-reflection: we know that they know. What does it mean that the origins of humankind were dark-skinned, and what does it mean that we have dismissed that fact? Marshall's paintings thus provoke ethical questioning and invite viewers to reconsider how the stories of society have been told and retold through the arts. What have we missed through our failure to tell and visually represent certain stories? This is what Marshall seeks to find out.

Though the questions that Marshall poses are often difficult, his art always maintains an air of hospitality. This is accomplished with straightforward

[74]Kerry James Marshall and Terrie Sultan, "Notes on Career and Work," in *Kerry James Marshall* (New York: Harry N. Abrams, 2000), 119.

iconography and symbolism, "a predilection for literalism and a resistance to metaphor," along with a desire to understand the teaching advantages of images.[75] One of the main questions Marshall poses to the institution of art regards its elitism, and so his own pictures open up a hospitable space for any viewer to understand its meaning; we don't have to wade our way through the mire of hidden concepts, many of which require extensive education to understand at all. No, Marshall's paintings open an egalitarian space in the museum, the child from one of his project-house paintings gaining as much potential insight as the Ivy League graduate. The scale of these large unstretched canvases also welcomes us effortlessly into this world, with the boundaries that might exist between white and black communities torn down in the act of looking, breathing, paying attention. The large, brightly colored paintings serve to create contexts of openness and connection, even while they lead us to question traditionally held beliefs about the spaces or communities displayed.

Here, in his tendency to produce modern genre paintings like those of Vermeer, he provides a context for his viewers to revise their sense of place, to see that the places we have drawn for ourselves both physically and socially (and that the institution of art has drawn for us as well) are in fact more permeable than we imagine; to see "the other" is to see that they are not other at all. Two of Marshall's best-known paintings are *De Style* (1993) (plate 7) and its later counterpart *School of Beauty, School of Culture* (2012). Here we are opened to the world of the black barbershop and the beauty parlor, social institutions in black communities that exist as places of storytelling, remembering, and community life. One of his larger canvases (almost ten by ten feet), *De Style* functions to exegete both the project of modern painting and everyday black community life.

The colors he chooses, along with the title, are a nod to Piet Mondrian and the De Stijl movement, though the style is far from the movement's focus in pure abstraction. Marshall captures a scene from everyday life, though one imagined simultaneously as sacred space; five men populate the shop, and "the barber's hand is benedictively raised behind his client's head, his own head emanating rays of light in a nod to the Flemish masters, their images of

[75]Dieter Roelstraete, "Visible Man: Kerry James Marshall, Realist," in Molesworth, *Mastry*, 50. Marshall, "Notes on Life and Work," 120.

beatification."[76] *School of Beauty, School of Culture* depicts a similar place, though in feminine terms, "the two making a diptych of a kind: two intimate spaces in which men and women reimagine themselves, paintings that themselves reimagine what a black life looks like from the outside."[77] While much could be identified by way of imagery and symbolism in these pictures, I note for our purposes here only the role of the place. These places form a sort of third space for the black community, a place where community congregates, a place of their own where people can reimagine themselves in whatever ways they choose apart from white gaze. These places often function like the comfort of home, where members can let their hair down (quite literally in these cases) in a way that white society generally prevents. The figures are simultaneously relaxed and idealized, the men in *De Style* holding the same tilt of the head, the same measured look of confidence. The flatness of the image hints at Mondrian's modernist De Stijl, though the figures have a medieval quality as well, their spirituality and symbolism shown through in the flattening of the image, which is simultaneously able to retain its grounding in the physical world of place. *School of Beauty, School of Culture* is more populated and has more energy, a woman striking a pose in the foreground while a child plays near a distorted image of Disney's Sleeping Beauty on the ground. Traditional concepts of beauty are thus questioned here as well, as we gaze into the space of beauty making, women hard at work on creating both their culture and accompanying style in relation to cultural models of beauty.

While these are personalized places of comfort that are neither domestic nor fully public, Marshall also shows both fully public and fully private life as well, providing viewers with more intimate glimpses at the self in the home. These reflect the ways that beauty is imagined from inside the domestic space, as in *Untitled (Mirror Girl)* (2014), along with life in the public sphere, in project houses or public spaces such as the park, as in his *Garden Projects* series. Many of the project homes he presents were built to house mass movements of people heading north in the mid-twentieth century, as chronicled in Jacob Lawrence's *Migration Series*. Lawrence has recounted the migration of African Americans to the cities of the North who would become occupants of these housing projects. Robert Storr describes these migrants as

[76]Mason, "Kerry James Marshall Is Shifting the Color of Art History."
[77]Mason.

"permanently damaged by dislocation" and other factors such as poor edu-
cation, employment problems, inaccessibility to resources, and institutional
oppression, and Marshall's characters are "denizens of that world."[78] However,
rather than embracing the negative stereotype, Storr describes, "[Marshall's]
characters denote *joie de vivre* and confidence rather than suffering and grim
endurance."[79] In some sense, this might be attributed to their being put back
into a positive (and positively represented) *place,* one that conveys the true
expression of black identity and self apart from white commentary and op-
pression, and that celebrates the life of work, leisure, beauty, daily life, and
love in the black community.

The *Garden Projects* series recounts housing projects built in Chicago and
named after gardens: Altgeld Gardens, Wentworth Gardens, Stateway Gardens,
Rockwell Gardens.[80] Marshall describes these paintings as "[having] to do
with the futility of trying to beautify large, institutional housing complexes that
had been built by the federal government."[81] Their garden themes convey a
utopian dream, but one that quickly became "the opposite of what their names
suggested," as Marshall describes.[82] The series communicates the extent to
which the places we occupy also occupy us and form our life in the world. Tim
Gorringe, as we saw earlier, understands this dynamic as profoundly theo-
logical, with the buildings and the spaces that we occupy promoting or discour-
aging justice and beauty, encapsulating the good life and a kingdom telos or
moving us further from it.

Marshall's paintings, however, while they address the negative ways in
which these places came to function, also act as bastions of hope. The people
who occupy these places communicate possibility and longing, leisure and joy.
In *Better Homes, Better Gardens* (1994), a couple walks past the Wentworth
Gardens sign hand in hand, the "blots" signature to Marshall's style at this time
forming a sort of halo or dove-like spiritual presence above the couple's
heads.[83] Birds hover in the background, rays of light emanate onto the scene,

[78]Robert Storr, "Chromophilia and the Interaction of Color," in *Kerry James Marshall: Look, See* (London:
 David Zwirner Books, 2014), 13.

[79]Storr, 13.

[80]Kerry James Marshall, "Notes on Life and Work," 119.

[81]Marshall, 119.

[82]Marshall, 120.

[83]Roelstraete, "Visible Man: Kerry James Marshall, Realist," 51-53.

and flowers grow all over the lush green grass. These are scenes that convey the hope of the pastoral paintings of Europe, though the knowledge that this hope is not always met lingers in the background. Many of these are imbued with a spiritual presence, as in *Many Mansions* (1994), which draws on John 14:2 but changes the language to emphasize the overwhelmingly feminine presence of this housing project, where male populations drop in their teenage years and the women and children are left to occupy the space.[84] A banner reads, "IN MY MOTHER'S HOUSE THERE ARE MANY MANSIONS." The people's eschatological hope is actualized in the places they are forced to occupy, their imagination for a better place put into action by (female) members of their own community.

In *Past Times* (1997), the culmination of this series, we see a pastoral scene depicting visitors to the park, a family occupying the foreground with a picnic lunch, music streaming from the boom boxes of the Temptations's "Just My Imagination (Running Away with Me)," and the popular hip-hop lyric "With my hand on my money and my money on my mind." Debra Brehmer describes the scene as "show[ing] black people engaged in traditionally white pursuits such as motor-boating, water-skiing, and playing croquet and golf," recalling inauthentic cultural appropriation with the lyrics (as they have been adopted by white audiences) and the culture of Seurat's *A Sunday Afternoon on the Island of La Grande Jatte* (1884) peopled with black figures instead of white ones.[85] The scene makes us question the comfort of the black community in the public space, as the feeling differs markedly from the barbershop or project house complexes and especially from the domestic spaces that Marshall depicts.

Untitled (Mirror Girl) (2014), on the other hand, shows true life in way that contrasts with the subdued quality of the characters in *Past Times*. The girl holds her naked breasts in a playful way, smiling into the mirror in her bedroom, her attitude unaffected by the mess of clothes lying on the floor around her. She is joyous and free, signifying a freedom one finds only in one's most intimate sense of home and in the company of someone one loves. The image suggests the beauty of the female figure but also of black life in the home itself.

[84]Marshall, "Notes on Life and Work," 120.
[85]Debra Brehmer, "How Kerry James Marshall Rewrites Art History," *Hyperallergic*, July 12, 2016, https://hyperallergic.com/310477/how-kerry-james-marshall-rewrites-art-history/.

The viewer has been invited to witness a profoundly intimate moment in the place of the home, which destroys that boundary between the self and other, revealing simply the joy and beauty of life as human beings in the world.

It is clear that Marshall's work serves an important role in contemporary society. "Know your place"—as society tells white and black members different stories regarding our place in the world, Marshall presses the imperative to its theological end. If we open ourselves to know our place—both social and geographical—we will see that these images are both locating and dislocating, functioning so in different ways for black and white audiences. Black viewers will find a sense of home in Marshall's works, their stories, both positive and negative, given a microphone and stage. White viewers might begin to feel their own ignorance, finding themselves in places unknown, and yet if they allow it, welcomed into a new form of knowledge. Marshall's creative imagination thus questions and attempts to expand our moral identity. In his address of race and social place in society, Marshall further encourages viewers to consider the ways we practice social hospitality and openness. His paintings open up a hospitable place to truly *see* the black community, to let the people and places of Marshall's world enter into our imaginations and expand the narratives of culture and society as we have known them so far. It is in those moments of surprise, when we see the blackness of Marshall's subjects, a blackness that is "non-negotiable," that we can step into another's place and see the other's beauty and power, freedom and love.[86] These are the moments and places where we find our social imaginaries and practices being altered before our very eyes, being dislocated so as to be relocated again.

CONCLUSIONS: VISUAL ART AND SOCIETY

What can we conclude about the visual arts as they function on a social level, whether by reenvisaging social place and practice or residing in social contexts with the aim of transformation? First, *art gives structure to society* both physically and imaginatively. As such, art provides a framework for thinking and acting in society in hospitable ways as it relates to race, place, politics, or social practices that determine the nature of our corporate life together. Art functions as a paradigmatic liturgy of placemaking while contributing real images

[86]On blackness of the images, see Mason, "Kerry James Marshall Is Shifting the Color of Art History."

and contexts for the wider enacted space of people engaged in acts of place-making. As both aesthetic form and social practice, art invites new and transformed relationships in and to our environments.

Second, *art invites a cruciform involvement with the world*, displacing us so as to place us imaginatively into relationship with other people and places, calling us out of our ways of being and into new and transformed ways of imagining our lives together. Often this work may attempt to disrupt or challenge social frameworks that are exclusionary, while other times art may jolt us into moments of delight or surprise in response to a beautiful place or image. Transformed social action may occur in response to these aesthetic encounters, motivating us to actually take up our crosses, to take care of our places, to welcome the stranger, to give our cloaks in addition to our shirts (Mt 5:40).

Third, as it functions in a cruciform involvement with the world, *art cultivates and reimagines beauty in society,* which *motivates hope and eschatological imagining* of our future places. Beauty forms a structure for social imaginaries and indwelling in our places while also functioning as ethical indicator, revealing the ways in which spirituality is practiced by measuring visual cues. This beauty is not simply pretty but is a cruciform beauty that takes its features from Christ's kenotic involvement in the life of the world, his obedient action and response to become displaced for the sake of our placement in God's kingdom.

Fourth, *art therefore becomes a tool for kingdom living and working in the world.* As Christians, our lives exist as part of two worlds, and our amphibious involvement with those worlds remains a process of journeying, creatively homesteading and redemptively homecoming in the places to which we have been called for the sake of the kingdom. While we wait on the coming King, we are called to take up our crosses and proclaim the message of Christ to all the places of the world. In the societies we create, we can cultivate dispositions and practices, which reveal the heavenly city or not. While our final place is still being made, Christians are called to placemaking practices in society that serve the common good, revealing that God's kingdom is not like the kingdom of this world and so offers hospitable entry into a different way of life that transcends the boundaries society places on us. Thus it offers hope for future life shared together.

A Placed Theology of the Arts

Cultivating Theological Imagination and Sense of Place

In each of the four arenas above—the natural world, the home, the church, and society—we have seen how art, imagination, and sense of place are consistently entangled and intertwined. It has proven to be a difficult task to isolate these separate threads, as when one is tugged or pulled at, the others move with relational force. Like a particular section cannot be removed from a woven tapestry without affecting the other parts, so also our experience in the world as both physically placed and aesthetically experienced cannot be removed for inspection without taking the other pieces with it.

While we have explored the contours of a Christian theology of placemaking more generally, I have also argued that the arts make the particular contribution of cultivating a deeper sense of place and theological imagination in the Christian life, which enables us to deeply and thoughtfully engage with the issues of contemporary life that seek our attention today. As such, my concern largely rests on how Christians consider and consistently engage with the arts in their daily lives, including aesthetic contemplation, daily practical use, or social practice. Along these lines, I have suggested that art can be considered a *context* for development of theological imagination and sense of place, along with providing a *catalyst* for theological reflection and mission, the making of hospitable and welcoming places as part our calling as members of the kingdom of God. In this task, art functions paradigmatically as a microcosm of wider forms of placemaking, providing in both practice and symbol a lens for understanding other sorts of placemaking actions in the world today, particularly as they enable us to participate both imaginatively and actively in the project of creation and redemption.

I will begin this final chapter by recalling in brief sketch and summary the dialectics between art and place that have been established thus far, while also mapping certain theological points onto these relationships in order to understand their significance in the metanarrative of creation and redemption. Following this sketch, I will assess the relationship among art, imagination, and place in theological terms, establishing a trinitarian, eschatological framework for thinking about the arts and placemaking as an act of love that cultivates our loves. I will argue that the arts serve to dynamically structure our lives in place through training us in love and a theological imagination understood in terms of God's calling to us as placemakers. What results, hopefully, is the motivation to cultivate an aesthetically engaged sense of place, along with the development of a placed theology and practice of the arts, both of which serve to cultivate Christian life in the world and encourage responsible practice within all the spheres of our dwelling there.

THEOLOGICAL DIALECTICS OF ART AND PLACE

We have so far established a close relationship between art and place. Scholars regularly use spatial language or metaphors of place when describing the roles and characteristics of the arts, a fact that highlights place as the ground of our being and experience in the world. John Dixon emphasizes that art is a "constructive" activity—that "Everything man does manifests either *his place within the related order* or his attempts to lay hold of that reality and understand it."[1] In other words, the arts enable us to see and respond to the gift of creation and discover in it hints at the reality of God's presence and insights into our proper relationship to it. Art becomes a catalyst for epistemological reflection, knowledge acquired through simply placing us further in the world. Colin Gunton further suggests redemptive possibilities for the arts in terms of place, arguing that art takes the form of "a re-creation, of a re-ordering of *that which is out of place*."[2] While these theologians use the term *place* in more metaphorical ways, Craig Bartholomew states the relationship between art and place more directly, suggesting that the arts have "a unique capacity to

[1]John W. Dixon, *Nature and Grace in Art* (Chapel Hill: University of North Carolina Press, 1964), 96-97, emphasis added.
[2]Colin Gunton, "Creation and Re-Creation: An Exploration of Some Themes in Aesthetics and Theology," *Modern Theology* 2, no. 1 (1985): 1-19, emphasis added.

evoke the multidimensional nature of place."[3] Here these relationships are demonstrated in terms of art's active role in placemaking. Heidegger similarly argues, "Poetry is what really lets us dwell. . . . Poetic creation, which lets us dwell, *is a kind of building*."[4] Wallace Stegner further asserts that "no place is a place until it has a poet,"[5] and Michel de Certeau corroborates this view when he suggests, "Stories thus carry out a labor that constantly transforms places into spaces or spaces into places."[6] Human artistry can make a place for us, structuring those spatial structures, which then influence us. All of these thinkers reveal the ways in which our embeddedness and emplacement in the world are not only givens for the artist's work but very often become a key outcome of creative making. Artists, therefore, in their enactment of aesthetic calling in the world, build contexts for us in which we are imaginatively enabled to set about other kingdom work.

Below I address six key dialectic features of art and place in light of their theological significance and interpretation, facts that reveal the multidimensional nature of both art and place and their relationship to each other in theological terms: the physical/spiritual, the particular/universal, the individual/communal, the given/made, beauty/usefulness, and contemplation/action. I map out the points traced here in skeletal form alongside thematic features of the story of creation and redemption, each set of relationships corresponding to particular points from Christian theological doctrine. While this exercise does not seek to be comprehensive, it should serve to highlight the ways in which art, place, and a theological imagination are intertwined in practice, and that our participation in the kingdom of God—our work in both creation and redemption—can be beneficially considered as a placemaking activity born in aesthetic engagement with the world around us. Art, of course, does not account for the whole of our placed existence in the world, but as it seeks to structure both the places around us and our present imagining of ourselves, others, and God within those places, the exercise may potentially be fruitful for considering divine presence and revelation alongside human calling and work.

[3]Craig G. Bartholomew, *Where Mortals Dwell: A Christian View of Place for Today* (Grand Rapids: Baker Academic, 2011), 314.

[4]Martin Heidegger, *Poetry, Language, Thought* (New York: Harper & Row, 1971), 215.

[5]Wallace Stegner, *Where the Bluebird Sings to the Lemonade Springs: Living and Writing in the West* (New York: Penguin Books, 1993), 205.

[6]Michel de Certeau, *The Practice of Everyday Life* (Berkeley: University of California Press, 1984), 118.

1. *Physicality/spirituality.* Much of our discussion in previous chapters has centered on the physicality of art and a theological evaluation of ourselves as active embodied agents in place. The spirituality of a place or person cannot ultimately be disentangled from the body and place that roots their existence. Jeremy Begbie reminds readers that in Scripture we see a judgment of creation as good without further qualification; that is, we do not have to justify the physical nature of things by stating that they always take us beyond to some form of ultimate reality.[7] While the arts may indeed take us beyond the physical world, they should certainly not be reduced to anything less than their physical structure.[8] While we have addressed visual art, objects, and practices that clearly draw on the physical world, the observation easily applies to other arts as well. Even music, the most unearthly or transcendent of the arts, is physical in nature and can connect us further to the physical world.[9] Sounds ring in our eardrums, or our hands touch carved wood or molded bronze in order to create beautiful sound.

Worldmaking is one useful conceptual lens for understanding the relationship between physical places or art objects and their spiritual, or at least immaterial, dimensions. Linda Schneekloth and Robert Shibley use this language to argue that placemaking is not just a matter of physical construction, but rather "It is about 'world making' in a much broader sense because the practice literally has the power to make worlds—families, communities, offices, churches, and so on. Each act of placemaking embodies a vision of who we are and offers a hope of what we want to be as individuals and as groups who share a place in the world."[10] Places, we have seen, are never fully material or extramaterial. Places embody meaning and enacted relationships that cannot be reduced to their physical structure, but that also cannot be wholly disentangled from their physical structure.

[7]Jeremy S. Begbie, *Voicing Creation's Praise: Towards a Theology of the Arts* (London: Continuum, 1991), 205.

[8]Aidan Nichols, *The Art of God Incarnate: Theology and Image in Christian Tradition* (London: Darton, Longman and Todd, 1980), 90; Trevor Hart, "Through the Arts: Hearing, Seeing and Touching the Truth," in *Beholding the Glory: Incarnation Through the Arts*, ed. Jeremy Begbie (Grand Rapids: Baker Books, 2000), 23. Both of these thinkers prefer incarnational language when thinking about the arts and their embeddedness in the world rather than sacramental language.

[9]See Victor Zuckerkandl, *Sound and Symbol: Music and the External World* (London: Routledge & Kegan Paul, 1956).

[10]Linda H. Schneekloth and Robert G. Shibley, *Placemaking: The Art and Practice of Building Communities* (New York: John Wiley and Sons, 1995), 191.

The arts have often been conceptualized in similar ways. In his *Religious Aesthetics*, Frank Burch Brown grounds our mental and spiritual awareness in the body, stating that we understand things and process them mentally through our bodily engagement with the external world, applying this framework then to a reflection on the religious dimensions of artistic practice. "Precisely because we are embodied, thinking, passionate beings who want meaning and meaningfulness, truth and emotional satisfaction," he writes, "we cannot be engaged wholly except through forms that imaginatively encompass and orient us within something like a world."[11] For Brown, the act of worldmaking links physical and the spiritual dimensions and offers something uniquely suited to the development of a theological imagination as it regards the real world. Worldmaking communicates the tendency of art to embody and make a world through which we can understand variously different possibilities, *whether or not they actually take place in the real world*. When art "makes a world," though, it develops on both physical and mental awareness, so that even if a place or world is wholly imagined, it bears some resemblance or response to the current world with which an artist works. Projected worlds, in other words, are "always *anchored to* entities existing in the actual world."[12] The imaginative act is understood precisely in terms of its relationship to the real and calls out the multiplicity of meaning present within physical places or practices themselves, while also inviting us to active response within the real world in which we dwell. The arts, therefore, in their imaginative "worlding" tendencies, allow further reflection on the multidimensionality of places and their people, which become a central part of communal placemaking.

As we witnessed in chapter two, while a doctrine of creation sets the stage for understanding the value of physicality and our material embeddedness in

[11]Frank Burch Brown, *Religious Aesthetics: A Theological Study of Making and Meaning* (Princeton, NJ: Princeton University Press, 1989), 109. See also Amos N. Wilder, "Story and Story-World," *Interpretation: A Journal of Bible and Theology* 37, no. 1 (January 1983): 353-64, who argues that art (particularly story) makes a space through worldmaking.

For a fuller elaboration of this the role of the physical in processing mental information, see Mark Johnson, *Body in the Mind: The Bodily Basis of Meaning, Imagination, and Reason* (Chicago: University of Chicago Press, 1987); *The Meaning of the Body: Aesthetics of Human Understanding* (Chicago: University of Chicago Press, 2008). A similar view is expressed in more popular form by Matthew B. Crawford, who advocates the role of manual labor in understanding and experiencing the world in *Shop Class as Soul Craft: An Inquiry into the Value of Work* (New York: Penguin, 2009).

[12]Nicholas Wolterstorff, *Works and Worlds of Art* (Oxford: Clarendon, 1980), 356.

the world, it is Christ himself, the Creator made materially present in the incarnation, along with that presence's reenactment in our eucharistic sign making as the church, that helps us as Christians better understand the significance of the material practices of placemaking through the arts. Christ made a place for himself in the incarnation, taking flesh and dwelling in the world. This story of Jesus on earth—which both orients itself backward to creation (Jn 1:1 recalling creation itself) and looks forward to the salvation of the world in his presence and sacrifice (Jn 3:17), and ultimately toward the new creation—enables us to truly understand those two realities of physical and spiritual existence. As we lift up signs in our eucharistic participation or in the wider sign-making practices of the arts, we acknowledge the spiritual dimension of physical materials—the ways in which we can experience God's presence in bread and wine, or even paint and wax—as active encounters with God through the material world. This dialectic is witnessed in both the arts themselves and the places that they rely on and structure. A place is never simply a piece of ground but the meaning and action within it. A painting is never simply a colored canvas but an interpretation of the world around us, spiritually or emotionally charged with a reality beyond that which is physically present. Both exteriorize the dimensions of what it means to be creatures who are both physical and spiritual, both breath and dust made into living souls. We do not move past the physical as if we were playing some existential game of leapfrog, but rather we experience the deepest dimensions of God's relationship to his creation within the very physical foundations of the world he has laid.

2. Particularity/universality. The dialectic of the physical and the spiritual is naturally related to the particular and the universal, both being dynamics that never seem to lose their force of philosophical or theological inquiry. Art, like place, is always a particular work, act, or object. A painting is *this* painting; a musical piece is always *this* version or performance (and so influenced by the place in which it is made/performed). The arts can also help us perceive and attend to the particularities of the places in which we live. So the particularity of artistry can simultaneously be described in terms of *what art is* (as particular object) and *what art does* (drawing our attention to temporally located places throughout history). But the moment we attempt to lay hold of the particularity of these realities, the one behind the many reasserts its

presence. We must ask ourselves, then, What universal qualities or reality do the arts manage to embody *within* those particular placements and expressions through time and history?

A particular work of art can reflect and make a place what it is, contributing to place identity and providing the main artifacts through which people associate and acquire a sense of place. For instance, the town of Portland, Oregon, prides itself for its particular sense of place—the town has a unique character, and a large part of this sense of place is attributed to the local art scene. Similarly, many cathedrals in the United Kingdom, such as Liverpool Cathedral or St. Martin-in-the-Fields, explored in chapter four, have added modern artworks to their sanctuaries and grounds to communicate an expressly spiritual sense of place. The artwork, no doubt, plays a major role in telling the community what type of place this church is, along with identifying and forming the spiritual atmosphere of the worshiping congregation. The artist as placemaker, in other words, can contribute very real structures to the place, which actually contribute to particular place identity.[13] Oftentimes, if an artwork is famous enough, we will recognize the place based on the artwork residing there, as in Anish Kapoor's *Cloud Gate* at Millennium Park in Chicago. Without the sculpture, one might be unable to immediately identify the plaza from other similar urban landscapes.

As they contribute to place identity in these ways, artworks might be said to belong to a place and time in both purpose and meaning, but most artworks can also acquire new meaning as they transit time and places. They can transcend their particular contexts in appropriate and sometimes universal ways while remaining thoroughly grounded within them. In this way artistic actions and objects are both synchronic and diachronic, wrapped up in the particularity of one place and time while being connected through time to other places and storied events.[14] Picasso's adaptation of African masks in his cubist paintings is one relevant example of this, and in this sense we might understand the artifact (both the mask and Picasso's adaptation of it) as Yi-Fu Tuan suggests—as a place or context itself that acquires meaning over time and in

[13]This is the preferred term in Dixon, *Nature and Grace in Art*. See also my earlier discussion of Bourdieu on the potential for art to be a "structuring structure."

[14]The notable exception to this is ephemeral art, where the artifact is temporary. The work of Christo and Jeanne-Claude or Andy Goldworthy's land installations are good examples of this kind of art. The photograph of the work is often all we have left and the main mode through which to experience the piece.

relation to variously different uses.[15] The universal quality of the artwork is carried over in all its particular uses, interpretations, and adaptations across cultures and times.

This relationship between the particular and the universal can also be identified in the reflexive nature of placemaking—or what art does for us internally. One job of the artist is to help us *realize* the significance of the particular places we live in and perhaps grant them further meaning. Flannery O'Connor saw this as a central part of her job as an artist. "As a novelist," she says, "the major part of my task is to make everything, even an ultimate concern, as solid, as concrete, as specific as possible."[16] O'Connor hints at the reciprocal relationship between the particular and the universal in her writing about fiction, and she suggests that art unifies our sense of this relationship. If we want to understand ultimate concerns, she claims, we must see them through the real, particular circumstances we experience here in the world.[17] Place, she notes, is foremost in those circumstances and central to our understanding of particularity. "The Catholic novel that fails," she argues, "is a novel in which there is *no sense of place*, and in which feeling is, by that much, diminished. Its action occurs in an *abstracted setting* that could be *anywhere and nowhere*."[18] Ultimate concerns, or "ultimate reality," to use Paul Tillich's preferred phrase, cannot be abstracted elements "beyond" the work of this world.[19]

This is where O'Connor in her personal artistic consciousness perhaps surpasses the theological perceptiveness of Tillich on the arts. While Tillich finds ultimate reality *best* in abstraction (particularly abstract expressionism), O'Connor recognizes the importance of attending to the particular and letting that inform one's vision of transcendent, ultimate, or universal realities. This is not to suggest that abstraction in art is somehow inferior to "realistic" art, though. O'Connor herself acknowledged the outlandish and often unrealistic

[15]Yi-Fu Tuan, *Place, Art and Self* (Charlottesville: University of Virginia Press, 2004), 3.

[16]Flannery O'Connor, *Mystery and Manners* (London: Faber and Faber, 1972), 155.

[17]Karl Rahner also notes this relationship in his "Theology and the Arts" but focuses on the transcendent nature of humanity that is reflected through particular histories. "Both art and theology are rooted in man's transcendent nature. But it is important to see why and how this human transcendence is always represented in art in a quite definite, particular and historical way. True art embodies a very definite, particular and historical instance of human transcendence." Gesa Elsbeth Thiessen, *Theological Aesthetics: A Reader* (London: SCM Press, 2004), 222.

[18]O'Connor, *Mystery and Manners*, 199, emphasis added.

[19]See Paul Tillich, *On Art and Architecture*, ed. John Dillenberger and Jane Dillenberger (New York: Crossroad, 1987), 139-57.

quality of her own work while at the time noting its simultaneous attention to truth and particularity of a specific place. The point is that abstraction, both in art and in theology, is still very much grounded in the actual world and must in fact call us back to it. Picasso's abstract nudes told no less of the particular world in which he lived. Beethoven's *Moonlight Sonata* conveys a particular mood that we can associate with his real life and experience. These artists' works can still be understood in terms of what Richard Viladeseau calls "texts of" their particular time, place, culture, and religion.[20] The artwork serves as the locus of embodying particular values, philosophies, and religious ideas from a particular culture in place, whether or not the artists explicitly do so in the subject matter of their work.

Like God's own redemptive interaction with the world, universal aims and presence are experienced and understood primarily through the particularity of encounters and calling, broadly understood through the theological lens of election. God calls a particular people, sends his particular Son, all for the sake of all of creation. Within this divine dynamic of particular engagement with the world (and this is not easily disentangled from the physicality of the world God has made and therefore the necessity of particular encounter), we understand our own placemaking through the arts, navigating that back-and-forth tension between presence and absence, between the one and the many, between the particular and the universal in our very being-in-the-world.

These themes might be understood on another level by looking again at the placedness of eucharistic practice, which draws us not only into physical-spiritual exchange but also into the dynamics of the particular-universal. William Cavanaugh's study of the Eucharist as "one privileged site for the Christian spatio-temporal imagination" is helpful in developing some of these themes in relation to space and place as well as to broader conceptions of sign making.[21] Cavanaugh suggests not only that the relationship between the particular and the universal is best mediated by the Christian community's

[20]Richard Viladesau, *Theology and the Arts: Encountering God Through Music, Art and Rhetoric* (New York: Paulist, 2000), 124.

[21]William T. Cavanaugh, *Theopolitical Imagination: Discovering the Liturgy as a Political Act in an Age of Global Consumerism* (London: T&T Clark, 2002), 4. David Jones also argues that "*all* men and their practices" partake in sign making, so we might expand this dynamic to artistic sign making as well. See David Jones, "Art and Sacrament," in *Artist and Epoch: Selected Writings by David Jones*, ed. Harman Grisewood (London: Faber and Faber, 1959), 166.

practice of the Eucharist, but also that the "Eucharist as an earthly practice of peace and reconciliation" is the means by which we participate locally in Christ's universal redeeming purposes.[22] The particularity of each aspect of the Lord's Supper—the bread and wine as the actual, physical place of Christ's presence, the particular community's location, and the distinctive features of each congregation's improvisational and earthly enactment of the liturgy—are key elements of thinking both locally and globally about the presence of Christ. Cavanaugh argues that this particular-universal relationship is only fully understood in the practice of the Eucharist:

> The Eucharist produces a catholicity which does not simply prescind from the local, but contains the universal *Catholica* within each local embodiment of the body of Christ. The body of Christ is only performed in local Eucharistic community, and yet in the body of Christ spatial and temporal divisions are collapsed. In the complex space of the body of Christ, attachment to the local is not a fascist nostalgia for *gemeinschaft* in the face of globalization. Consumption of the Eucharist consumes one into the narrative of the pilgrim City of God, whose reach extends beyond the global to embrace all times and places.[23]

If we take Cavanaugh's suggestion seriously, we will see that other Christian placemaking practices, while concerned and aimed ultimately at communion with the wider world, must materialize out of local practices that are earthed in the places to which they are called. The church's "eucharistic mission," Balthasar claims, is to engage the whole cosmos in the "trinitarian exchanges of love" brought to life through participation in space, time and motion.[24] Through acts of creative—and indeed artistic—placemaking, the people of God may reveal God's love and presence to the world, while actually participating in that very love that Christ has made available to us. But these practices will always be based in a solidly local imagination, out of which God's love is made manifest to the world in decidedly concrete ways. Those actions in place function as microcosm of the universal reality of God's presence and action with us, our own temple work expressed in our aesthetic imagining and

[22]Cavanaugh, *Theopolitical Imagination*, 51.

[23]Cavanaugh, 98-99.

[24]Nicholas Healy and David L. Schindler, "For the Life of the World: Hans Urs von Balthasar on the Church as Eucharist," in *The Cambridge Companion to Hans Urs von Balthasar*, ed. Edward T. Oakes, SJ, and David Moss (Cambridge: Cambridge University Press, 2004), 62.

acting in the world, what Mark Wynn calls the "bodying forth" of spiritual presence through the particularity of the arts and place.[25]

3. *Individuality/community.* As we have witnessed throughout, both art and placemaking are reflections of both the individual self and life in community, influencing both personal spirituality and communal worship in the church, or signifying one's sense of self in the home along with one's hospitable dispositions to guests or neighbors. While both artistry and sense of place can be individual reflections of our loves, these loves are tied to the social imaginaries present in cultured communal making, resultant from one's being in communion with the world outside the self. I have argued that the arts can put us into deeper relationship with the community of creation, that they connect us and structure our relationships to members of the natural world, the home, the church, and society. All of these are reflections of a personal sense of place, or love of place, that deepest inner working of our soul that imagines where we are in relation to the world. But this personal imagination and self-reflection always break their boundaries, our personal dwelling in the world never able to separate itself from a social life of being in place.

One way to understand this dynamic between the personal and the communal is through the lens of hospitality, the making of a space in one's interior life for that which is "other" or outside, an intentional and self-giving act of love. In the making of a hospitable space community belonging is truly achieved, an opening up in a decidedly risky and sacrificial act to allow communion through the expansion of love. As we saw in both church and home, we model our own artistic placemaking practice after that of divine love, a kenotic outpouring of love expressed in the self-giving of the Father, the obedient and loving response of the Son, and the eternal communion as bound together in the Spirit.

Artistic practice functions paradigmatically in this regard, the artist pouring herself and her love into the work, working with materials in participation, encouraging them to be obedient without coercion, and hospitably offering a place for community engagement to occur over time, which adds to both meaning and presence in the community's own acts of hospitable exchange, contemplation, and social practice. All of these create a dynamic

[25]Mark R. Wynn, *Faith and Place: An Essay in Embodied Religious Epistemology* (Oxford: Oxford University Press, 2009), 14, 38.

of community around the work—the artist's own imagining of what meaning and purpose the piece might hold being made vulnerable to change and dynamic exchange with the world. This submission can be revelatory for both the artist and the audience.[26] Steven Guthrie discusses the value of submission in communal singing, that we surrender freedom to the other in engaging in the communal practice.[27] Wallace Stegner uses similar language to talk about relationships to place, drawing out the communal framework of place and suggesting that we must submit to its history and stories in order to fully dwell there.[28] In both actions, submission actually increases freedom and relationship rather than diminishing it, with the expansion of one's own individual sensibilities about the world occurring in communal dialogue.

While modernity may compel us to see its artists above society in order to preserve freedom and originality, the model presented here places the artist back into the world, into that dynamic exchange of ideas and identity on a community level. The modern conception, of course, only works in a dismissal of our most basic ways of being in the world, which include our relatedness to other people and to God. Art rather obviously always takes place in a context, in a society, or in some set of human relations. Art does not take place in a vacuum; it takes place *in a place*! Clifford Geertz suggests that as a complex arrangement of cultural signs and symbols, art depends on a community to give those signs meaning.[29] The artwork, in this way, *must* be read in light of its place in a society or context. Though the meaning of it symbols may change over time, the community is the executor of meaning.

But this does not mean, as Wolterstorff avers, that the artist is "merely a mouthpiece for that [social] practice."[30] While the artist always works from

[26]This, of course, is one way that an analogy between God and human artist breaks down, as God's knowledge through making is decidedly different from any revelation that the artist might newly experience in the process of making.

[27]Steven R. Guthrie, *Creator Spirit: The Holy Spirit and the Art of Becoming Human* (Grand Rapids: Baker Academic, 2011), 88.

[28]Stegner, *Where the Bluebird Sings*, 206. This type of submission might also be considered a form of cohabitancy with already existing community, as understood in Edward Casey, *Getting Back into Place: Toward a Renewed Understanding of the Place-World* (Bloomington: Indiana University Press, 1993), 291.

[29]Clifford Geertz, *Local Knowledge: Further Essays in Interpretive Anthropology* (London: Fontana, 1993), 118. Meanings can also change over time. For instance, we ascribe different meaning to funerary masks than did primitive cultures.

[30]Nicholas Wolterstorff, "The Work of Making a Work of Music," in *What Is Music? An Introduction to the Philosophy of Music*, ed. Philip Alperson (University Park: Pennsylvania State University Press, 1987), 112.

something given (community practices, standards, traditions, styles, and so on), she is also remaking the tradition, adding something new or of value to it. The artist, then, while being influenced by the world and her social traditions, also exercises some influence on the place and community. Geertz includes this reciprocity in his contextual theory of art, suggesting, "Works of art are elaborate mechanisms for defining social relationships, sustaining social rules, and strengthening social values," all key elements in the structuring of a society.[31] Artworks, in these terms, affect the sense of place or community by engaging with social structures in profoundly new and sincere ways. Oftentimes art opens up new possibilities for redefined social structures that are more ethical or religious in their goals.

Wolterstorff understands art's role in *remaking* a place or community through what he calls world projection, similar to Brown's notion of world-making introduced above.[32] While world projection is but one of the many actions that art is used to perform, it serves a primary and pervasive role in the way that we encounter and engage with places in new or different ways.[33] Art cultivates "man's powers for envisagement"—it allows us a way to envisage the world in ways other than the way it actually exists.[34] Art can confirm, concretize, illuminate, alter, evoke emotion, model tendencies in, or give hope and consolation in relation to the community or world around us.[35] Iris Murdoch envisages a similar role for imaginative and creative world projection. By making "pictures of himself," she describes, the artist reflects on his relationship to place and all that it entails (with implications in the social, moral, ethical, economical, and spiritual spheres), "and then comes to resemble that picture."[36] Our pictures, therefore, will reflect our sense of community responsibility, placedness, and moral standing in the world, while simultaneously allowing us a means by which to affect it. This transformative vision that both Wolterstorff and Murdoch communicate operates on both the individual and community level, the work of art providing a context in

[31]Geertz, *Local Knowledge,* 99.

[32]Heidegger also describes art as a form of "worlding" in the "The Origin of the Work of Art," in Martin Heidegger, *Poetry, Language, Thought* (New York: HarperCollins, 1971).

[33]Nicholas Wolterstorff, *Art in Action: Towards a Christian Aesthetic* (Grand Rapids: Eerdmans, 1980), 122.

[34]Wolterstorff, 123.

[35]Wolterstorff, 144-49.

[36]Iris Murdoch, "Metaphysics and Ethics," in *Iris Murdoch and the Search for Human Goodness,* ed. Maria Antonaccio and William Schwiker (Chicago: University of Chicago Press, 1996), 252.

which both artist and audience may experience a greater insight for the way the world could be.

4. Given/made. The process of world projection or worldmaking suggests that something new is being contributed in either actuality or imagination, though this newness is always set against the givenness of things that are already present. Theologically, the relation of that which is given to that which is made is exercised in the Spirit's motivation of our imaginative efforts in the world, to take those gifts offered us and to make something more of them or draw out some meaning from within them. Placemaking, I have already suggested, is adding something to place itself, to one's own knowledge of it, or to the community life within it—it is making a "place" out of a "space." But placemaking is also understood as a response or submission to what is already there—a remaking or unfolding of the place already given. Jacques Maritain links these two aspects—givenness and making—in relation to the art event. Art, he says, is "the fruit of a spiritual marriage which joins the *activity of the artist* to the *passivity of a given matter*."[37] For Maritain, the artist's working with the world is a reflection and representation of the communion between the artist's own inner life with the inner life of the objects of the world. Artistry is a vehicle for human participation in the givenness of creation, while simultaneously functioning as a tool for opening up more out of it. Art is never merely imitative but seeks to draw out *more* from the objects and places with which it interacts.[38]

Rowan Williams expounds on Maritain: "The 'what' of what is known is not something that simply belongs to the given shape we begin with in our perception; it extends possibilities, or even, to use a question-begging word, *invites* response that will continue and re-form its life, its specific energy."[39] Williams implies that the world brims over with additional meaning and presences that we do not know. Human artistry, as a proper act of obedience, as he describes it later, seeks to discover the gratuitous traces of God's presence there, unfolding in artistic form, and echoing in artistic placemaking, the "character of God's love as shown in making and becoming incarnate."[40] The

[37]Quoted in Thiessen, *Theological Aesthetics*, 327, emphasis added.
[38]Rowan Williams, *Grace and Necessity: Reflections on Art and Love* (London: Continuum, 2005), 18-23.
[39]Williams, 139.
[40]Williams, 165.

incarnation, as an act of love, becomes the paradigm through which artistry is understood—God's grace and love poured forth in the incarnation reveal something about the nature of human artistry and placemaking in the world. Just as the incarnation simultaneously affirms and transforms creation, our artistry, as it finds meaning in the person and work of Christ, participates in this simultaneous affirmation and transformation.[41]

An incarnational theology of art, therefore, is a "making significant" that draws on the possibilities of the physical world that God has already given to us, while seeking to extend them in a Spirit-led way.[42] Ben Quash draws this out in an investigation of the relation between the given and the found, the work of the Spirit explored in the dynamics of maculation, reception, and abduction, practices which enable the unfolding of "more" in our encounters with others and the world.[43] The Spirit works operatively to draw out and make meaning through imaginative encounter, meaning which may already be present, but which can also, properly understood, be understood as an act of making. This is what Trevor Hart calls "added-value," or something which "characteristically renders back something more or other than is given to it in nature as raw material."[44] Humans are not simply rearranging the material of creation but they are adding value to it in creative and new ways.

While Quash communicates the dynamic as one between the given and found, here I have stated the dialectic as a relationship between the *given and*

[41]Placemaking and artistry, of course, are not solely matters of christological concern but ones of trinitarian scope. Viewed in light of the work of the Father and Holy Spirit, we can more fully understand Christ's work in redemption of creation over time and see how we participate in that action through the work of the Holy Spirit in us. William Dyrness is critical of claims that focus too much on the christological dimension alone, suggesting that "The center of the story, however important, should not be taken for the whole." While this is true, our place of entrance into the life of the Trinity is the work of Christ, and this particular fact should not be left unnoted. Scholars who seek a more general aim by deemphasizing the importance of the incarnation seem to be moving too hastily and removing a central element of the way we understand creation and redemption working together. In light of this, I acknowledge the inherent relatedness of incarnational and trinitarian approaches to the arts, suggesting not that the persons of the Trinity be taken in turns but that, as he is the particular man through whom we are reconciled to the Father and gifted the Spirit, Christ should remain a central way that we interpret and understand our life in the world of places and our artistic actions that help make us at home within them. William A. Dyrness, *Visual Faith: Art, Theology, and Worship in Dialogue* (Grand Rapids: Baker Academic, 2001), 93.

[42]See Rowan Williams, "Poetic and Religious Imagination," *Theology* 80 (1977), 178-87. For a similar concept of "making special" see Ellen Dissanayake, *What Is Art For?* (Seattle: University of Washington Press, 1988).

[43]Ben Quash, *Found Theology: History, Imagination, and the Holy Spirit* (London: Bloomsbury, 2013).

[44]Hart, "Through the Arts: Hearing, Seeing and Touching the Truth," 5.

made. "To make" conveys a stronger sense of human participation in the unfolding of meaning in relation to the Spirit, especially in artistic terms, not simply discovering things that are hidden (like a cosmic game of hide-and-seek) but an actual addition of something new, newness that is nevertheless made in response to the Spirit's directive presence.[45] While this theological view must begin with a proper view of creation as given, a *purely* creational account of artistry cannot take us far enough in this regard; we need a christological underpinning to reveal this potentially additive effect of our artistic practice. Christ, sharing in all human likeness, compels us to think about our own human response to God and suggests that we might also share and participate in a similar, embodied way in God's redemptive activity in this world. This is not just a general claim but has specific implications for our artistic practices. Hart avers:

> Responsible creativity of an artistic sort is thus not only warranted, but may be viewed as *an unconditional obligation* laid upon us and called forth by God's gracious speaking to humankind in the life, death, and resurrection of the Son. Indeed, we may go further and suggest that it is not only a proper response to, but also *an active sharing in* (albeit in a distinct and entirely subordinate mode) God's own creative activity within the cosmos.[46]

Through the incarnation and work of Christ, our own placemaking actions can meet those of God in a way not dissimilar to the artists in the tabernacle, an active sharing in God's own activity and presence. In our free response and submission to that which is given, the artist may draw out meaning and, in the act of finding or making, contribute new meaning to an object or place. We saw how this might look in artistic engagement in the natural world with Peter von Tiesenhausen's installations. In acknowledging the meaning present, we set up pillars like Jacob did at Bethel, creating new spaces and finding new ways of experiencing God in the world.

 5. Beauty/usefulness. In his essay "The Gospel: How Is Art a Gift, a Calling and an Obedience?" Andy Crouch suggests that one of the profound gifts of

[45]See footnote in chapter two on the distinction between *creation ex nihilo* and *creatio continua*, along with terms *bara* and *asah* in the Genesis account to convey two different types of making, ascribed respectively to God and to humans. The addition of newness here is not suggestive of an ontological addition, as only God can do in the sense of creation from nothing, but one of meaning, a new configuration of given things that has not been that particular way before.

[46]Hart, 18, emphasis added.

God to the world is beauty hidden in order be to found or discovered.[47] Objects of beauty are hidden and must be uncovered and cultivated in order to be experienced and delighted in, and these experiences and objects are profoundly *unuseful*. Crouch hints at an important dichotomy in discussions of art and craft—the distinction between that which exists to be beautiful and that which exists to be useful. Later he suggests that "art can be provisionally defined as those aspects of culture that cannot be reduced to utility."[48] Art, therefore, names the things that we do in culture that are useless. Crouch's reasons for this are fleshed out in his analogy of art to religion, those things we do such as worship and prayer being precisely useless, and their character driven in part by their being decidedly so. Crouch argues, "If we have a utilitarian attitude toward art, if we require it to justify itself in terms of its usefulness to our ends, it is very likely that we will end up with the same attitude toward worship, and ultimately toward God."[49] Worship does not suit an immediate *purpose* and then is left behind; it responds to the gratuitous presence of God's own being and so revels in that presence in ways that go beyond merely performing our duties to the deity. Worship and prayer are gifts to us, meant to reveal the grace with which God extends to his creation. There is *more* than what is needed for basic survival, just as parents offers gifts to their children to witness their joy or delight. Art, then, manifests this gratuitous beauty as delight rather than duty.[50]

What might we make of Crouch's argument in light of the theories of art drawn on so far, particularly those that see a social or ethical function to art, or those that seek to draw art and craft together in a manner that unites beauty and usefulness? The latter is represented well by key figures of the arts and crafts movement such as Morris and Ruskin, who maintain a desire to understand the function of art in useful everyday life. If we divorce art from life and action, then we end up with a dangerous dualism that places beauty in those arenas of the world where only the privileged have access. For advocates of the arts and crafts movement, or for those such as Wolterstorff or Berry who

[47]Andy Crouch, "The Gospel: How Is Art a Gift, a Calling, and an Obedience?," in *For the Beauty of the Church*, ed. W. David O. Taylor (Grand Rapids: Baker Books, 2010), 33.

[48]Crouch, 36.

[49]Crouch, 40.

[50]Makoto Fujimura makes a similar argument regarding the unusefulness of art in Makoto Fujimura, *Culture Care: Reconnecting with Beauty for Our Common Life* (Downers Grove, IL: InterVarsity Press, 2017).

maintain more functional approaches to the arts, beauty is gratuitous and yet can still find its roots in the everyday reality of life.

While Crouch does not seek to disentangle art and beauty from the everyday world (in fact, in rooting their dynamics in the creation story, we might say he seeks to find their roots in the very world God has given in grace), we should be careful not to conclude too stark a separation between beauty and usefulness in theological terms. An analogy might be made between the gift of beauty and the gift of salvation, both of which must be understood as an expression of divine grace. While useful in some sense (in soteriological terms, it is quite useful for us if our eschatological freedom is to be maintained, while in artistic terms, art serves the types of purposes in the world discussed throughout this book), its ontic condition stems from grace and love rather than utilitarian ends. In other words, the separation between beauty and utility may certainly apply when understood as *an ontological articulation of* God's original and manifold grace to the world, though one might speak of the usefulness of beauty *in phenomenological practice and action* in all the ways we have witnessed above. The arts add more to that which is necessarily present (beauty being distinctively different from shelter, food, clothing, or sleep) but offer a means of dwelling in the world that is *teleologically fulfilling,* that is, fully expressive of our designated ends as creatures made in God's image and called into communion and participation in his triune love. We are called into beauty, which serves to baptize us into ethical response and contemplation of the world's true nature as a creation by God. While this could be asserted in utilitarian tone, it is rather out of the sheer joy and delight, desire and attraction, that beauty calls us forth. But out of this delight and desire, we learn to act and think in kingdom terms.[51]

So in highlighting the uselessness of beauty and art, must we negate the ethical and epistemological conclusions that might be reached regarding artistic practice? Can we talk about function without making art simply a means to an end? I think so, but we also must not exchange one set of

[51]The role of beauty in more utilitarian spaces (spaces of daily use) such as city architecture is addressed by both Gorringe and Jacobson. Both conclude that there is significance to beauty in life that we cannot disentangle from other areas of necessary practice. See T. J. Gorringe, *A Theology of the Built Environment: Justice, Empowerment, Redemption* (Cambridge: Cambridge University Press, 2002), 216-20; Eric O. Jacobson, *The Space Between: A Christian Engagement with the Built Environment* (Grand Rapids: Baker Academic, 2012), 252-68.

assumptions for the other. The active and formative role that natural beauty and art have to offer the places of the world and us within them can be disentangled from didactic use, yes, but cannot, it should be noted, be disentangled from the transformational impact that results through discipleship in the language of art and beauty. When we invest ourselves in the arts, we are embracing the fullness of what it means to be humans who delight in the presence of God, but just as the spirit is bound to the body, or the particular to the universal, the individual to the community, so also the joy we take in God's presence and beauty serves to form us for responsible care, action, and mission in the world.

6. Contemplation/action. The question of art's uselessness raises some concerns regarding whether any sort of active role can be attributed to beauty or the arts. We have seen throughout our discussion of the various places of society that we can identify the transformational role of the arts in places, at least in part, by their cultivation of beauty in a fallen world, beauty that, as Balthasar argues, reveals the beauty of the form of Christ himself, his presence known actively in the places of his creation through the form of beauty. It deserves return, then, to the features of placemaking and the arts that suggest a relationship between form and action in order to assess the potentially active role of art and beauty in the world.

In our discussion of place throughout, we saw how sense of place is both a contemplative and an active reality, self-identity and reflection born out of love for a place and its community but resulting in action and transformation of the physical place not only to suit one's own needs but to make it better also for one's neighbors or future generations. This involves seeing across different times and places, but it begins in the contemplative life born in one's rooted, embodied existence. Our *sense of place thus informs our placemaking,* our love of place habituating and motivating our active engagement with the world around us. Art influences both of these, providing a "structuring structure" and a "structured structure" through which to understand our life in the world and our transformative action within it.[52]

These dynamics of both art and place are reflected in the church's sense of missional calling in the world, which might also be described in terms

[52]See my discussion of Bourdieu in chapter 1. Pierre Bourdieu, *Outline of a Theory of Practice,* trans. Richard Nice (Cambridge: Cambridge University Press, 1977), 72.

of that homesteading/homecoming dynamic, or the place-displacement-reimplacement narrative described in chapters four and five. Our mission as participants in the kingdom of God is to mark out those places of God's presence and cultivate a shared faith and action in community. In this sense, the two dialectic exchanges come into relation, the usefulness or uselessness of beauty standing in relationship to the active and potentially redemptive role it might serve for both Christian contemplation and mission. Both John de Gruchy and Timothy Gorringe highlight this dynamic role of beauty in their explorations of art in society, the former featuring visual art and the latter highlighting the role of architecture. Both, however, see the beautiful as a way to engage the transformational, art and architecture being an active catalyst for social and spiritual change (and both of these being connected in their practiced application). Beauty demonstrated in the arts and architecture provides a context in which sense of place can be ignited and spiritual growth exercised. This is decidedly useful in one sense, though it is not the utilitarian function that drives the active role as such; rather, it is the fullness of living as the image of God, cultivating not only survival but creaturely flourishing and at-home-ness in a world that is awash with God's glory and presence even as we look forward to the fullness of that presence in the new creation. Imaginative contemplation and action thus converse in dynamic exchange, our personal sense of place generating placemaking actions, and those actions reciprocating and habituating new ways of loving and imagining our places in relation.

These six dialectic exchanges do not exhaust the possibilities of ways in which one might consider the multiplicity of meaning and dimensions of experiencing either art or place. They should, however, highlight and recall some of the key arguments I have made throughout, reminding readers of the multifarious dimensions of human making and meaning in the world, along with the fact that every aspect or place of our life in the world must contend with these dimensions. In this final section we will assess the role of art as a form of placemaking in the Christian life by suggesting that our placemaking practices, of which the arts are a characteristic feature, uphold an eschatological focus and hope, which draws us into mission and contributes to our participation in the work of creation and redemption.

AN ESCHATOLOGICAL FRAMEWORK FOR
PLACEMAKING AND THE ARTS

If our concepts of both art and place began with a doctrine of creation, then it is appropriate that they see their conclusion in a doctrine of new creation, an eschatological imagination that pictures the telos of faith, hope, and love with proleptic force and concretizes the ways in which those dispositions are worked out in present action. We navigate between our present being and our hope for the future, our longing for new creation being realized in momentary glimpses in this world, even while it remains incomplete. While we have focused largely on a creationally and therefore christologically centered theology of place and the arts, in this final section we explore the ways in which an eschatologically oriented theological approach might help us further understand the dynamics among art, imagination, and place envisioned so far.

Trinitarian exchanges of love and eschatological imagining. The imagination is a faculty that produces the ability to see that which is not *there*, or *not yet*, or that which *could be*. It offers, as we saw in chapter five, the ability to love, which includes seeing something or someone as they truly are and as they might be, offering oneself up to the other in listening and response, care and attention, and presence and action. We began this investigation by addressing that sense of place is always about love of place, what Yi-Fu Tuan calls topophilia, and that to feel at home and to make others feel at home—whether in the natural world, in the home, in the church, or in society—we should see our thoughts and actions as extensions of how our loves are directed toward something. As James K. A. Smith summarizes, "We are what we love."[53] How this dynamic of love is expressed in human artistry and placemaking in both present and eschatological focus is best answered in trinitarian terms, in that dynamic, hospitable exchange of love in eternal kenosis, that pouring out of the self for the sake of the other. This exchange is delivered with imaginative force when we consider both the immanent and economic realities of divine love, the giving of love in circumincession of the divine persons and the offering out of that love in the economy of salvation. This love is known to us namely in the person of Christ crucified, buried, and raised, his obedient offering for the sake of the redemption of all things (Col 1:15-20), and further

[53]James K. A. Smith, *You Are What You Love: The Spiritual Power of Habit* (Grand Rapids: Brazos, 2016).

called forth in the giving of the Spirit's presence in community as we hope for new creation.

The Spirit occupies our imaginative space, working through that faculty to transform our hearts and minds in the love of God. As an act of love or affection, our imaginative work might be understood in its relationship to the Spirit's inspiration and movement in the world, and acts such as human artistry and placemaking realized as imaginative extensions. The revelation that might be offered through these events will then be the result of divine action and inspiration, while still being thoroughly bound up in human response and responsibility. Place, therefore, being *made known* to us through imaginative disclosure, can also be conceptualized in terms of the Spirit's work and disclosure in the world and in our responsive acts of placemaking within it. In placed terms, the Spirit may provide the possibility of looking forward to the eschaton as fully placed, but the realization of our eschatological telos is made possible in the Spirit's revealing of the overlapping nature of the kingdom that is to come with the world as it is, our ultimate reimplacement being revealed in our acts of Spirit-led homecoming and homesteading, or placing and displacing, in the current world.[54] We might, then, formulate a theological rationale for the arts that focuses precisely on their dynamic placing and displacing of us in the world, along with their correspondent structuring of our theological imagination, which motivates us to seek and act out both goodness and truth in the world around us.[55]

This dynamic reflects the paradigm of homesteading and homecoming as explored in previous chapters. Both actions, homesteading (the act of making a place somewhere for the first time in conversation with previous occupants) and homecoming (the act of returning to a place already known or occupied but with new eyes to see and with renewed vision for dwelling), require a synthesis of past and future with current experience, all time known as it only can be, in the present moment. We ask ourselves, What might my homesteading here

[54]N. T. Wright speaks of the "overlapping and interlocking" of heaven and earth, made known in the Spirit's revealing of "divine echoes" in things such as beauty, community, spirituality, and justice. N. T. Wright, *Simply Christian* (New York: HarperSanFrancisco, 2006), especially section 1 on divine echoes.

[55]J. R. R. Tolkien advocates something of the dynamic in "On Fairy Stories" when he suggests that fairy stories provide escape, recovery, and consolation from the real world and return back to it, not only with new eyes to see the world but with hope for a happy ending. "On Fairy Stories," In *Tree and Leaf* (London: Unwin, 1964).

result in, and does it respect that which has come before it? How might my renewed actions in the act of homecoming influence my continued dwelling here? These questions have both present and eschatological force, being realized in the present but understood also in future terms. Like our own placement in the world as Christians, we see a realized kingdom of God present with us in all our communal engagement with one another and God's good creation, but we also look forward with hope to the kingdom of God experienced fully in the event of new creation, our own creative homesteading and redemptive homecoming modeled after that back-and-forth of our creaturely placed existence in the world and our being members of God's household in the heavenly terms.

Our eschatological hope, however, can only truly be expressed in that day-to-day life of our being and dwelling in the world of space-time. Our imagination lingers in future moments, only to return solidly back to earth. And as the imagination teaches us to occupy all times and all spaces, we become, as it were, all things to all people. In the Spirit's work to reveal the trinitarian work of love in creation and redemption, we model our own placemaking activities after such dynamics and so practice our eschatological hope in the present moments of our life in place. The mutually reinforcing and influencing relationship between art, imagination, and place that we see here, then, reveals the ways in which both artistry and human placemaking more widely might play a substantial role in the pursuit of the kingdom of God and the act of discipleship and social justice in the world. The arts can mold our imagination to consider possibilities outside our own immediate experience, and so make possible a more thoughtful and attentive living in the world, where eschatological hope drives our creative and responsible engagement in all the places of our lives together.

The possibility of redemption? These observations may raise the question of the possibility of talk of redemption in relation to human activity and cultured practice. To suggest that the arts do something in this world that has lasting significance for the divine-human relationship or for wider creational transformation is, of course, a rather contentious claim, and some theologians are more open to the prospect than others. Timothy Gorringe warns against viewing art as redemptive *in itself*, deeming the concept a "child of romanticism."[56] Rather than elevating art to a form of religion, Gorringe argues that art cannot

[56]T. J. Gorringe, *Earthly Visions: Theology and the Challenges of Art* (New Haven, CT: Yale University Press, 2011), 19.

by itself give us access to the divine, perform a prophetic role, or directly affect the primary concerns that face society today that are in need of redemption: war, famine, disease, environmental concerns, and displacement of people, among others. But while Gorringe at first seems overly critical, he does not totally dismiss the redemptive role of art. Rather, his critique rids art of the implication that it possesses some inherent power of its own. In fact, in his theology of the built environment, he presses the redemptive understanding of placemaking further to suggest the significant role of human making and building in reconciliation and the pursuit of justice in society. But even there it is only the result of God's grace toward us that true transformation through placemaking occurs. Redemption, in these terms, is understood as continual event, like place and divine revelation there, where the Spirit's presence is continually at work and which calls forth human response.[57]

The tendency to temper the redemptive aspects of art is found in others' work as well. While John Dixon speaks of the "arts of redemption," and Patrick Sherry suggests that the arts might also serve a redemptive function, both of these authors are reticent to take the theme too far.[58] Sherry suggests that the arts might not actually *be* redemptive but that they can *"express"* redemption in a variety of ways, his emphasis being on the arts primarily in a heuristic role rather than as participating in redemption itself through the actual making process.[59] Dixon connects art and redemption more closely but still shifts his focus to less definite claims regarding the redemptive function of the arts. He argues:

> Man cannot make a redemptive art, but he can make an art that communicates what he experiences of redemption as a man and what he knows of it as an artist. Only God is the Redeemer, and the artist who sets himself the task of creating an art of redemption only manifests further the art of the fall, the setting up of false gods as idols. Yet the artist works in a world where redemption is the key act in the ordering of life.... His work must embody the structure of events *out of which the work of redemption could proceed* and within which it still acts.[60]

[57]Recall my discussion of place and revelation as event from chapter 4.

[58]Dixon, *Nature and Grace in Art*, 72. He differentiates the "arts of redemption" from the "arts of creation," "the arts of man in the image of God," and "the arts of the fall."

[59]Patrick Sherry, *Images of Redemption: Art, Literature and Salvation* (London: T&T Clark, 2003), 161. He prefers the term *express* here to *show.*

[60]Dixon, *Nature and Grace in Art*, 78, emphasis added. I am unsure how an artist might *embody* works out of which redemption might occur without first *reflecting* on creating an art of redemption.

Dixon and Sherry both speak to the difficulty of suggesting redemptive possibilities for the arts, acknowledging, importantly, that it is ultimately God who redeems all of creation.

Jeremy Begbie similarly provides a thoughtful account of art as participating in redemption, while maintaining a comparable reticence to the likening of human work too closely to the divine. Begbie writes:

> To speak of the redemptive possibilities of art is of course hazardous, lest we detract from the supremacy of the redemption wrought in Christ, and lest we suggest that Christ's redemption is no more than an aesthetic re-ordering of material reality (when it is clearly much more than that.) Nevertheless, God's redemption in Christ clearly has an aesthetic dimension to it, and there would seem no good reason to deny that *we can share in* this dimension of divine activity through artistic endeavor.[61]

While we must note that redemption is certainly not limited to the aesthetic sphere (it involves what Begbie has not mentioned: namely, the moral, political, practical, and so on), artistry's contribution to a theology of redemption is rightly noted.[62] What might it mean to share in this divine activity through artistic acts of placemaking, then?

The incarnational approach to artistry that we have taken in previous chapters—its embodying particular, physical, and communal realities in the structures of human making—gives us a good foundation on which to build. Christ invites us to share with him in his creative and redemptive work through the Spirit's presence within us and our communities. As we participate in particular, physical, and communal ways in the places around us, we become, as it were, the hands and feet of Jesus. Redemption, in this sense, as George Pattison argues, has a decidedly fleshly element. It is a matter of total vision, transforming creation in *every* respect.[63] Christ as God come in the flesh reveals the possibility of redemption through and of the physical. Hart argues similarly: "That God has graciously placed himself in our midst for touching, hearing and seeing means that this same 'physical' and historical

[61]Begbie, *Voicing Creation's Praise*, 212-13, emphasis added.

[62]The artistic and the aesthetic of course are two different things. Brown, *Religious Aesthetics*, 14 and throughout. Begbie's argument has profound implications for a theology of the arts, though, in addition to a theological aesthetic.

[63]George Pattison, *Art, Modernity and Faith* (London: SCM Press, 1998), chap. 8.

manifestation must always be the place where we put ourselves in our re-
peated efforts to know him again and ever more fully."[64]

Like we saw throughout the garden/tabernacle-temple/church narratives
in chapter four, God's own encampment with his people is called forth in their
repeated liturgical seeking of his presence in communally made places. We
might experience the presence of God through those physical places, or in the
case of the arts residing there—through colors, shapes, sounds, and actions—
all of which underscores the significance of creaturely embodiment as divine
plan. Not only do we experience the presence of Christ through the physical,
but his incarnation involves transformation of the physical so that we are si-
multaneously *transformed in* Christ and become *transformative through* Christ
as we mirror his work, through the Spirit's guidance, in potentially redemptive
ways in the physical world.

This is where Hart's notion of art as value added is particularly helpful for
understanding our participatory work. It illuminates the dual purpose of
human artistry: that art is *added* value—it is not simply invention but some-
thing in addition to, a remaking and recomposition of that which is given;
and that art is *value* added—it is doing something special with creation, en-
hancing it in some way. The latter expression carries the specific theological
implication that as artists we are at the very least *anticipating* the redemption
and transformation of the world through Christ, offering up, at least in
glimpses, something that communicates beauty, goodness, and truth in es-
chatological terms.[65] The "transfigurative dimension of art (the way in
which art hands back more than nature initially grants it)" reveals its po-
tential sharing in the redemptive activity of God in creation.[66] We can ac-
tually add something to, or make something of, the world through our own
free, creaturely action.

[64]Hart, "Through the Arts: Hearing, Seeing and Touching the Truth," 24. For a similar line of logic for why
physical images can represent the divine, see St. John of Damascus, *On the Divine Images: Three Apologies
Against Those Who Attack the Divine Images*, trans. David Anderson (Crestwood, NY: St. Vladimir's Sem-
inary Press, 1980).

[65]See also Richard Bauckham and Trevor Hart, *Hope Against Hope: Christian Eschatology at the Turn of the
Millennium* (Grand Rapids: Eerdmans, 1999). Here they discuss anticipatory versus progressivist notions
of redemption and eschatology. We anticipate the renewal of creation, but this is not a matter of doing x,
y, and z in order to get there. Our participation will not involve performing a series of tasks to get to the
end, but rather, our actions will reveal anticipations of possible futures in Christ, pictures of the way things
should or could be.

[66]Hart, "Through the Arts: Hearing, Seeing and Touching the Truth," 21.

By appealing to the category of place, we might begin to clarify and extend Hart's claim further. The theology of place I have outlined above suggests that our creative and redemptive participation in Christ's work is a matter of localized placemaking, of faithfully responding to and inviting the presence of God into the places we are in and to which we are called. Christ calls us to love our neighbors in our local communities and invite his presence into those places in ever new and dramatic ways. It is precisely this little and local work that matters. A redemptive placemaking and adding of value will therefore be a *localized* placemaking that values the physical landscape and the role of beauty, that responds to the community's needs, and that notices the particularities of lived experience there. This redemptive work seeks to produce in microcosm the presence of God as it will be in all of creation. And while God's all-in-all presence will be unknown in its fullest until the eschaton, humans can still anticipate in their artistry the microcosmic reality of God's full presence with them in a renewed creation. Artists as placemakers look toward these ultimately redemptive aims in the ways that they choose to engage with and transform the immediate places and materials around them. Our calling in the kingdom now is to live faithfully in *this place* and so make it more fitting for God's presence with us there and in *all places*.

NON-CHRISTIAN ARTISTRY AND PARTICIPATORY PLACEMAKING

Given that many of the artists explored throughout have no direct profession of Christian faith, we must ask ourselves how we comprehend artistry born of unbelief in terms of its serving a possibly redemptive role. Can non-Christian artistry be conceptualized in terms of a theory of art as a calling to responsible placemaking?

The answer, I believe, may be best answered by noting something about the nature of art made by Christians. Art produced by God's people does not always participate in his plan in a positive way; in fact, our sinfulness and selfishness can move us further away from God's intentions for his creation. Furthermore, not all Christian art is good art. Take for example, again, the golden calf incident in Exodus. Though the Israelites were God's chosen people, they created out of idolatry and pride, and so failed to obtain divine approval or to call forth divine presence. Evaluating the manner in which art reflects redemptive possibilities, made by Christians and non-Christians alike, seems

then to be more a matter of its particular intentions and contributions to the world, along with its relationship to a more final picture of justice and reconciliation. If an artist's work produces or hints at a picture of place that meets those divine standards for life in the world as witnessed throughout the story of Scripture—things such as justice, mercy, peace, love, hospitality—then that work has redemptive possibilities no less than its Christian counterpart. In other words, as the artist engages in responsible placemaking, they can share in the creative and redemptive work of Christ in the world.[67]

If art, whether of non-Christian or Christian origins, is to be considered redemptive in any way, however, it must be God's inspiration and action in the world that make it finally capable of achieving that end. Human work might be said to *participate or share in* redemption, not achieve it in isolation. This participation entails the relationship between human and divine action, so that God's presence in the world is not an act of simple conjuring but a relationship and meeting between Creator and creature through inspired and creative acts of localized placemaking, which very often happen outside the boundaries of orthodox Christian belief.

A PLACED THEOLOGY OF THE ARTS

What are we to make, finally, of developing a theology of the arts in relation to the places of this world? How might art contribute to Christian living today? Two dynamics seem especially important as we conclude: a theology of presence and a theology of action.

Presence. A placed theology of the arts will include the foundational belief that art must be present in places to make any impact or communicate with any power. Just as a more traditional theology of place suggests the importance of being there, of dwelling in the world, so also our theology of art must find a place for the arts' sustained dwelling in our lives. We have considered the ways in which art functions in relation to various spaces of our lives—the natural world, the home, church, and society. And while the chosen examples only begin to scratch the surface of art's possibility for our relationship to and

[67]David Brown's work on theology and culture is helpful here, as he paints a picture of God present in a variety of places in the world, Christian and non-Christian alike. This is where God's action must remain central to our theology, though, a fact that Brown's work obscures in favor of divine generosity of presence in such places. See David Brown, *God and Enchantment of Place: Reclaiming Human Experience* (Oxford: Oxford University Press, 2004).

thinking about place, they highlight the multifarious ways in which artists engage with both physical places and their symbolic associations.

In many cases, the significance of the visual arts rests in their simply being there and making beautiful, beauty being a form of redemption against the ugliness of the world and a catalyst for renewed thinking on our proper place in relation to one another and the given creation. Beauty thus forms us for relation to the form of Beauty himself, suggesting that the presence we experience when we breathe in beauty may actually be the presence of God. In making such associations we can formulate a theology of divine presence in relation to the arts, though that presence, as we saw in chapter four, is one of active relationship and response, placed responses on the human end and placed encounters of the divine with us. In that paradox of divine omnipresence and particularity, we can understand the power of the arts to reveal in placed exchange a universal presence, simultaneously offering a picture of the world as it is and the world as it is immediately experienced. The arts' presence in our lives conveys that power, reminding us of presences that are absent and absences that are present, symbolic associations that are recalled through physical touch or sight, and remade and reevaluated on our placed encounter with them.

While sacrament is one category for thinking on these dynamics, a theology of presence more generally, or rather a theology of presence more *particularly*, which lays hold of God's presence in the world incarnationally, might better serve a placed theology of the arts. That concrete universal who has made himself flesh for us in an act of service and love suggests that placement in the world is a matter of *becoming actively present* to it, dwelling in and acting in love to make and transform the places to which we have been called. As such, our theology of the arts must contend with and model this active presence, understanding the role of art in all its dimensions in place— including its making beautiful, its critique and revolution, its affirmation or transformation—as participating in that incarnational work of God in the world, becoming present and placed so as to turn the world the upside down, to displace us in order to transform and reimplace us.

Action. Presence, then, filters into action. A theology of presence cannot remain static but suggests a dynamic working in the world. In addition to advocating for the presence of art in our lives, I have suggested that art is also

active, motivating us to be participants in the story of creation and redemption and forming our loves to better live and act in the world. As they enable our imaginative life, the arts filter into our active dispositions and ethical responses to the world, motivating our sense of responsibility and calling in the natural world, our practice of hospitality in the home, our sense of belonging and place in the church, and our work in the kingdom of God through social justice and placed hospitality in society.

In addition to its being considered a context or place of presence, art might also be a paradigmatic form of place*making*, a manner in which to actively respond to and transform the places around us and enabling us in both our creative homesteading and our redemptive homecoming in the world. Art, then, as Wolterstorff advocates, is at its core an object and instrument of action in the world, its purpose being neither solely for disinterested contemplation nor for elitist culture apart from life or nature. Art is entangled in all the parts of our lives, as I have attempted to show, whether those images and objects are hung on the walls of an art gallery, painted on the side of a building, or laid on the top of a guest bed in the home. As such, they function in all sorts of ways and largely in what I have summarized as forms of placemaking—practiced, creative, and imaginative responses to the places in which we are put.

In this manner I have suggested that art also teaches us to love, our sense of place being defined as *love* of place, which is an attitude and response that is *simultaneously perceptive and active*. As an invitation to and act of love, the arts baptize us into ethical response and understanding of true presence, forming in us a placed imagination grounded in the love of God, which allows for and sustains our continual journey of displacement and reimplacement that is the Christian life. Until heaven and earth are made new, we are never fully placed, justice is never fully served, and hospitality never fully practiced. But we see glimpses and glances at the fullness of God's kingdom, stones rolled back in hopeful expectation of the world fully redeemed. We might model our placemaking practices after this kenotic act of love, the pouring out of the self into the world for the sake of relationship. A placed theology of the arts, then, is fully relational, not only in its understanding of the art form itself—relationality being understood as response and communion among artist, materials, and audience—but also in terms of the wider religious

significance of the arts as they potentially body forth our relationships to one another, God, and the world that await those moments of hospitable exchange.

These dynamics reveal that a placed theology of the arts in the Christian life must at once be creational and christological while at the same time being properly trinitarian and eschatologically oriented. Not only does the story of Scripture reveal the values by which we live our lives in the world, but it also provides a lens through which to understand its established telos and our proper place within it. As the arts create contexts and make places for us that reveal these creational and redemptive ends, they can be understood to be part and parcel of what it means to be human, cultivating beauty and motivating us to ethical action in all the places of our lives. But as we have seen, these dynamics must always recognize their relationship to place, growing from our dwelling in the world and taking us on a journey of displacement so as to understand that our telos in the kingdom of God is one of reimplacement where we may finally feel at home. The arts, therefore, actively invite us to experience both a sense of home and homelessness, of locatedness and dislocatedness, enabling us to recognize what it means that we live in a time of the already but not yet. As such, they give us a context in which to actively practice our faith, a place from which to embark with hopeful imagination, and a ground for the extension of our love into the world as we model our sense of place after Christ's own, an obedient and loving response to the calling of God in creation and an active working out of that calling in particular moments of encounter in all the places of the world.

Conclusion

In April 1888, Vincent van Gogh wrote to Emile Bernard: "The imagination is certainly a faculty which we must develop, one which alone can lead us to the creation of a more exalting and consoling nature than the single brief glance at reality . . . can let us perceive. A starry night sky, for instance—look, that is something I should like to try to do."[1] In June of the following year, van Gogh completed his famous *Starry Night*, transforming the imaginations of future viewers and inviting them to perceive the reality of the world differently, to open up their hearts and minds to beauty, transcendence, and wonder. This imaginative portrayal of the world through bright colors and impastoed brushstrokes suggests the possibilities of art for cultivating a theological imagination and sense of place. Van Gogh calls our attention to God's presence in the little French town, the church steeple that reaches into the starry heavens reminiscent of those from van Gogh's own Holland home. Van Gogh could never escape his sense of rootedness in the world, which allowed him to call our attention to it in new and often transformational ways.

The liturgies of the contemporary world often teach us dispositions of self-centeredness and quick consumption, failing to train us in perception of the grace and beauty of the world around us. Artists such as van Gogh and the many contemporary artists explored throughout this book lead us to a new understanding of the world we reside in by reenchanting or recontextualizing it, by paying attention to it, or by revising the platform from which we view our places and others'. If we return to the questions with which we began—Why place? Why art?—we will see, on conclusion, that as embodied, creative creatures of God we cannot live well without either. The manner in which our

[1]Vincent van Gogh, *The Complete Letters of Vincent Van Gogh, with Reproductions of All the Drawings in the Correspondence* (Boston: Bulfinch, 2000), 3:478.

lives take shape is profoundly placed, and the development of our loves and imagination within those places will be paramount to the responsible cultivation of the Christian life.

Certainly much more is required of Christian living than trips to the art museum, supporting public art, or crafting a hospitable space of the home. But when we consider our phenomenological experience of the world, we must recognize that the images and places that surround us also make us who we are. We must then make our spaces into places that will make us better stewards of God's resources, more open to the strangers in our midst, more aware of God's presence in our communities, and more just in our dealings with others in society. On this Christian pilgrimage, our encounters with God and with one another in those places might be aesthetically shaped along the way, the arts attuning us to the beauty and particularity of God's creation and molding us with a proleptic sense of place that, both imaginatively and actively, motivates the creation of hospitable places together *in this world* that anticipate our life together in a fully emplaced kingdom economy.

Bibliography

Adamson, Glenn. *The Invention of Craft*. London: Bloomsbury Academic, 2013.

Ahmad, Noreen. "Ai Weiwei, 2016: Roots and Branches." Lisson Gallery press release. 2016.

Alexander, Kathryn B. *Saving Beauty: A Theological Aesthetics of Nature*. Minneapolis: Fortress, 2014.

Allen, John S. *Home: How Habitat Made Us Human*. New York: Basic Books, 2015.

Arnett, Paul, et al., eds. *Gee's Bend: The Architecture of the Quilt*. Atlanta: Tinwood Books, 2006.

"Art in the Cathedral." Liverpool Cathedral. Accessed March 16, 2018. www.liverpool cathedral.org.uk/home/about-us/art-in-the-cathedral.aspx.

Art in the Twenty-First Century. Season 7, episode "Legacy." Series created by Susan Dowling and Susan Sollins. Aired Nov. 7, 2014, on PBS.

Augé, Marc. *Non-Places: An Introduction to Supermodernity*. London: Verso, 1995.

Austin, J. L. *How to Do Things with Words*. Cambridge, MA: Harvard University Press, 1975.

Baal-Teshuva, Jacob. *Christo and Jeanne-Claude*. New York: Taschen, 2016.

Bachelard, Gaston. *The Poetics of Space*. Boston: Beacon, 1969.

Balthasar, Hans Urs von. *Engagement with God*. San Francisco: Ignatius, 2008.

———. *The Glory of the Lord: A Theological Aesthetics*. Vol. 1, *Seeing the Form*. New York: Ignatius, 1983.

———. *The Glory of the Lord: A Theological Aesthetics*. Vol. 7, *Theology: The New Covenant*. Edited by Joseph Fessio, SJ, and John Riches. San Francisco: Ignatius, 1989.

———. *Mysterium Paschale*. San Francisco: Ignatius, 1990.

———. *The Word Made Flesh*. Explorations in Theology 1. San Francisco: Ignatius, 1989.

Barker, Margaret. *Temple Theology: An Introduction*. London: SPCK, 2004.

Barth, Karl. *Church Dogmatics*. Vol. 2, part 1, *The Doctrine of God*. London: T&T Clark International, 1957.

———. *Ethics*. Edited by Dietrich Braun. Translated by Geoffrey W. Bromiley. New York: Seabury, 1981.

Bartholomew, Craig G. *Where Mortals Dwell: A Christian View of Place for Today*. Grand Rapids: Baker Academic, 2011.

Bauckham, Richard. *Bible and Ecology: Rediscovering the Community of Creation*. Waco, TX: Baylor University Press, 2010.

———. *Bible and Mission: Christian Witness in a Postmodern World*. Grand Rapids: Baker Academic, 2003.

———. *Jesus and the God of Israel: God Crucified and Other Studies on the New Testament's Christology of Divine Identity*. Grand Rapids: Eerdmans, 2008.

Bauckham, Richard, and Trevor Hart. *Hope Against Hope: Christian Eschatology at the Turn of the Millennium*. Grand Rapids: Eerdmans, 1999.

Baumgarten, Alexander Gottlieb. *Aesthetica*. Hildesheim: G. Olms, 1961.

Beale, G. K. *The Temple and the Church's Mission: A Biblical Theology of the Dwelling Place of God*. Downers Grove, IL: InterVarsity Press, 2004.

Beardsley, John, et al. *The Quilts of Gee's Bend*. Atlanta: Tinwood Books, 2002.

Begbie, Jeremy S. *Theology, Music and Time*. Cambridge: Cambridge University Press, 2000.

———. *Voicing Creation's Praise: Towards a Theology of the Arts*. London: Continuum, 1991.

Bell, Clive. *Art*. New York: Putnam, Capricorn, 1958.

Benson, Bruce. *Liturgy as a Way of Life: Embodying the Arts in Christian Worship*. Grand Rapids: Baker Academic, 2013.

Berry, Wendell. *The Art of the Commonplace: The Agrarian Essays of Wendell Berry*. Emeryville, CA: Shoemaker & Hoard, 2002.

———. *A Continuous Harmony: Essays Cultural and Agricultural*. Washington, DC: Shoemaker & Hoard, 1972.

———. *The Gift of Good Land*. Washington, DC: Counterpoint, 2009.

———. *Hannah Coulter*. Berkeley: Counterpoint, 2004.

———. *Home Economics*. Berkeley: Counterpoint, 1987.

———. *It All Turns on Affection: The Jefferson Lecture and Other Essays*. Berkeley: Counterpoint, 2012.

———. *Life Is a Miracle: An Essay Against Modern Superstition*. Berkeley: Counterpoint, 2000.

———. *The Selected Poems of Wendell Berry*. Washington, DC: Counterpoint, 1998.

———. *Sex, Economy, Freedom, & Community*. New York: Pantheon Books, 1993.

———. *Standing by Words*. San Francisco: North Point, 1983.

———. *A Timbered Choir: The Sabbath Poems 1979–1997*. Washington, DC: Counterpoint, 1998.

———. *The Unsettling of America*. San Francisco: Sierra Club Books, 1977.

————. *The Way of Ignorance and Other Essays*. Washington, DC: Shoemaker & Hoard, 2005.

————. *What Are People For?* New York: North Point, 1990.

Blenkinsopp, Joseph. *The Pentateuch: An Introduction to the First Five Books of the Bible.* London: SCM Press, 1992.

Botton, Alain de. *The Architecture of Happiness.* New York: Pantheon Books, 2006.

Bouma-Prediger, Steven, and Brian J. Walsh. *Beyond Homelessness: Christian Faith in a Culture of Displacement.* Grand Rapids: Eerdmans, 2008.

Bourdieu, Pierre. *Outline of a Theory of Practice.* Translated by Richard Nice. Cambridge: Cambridge University Press, 1977.

Bowden, Sandra. "Collecting as Calling." *SEEN* 16, no. 2 (2016): 2-5.

Brehmer, Debra. "How Kerry James Marshall Rewrites Art History." *Hyperallergic.* July 12, 2016. https://hyperallergic.com/310477/how-kerry-james-marshall-rewrites-art-history/.

Brook, Isis. "Craft Skills and Their Role in Healing Ourselves and the World." *Making Futures* 1 (2011): 304-11.

Brown, David. *The Divine Trinity.* London: Duckworth, 1985.

————. *God and Enchantment of Place: Reclaiming Human Experience.* Oxford: Oxford University Press, 2004.

Brown, Frank Burch. *Religious Aesthetics: A Theological Study of Making and Meaning.* Princeton, NJ: Princeton University Press, 1989.

Brueggemann, Walter. *The Land: Places as Gift, Promise, and Challenge in Biblical Faith.* 2nd ed. Minneapolis: Fortress, 1989.

————. *Theology of the Old Testament: Testimony, Dispute, Advocacy.* Minneapolis: Fortress, 1997.

Bryson, Bill. *At Home: A Short History of Private Life.* New York: Doubleday, 2010.

Buechner, Frederick. "The Longing for Home." In *The Longing for Home*, edited by Leroy S. Rouner, 63-78. Notre Dame, IN: University of Notre Dame Press, 1997.

Burke, Trevor J. "The Parable of the Prodigal Father: An Interpretive Key to the Third Gospel (Luke 15:11-32)." *Tyndale Bulletin* 64, no. 2 (2013): 217-38.

Burtynsky, Edward. "Exploring the Residual Landscape." Accessed March 15, 2018. www.edwardburtynsky.com/site_contents/About/introAbout.html.

Buttimer, Anne. "Home, Reach and the Sense of Place." In *The Human Experience of Space and Place*, edited by Anne Buttimer and David Seamon, 166-87. London: Croom Helm, 1980.

Casey, Edward S. *Earthmapping: Artists Reshaping Landscape.* Minneapolis: University of Minnesota Press, 2005.

———. *The Fate of Place: A Philosophical History*. Berkeley: University of California Press, 1998.

———. *Getting Back into Place: Toward a Renewed Understanding of the Place-World*. Bloomington: Indiana University Press, 1993.

———. *Remembering: A Phenomenological Study*. Bloomington: Indiana University Press, 2000.

Cavanaugh, William T. *Being Consumed: Economics and Christian Desire*. Grand Rapids: Eerdmans, 2008.

———. *Theopolitical Imagination: Discovering the Liturgy as a Political Act in an Age of Global Consumerism*. London: T&T Clark, 2002.

Certeau, Michel de. *The Practice of Everyday Life*. Berkeley: University of California Press, 1984.

Chapp, Larry. "Revelation." In *The Cambridge Companion to Hans Urs von Balthasar*, edited by Edward T. Oakes, SJ, and David Moss, 11-23. Cambridge: Cambridge University Press, 2004.

Childs, Brevard S. *Exodus: A Commentary*. London: SCM Press, 1974.

Chinn, Nancy. *Spaces for the Spirit: Adorning the Church*. Chicago: Liturgy Training Publications, 1998.

Clements, R. E. *God and Temple*. Oxford: Basil Blackwell, 1965.

"Cologne Cathedral Window." Gerhard Richter. Accessed March 16, 2018. www .gerhard-richter.com/en/art/other/glass-and-mirrors-105/cologne-cathedral -window-14890/?p=1.

Crawford, Matthew B. *Shop Class as Soul Craft: An Inquiry into the Value of Work*. New York: Penguin, 2009.

Creates, Marlene. "Artist's Statement." In *Places of Presence: Newfoundland Kin and Ancestral Land, Newfoundland 1989–1991*, 5-6. St. John's, Newfoundland: Killick, 1997.

———. "Nature Is a Verb to Me." In *Rephotographing the Land*, 9-10. Halifax, Nova Scotia: Dalhousie Art Gallery, Dalhousie University, 1992.

Crouch, Andy. "The Gospel: How Is Art a Gift, a Calling, and an Obedience?" In *For the Beauty of the Church*, edited by W. David O. Taylor, 29-43, Grand Rapids: Baker Books, 2010.

Crowther, Paul. *Art and Embodiment: From Aesthetics to Self-Consciousness*. Oxford: Clarendon, 1993.

Davies, Oliver. "The Theological Aesthetics." In *The Cambridge Companion to Hans Urs von Balthasar*, edited by Edward T. Oakes, SJ, and David Moss. Cambridge: Cambridge University Press, 2004.

Davies, W. D. *The Gospel and the Land: Early Christianity and Jewish Territorial Doctrine.* Berkeley: University of California Press, 1974.

Davis, Ellen. *Scripture, Culture, and Agriculture: An Agrarian Reading of the Bible.* Cambridge: Cambridge University Press, 2008.

Dean, Tacita, and Jeremy Millar. *Art Works: Place.* London: Thames & Hudson, 2005.

Dissanayake, Ellen. *What Is Art For?* Seattle: University of Washington Press, 1988.

Dixon, John W. *Nature and Grace in Art.* Chapel Hill: University of North Carolina Press, 1964.

Duncan, Sally Anne. "Reinventing Gee's Bend Quilts in the Name of Art." In *Sacred and Profane: Voice and Vision in Southern Self-Taught Art,* edited by Carol Crown and Charles Russell, 191-213. Jackson: University Press of Mississippi, 2007.

Dunn, James D. G. *The Theology of Paul the Apostle.* Grand Rapids: Eerdmans, 1998.

Dyrness, William A. *Poetic Theology: God and the Poetics of Everyday Life.* Grand Rapids: Eerdmans, 2011.

———. *Senses of the Soul: Art and the Visual in Christian Worship* Eugene, OR: Cascade Books, 2008.

———. *Visual Faith: Art, Theology, and Worship in Dialogue.* Grand Rapids: Baker Academic, 2001.

Eliade, Mircea. *The Sacred and the Profane: The Nature of Religion.* Orlando: Harcourt Brace, 1987.

Eliav, Yaron Z. *God's Mountain: The Temple Mount in Time, Place and Memory.* Baltimore: Johns Hopkins University Press, 2005.

Eliot, T. S. *Four Quartets.* Orlando: Harcourt, 1971.

———. *The Poems of T. S. Eliot: Practical Cats and Further Verses.* Edited by Christopher Ricks and Jim McCue. Vol. 2. Baltimore: Johns Hopkins University Press, 2015.

Fiddes, Paul. *The Creative Suffering of God.* London: Clarendon, 1992.

Fleming, Ronald Lee. *The Art of Placemaking: Interpreting Community Through Public Art and Urban Design.* London: Merrel, 2007.

Food and Agricultural Organization of the United Nations. *Food Wastage Footprint: Impacts on Natural Resources Summary Report.* Natural Resource Management and Environmental Department, 2013. www.fao.org/docrep/018/i3347e/i3347e.pdf.

Forest, Jim. "Through Icons: Word and Image Together." In *Beholding the Glory: Incarnation Through the Arts,* edited by Jeremy S. Begbie, 83-97. Grand Rapids: Baker Books, 2000.

Francis, Pope. *Laudato Si—On Care for Our Common Home.* Encyclical of the Roman Catholic Church. Our Sunday Visitor, 2015.

Freedman, David Noel, ed. *The Anchor Bible Dictionary*. New York: Doubleday, 1992.

Fretheim, Terence E. *Exodus*. Louisville: John Knox, 1991.

———. *God and World in the Old Testament: A Relational Theology of Creation*. Nashville: Abingdon, 2005.

Fry, Jacqueline. *The Distance Between Two Points Is Measured in Memories, Labrador 1988*. North Vancouver, British Columbia: Presentation House Gallery, 1990.

Fujimara, Makoto. *Culture Care: Reconnecting with Beauty for Common Life*. Downers Grove, IL: InterVarsity Press, 2017.

Garneau, David and Peter von Tiesenhausen. *Deluge*. Leithbridge, Alta.: Southern Alberta Art Gallery, 2000.

Garvey, Susan Gibson. *Marlene Creates: Landworks 1979–1991*. St. Johns, Newfoundland: Art Gallery, University of Newfoundland, 1993.

———. "Rephotographing the Land." Halifax, Nova Scotia: Dalhousie Art Gallery, Dalhousie University, 1992.

Geertz, Clifford. *Local Knowledge: Further Essays in Interpretative Anthropology*. London: Fontana, 1993.

George, Mark K. *Israel's Tabernacle as Social Space*. Atlanta: Society of Biblical Literature, 2009.

Gogh, Vincent van. *The Complete Letters of Vincent Van Gogh, with Reproductions of All the Drawings in the Correspondence*. Vol. 3. Boston: Bulfinch, 2000.

Gorringe, T. J. *The Common Good and the Global Emergency: God and the Built Environment*. Cambridge: Cambridge University Press, 2011.

———. *Discerning Spirit: A Theology of Revelation*. London: SCM Press, 1990.

———. *Earthly Visions: Theology and the Challenges of Art*. New Haven, CT: Yale University Press, 2011.

Gorringe, Timothy. *A Theology of the Built Environment: Justice, Empowerment, Redemption*. Cambridge: Cambridge University Press, 2002.

Greer, Betsy. "Craftivist History." In *Extra/Ordinary: Craft and Contemporary Art*, edited by Maria Elena Buszek, 175-240. Durham, NC: Duke University Press, 2011.

Grieb, A. Katherine. *The Story of Romans: A Narrative Defense of God's Righteousness*. Louisville: Westminster John Knox, 2002.

Gross, Bobby. "To Have and to (Be)Hold: A Personal Reflection on Collecting Art." *SEEN* 16, no. 2 (2016): 6-8.

Gross, Edie. "A Congregation Deepens Worship with Collaborative Visual Displays." *Faith and Leadership*, 2015. www.faithandleadership.com/congregation-deepens -worship-collaborative-visual-displays.

Grubbs, Morris Allen, ed. *Conversations with Wendell Berry*. Jackson: University Press of Mississippi, 2007.

Gruchy, John W. de. *Christianity, Art and Transformation: Theological Aesthetics in the Struggle for Justice.* Cambridge: Cambridge University Press, 2001.

Gunton, Colin. "Creation and Re-creation: An Exploration of Some Themes in Aesthetics and Theology." *Modern Theology* 2, no. 1 (1985): 1-19.

Guthrie, Steven R. *Creator Spirit: The Holy Spirit and the Art of Becoming Human.* Grand Rapids: Baker Academic, 2011.

Habets, Myk. *Theosis in the Theology of Thomas Torrance.* London: Routledge, 2009.

Hall, Douglas J. "Stewardship as Key to a Theology of Nature." In *Environmental Stewardship: Critical Perspectives Past and Present*, edited by R. J. Berry, 129-44. London: T&T Clark, 2006.

Hamilton, Victor P. *The Book of Genesis: Chapters 1–17.* Grand Rapids: Eerdmans, 1990.

———. *The Book of Genesis: Chapters 18–50.* Grand Rapids: Eerdmans, 1995.

Harries, Karsten. *The Ethical Function of Architecture.* Cambridge, MA: MIT Press, 1997.

Hart, Trevor. *Between the Image and the Word: Theological Engagements with Imagination, Language and Literature.* Dorchester, UK: Henry Ling Limited, 2013.

———. "Creative Imagination and Moral Identity." *Studies in Christian Ethics* 16, no. 1 (2003): 1-13.

———. *Making Good: Creation, Creativity, and Artistry.* Waco, TX: Baylor University Press, 2014.

———. "Migrants Between Nominatives: Ethical Imagination and a Hermeneutics of Lived Experience." *Theology in Scotland* 6, no. 2 (1999): 31-44.

———. *Regarding Karl Barth: Toward a Reading of His Theology.* Eugene, OR: Wipf and Stock, 1999.

———. "Through the Arts: Hearing, Seeing and Touching the Truth." In *Beholding the Glory: Incarnation Through the Arts*, edited by Jeremy Begbie, 1-26. Grand Rapids: Baker Books, 2000.

Harvey, David. *Social Justice and the City.* Rev. ed. Athens: University of Georgia Press, 2009.

Hauck, F. "μένω." In *Theological Dictionary of the New Testament.* Edited by Gerhard Kittel, Translated by Geoffrey W. Bromiley. Vol. 4: 576. Grand Rapids: Eerdmans, 1967.

Hayes, Shannon. *Radical Homemakers: Reclaiming Domesticity from a Consumer Culture.* Richmondville, NY: Left to Write Publishers, 2010.

Hays, Richard B. *The Moral Vision of the New Testament: A Contemporary Introduction to New Testament Ethics.* New York: HarperOne, 1996.

Healy, Nicholas, and David L. Schindler. "For the Life of the World: Hans Urs von Balthasar on the Church as Eucharist." In *The Cambridge Companion to Hans Urs von Balthasar*, edited by Edward T. Oakes, SJ, and David Moss, 51-63. Cambridge: Cambridge University Press, 2004.

Heidegger, Martin. *Poetry, Language, Thought*. New York: HarperCollins, 1971.

Homer. *The Odyssey*. Translated by Robert Fagles. New York: Penguin Classics, 1999.

Inge, John. *A Christian Theology of Place*. New York: Routledge, 2016.

Jacobs, Jane. *The Death and Life of Great American Cities*. Harmondsworth, UK: Penguin, 1972.

Jacobson, Eric O. *The Space Between: A Christian Engagement with the Built Environment*. Grand Rapids: Baker Academic, 2012.

Jensen, Robin Margaret. *The Substance of Things Seen: Art, Faith, and the Christian Community*. Grand Rapids: Eerdmans, 2004.

St. John of Damascus. *On the Divine Images: Three Apologies Against Those Who Attack the Divine Images*. Translated by David Anderson. Crestwood, NY: St. Vladimir's Seminary Press, 1980.

Johnson, Mark. *Body in the Mind: The Bodily Basis of Meaning, Imagination, and Reason*. Chicago: University of Chicago Press, 1987.

———. *The Meaning of the Body: Aesthetics of Human Understanding*. Chicago: University of Chicago Press, 2008.

Jones, Catherine. "Tracey Emin Loves New Liverpool Cathedral Artwork." *Liverpool Echo*. September 19, 2008. www.liverpoolecho.co.uk/news/liverpool-news/tracey-emin-loves-new-liverpool-3472750.

Jones, David. "Art and Sacrament." In *Artist and Epoch: Selected Writings by David Jones*, edited by Harman Grisewood, 143-79. London: Faber and Faber, 1959.

Kalina, R. "Gee's Bend Modern." *Art in America* 91, no. 10 (2003): 104-9, 148-49.

Kant, Immanuel, and J. H. Bernard. *Critique of Judgment*. New York: Hafner, 1966.

Keefe, Stephen. "This Canadian Artist Halted Pipeline Development by Copyrighting His Land as a Work of Art." *VICE*. Nov. 6, 2014. www.vice.com/read/this-canadian-artist-halted-pipeline-development-by-copyrighting-his-land-as-a-work-of-art-983.

Kidwell, Jeremy H. *The Theology of Craft and the Craft of Work: From Tabernacle to Eucharist*. London: Routledge, 2016.

Kilde, Jeanne Halgren. *Sacred Power, Sacred Space: An Introduction to Christian Architecture and Worship*. Oxford: Oxford University Press, 2008.

Kimmelman, Michael. "Art Review: Jazzy Geometry, Cool Quilters." *New York Times*. Nov. 29, 2002. www.nytimes.com/2002/11/29/arts/art-review-jazzy-geometry-cool-quilters.html.

Klassen, Teri. "Review of Gee's Bend: The Architecture of the Quilt." *Museum Anthropology Review* 2, no. 2 (Fall 2008): 124-26.

Kristeller, Paul Oskar. *Renaissance Thought 2: Papers on Humanism and the Arts*. New York: Harper & Row, 1965.

Kunstler, James Howard. *The Geography of Nowhere: The Rise and Decline of America's Man-Made Landscape*. New York: Simon and Schuster, 1993.

———. *Home from Nowhere: Remaking Our Everyday World for the Twenty-First Century*. New York: Simon and Schuster, 1998.

Lakoff, George, and Mark Johnson. *Metaphors We Live By*. Chicago: University of Chicago Press, 1980.

Lane, Belden C. *Landscapes of the Sacred: Geography and Narrative in American Spirituality*. Expanded ed. Baltimore: Johns Hopkins University Press, 2001.

Leax, John. "Memory and Hope in the World of Port William." In *Wendell Berry: Life and Work*, edited by Jason Peters, 66-75. Lexington: University of Kentucky Press, 2007.

Lefebvre, Henri. *The Production of Space*. Translated by Donald Nicholson-Smith. Oxford: Blackwell, 1991.

Levenson, Jon D. *Creation and the Persistence of Evil: The Jewish Drama of Divine Omnipotence*. Princeton, NJ: Princeton University Press, 1988.

———. "The Temple and the World." *The Journal of Religion* 64, no. 3 (July 1984): 275-98.

Lippard, Lucy R. *The Lure of the Local: Senses of Place in a Multicentered Society*. New York: New Press, 1997.

Lucie-Smith, Edward. *The Story of Craft: The Craftsman's Role in Society*. Oxford: Phaidon, 1981.

Lundin, Roger. "The Beauty of Belief." In *The Beauty of God: Theology and the Arts*, edited by Mark Husbands, Daniel Treier, and Roger Lundin, 184-208. Downers Grove, IL: IVP Academic, 2007.

MacDonald, Nathan. "The *Imago Dei* and Election: Reading Genesis 1:26-28 and Old Testament Scholarship with Barth." *International Journal of Systematic Theology* 10, no. 3 (July 2008): 303-27.

Malpas, J. E. *Place and Experience: A Philosophical Topography*. Cambridge: Cambridge University Press, 1999.

Marcus, Clare Cooper. *House as a Mirror of Self: Exploring the Deeper Meaning of Home*. Berkeley: Conari, 1995.

Marshall, Kerry James, and Terrie Sultan. "Notes on Career and Work." In *Kerry James Marshall*, 113-23. New York: Harry N. Abrams, 2000.

Mason, Wyatt. "Kerry James Marshall Is Shifting the Color of Art History." *New York Times Style Magazine*. October 17, 2016. www.nytimes.com/2016/10/17/t-magazine/kerry-james-marshall-artist.html.

Massey, Doreen. *Space, Place, and Gender*. Minneapolis: University of Minnesota Press, 1994.

McCullough, James. *Sense and Spirituality: The Arts and Spiritual Formation* Eugene, OR: Cascade Books, 2015.

McNutt, David. "Finding Its Place: How Karl Barth's Ecclesiology Can Help the Church Embrace Contemporary Art." In *Contemporary Art and the Church*, edited by W. David O. Taylor and Taylor Worley, 159-170. Downers Grove, IL: IVP Academic, 2017.

Merleau-Ponty, Maurice. *The Phenomenology of Perception*. London: Routledge & Kegan Paul, 1962.

Merton, Thomas. *No Man Is an Island*. New York: Barnes and Noble Books, 2003.

Michaelis, Wilhelm. "σκηνόω." In *Theological Dictionary of the New Testament*. Edited by Gerhard Friedrich. Translated by Geoffrey W. Bromiley. Vol. 7: 386. Grand Rapids: Eerdmans, 1971.

Michel, Jen Pollock. *Keeping Place: Reflections on the Meaning of Home*. Downers Grove, IL: InterVarsity Press, 2017.

Miles, Malcolm. *Art, Space, and the City: Public Art and Urban Futures*. London: Routledge, 1997.

Miles, Margaret. *Image as Insight: Visual Understanding in Western Christianity and Secular Culture*. Boston: Beacon, 1985.

Molesworth, Helen. "Thinking of a Mastr Plan: Kerry James Marshall and the Museum." In *Mastry*, edited by Helen Molesworth, 27-43. New York: Skira Rizzoli, 2016.

Moltmann, Jürgen. *God in Creation*. Minneapolis: Fortress, 1993.

———. "God's Kenosis in the Creation and Consummation of the World." In *The Work of Love: Creation as Kenosis*, edited by John Polkinghorne, 137-51. Grand Rapids: Eerdmans, 2001.

Morgan, David. *The Embodied Eye: Religious Visual Culture and the Social Life of Feeling*. Berkeley: University of California Press, 2012.

Moses, Monica. "Faith in Craft." *American Craft Magazine*, Issue 2, Volume 74 (April/ May 2014). https://craftcouncil.org/magazine/article/faith-craft.

Muir, John. *My First Summer in the Sierra: With Illustrations*. St. Louis: J Missouri, 2013.

Murdoch, Iris. "Metaphysics and Ethics." In *Iris Murdoch and the Search for Human Goodness*, edited by Maria Antonaccio and William Schwiker, 236-52. Chicago: University of Chicago Press, 1996.

Murray, Lesley. "Placing Murals in Belfast: Community, Negotiation and Change." In *The Everyday Practice of Public Art: Art, Space and Social Inclusion*, edited by Cameron Cartiere and Martin Zebracki, 45-62. New York: Routledge, 2016.

Navone, John J., SJ. "Divine and Human Hospitality." *New Blackfriars* 85, no. 997 (May 2004): 329-40.

Neilson, Laura. "One Artist's Long Island Home: A Meditation in White." *New York Times Style Magazine.* September 12, 2016. www.nytimes.com/2016/09/12/t-magazine /art/lia-chavez-artist-long-island-home-tour.html.

Newbigin, Lesslie. *The Open Secret: Sketches for a Missionary Theology.* Grand Rapids: Eerdmans, 1978.

Nichols, Aidan. *The Art of God Incarnate: Theology and Image in Christian Tradition.* London: Darton, Longman and Todd, 1980.

Oakes, Edward T. "The Apologetics of Beauty." In *The Beauty of God: Theology and the Arts,* edited by Mark Husbands, Daniel Treier, and Roger Lundin, 209-26. Downers Grove, IL: IVP Academic, 2007.

O'Connor, Flannery. *Mystery and Manners.* London: Faber and Faber, 1972.

Patai, Raphael. *Man and Temple: In Ancient Jewish Myth and Ritual.* London: Thomas Nelson and Sons, 1947.

Pattison, George. *Art, Modernity and Faith.* London: SCM Press, 1998.

———. "Is the Time Right for a Theological Aesthetics?" In *Theological Aesthetics After von Balthasar,* edited by O. V. Bychkov and James Fodor, 107-14. Aldershot, UK: Ashgate, 2008.

Perrin, Nicholas. *Jesus the Temple.* Grand Rapids: Baker Academic, 2010.

Peterson, Karin Elizabeth. "Discourse and Display: The Modern Eye, Entrepreneurship, and the Cultural Transformation of the Patchwork Quilt." *Sociological Perspectives* 46, no. 4 (2003): 461-90.

Pinnock, Clark H. *Most Moved Mover: A Theology of God's Openness.* Grand Rapids: Baker Academic, 2001.

Pinnock, Clark, et al. *The Openness of God: A Biblical Challenge to the Traditional Understanding of God.* Downers Grove, IL: InterVarsity Press, 1994.

Pogrebin, Robin. "Ai Weiwei Melds Art and Activism in Shows About Displacement." *New York Times.* October 20, 2016. www.nytimes.com/2016/10/21/arts/design /ai-weiwei-melds-art-and-activism-in-shows-about-displacement.html.

Pohl, Christine D. *Making Room: Recovering Hospitality as a Christian Tradition.* Grand Rapids: Eerdmans, 1999.

Polanyi, Michael. *The Tacit Dimension.* New York: Anchor Books, 1967.

Polkinghorne, John. *Science and Providence: God's Interaction with the World.* Philadelphia: Templeton Foundation Press, 1989.

Pollan, Michael. *A Place of My Own: The Architecture of Daydreams.* London: Penguin Books, 2008.

———. *The Omnivore's Dilemma: A Natural History of Four Meals.* New York: Penguin, 2007.

Pollio, Vitruvius. *The Ten Book of Architecture*. Huntington, WV: Empire Books, 2011.

Pople, Kenneth. *Stanley Spencer: A Biography*. London: HarperCollins, 1991.

Povoledo, Elisabetta. "Christo's Newest Project: Walking on Water." *New York Times*. June 16, 2016. www.nytimes.com/2016/06/17/arts/design/christos-newest-project -walking-on-water.html.

Pugin, A. Welby. *The True Principles of Pointed or Christian Architecture*. London: Academy Editions, 1973.

Pye, David. *The Nature and Aesthetics of Design*. New York: Van Nostrand Reinhold, 1978.

Quash, Ben. "Contemporary Art and the Church." Keynote address, Christian in the Visual Arts Conference, Grand Rapids, Calvin College, 2015.

———. *Found Theology: History, Imagination, and the Holy Spirit*. London: Bloomsbury, 2013.

Rad, Gerhard von. *Genesis: A Commentary*. Translated by John H. Marks. London: SCM Press, 1961.

———. *Old Testament Theology: The Theology of Israel's Historical Traditions*. Vol. 1. Edinburgh: Oliver and Boyd, 1962.

Rae, Murray A. *Architecture and Theology: The Art of Place*. Waco, TX: Baylor University Press, 2017.

Reinhold, H. A. *Liturgy and Art*. New York: Harper & Row, 1966.

Relph, Edward. *Place and Placelessness*. London: Pion Limited, 1976.

Richards, Kent Harold. "Bless/Blessing." In *The Anchor Bible Dictionary*, ed. David Noel Freedman, 753-55. New York: Doubleday, 1992.

Ricoeur, Paul. *Memory, History, Forgetting*. Translated by Kathleen Blamey. Chicago: University of Chicago Press, 2004.

Rilke, Rainer Maria. *The Selected Poetry of Rainer Maria Rilke*. Translated by Stephen Mitchell. New York: Vintage International, 1989.

Risatti, Howard. *A Theory of Craft: Function and Aesthetic Expression*. Chapel Hill: University of North Carolina Press, 2007.

Robertson, Kirsty. "Rebellious Doilies and Subversive Stitches: Writing a Craftivist History." In *Extra/Ordinary: Craft and Contemporary Art*, edited by Marina Elena Buszek, 184-203. Durham, NC: Duke University Press, 2011.

Roelstraete, Dieter. "Visible Man: Kerry James Marshall, Realist." In *Mastry*, edited by Helen Molesworth, 47-55. New York: Skira Rizzoli, 2016.

Rookmaaker, Hans. *Art Needs No Justification*. Vancouver: Regent College Publishing, 2010.

Rouner, Leroy S., ed. *The Longing for Home*. Notre Dame, IN: University of Notre Dame Press, 1997.

Rowley, H. H. *The Biblical Doctrine of Election*. London: Lutterworth, 1952.

Ruskin, John. *The Stones of Venice*. Dover ed. 3 vols. Mineola, NY: Dover, 2005.

Rybczynski, Witold. *Home: A Short History of an Idea*. New York: Viking, 1986.

Ryden, Kent. *Mapping the Invisible Landscape: Folklore, Writing, and the Sense of Place*. Iowa City: University of Iowa Press, 1993.

Scarry, Elaine. *On Beauty and Being Just*. Princeton, NJ: Princeton University Press, 1999.

Schaeffer, Francis A. *Art and the Bible*. Downers Grove, IL: InterVarsity Press, 1973.

Schneekloth, Linda H., and Robert G. Shibley. *Placemaking: The Art and Practice of Building Communities*. New York: John Wiley and Sons, 1995.

Schuman, Joel James, and L. Roger Owens, eds. *Wendell Berry and Religion*. Lexington: University Press of Kentucky, 2009.

Schwartz, Joan M. "Constituting Places of Presence: Landscape, Identity and the Geographical Imagination." In *Places of Presence: Newfoundland Kin and Ancestral Land, Newfoundland 1989–1991*, 9-17. St. John's, Newfoundland: Killick, 1997.

Seerveld, Calvin. *Rainbows for a Fallen World: Aesthetic Life and Artistic Task*. Toronto: Toronto Tuppence, 1980.

Sennett, Richard. *The Craftsman*. London: Penguin Books, 2009.

Sheldrake, Philip. *Spaces for the Sacred: Place, Memory and Identity*. London: SCM Press, 2001.

Sherry, Patrick. *Images of Redemption: Art, Literature and Salvation*. London: T&T Clark, 2003.

Silberberg, Susan, et al. *Places in the Making: How Placemaking Builds Places and Communities*. Cambridge, MA: Massachusetts Institute of Technology: Department of Urban Studies and Planning, 2013.

Smith, James K. A. *Awaiting the King: Reforming Public Theology*. Grand Rapids: Baker Academic, 2017.

———. *Desiring the Kingdom: Worship, Worldview, and Cultural Formation*. Grand Rapids: Baker Academic, 2009.

———. *Imagining the Kingdom: How Worship Works*. Grand Rapids: Baker Academic, 2013.

———. "Practicing Presence: Shaping Places That Shape Us." Lecture at Laity Lodge in St. Paul, Art House North, June 2016.

———. *You Are What You Love: The Spiritual Power of Habit*. Grand Rapids: Brazos, 2016.

Smith, Karen, Hans Ulrich Obrist, and Bernard Fibicher. *Ai Weiwei*. London: Phaidon, 2009.

Sommer, Benjamin D. "Conflicting Constructions of Divine Presence in the Priestly Tabernacle." *Biblical Interpretation* 9, no. 1 (2001): 41-63.

Stecker, Robert. "Definition of Art." In *The Oxford Handbook of Aesthetics*, edited by
 Jerrold Levinson, 136-54. Oxford: Oxford University Press, 2005.

Stegner, Wallace. *Where the Bluebird Sings to the Lemonade Springs: Living and Writing
 in the West*. New York: Penguin Books, 1993.

Steiner, George. *After Babel*. Oxford: Oxford University Press, 1992.

Storr, Robert. "Chromophilia and the Interaction of Color." In *Kerry James Marshall:
 Look, See*. London: David Zwirner Books, 2014.

Strathmann, H. "Λατρεία." In *Theological Dictionary of the New Testament*, vol. 4: 58-65.
 Edited by Gerhard Kittel. Translated by Geoffrey W. Bromiley. Grand Rapids:
 Eerdmans, 1968.

———. "Λατρεύω." In *Theological Dictionary of the New Testament*, vol. 4: 58-65. Edited by
 Gerhard Kittel. Translated by Geoffrey W. Bromiley. Grand Rapids: Eerdmans, 1968.

Taylor, Charles. *Modern Social Imaginaries*. Durham, NC: Duke University Press,
 2004.

Terrien, Samuel L. *The Elusive Presence: Toward a New Biblical Theology*. San Francisco:
 Harper & Row, 1978.

Thiessen, Gesa Elsbeth. *Theological Aesthetics: A Reader*. London: SCM Press, 2004.

Tillich, Paul. *On Art and Architecture*. Edited by John Dillenberger and Jane Dillen-
 berger. New York: Crossroad, 1987.

Toews, Ian. "Atacama Desert (Chile) with Edward Burtynsky." In *Landscape as Muse*.
 Season 1, Episode 26, 291 Film Company, 2007.

Tolkien, J. R. R. "On Fairy Stories." In *Tree and Leaf*. London: Unwin, 1964.

Torrance, Thomas F. *The Mediation of Christ*. Exeter, UK: Paternoster, 1983.

———. *Space, Time and Incarnation*. London: Oxford University Press, 1969.

Tuan, Yi-Fu. *Place, Art and Self*. Charlottesville: University of Virginia Press, 2004.

———. *Space and Place: The Perspective of Experience*. London: Edward Arnold, 1977.

———. *Topophilia: A Study of Environmental Perception, Attitudes and Values*. New
 York: Columbia University Press, 1990.

Turner, H. E. W. *Jesus the Christ*. Oxford: Mowbrays, 1976.

Turner, Harold W. *From Temple to Meeting House: The Phenomenology and Theology of
 Places of Worship*. The Hague: Mouton, 1979.

Vanstone, W. H. *Love's Endeavour, Love's Expense: The Response of Being to the Love of
 God*. London: Darton, Longman and Todd, 1977.

———. *The Stature of Waiting*. American ed. New York: Morehouse, 2006.

Vartanian, Hrag. "Ai Weiwei Explores the Scale of Crisis in Four Large Installations."
 Hyperallergic. November 4, 2016. https://hyperallergic.com/335914/ai-weiwei
 -explores-the-scale-of-crisis-in-four-massive-installations/.

Viladesau, Richard. *Theology and the Arts: Encountering God Through Music, Art and Rhetoric.* New York: Paulist, 2000.

Vogel, Carol. "Next from Christo: Art That Lets You Walk on Water." *New York Times.* October 21, 2015. www.nytimes.com/2015/10/25/arts/design/art-that-lets-you-walk-on-water.html.

Volf, Miroslov. *Exclusion and Embrace: A Theological Exploration of Identity, Otherness, and Reconciliation.* Nashville: Abingdon, 1996.

Wainwright, Geoffrey. "Eschatology." In *The Cambridge Companion to Hans Urs von Balthasar,* edited by Edward T. Oakes, SJ, and David Moss, 113-27. Cambridge: Cambridge University Press, 2004.

Walton, John H. *Ancient Near Eastern Thought and the Old Testament: Introducing the Conceptual World of the Hebrew Bible.* Grand Rapids: Baker Academic, 2006.

———. *The Lost World of Genesis One: Ancient Cosmology and the Origins Debate.* Downers Grove, IL: IVP Academic, 2009.

Warnock, Mary. *Imagination and Time.* Oxford: Blackwell, 1994.

———. *Memory.* London: Faber & Faber, 1987.

Watkins, James M. *Creativity as Sacrifice: Toward a Theological Model for Creativity in the Arts.* Emerging Scholars. Minneapolis: Fortress, 2015.

Webster, John. "Balthasar and Karl Barth." In *The Cambridge Companion to Hans Urs von Balthasar,* edited by Edward T. Oakes, SJ, and David Moss. Cambridge: Cambridge University Press, 2004.

Weinfeld, Moshe. *Deuteronomy and the Deuteronomic School.* Oxford: Clarendon, 1972.

Welker, Michael. *Creation and Reality.* Minneapolis: Fortress, 1999.

Westermann, Claus. *Creation.* Translated by John J. Scullion. London: SPCK, 1974.

———. *Genesis 1–11: A Commentary.* London: SPCK, 1984.

White, Lynn, Jr. "The Historical Roots of Our Ecologic Crisis." *Science* 155, no. 3767 (March 10, 1967): 1203-7.

Wilder, Amos N. "Story and Story-World." *Interpretation: A Journal of Bible and Theology* 37, no. 1 (January 1983): 353-64.

Williams, Rowan. "Balthasar and the Trinity." In *The Cambridge Companion to Hans Urs von Balthasar,* edited by Edward T. Oakes, SJ, and David Moss, 37-50. Cambridge: Cambridge University Press, 2004.

———. *Grace and Necessity: Reflections on Art and Love.* London: Continuum, 2005.

———. *On Christian Theology.* Oxford: Blackwell, 2000.

———. "Poetic and Religious Imagination." *Theology* 80 (1977): 178-87.

Wirzba, Norman. *Living the Sabbath: Discovering the Rhythms of Rest and Delight.* Grand Rapids: Brazos, 2006.

———. *The Paradise of God: Renewing Religion in an Ecological Age*. Oxford: Oxford University Press, 2003.

Wolterstorff, Nicholas. *Art in Action: Towards a Christian Aesthetic*. Grand Rapids: Eerdmans, 1980.

———. *Art Rethought: The Social Practices of Art*. New York: Oxford University Press, 2015.

———. "The Work of Making a Work of Music." In *What Is Music? An Introduction to the Philosophy of Music*, edited by Philip Alperson, 103-29. University Park: Pennsylvania State University Press, 1987.

———. *Works and Worlds of Art*. Oxford: Clarendon, 1980.

Wright, N. T. *The New Testament and the People of God*. Minneapolis: Fortress, 1992.

———. *Paul and the Faithfulness of God*. Minneapolis: Fortress, 2013.

———. *Simply Christian*. New York: HarperSanFrancisco, 2006.

Wynn, Mark R. *Faith and Place: An Essay in Embodied Religious Epistemology*. Oxford: Oxford University Press, 2009.

Yablonsky, Linda. "Sound Garden." *New York Times Style Magazine*. March 30, 2012. www.nytimes.com/2012/04/01/t-magazine/doug-aitkens-sound-garden.html.

Zuckerkandl, Victor. *Sound and Symbol: Music and the External World*. London: Routledge & Kegan Paul, 1956.

Image Credits

2.1. Courtesy of Paul Petro Contemporary Art, Toronto. Used by permission of Marlene Creates.

2.2. Courtesy of Peter von Tiesenhausen.

3.1. Used by permission of Jenny Hawkinson.

3.2. Courtesy of Marianne Lettieri. Photo by Aimee Santos.

4.1. Courtesy of Brian Catling.

4.2. Library of Congress, Prints and Photographs Division, HABS ALA,37-BIRM,33—13.

5.1. *Crucifixion* (oil on canvas), Spencer, Stanley (1891–1959) / Private Collection / Bridgeman Images.

Color Insert

1. © Wolfgang Laib, Courtesy Sperone Westwater, New York. Digital Image © The Museum of Modern Art/Licensed by SCALA / Art Resource, NY.

2. Copyright: Christo. Photo: Wolfgang Volz/laif/Redux.

3. Courtesy of Peter von Tiesenhausen.

4. Courtesy of Marianne Lettieri. Photo by Fred Anderson.

5. Pitkin Studio / Art Resource, NY.

6. Photo copyright Julian Stallabrass, Flickr, 2010. CC BY 2.0 (cropped).

7. © Kerry James Marshall. Courtesy of the artist and Jack Shainman Gallery, New York. Digital Image © Museum Associates / LACMA. Licensed by Art Resource, NY.

Author Index

Alexander, Kathryn B., 43-46

Bachelard, Gaston, 71, 76, 114, 149

Balthasar, Hans Urs von, 36-37, 39-40, 134-35, 141, 147-48, 168-69, 178, 209, 218

Barth, Karl, 138-39, 148-49, 162, 172

Bartholomew, Craig G., 26, 138, 168, 172, 201-2

Bauckham, Richard, 25-26, 32, 34, 137

Beale, G. K., 125-27, 134

Begbie, Jeremy S., 18-19, 33-34, 43, 120, 148-49, 177, 203, 224

Benson, Bruce, 142, 146

Berry, Wendell, 3, 7, 12, 19-20, 27, 42, 46, 64-65, 67, 75, 77, 93, 116-17, 120-21, 148, 216

Bouma-Prediger, Steven, 63, 151, 170-71, 188-90

Bourdieu, Pierre, 15-16, 20, 22, 52, 141, 206, 218

Brown, David, 8, 46, 130, 227

Brown, Frank Burch, 145-46, 204, 212, 224

Brueggemann, Walter, 9-10, 32-33, 74, 76

Casey, Edward S., 8, 10, 56-57, 76-77, 84-86, 112, 132, 134, 138-39, 151, 170, 211

Cavanaugh, William T., 78, 101, 138, 189, 208-9

Certeau, Michel de, 9, 78, 202

Crouch, Andy, 88, 215-17

Davis, Ellen, 28-29, 31-32, 75-76, 78, 81

De Gruchy, John W., 43, 120, 178-80, 219

Dixon, John W., 201, 206, 223-24

Dyrness, William A., 129, 140, 149-50, 153, 214

Eliot, T. S., 25, 151

Fretheim, Terence E., 27, 32, 34, 46, 126, 132

Fujimura, Makoto, 86, 216

Geertz, Clifford, 211-12

George, Mark K., 131-32, 143

Gorringe, Timothy, 11, 46, 74, 106, 128, 130, 169-70, 175-76, 178-79, 183, 191, 196, 217, 219, 222-23

Greer, Betsy, 99-100

Hart, Trevor, 42, 44, 46, 58, 86, 89, 91, 93, 97-98, 117, 138, 176-77, 203, 214-15, 224-25

Hays, Richard B., 170-71, 183

Heidegger, Martin, 10, 65, 144, 202, 212

Inge, John, 10, 75, 84, 125, 130, 132, 170

Jacobs, Jane, 72, 173, 175-76, 180

Jacobson, Eric O., 173, 217

Jensen, Robin Margaret, 140-41, 143, 149

Johnson, Mark, 9-10, 19-20, 119, 143, 176, 204

Jones, David, 101, 208

Kant, Immanuel, 18, 88

Kristeller, Paul Oskar, 18, 88

Kunstler, James Howard, 7, 72, 175

Lane, Belden C., 132, 134

Lefebvre, Henri, 9, 86, 97, 131

Levenson, Jon D., 26, 126, 134

Malpas, J. E., 9, 11, 51, 57

McCullough, James, 17, 21, 92

Merleau-Ponty, Maurice, 143

Michel, Jen Pollock, 70, 79, 151

Miles, Margaret, 145, 176

Moltmann, Jürgen, 35-36

Murdoch, Iris, 212

O'Connor, Flannery, 207

Perrin, Nicholas, 39, 136, 138

Pohl, Christine D., 80, 84

Quash, Ben, 25, 27-28, 45, 86, 98, 146, 162-63, 214

Rad, Gerhard von, 26-28, 32

Relph, Edward, 10-16, 143

Ricoeur, Paul, 77, 94, 115

Risatti, Howard, 88-92

Ruskin, John, 89, 94, 101, 216

Rybczynski, Witold, 71, 74

Sennett, Richard, 89-93, 97-98, 101, 106

Sheldrake, Philip, 10, 54, 76, 78

Smith, James K. A., 14-17, 20, 28, 63, 67, 117, 119, 139-41, 143, 149, 151, 170, 172, 176, 220

Stegner, Wallace, 10, 13, 202, 211

Taylor, Charles, 15, 176

Torrance, Thomas F., 137, 167-68

Tuan, Yi-Fu, 10, 13-14, 66-67, 206-7, 220

Vanstone, W. H., 35-36, 63

Walsh, Brian J., 63, 151, 170-71, 188-90

Warnock, Mary, 78

Welker, Michael, 27, 31-32, 44

Westermann, Claus, 27

Williams, Rowan, 36, 43, 213-14

Wirzba, Norman, 33, 41, 72, 75, 106

Wolterstorff, Nicholas, 18, 20, 68, 88, 91-92, 177, 179-81, 204, 211-12, 216, 229

Wright, N. T., 38-41, 78, 221

Wynn, Mark R., 10, 15, 134-35, 147, 210

Subject Index

aesthetic(s), 18-20, 43-45, 48-49, 65, 81, 88-89, 91, 108-11, 119, 121, 134-35, 140-42, 144-47, 159-61, 175-76, 178-83, 193, 199, 200-202, 224, 232

architecture, 18, 72, 112, 113, 160, 173, 178, 217, 219
See also built environment

beauty, 3, 8, 18, 29, 36-38, 43-49, 60, 62, 64-66, 80, 82, 93, 105, 108, 11, 119-21, 129, 135, 139-42, 144-45, 147-50, 155-57, 159, 168, 171, 173-74, 176-83, 192-99, 202, 215-19, 221, 225-26, 228, 230-32

belonging, 4, 11-14, 63, 70, 74, 116, 124, 139-41, 144, 146, 150-52, 154, 158, 160-63, 169, 175, 177-78, 183, 189, 210, 229

built environment, 47-48, 111-13, 173-80, 223

Burtynsky, Edward, 29-30

calling (vocation), 24-27, 31-41, 43-44, 49, 65-66, 68, 73, 75, 77, 80, 91-92, 96, 98-101, 118, 121, 124, 126-31, 133, 135, 137, 139-40, 142, 145, 147, 173, 183, 189, 191, 200-202, 208, 215-16, 218, 226, 229-30

Catling, Brian, 144-45

Christo, 47-49

church, 2-4, 19, 41-42, 79-81, 106, 123-28, 131, 135-63, 169-70, 189, 206-7, 209-10, 218, 225

Cologne Cathedral, Germany, 159

community, 3-4, 7-8, 11-14, 27, 32, 34, 38, 44, 49-50, 52, 54, 56, 58, 64, 68-69, 73, 75-79, 81-82, 84-85, 100-101, 103, 108-9, 111-20, 123-24, 128, 130-63, 165,

170-76, 179-83, 185, 190, 192-98, 206, 208-13, 218-19, 221, 226

consumerism, 3, 19, 100-101

contemplation, 18, 21, 88, 91, 98, 114, 116, 142, 147, 158, 162, 179, 200, 202, 210, 217-19, 229

craft, 3, 14, 21, 72, 87-104, 108, 110-16, 119, 129, 160-61, 216

Craftivist Movement, 99-100

Creates, Marlene, 49-59

creation
doctrine of, 3, 24, 26-28, 31-32, 34-44, 52, 72, 83, 91-93, 98-99, 117, 121, 126-28, 131-37, 139, 140, 142, 144-45, 149, 151-52, 154-57, 161, 163, 166, 169, 171-73, 176, 178, 191, 200-202, 203-5, 214-15, 219, 220-26, 228-32
world, 2, 9, 14, 24, 26-28, 32, 34, 53-54, 58, 62-68, 73-75, 80, 125, 126-28, 131-37, 149, 163, 167, 190, 203, 210, 213-18

creativity, 27, 35-36, 44, 58, 89, 92-93, 98, 118, 130, 158, 161, 215

cross (crucifixion), 4, 39-40, 42-43, 59 60, 135, 142, 148, 153, 156, 160, 166-72, 177, 182-83, 191, 199

desire, 15-16, 29, 35-37, 72, 74, 82, 104, 112-13, 119-20, 129-30, 140-42, 149, 164, 186, 217

displacement, 4, 14, 107, 164-66, 168-72, 183-91, 219, 223, 229-30

diversity, 142, 174, 182, 192

ecology, 86

election, 25, 33, 38-40, 68, 125, 208

embodiment, 3, 20, 39, 78, 111, 128, 135, 145, 154, 189, 209, 225

Emin, Tracey, 158-59

ephemeral art, 47, 50-51, 206

eschatology, 35-36, 40-43, 62, 73, 78, 82-83, 86, 93, 136, 138, 147, 149, 153 54, 161-63, 169, 171-72, 188-89, 197, 199, 201, 217, 219-22, 225, 230
See also new creation

ethics, 4, 31, 33, 44, 46-47, 55, 72, 77, 81, 86, 88, 147, 176-78, 181, 183, 191, 193, 199, 212, 216-17, 229-30

Eucharist, 78-79, 101, 106, 115, 189, 205, 208-9

exile, 14, 26, 73-74, 77, 94, 96, 133

Garden of Eden, 27, 33-34, 38, 60, 68, 73, 80, 124, 126-28, 130, 133, 225

gift (givenness), 14, 26, 34-36, 39, 42, 53, 68, 74-75, 80, 121, 161, 168, 201, 213-17

God
Father, 39, 83-84, 169, 210, 214
Holy Spirit, 39, 45-46, 84, 129, 138-39, 154-55, 162-63, 210, 214-15, 221
Son, 84, 135, 165, 208, 210, 215 (*see also* Jesus Christ)

good food movement, 81

goodness, 3, 24, 36-37, 41, 44, 48-49, 53, 65, 67, 74, 82, 147, 163, 178, 193, 221, 225

grace, 34, 40-41, 63, 74, 82-83, 135, 157, 214, 216-17, 223, 231

habitus, 15, 71, 85, 132, 141-42, 146

Hawkinson, Jenny, 95

heaven, 14, 39, 63, 73, 83, 102, 134, 137, 148, 168-72, 189, 199, 221-22, 229

home, 1-4, 14, 38, 55-56, 69-122, 131, 133, 139, 149-51, 153-55, 157,

160-62, 154-65, 169, 171-72, 180, 184, 188-90, 193, 195, 197-98, 210, 219-20, 229

homecoming, 12, 16, 19, 63, 73, 84-87, 97, 107-8, 124, 151, 153, 155, 162, 170, 189, 199, 219, 221-21, 229-30

homelessness, 3, 17, 73, 170, 172, 191, 230

homemaking, 3, 63, 69, 73, 75, 79, 87, 102, 107, 119-20, 188-89

homesickness, 1, 23

homesteading, 84-87, 107, 120, 124, 151, 153, 155, 162, 170, 199, 219, 221-22, 229-30

hope, 16, 40, 42, 62-64, 71-72, 102, 112, 114-16, 136, 148, 153, 162, 172, 175, 183, 188, 190-91, 193, 196-97, 199, 203, 212, 219-22, 229-30

hospitality, 3-4, 16-17, 69-73, 79-84, 86, 92, 97-98, 103, 116-17, 120-21, 146, 149, 150-51, 159, 175, 177, 178, 183, 189, 193, 198, 210, 227, 229

image of God/*imago dei*, 2, 28, 31-34, 36-39, 40-41, 43, 127, 133, 219

imagination, 4, 5, 11, 14-17, 20-23, 25-29, 42, 45, 66, 68, 72-73, 77, 91, 108, 117, 121-22, 144, 150-51, 157, 162-63, 173, 176-77, 182-84, 188, 197, 198, 200-202, 204, 208-10, 213, 220-22, 229-32

 failure of, 29, 42, 68, 188

 geographical, 57-59, 112-13, 174

 local, 188, 209

 placed, 163, 177, 229

 theological, 2-5, 16-17, 25, 27, 41, 49, 124, 170, 182, 200-202, 204, 221, 231

Jesus Christ, 33-34, 37-39, 41, 43, 46, 78-79, 82, 134, 136-38, 154, 166, 168-70, 172, 189, 205, 224

justice, 8, 17, 44, 165, 174, 188, 193, 196, 222-23, 227, 229

kenosis, 35-36, 93, 169, 220

kingdom of God, 2, 5, 49, 78, 116-17, 139, 150, 153, 155, 157, 165, 167, 170-71, 178, 182-84, 190, 200, 202, 219, 222, 229-30

knowledge (epistemology), 8, 10, 15, 18-19, 27, 42, 45-46, 76, 98, 143, 147, 193, 198, 201, 213

Laib, Wolfgang, 37-38

land, 3, 12, 14, 19, 24, 29, 33, 49, 51, 55-57, 59, 62, 73-75, 77-78, 81, 85-86, 96-97, 108, 110-11, 133

landscape, 8, 23-25, 29-30, 37, 43-44, 46-49, 50-52, 54-60, 62-68, 70, 112, 180, 206, 226

Lettieri, Marianne, 102-8

liturgy, 4, 11, 41, 67, 75, 78, 90, 105-6, 119, 124, 138-46, 158, 160, 162, 173-74, 178, 180, 182, 198, 209

Liverpool Cathedral, UK, 158

love, 11, 14-17, 25-26, 29-32, 35-38, 40, 42-45, 48-49, 64-66, 72, 75, 79-80, 83-84, 93, 99, 104-5, 117-21, 124, 139-42, 147-48, 154, 158, 160-61, 165, 168-72, 178, 190-91, 196, 198, 201, 209-10, 213-14, 217-18, 220-22, 226-30, 232

Marshall, Kerry James, 191-98

memory, 3, 11, 14, 49, 55-56, 76-78, 92-97, 100, 102-5, 107, 109, 114-16, 119, 146, 150, 153, 161-62, 164, 178, 181-82, 189

migrant crisis, 4, 16, 164, 186-87, 191

mission, 40, 78, 124, 135, 138, 140-41, 144-45, 147-50, 152-53, 155, 157-58, 161, 163, 178, 200, 209, 218-19

modern art, 18, 87, 109-11, 206

mural art, 179-83

naming, 25-27, 65

new creation, 3, 40-42, 59, 62-63, 68, 131-32, 137, 145, 152, 154, 161-63, 169, 171-72, 183, 205, 219, 220-22

 See also eschatology

particularity, 7, 42, 46, 49-51, 53-55, 58-59, 66-68, 82, 97, 100-101, 135, 137-38, 149, 156, 163, 170, 187, 205-10, 228, 232

phenomenology, 141, 143, 146, 151, 188

physicality, 2, 46, 48, 58, 66, 82, 90-92, 102-4, 116, 143, 145, 163, 203-4, 208

pilgrimage, 84, 170, 172, 232

place

 as "event," 132, 134-35, 223

 sense of, 1-2, 4-5, 7, 11-17, 21, 25, 30, 40, 42, 45-46, 49-50, 66, 73-74, 84-85, 91, 94, 99-100, 102, 108, 117-19, 123, 146-49, 154, 157, 159-60, 165, 169, 171-72, 174-75, 177-78, 180-81, 183, 194, 200-201, 206-7, 210, 212, 218-20, 229-32

 versus space, 9-11

placelessness, 100, 180

placemaking, 2, 4, 10, 11-14, 16, 22, 25, 27-28, 31-32, 34, 42-43, 49, 55-57, 60, 67, 84, 86-87, 92, 98, 100-102, 106, 124, 126-28, 131, 134-41, 144, 147, 149, 151, 154-55, 165, 172-75, 177, 179-80, 182-84, 189-90, 198-205, 207-10, 213-15, 218-24, 226-27, 229

politics, 74, 100, 164, 181, 198

presence, 4, 8, 25, 33, 38-39, 41, 44, 46, 49-52, 54-56, 58-61, 63-64, 67, 73, 80, 84, 92-93, 99, 101-2, 115, 118, 121, 123-44, 147-56, 161-63, 169-70, 178, 193, 196-97, 201-2, 205-6, 208-10, 213, 215-16, 218-21, 223-29

prodigal son, 82-84

public art, 116, 175, 181-83, 232

quilts (Gee's Bend), 108-16

redemption, 35-36, 38-44, 60, 63, 72, 83, 91, 93, 99, 107, 117, 131, 135-39, 142, 144, 148-49, 153-57, 161-63, 166, 169, 171-73, 176, 178, 190-91, 200-202, 214, 219-20, 222-29

refugee, 164, 184-90

 See also migrant crisis

responsibility, 3, 14, 34, 39, 43, 47-48, 58, 73-74, 78, 82, 86, 99, 166, 183, 212, 221, 229

resurrection, 3, 41-43, 78, 93, 107, 145, 148, 153, 157, 166, 169-70, 215

Richter, Gerhard, 159

revelation (divine), 46, 48, 80, 128, 130, 135, 138, 169, 172, 183, 191, 202, 221, 223

sabbath, 75

sacrament, 79, 84, 101, 130, 132, 138, 147-48, 228

sacred space, 106, 123, 125, 128, 130-33, 194

salvation, 44, 83, 125, 131, 137, 147, 205, 217, 220

servanthood, 37

service, 2, 39-40, 81, 124, 140, 144-47, 149-50, 158, 161, 228

Spencer, Stanley, 166-67

spiritual formation, 21, 139-40, 160, 176

St. Martin-in-the Fields, London, 144-45

stewardship, 25, 33, 39, 68

tabernacle, 33, 39, 60, 124-33, 137, 143, 145, 161-62, 215, 225

temple, 38-39, 73, 124-39, 209, 225

Tiesenhausen, Peter von, 59-65

tradition, 5, 21, 51, 68, 78, 85, 102, 108-9, 115, 125, 158, 164, 191-92, 212

transformation, 43, 54, 65, 91, 102, 148-49, 152, 154, 162, 169-70, 176, 178, 183, 198, 214, 218-19, 222-23, 225, 228, 231

Trinity, 36, 81, 84, 214

truth, 36-37, 56, 82, 118, 134, 142, 145, 147, 178, 193, 204, 208, 221, 225

Van Gogh, Vincent, 231

Wales Window, 16th St. Baptist Church, Birmingham, 52-53

Weiwei, Ai, 183-91

worship, 20, 75, 79, 105-6, 116, 123-35, 139-63, 175, 206, 210, 216

Wynn, Keaton, 96-97

Scripture Index

OLD TESTAMENT
Genesis
1, 26, 27, 28
1:1, 26
1:5-10, 26
1:7, 26
1:11, 32
1:16, 26
1:17, 32
1:21, 26
1:22, 32
1:24, 26, 32
1:25, 26
1:26-27, 26, 31
1:26-28, 31, 33
1:27, 31
1:28, 31, 32, 34
1:31, 24, 26
2, 33
2:3, 26
2:4, 26
2:9, 80
2:15, 32
2:19-20, 26
3, 33, 130
5:1-3, 31
9:5-6, 31
12:7, 74
18, 80
18:2, 80
18:5, 80
18:6-7, 80
19:1, 80
19:15, 80
28:16, 60

Exodus
25, 128
31, 129
31:3-5, 129
31:6, 129
31:11, 129

32:1, 130
32:2-4, 130
35, 129
35:22-24, 130
39, 129

Leviticus
19, 81
26:41-42, 77

Numbers
3:7-8, 127
8:25-26, 127
18:5-6, 127

Deuteronomy
8:18, 76

1 Chronicles
23:32, 127

Psalms
77:11, 76
118:22-23, 136
137, 73
137:4, 74

Isaiah
5, 136
40, 25
40:26, 25
40:28, 26

Ezekiel
28:13-18, 126
40, 129
44:14, 127

NEW TESTAMENT
Matthew
4:18-22, 79

5:40, 199
8:22, 79
25:40, 153

Mark
5:19, 79
8:34, 170
12:1-11, 136

Luke
7:36-50, 83
8:22-39, 189
8:39, 79
9:57-62, 79
9:59, 83
9:60, 189
10:25-37, 82, 83
13:29, 82
14:16-24, 82
15, 82
15:11-32, 83
22:19, 76
22:30, 82
24, 170

John
1:1, 205
1:14, 136, 137, 145
2:19, 136
3:16, 148, 165
3:17, 205
14:2, 197
14:3, 137
20:24-29, 169

Acts
1:8, 137

Romans
8:18-23, 39
12, 79
12:4-5, 159

12:13, 17, 79
13:14, 54

1 Corinthians
11:7, 38
12:12-27, 159
15:45, 137

2 Corinthians
4:4, 38
5:17, 39

Galatians
4:9, 39

Philippians
2:6, 39
2:12, 147

Colossians
1, 40
1:15, 38
1:15-20, 38, 41, 220
1:18, 38, 40, 41
3, 38
3:10, 38

Hebrews
4:14, 127
8:2, 129
11:13-14, 14

2 Peter
1:4, 160

Revelation
7:15, 136
12:12, 136
13:6, 136
21, 126, 172
21:3, 136, 171

IVP Academic's Studies in Theology and the Arts (STA) seeks to enable Christians to reflect more deeply upon the relationship between their faith and humanity's artistic and cultural expressions. By drawing on the insights of both academic theologians and artistic practitioners, this series encourages thoughtful engagement with and critical discernment of the full variety of artistic media—including visual art, music, literature, film, theater, and more—which both embody and inform Christian thinking.

ADVISORY BOARD:

- **Jeremy Begbie,** professor of theology and director of Duke Initiatives in Theology and the Arts, Duke Divinity School, Duke University
- **Craig Detweiler,** president, The Seattle School of Theology and Psychology
- **Makoto Fujimura,** director of the Brehm Center for Worship, Theology and the Arts, Fuller Theological Seminary
- **Matthew Milliner,** assistant professor of art history, Wheaton College
- **Ben Quash,** professor of Christianity and the arts, King's College London
- **Linda Stratford,** professor of art history and history, Asbury University
- **W. David O. Taylor,** assistant professor of theology and culture, director of Brehm Texas, Fuller Theological Seminary
- **Judith Wolfe,** lecturer in theology and the arts, Institute for Theology, Imagination and the Arts, The University of St. Andrews

ALSO AVAILABLE IN THE
STUDIES IN THEOLOGY AND THE ARTS SERIES

Contemporary Art and the Church
edited by W. David O. Taylor and Taylor Worley

The Faithful Artist
by Cameron J. Anderson

Mariner
by Malcolm Guite

Modern Art and the Life of a Culture
by Jonathan A. Anderson and William A. Dyrness

A Subversive Gospel
by Michael Mears Bruner

Finding the Textbook You Need

The IVP Academic Textbook Selector
is an online tool for instantly finding the IVP books
suitable for over 250 courses across 24 disciplines.

ivpacademic.com
